THE HISTORY OF MOTION GRAPHICS

from Avant-Garde to Industry in the United States

Michael Betancourt

D1333733

Wildside Press

The History of Motion Graphics: from Avant–Garde to Industry in The United States

Published by Wildside Press

Written with the support of a *2011 Presidential Fellowship* from the Savannah College of Art and Design

ISBN 9781434441508 (trade)

ISBN 9781434441515 (case laminate)

FIRST EDITION

1 2 3 4 5 6 7 8 9

University Centre at
Blackburn
College

Telephone: 01254 292165

Please return this book on or before the last date shown

<div>

SHORT LOAN

7 DAY LOAN ONLY

NO RENEWAL

</div>

CONTENTS

PREFACE

This book is not a history of cinema, either avant-garde or commercial. Its principal concern lies with surveying how both kinds of media production intersect, in the process creating the field of "motion graphics" in the adaptation of experimental film aesthetics—both by the artists themselves and their peers in the commercial industries. Running parallel to the commercial applications of motion graphics are the genres of abstract film, video art, and computer graphics; their relationship to the commercial industry is an apocryphal part of film history. This survey grew from a specific need for an in-depth, historically robust examination of the synaesthetic tradition in experimental media that contemporary motion graphics has implicitly assimilated from the earlier abstract cinemas, visual music performances, and video art practices of the twentieth century. This book surveys the historical context and contributions of exemplary artists and designers whose work was essential in building these connections. A story emerges showing how the ideas of abstract film, visual music, and kinetic typography became "motion graphics" in the United States out of a diverse collection of domestic and international sources that were closely involved with each other: "motion graphics" would not exist without this intersection of avant-garde and industry.

Unlike most considerations of the history of motion graphics in the United States that focus on the field of broadcast design, this history begins with the early attempts to creating a kinetic analogue to painting. Artists trying to create a "motion painting"—to render the implied motion of painterly effects as actual movement—helped establish the techniques of motion graphics, its visual grammar, and through their aspirations to invent a "visual music," created the conventions of synchronizing sound to image. The interplay between commercial and avant-garde film have existed since artists began experimenting with motion pictures. The desire to reach a broad, popular audience has been a recurring part of avant-garde media production since painter Léopold Survage attempted to commercially produce an abstract film with the French Gaumont film company in 1914. The movement between experimental and commercial production continued with Walther Ruttmann's animations done in Germany in the 1920s (the American film studio Twentieth Century Fox even hired him for a project in 1926).

This survey relates broadcast design, advertizing, and commercials to their aesthetic sources in the avant-garde. It is a history where the abstract painting that Ruttmann abandoned for film provides the earliest grounding for all the later

developments, including abstract film and visual music (twin traditions, closely related, yet independent) that converged in 1950s Hollywood to transform graphic design into feature film title sequences.

It is this longer history that is the focus of this study: the invention of motion graphics began not as a commercial need, but from the desire of artists working at the start of the twentieth century to engage with their interests in synaesthesia, abstraction and simultaneity through the new technology of motion pictures. The technological trajectory this historical consciousness reveals is one where the movement is always towards greater precision, efficiency and control over the image seen on-screen—and it is a development that proceeds from "messy" technology improvised or manually controlled through a systematic analysis towards a repeatable, finely adjustable *standardized* apparatus. This technological evolution is apparent in the histories of optical printing, signal processing, and computer animation—all methods and approaches used in the creation of motion graphics.

Studying the history of motion graphics requires that a close look at the origins of their stylistic and visual basis in the early years of the twentieth century and the battle over Modernism that continued through the 1950s. The organization of this story is deeply mired in several distinct fields, each of which has a more-or-less established history, but whose combination when organized around the central locus of *motion graphics* changes their relationships to each other and to the larger histories of art, film, and design. The range of artistic and commercial practices that collectively can be called "motion graphics": visual music, abstract animation, broadcast design, kinetic typography and title design demonstrates a shared history of common sources where motion pictures is treated as a graphic medium, rather than as a substitute for dramatic theater or narrative storytelling. This hybrid tradition is immediately evident watching even the most banal contemporary TV commercial.

01

PREHISTORY

Motion graphics was the last major aesthetic innovation of the nineteenth century to fully emerge during the twentieth. Converging in the final decades of the twentieth century, "broadcast design," "mobile graphics," the "absolute film," "titles," or even simply "animation" have all been used to identify what would become "motion graphics." Any history of the field requires a consideration of how its aesthetics and the varied uses common to contemporary "motion graphics" first emerged from experiments with kinetic abstraction in the late nineteenth and early twentieth centuries. The nexus of abstract film's synchronized geometries with live action outside the framework of narrative, the conventions of synchronized sound and image, and finally the development of kinetic typography shows that motion graphics are more than animated graphic designs.

This field began with the first abstract films made by the Futurist painters in 1909, but these experiments, now lost, did not spring suddenly into being. They emerge from a larger context, one that also produced abstract art generally, and helped establish the foundations for other, superficially unrelated fields such as the 'light show' performances common to spectacular events such as the opening ceremonies for the Olympic Games, or the fireworks shows produced nightly at the Walt Disney theme parks. Central to this development is the impact of synaesthesia on art in the early twentieth century: the influence of "visual music" is visible in commercial motion graphics, most obviously in television commercials, animated logos and graphics, and in the title sequences created for feature films. The aesthetic principles that organize and structure the relationship of image to soundtrack, originates with the earliest abstract films, and before them, with color music.

Motion graphics emerged after centuries of earlier developments and a general cultural aspiration to create a visual art comparable to music: literally a "visual music." The history of color music, the first attempt at creating such an art, and its more contemporary descendant visual music, established the ways that sound and image can be related to each other in a visual medium such as motion pictures. This connection to abstract art creates that work's transcendent or spiritual content—by considering the development of color music the origins of these meanings necessarily emerge as part of understanding the development and organization of the abstract films that are the foundation for motion graphics, precisely because

11

motion graphics are essentially abstract images set in motion: while the linkage of sound and color is an arbitrary phenomenon, in the most successful examples of abstract animation by artists such as Oskar Fischinger, or in title sequences for feature films, creates the illusion of a direct, natural link comparable to lip-sync between sound and image. The art historian's term for this kind of connection is "synaesthetic."

SYNAESTHESIA

The idea of synaesthesia has influenced much of the Euro-American aesthetic tradition—not just motion graphics, but painting, sculpture, and philosophy, as well as playing a role in the development of contemporary ideas about the nature of light and the relationship of light and sound. It is an on-going tradition that continues to develop in contemporary work by artists using digital technology. Prior to the 1980s, motion graphics were almost entirely limited to media made by artists. "Synaesthesia," as a term for connections between sound and image, is used in both psychology and art history:

> In *psychology,* where it identifies a specific perceptual phenomena where one sense simultaneously produces two sensations, most famous as seeing colors when one hears sound.

> In *art criticism and art history,* to define art works where (most often) visual forms are produced as an analogue to music: in synaesthetic abstraction, these connections are explicitly made by the artists in their work.

For psychology it describes an actual experience, in art history its use is metaphoric, a description of art whose design, meaning or inspiration originates with attempts to create art modeled on musical forms, or presenting visual imagery that resembles the various shapes and forms seen by synaesthetes. The use of "synaesthesia" to describe art entails an ambiguity: where for psychology "synaesthesia" refers specifically to cross-modal sensory experiences, such as seeing colors at the same time as sounds, in art the use is often metaphoric, identifying works that attempt to present analogues for one sense, typically sound or music, within another art, most commonly visual art. These ambiguities are a part of how "synaesthesia" has been used in art.[1] They appear because "synaesthesia" often refers to both the actual experience of synaesthesia and its use as analogy in describing an artwork. The literal cross-modal phenomena of synaesthesia is of interest to the history of motion graphics, but only as a reference point for artists such as Vassily Kandinsky whose paintings display the types of visual form also seen in synaesthetic hallucinations, thus providing a clear link between his abstract images and synaesthesia as psychologist Cretien van Campen has noted:

> Kandinsky's early abstract paintings (that he labeled with musical titles such as Composition and Improvisation) contained the sort of blobs, lines, spirals and lattice maps that are experienced by synaesthetes.[2]

The possibility that some artists initially promoting abstraction—avant-garde painter Vassily Kandinsky especially—were themselves synaesthetes offers a further connection between early abstraction and synaesthesia.[3] The forms and

shapes in Kandinsky's paintings demonstrate two things: a use of forms seen in synaesthetic hallucinations and the direct connection of these works to a musical analogy (via their titles). His work is typical of the earliest abstract art whose emergence coincides with a wide-spread interest in synaesthesia from both a scientific and an artistic perspective. These geometric, abstract colored forms also appear in the abstract paintings of other artists working during this period, and find direct translation into motion in the first abstract films (see Chapter 2).

This idea of visual or color music is a wide-spread concern in European culture. It appears within entertainment media, often with little to no explanation, precisely because we are already familiar with the idea of sound and image being closely related, and visualizations of sound having specific forms and appearances. The presence of this type of imagery in an artist's work places it in the tradition of synaesthetic abstraction—an abstraction whose direct points of reference are the meanings assigned to synaesthetic visualizations of sound. Roger Fry, one earliest critics most connected with Formalist art criticism in the twentieth century, identified the aspiration to the state of music as essential to early abstraction:

> [The Post-Impressionists] do not seek to imitate form, but to create form; not to imitate life, but to find and equivalent to life. By that I mean that they wish to make images which by the clearness of their logical structure, and by their closely-knit unity of texture, shall appeal to our disinterested and contemplative imagination with something of the same vividness as the things of actual life appeal to our practical activities. In fact, they aim not at illusion but at reality. The logical extreme of such a method would undoubtedly be the attempt to give up all resemblance to natural form, and to create a purely abstract language of form—a visual music.[4]

Fry's focus on the physically apparent form of the art—its purely visual aspects such as compositional elements (color, line, shape and texture)—is the foundation of Formalist art criticism. His recognition that the Post-Impressionist painters Henri Matisse, Pablo Picasso, André Derain, Auguste Herbin, Jean Marchand and André L'Hote were attempting a "visual music" demands the recognition that early abstraction was concerned with synaesthetic, hybrid responses dominate the development of the aesthetic forms. These ideas were common at the start of the twentieth century. The logical development Fry recognizes, the giving up all resemblance to natural form for an art of abstract geometry, happened in avant-garde painting during the 1910s. This revolution in form and design lead to many artists recognizing that movement, made possible by motion pictures, was a natural extension of these concerns. Otherwise independent fields converge in the shared history of synaesthesia: the idea of a visual art comparable to music produced using abstract forms.

However, it is important to acknowledge that contemporary understandings of "abstract" and the early history and meaning of "abstract" are different. The meaning at the start of the twentieth century has been obfuscated by art critic Clement Greenberg's mid-century revisions and redefinitions of this concept (see Chapter 4). Reaching this understanding of abstract form requires a recognition that it is a tradition of abstraction distinct from the reductive purity of Greenberg's theorization of Modernism as a painterly practice that disrupts naturalism to

become increasingly abstract, in the process discarding hybrid, avant-garde forms in the name of autonomy for art.[5] The tradition of synaesthetic abstraction and Greenbergian Modernism are incompatible. Art historian Jeffrey T. Schnapp has identified a distinct understanding of abstraction operative in the period prior to the 1950s when Greenberg came to prominence. It is this conception that guides the development of the abstract film:

> [...] "abstraction" rarely meant abstract in any pure, rigorously formal, non-referential, and non-representational visual sense, accommodating instead a wide array of hybrid formulations. [...] At once pictorial, poetic, and philosophical, it is embedded within a genre whose history can be traced back to romanticism, but whose moment of triumph comes at the end of the nineteenth century in the context of symbolism, decadentism and the avant-gardes: the interior landscape. [...] As initially employed in twentieth-century cultural debates, "abstraction" signifies less a distinctive pictorial practice that disrupts naturalism in the name of autonomy of art than a mode of unfettered exploration of the world—hence the referential trace embedded in the word "landscape"—closely allied with visionary states: meditation, dreaming, delirium, hallucination. [...] So understood, "abstraction" opens up the prospect of an art that, following in the footsteps of pure philosophical inquiry, symphonic music and certain expressions of spirituality, finds in geometry not only the new vernacular of the era of industry but also the secret language of the psyche or of the world, or of the psyche as world; an art that is "abstract" inasmuch as it has withdrawn from the realm of appearances in the pursuit of something anticipating the noumenal.[6]

The "visionary states: meditation, dreaming, delirium, hallucination" Schnapp identifies are all mental conditions that are implied by "synaesthesia." The connection of this subjective experience to art lies with the invention of color music during the eighteenth century, and its implementation in the nineteenth and early twentieth centuries. Much of the work with abstraction prior to World War II can be accurately described as synaesthetic, and in the case of some artists such as Kandinsky, the kinds of forms seen in synaesthesia are a direct source of his imagery. It is from this foundation that the first abstract films were created, and it is the goal of creating a visual analogue to music—literally a "visual music"—that provided the intellectual content of their work.

Early abstract art reveals an analogy between imagery and music that follows the earlier Romantic interest in synaesthesia as a merging of "subjective" and "objective" world views[7]; the initial emergence of abstract art coincides with a wide-spread interest in synaesthesia from both a scientific and an artistic perspective.[8] Cultural groups interested in synaesthesia were also disenchanted with the rigorous, rational world of normative scientific and psychological theory. Historian Kevin Dann notes in his book *Bright Colors, Falsely Seen*:

> The triumph of behaviorists' view of the human mind and body as reacting machines only served to intensify the Romantic quest for art forms and theories of knowledge that de-emphasized the world of material causes. Romantics held fast to the ideal of the primacy of the imagination, and

synaesthetes would continue in their eyes to offer proof positive of the possibility of attaining new ways of knowing.[9]

The nineteenth century viewed synaesthesia as an escape from the predetermined, mechanical world described by the empirical methods and rational procedures of materialist science and behaviorist psychology. As Dann suggests, both synaesthetic art and the physiological phenomenon of synaesthesia were viewed as escapes from the predetermined, mechanical world being described by the empirical methods and rational procedures of materialist science. At the end of the nineteenth century, when the art world was searching for an alternative to the reductive, mechanical conception of the human mind then developing in the sciences—based on the then-current view of the universe as a clockwork mechanism—synaesthesia offered an apparently unpredictable, highly subjective counter-example. The revival of concerns with color music (due to the newly-available electric lights) coincides with this rejection of a mechanistic, predictable view of human consciousness.

Synaesthesia became prominent at the end of the nineteenth century because it defied easy explanation at the time, in art, it offered a means to counter the claims of universal truth being made by a newly developing materialist science and psychology. When these views first began to appear, they prompted a cultural "war" that played out in a variety of distinct ways: first as the Romantic movement, then as Impressionism and the avant-garde in the fine arts; at the same time, in the fields of design and applied art, it took the form of the "Arts and Crafts Movement" in the UK and US, was called "Art Nouveau" in France and the "Vienna Secession" or "Jugendstyl" elsewhere in Europe—all were Modern movements whose ideals would come to dominate the twentieth century. These related movements are all a reflection of the cultural conflict over the discoveries being made by materialist science and psychology, as well as the rise of industrialization and the mass market.

As Dann observed about nineteenth century Romantic ideology, synaesthesia's sensory fusion was understood as a 'primordial purity' superior to the 'fallen' state of normal perception.[10] Abstract artists rejecting the materialist approach were included in every major art movement from Romanticism through Surrealism. It is immediately recognizable in the elevation of irrationality and emotion over logic and reason. Contemporary clichés about artists as being more sensitive, emotional and irrational are the direct result of this history.

This recovery of primal experiences—the more "accurate" depiction of reality—links early abstraction to Romantic "non-rational" world views produces the quasi-religious universal "spiritualism" and transcendental meanings of abstraction generally. Synaesthetic art, by adopting the form of cross-sensory modality, presents this transcendental Romanticism, and authorizes the aesthetic interest in irrational states of consciousness and perception. This transcendentalism deeply influenced abstract filmmakers such as Oscar Fischinger, the Whitney brothers, Jordan Belson and Harry Smith, as well as many others. It provides the formal foundations for the various theories of audio-visual synchronization used by motion graphics, and is the reason that abstract film often claims to have a transcendent, or spiritual meaning: this interpretation is a function of this larger history.

COLOR MUSIC

The pre-history of motion graphics is identical to the history of color and visual music; kinetic typography only emerged in the development of motion graphics after World War I. The invention of abstract animation, the first type of motion graphics, develops directly from the concerns of color music. This aesthetic provides the most basic meaning and formal structure for motion graphics, abstract film and video, as well as the contemporary VJ who performs visuals live. This early history defined the formal parameters for motion graphics as an art form.

The synaesthetic conception that gives rise to motion graphics is part of the common heritage of European civilization. The ideas of color music as a concept are well established in the popular imagination. In the climax of Steven Spielberg's film *Close Encounters of the Third Kind* (1977), color music has a central role in the narrative itself: without the color music sequence, the end of the film would be entirely different in tone and character. The performance in *Close Encounters of the Third Kind* is very striking. It shows several key features of color music at the same time: its linking of specific color-tone combinations, its nature as live performance, and in an almost absurd literalization of color music's universal aspirations, it is how humans communicate with aliens. In what resembles a psychedelic lightshow/concert, a spaceship lands and the aliens reveal themselves to be (literally) "out of this world." The essential features of any color (or visual) music are all apparent in this film's performance:

(1) there is a direct, visible relationship between color and sound

(2) the relationship, while arbitrary, remains constant

(3) the relationship produces a synaesthetic effect (the result of the first two conditions, listed above, being met)

(4) it is often performed live for an audience

(5) it has explicitly "universal" aspirations

The universal aspirations of this tradition are immediately, and literally, obvious in this scene where humans communicate with aliens using a keyboard instrument playing musical tones synchronized with a lighted screen of colored bars resembling the then-contemporary videogame *Breakout*. Individual colors are arranged into a block organized by hue and intensity to resemble the spectrum.

The distinction between "color music" and a closely related form, "visual music" lies with the claims made about the relationship between sound and color: artists who speak about a "color music" view the connection of a specific color to a particular note (such as C# is violet) as based on an empirical fact about the physical nature of the world, on a par with other empirical facts such as gravity or electro-magnetism. This idea of a direct, absolute connection has been discredited; the works that are belong to the synaesthetic tradition, but do not make scientistic claims, are called "visual music."

Color music is based on the idea that there is a physical, real relationship between the colors of the spectrum and the intervals of the octave. Painter and color music inventor A. Wallace Rimington constructed his Colour–Organ based

on what he incorrectly believed to be a fundamental, physical fact of the world: that the relationship of sound to color is a reflection of an innate, underlying reality, and is not subject to change or revision. He unveiled his invention in 1895, announcing his new art of Colour-Music after receiving a patent on his instrument:

> In the instrument I have invented, and which I propose to call the 'Colour–Organ,' I have taken a certain number of points, at carefully calculated intervals, along the whole length of this spectrum band, and have devised means for obtaining the colour at these points as accurately as possible, in much larger quantity, and in variable intensity. The colours thus selected have been placed under the control of a keyboard like that of a pianoforte.[11]

The design of his Colour–Organ is typical of these instruments: a keyboard allows projection of a burst of color onto a screen or curtain, which is often synchronized with music. It is a direct presentation of the synaesthetic idea of a connection between color and music. For "color music" artists, this connection is an innate property of the physical world, not something they have invented. Unfortunately for Rimington and other color music artists, connections between sound and color are fundamentally arbitrary, and demonstrate nothing but the artist's own thinking. The nature of the note-color relationships depends on the decisions made by the artist constructing the device; there is no physical relationship between color and tone.

However, Rimington's belief was not unusual at the time, reflective of a debate over the nature of light which was part of a larger paradigm shift in physics inaugurated by Isaac Newton's book *Opticks* (1704) that continued through the development of Werner Heisenberg's quantum theory in the 1920s. The difference between "color music" and "visual music" lies with this recognition: *any relationship between sound and color is arbitrary, a construction, and has no relationship to physical reality.*

This debate over the nature of light and its relationship to sound is the source of abstract art's transcendent meanings. The prism and the meaning of the color spectrum it produced was one of the foundational controversies in empirical science and is a major focus in Newton's book. Consider the image of light passing through a prism that has become synonymous with the psychedelic band Pink Floyd; their choice of it is not accidental. The meaning it suggests—*of transcendent reality and psychedelic visions*—existed prior to their adopting it. This meaning reveals the lasting influence of color music and a much earlier controversy about optics and empiricism in European culture. It was a conflict between two paradigms distinguished by how they interpreted the physically observable phenomenon of the color spectrum produced when sunlight passes through a glass prism:

breaking light (Mediaeval)

refracting light (Isaac Newton)

The idea that light is "broken" by a prism is the earlier idea that the appearance of different colors is a result of the prism corrupting the purity of the pure, white light, thus creating the colors we see. This idea was produced by a theological world view known as the Harmonia Mundi. It is a Mediaeval concept from Christian theology

presenting a complete paradigm where everything is "in its place" in a divinely ordered universe organized into a hierarchy, with each part of the observable world fitting into a specific, pre-ordained position. It is a system that immediately offers a vision of order where parallels between different elements, metals, colors and musical notes are immanent and apparent.

The Mediaeval view claimed that light was a vibration in Aristotle's fifth element, *Ether,* just as sound was a vibration in the air. According to this view, sunlight is complete, and the colors which appear in a spectrum are a result of the prism changing the basic nature of the light (corrupting, or breaking it). The prism destroyed the purity of the sun's light; in this view the colors signified a "fall" comparable to "original sin." It is a fundamentally theological account, one that was supported by the apparent similarities between how sound waves act and how light acts in the environment (for example, from a candle or fire):

Spread out uniformly in space

Penetrate materials

Diminish with distance

This collection of similarities are all based on the fact that light and sound can be felt: light in the form of heat, and sound in the form of vibrations. These correlations led Mediaeval thinkers to believe that sound and light were somehow related; thus, the idea of "ether" as the medium through which light travels. In fact, the perceived similarities noted by Mediaeval theologians between light and sound are an illusion, a fantasy produced by their *a priori* model of universal order.

The Catholic church's theological account of universal order, the "Harmonia Mundi," suggested equivalences between different phenomena, and was treated as more than just a theological invention—this system was a topic of "scientific debate" and the assumptions provided the grounding for an entire paradigm of how the universe worked. Color music, with its connections between light and sound, with each color fitting into a specific slot in the musical scale echoes this paradigm.

Isaac Newton's ideas were part of a reconsideration of this conception of the world, in the process, replacing it with empirical science. His book *Opticks* (published in 1704) presented a then-radical interpretation of the prism's effect on sunlight and modeled its colors on the new discovered primary hues—red, yellow and blue. In Newton's account, the prism did not break the sunlight, it revealed the innate colors contained in the light before its encounter with the prism; this is the meaning of refraction.

Yet it is useful to recognize that Newton is a transitional figure; his ideas still contain some of the assumptions of the paradigm he is replacing. His involvement with alchemy is apparent in how he organizes his spectral diagram: his

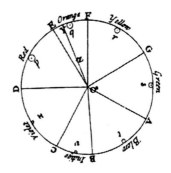

Color Disk, Isaac Newton, *Opticks,* 1704

vestigial medievalism—assigning notes to colors—remains a topic of scientific debate into the nineteenth century when it finally gets resolved. His theory of optics was one of the central scientific debates of this era: the issue of what happens when light passes through a prism. The invention of color music emerges directly from attempts to resolve this debate by showing that Newton was wrong about the nature of light. Its initial basis lies with attempts to demonstrate the linkages between color and sound that the Harmonia Mundi predicted. While all these attempts are futile (there is no linkage beyond what we choose to create), the concept of this linkage is essential to the development of color music itself in the eighteenth and nineteenth centuries. The relationship with synaesthesia, adopted around at the start of the twentieth, was the final attempt to reconcile empirical facts with the theological claims of color music; the transfer of spiritual meanings to synaesthetic forms followed from the color music debate. The importance of synchronization to this work shaped early abstraction and established the audio-visual conventions that motion graphics would inherit.

COLOR MUSIC INVENTORS

Color music before the eighteenth century has a murky history, complicated by lack of records, confused historical descriptions, and the use of metaphors in place of precise detail. The idea that color and sound might have a relationship is ancient, mentioned in Aristotle's book on sensation, *De Sensu et Sensibili*. The influence of his ideas stretches into the present—it was Aristotle who first proclaimed there are five senses, (sight, hearing, touch, taste and smell). The earliest known instrument for creating color music is from 1795; while it is possible there were experiments with creating color music before the eighteenth century, such as the performance of a "color music" by Mannerist painter Arcimboldo in 1590,[12] what these may have been like is now forgotten.

Louis-Bertrand Castel (1688 – 1757)

Father Castel was a Jesuit mathematician and scientist who developed the first modern color music as an argument against Isaac Newton's theory of optics. To demonstrate his theory he attempted to construct an instrument between 1725 and his death in 1757 called the *Clavecin pour les yeux* (Ocular Harpsichord). It depends on the Harmonia Mundi's claim that light and sound are fundamentally similar phenomena. The earlier Jesuit polymath and Renaissance "natural philosopher" Athanasius Kircher provided the basis for Castel's argument against Newton:

> This premise, for sound to be similar to light, sound must be like light in all ways, it must spread out because it has the same source. [...] Just as the light from a fire spreads different colored bodies in different directions around itself, so is sound spread through the air by moving bodies that carry its qualities. [...] When a musical instrument sounds, if someone were to perceive the finest movements of the air, they would see nothing but a painting with an extraordinary variety of colors.[13]

The foundation of Kircher's argument is the similarity of light and sound, and leaps from this correlation to the translation of sound into image—"a painting with an extraordinary variety of colors"—that directly evokes the idea of color music.

Those relationships posed by Kircher's discussion imply a physical connection that, if correct, would be demonstrable through the construction of a musical-scientific device—both Castel's ocular harpsichord and Rimington's colour organ were attempts to build such a contraption, just as the piano-forte (an ancestor to the piano) demonstrated Newton's laws of motion—action and reaction presented through the movement of the keys that caused small hammers to strike notes from wires drawn taught inside the device. That most color music instruments are "pianos" reflects this *attempt* to demonstrate a non-existant scientistic relationship between color and sound through their instruments.

While Castel himself fell into obscurity following his death, the idea of a color music device did not. By the start of the twentieth century, the ideas of sound-image synchronization and synaesthesia are seemingly everywhere in the visual arts. The metaphor of the color piano that Kandinsky uses to discuss his own paintings describes the literal foundation of color music:

> Once more the metaphor of the piano. For "color" or "form" substitute "object." Every object has its own life and therefore its own appeal; man is continually subject to these appeals. But the results are often dubbed either sub- or super-conscious. Nature, that is to say the ever-changing surroundings of man, sets in vibration the strings of the piano (soul) by manipulation of the keys (the various objects with their several appeals.)[14]

The color piano metaphor Kandinsky uses is not merely coincidental. He was involved with various projects based on a synaesthetic transfer from sound to color, such as the play *Die Gelbe Klang* (The Yellow Sound). The description he employs—a keyboard instrument capable of producing color-tones—is typical of the majority of color organs produced throughout the nineteenth century and into the twentieth. Kandinsky's metaphor draws from and shows the continuity between the synaesthetic work of painters and the wave of technological innovation where artists constructed various kinds of color organ using electrical light.

Alexander Wallace Rimington (1854 – 1918)

A. Wallace Rimington is typical of almost every inventor of a visual/color music instrument and system: he believed that his invention was both unprecedented and entirely original. Rimington notes this fact in his 1912 introduction to his book on his color organ, stating bluntly that "An art, which, when I first conceived of it, I supposed to have been hitherto unthought of."[15] His lack of awareness of other artists and inventors is typical. In most cases, the differences between one invention and another is primarily about the arrangement of colors to notes, rather than the organization and implementation of these arrangements which tended to change, matching whatever the most "cutting edge" light-producing technology was at the time. In constructing his device, he drew from commonly held ideas about how sound and color were related, and influenced by the focus on synaesthesia in his era, then built a machine to exploit this "common knowledge" relationship.

First shown publically in 1895, his instrument used rear-projection onto a sheet in his studio, remaining hidden from the audience who saw only pulses and flashes of color on the curtain hiding both colour piano and player. It is a strange

arrangement. His design offers a glimpse of an alternative to the presentation form adopted by motion pictures. The concept of a performance of visual music as in a movie theater did not appear until after the successful commercial expansion of motion pictures.

Bruno Corra (1892 – 1976) & Arnaldo Ginna (1890 – 1982)

Brothers Corra and Ginna were members of the Italian avant-garde movement called Futurism. In 1913, they discussed their color music invention, now lost, in a Futurist Manifesto titled *Abstract Cinema – Chromatic Music.* There has been a consistent sharing of ideas and visual techniques between visual music, abstract film and motion graphics as artists working in one form shift their attention to another. Physical image production techniques used in live performances have found their way into films, while filmmakers have abandoned motion pictures to perform live. With the general availability of electrification starting in the 1880s, these ideas became visible through a series of developments and inventions whose sole purpose was to enable the performance of color in the same way as music: color music:

> Yet we felt the obvious need of a subdivision of the solar spectrum, even an artificial and arbitrary one (since the effect stems principally from the relationships between the colors that impress the eye). Consequently we selected four equally distanced gradations in each color. We had four reds chosen at equal distances in the spectrum, four greens, four violets, etc. In this way we managed to extend the seven colors in four octaves. After the violet of the first octave came the red of the second, and so on. To translate all this into practice we naturally used a series of twenty-eight colored electric light bulbs, corresponding to twenty-eight keys. Each bulb was fitted with an oblong reflector: the first experiments were done with direct light, and in the subsequent ones a sheet of ground glass was placed in front of the light bulb. The keyboard was exactly like that of a piano (but was less extensive). When an octave was played, for example, the two colors were mingled, as are two sounds on the piano.[16]

This instrument, as with many other designs, employed colored light bulbs synchronized to the keyboard of either a piano or an organ. The piano is the dominant model for this device, even used in Spielberg's 1977 film *Close Encounters of the Third Kind.* Corra and Ginna's work demonstrates the close connections—in fact, direct relationship and movement—between painting, color music and abstract film at the start of the twentieth century, factors that remain a constant part of the avant-garde's work with motion graphics.

The transfer between creating abstract films and building color organs has been part of both histories since Corra and Ginna abandoned their experiments with constructing a color organ to make (now lost) abstract films. Their decision to shift from building a color organ to focusing on motion pictures was a result of the technical difficulties in achieving an effective result with their device:

> This chromatic piano, when it was tried out, gave quite good results, so much so that at first we were under the illusion that we had resolved the problem definitively. We amused ourselves by finding all sorts of chromatic

mixtures, we composed a few color sonatinas—notturni in violet and mattinate in green. We translated, with a few necessary modifications, a Venetian barcarolle by Mendelssohn, a rondo by Chopin, a Mozart sonata. But at last, after three months of experimentation, we had to confess that with these means no further progress could be made. ... We turned our thoughts to cinematography, and it seemed to us that this medium, slightly modified, would give excellent results, since its light potency was the strongest one could desire. [17]

Their change from color music to abstract film was neither a failure of aesthetics nor a conceptual deficiency, but a technological one: their color organ did not allow the production of the kinds of visuals they wanted to make. As their decision to work with hand painted film shows, the construction of electro-mechanical systems for creating live visual music and the invention of devices for the generation of abstract films have many elements in common. There are abstract filmmakers, such as John and James Whitney, whose experiments with creating abstract films required their construction of what are essentially varieties color organs, but instead of being used for live performance, their devices worked as part of a motion picture animation set-up, generating imagery for film instead of directly, in a live performance.

Other visual music inventors built color organs and then, like Charles Dockum, used their machinery in the production of abstract films synchronized to music. The development and history of the abstract film is difficult to separate from the history of visual music. For some historians, such as William Moritz, there is no distinction between the traditions apparent in the abstract film and those of visual music. The work of abstract filmmakers who focused on geometric forms, (often) synchronized to music, constitutes an on-going tradition of visual music:

Indeed, visual music has a history that parallels that of cinema itself. For centuries artists and philosophers theorized that there should be a visual art form as subtle, supple, and dynamic as auditory music—an abstract art form, since auditory music is basically an art of abstract sounds. As early as 1730, the Jesuit priest Father Louis-Bertrand Castel invented an Ocular Harpsichord, which linked each note on the keyboard with a corresponding flash of colored light. Many other mechanical light-projection inventions followed, but none could capture the nuanced fluidity of auditory music, since light cannot be modulated as easily as "air." The best instrument for modulating light took the form of the motion picture projector. [18]

As Moritz notes, the creation of abstract art specifically seeking visual equivalents to the forms and structures of music defines a historical tendency that can continue using film. The history of visual music implied by Moritz is one where a desire to create a synaesthetic art motivates the invention of visual music instruments and the eventual dominance of abstract film. As his discussion shows, the history of visual music on film may be identical to the history of abstract film. These links between the abstract film tradition and the synaesthetic performances of visual music reveal the intimate connections between the development of motion graphics, abstract film/video and the development of the technologies enabling the live performance of visual music.

VISUAL MUSIC

Parallel to the development of motion graphics and abstract film in the twentieth century is the history of visual music and the production of kinetic graphics for an audience, often done live, or using specially constructed machines to autonomously cycle through a set sequence of movements. It is distinct from color music primarily in the organization of tone-to-color: for visual music, the synchronization was exclusively an *aesthetic* parameter (*not* a scientific fact) whose modulation would determine the mood and character of the finished work.

Visual music has a closely related, yet independent, history from abstract film that periodically also intersects with the development of motion graphics; often artists will move between film/video and live performance, and especially starting in the 1950s would also work commercially, bringing their aesthetic expertise to television commercials, film title sequences and other programs for a mass market audience. This consistent interplay between visual music and the production of abstract film and video is apparent in the convergence of both the field live visual music and the contemporary field of motion graphics in the 1990s through the use of high speed digital computers; their merging in the field of VJ is unsurprising given their history as 'fellow travelers' departing from the same point of origin. A brief consideration of visual music is useful in coming to an understanding of the ways that its developments relate to the history of motion graphics generally.

The history of visual music is extensive; while there are many points of contact between it and motion graphics, out of the large number of artists, inventors and inventions, only a few have had a lasting impact, either technologically or aesthetically on the motion graphics field. Two of them, Mary Hallock-Greenewalt and Thomas Wilfred are of utmost significance in the development of both technology and aesthetics used in motion graphics and their impact is wide spread, if rarely acknowledged.

Wilfred and Hallock-Greenewalt share certain features in common: both were trained as musicians and had successful careers as soloists before becoming involved with the invention and exhibition of their "new art" based on light instead of sound. They were both highly skilled electrical engineers, patenting their designs and inventions. Each of them also wrote extensively on the aesthetics of their art and published their ideas. Yet, they were quite explicitly rivals: Hallock-Greenewalt sued Wilfred for patent infringement in the 1930s, and their aesthetics, while similarly based on modulation of lighting, are incompatible.

Mary Hallock-Greenewalt (1871 – 1951)

Mary Hallock-Greenewalt was born in Beirut, Syria, but was raised among the elite families of Philadelphia. She filed eleven patents between 1919 and 1927 primarily containing innovations in electrical lighting that have become essential features of media production, all while performing as a piano soloist with both the Philadelphia and Pittsburgh symphony orchestras. Some of her patents describe complex systems of electrically switched lights, remote controlled motors that can switch filters and change gobos in lamps, and a central switching board capable of manipulating all the lamps at the same time. Her various patents were formal descriptions of the elements (including a system of notation based on scores for music) that created a new, technological art form. These components were all

created to produce the carefully orchestrated graduations of colored light that are the foundation of her system of visual music, which she named *"Nourathar"*—a combination of Arabic words meaning "essence of light."

What is especially notable about her instrument for performing this light music, the *"Sarabet"* (named in honor of her mother Sarah Beth), is that even though trained and employed as a concert pianist, Hallock-Greenewalt did not employ the piano keyboard as the basis for her control system, instead designing a table-sized interface with slider bars and thumb dials to control her lighting system. These sliders would show the intensity of light against a graduated scale. Any lamp could be switched on at any level of brightness and could be faded up or down using the rheostat. The illumination could be adjusted by directly moving the sliders, through use of a pedal, and with toggle-switches that worked like individual keys. The resulting control over lighting allowed a continuous adjustment from none to full.

Her Sarabet underwent continuous refinement and tinkering, with the various improvement and modifications resulting in four discrete patents for the different variations in her design. Because it was an electro-mechanical system, setting it up for a performance would often require modifications and significant changes to the placement and number of lamps in order to achieve a full coverage of the performance space's architecture and the geometry of the concert hall. It enabled the central control and adjustment of the network of lights in two ways:

(1) the 1500 watt lights were controlled based on six increments of light intensity: *starlight, moonlight, twilight, auroral, diurnal* and *superbright*

(2) each lamp used a motorized color wheel to change colors drawn from the entire spectrum: violet, blue, green, yellow, orange and red filters

Nourathar did not otherwise employ imagery of any kind, relying on the graduated fades and direct switching on and off to achieve its effects. While it is possible for the lamps developed by Hallock-Greenewalt to use gobo filters to give shape to the light, she did not develop this potential—instead, she focused on fields of color, more like some of the abstract expressionist painters who were to follow, decades later. The mixture of hues would happen as the light played across the surface of the architectural space or screen. These performances were environmental, rather than image or symbol-based. Nourathar is an early example of architectural lighting being used aesthetically, and as a result, its influence on motion graphics is primarily through Hallock-Greenewalt's technological innovations, rather than aesthetics.

Nourathar emphasized the unmodulated use of light in architectural space—the play of colored light across the smooth expanse of an arched or domed space, often accompanied by music, and the Sarabet is a typical example of how the electro-mechanical devices constructed during this period literally built their aesthetics into the machine itself. The decisions about what relationships between sound and image are acceptable must be made by the artist before construction of the instrument: in the case of the Sarabet and Nourathar, the gradual and nuanced play of colored light without projection of imagery or forms in motion defines the difference between it and Thomas Wilfred's Lumia, which was built around the projection of abstract forms in motion.

In patent no. 1,385,944, she proposed a scoring system for Nourathar that was adapted from music notation. The purpose of this system was to enable repeat performances of the same composition; at the same time, it also facilitated the synchronization of these performances with orchestral music. The notations corresponded to the design and markings on the Sarabet's control system and corresponds to the aesthetics of Nourathar: it was broken into three banks of light corresponding to the physical lamp placement throughout the performance space—front, center and rear. Since her performances often happened in movie theaters and used the movie screen, this division could equally be "top, middle, bottom." They also identify varying levels of illumination, with the corresponding intensities her lamps could produce a range of intensities: *starlight, moonlight, twilight, auroral, diurnal* and *superbright.*

Unlike many of her contemporaries, Hallock-Greenewalt recognized there is no relationship between color and music. This feature of Nourathar is apparent in her organization of color not as an octave. The choices being made to synchronize color and sound were arbitrary, guided by the taste of the composer/performer. Her central recognition in the aesthetics of Nourathar was that the harmonic mixing of sound does not have a parallel with light, which additively combines to produce new, independent colors, rather than musical harmony.

The central element of Nourathar, the graduated play of light, required the development of a new type of lighting control: the "rheostat," which enabled her Sarabet to fade the lamps from full intensity to darkness: the divergence between tonal values of sound and light were resolved through the light-to-dark scale of her instrument. No two colors could be shown at the same intensity at the same time. Each position in her scale allowed for only one lamp to be at that level at a time, thus building Nourathar's aesthetic of tonal values into the mechanics of the Sarabet. Closely related to this ability to control tonal values was the mercury switch invented to silence the noise from lamps being switched on and off, thus enabling the use of her Sarabet in orchestral and concert settings without interfering in performance of the music.

Both of these patented innovations were almost immediately pirated by both Edison's General Electric Company and Westinghouse for use in their theatrical lighting divisions. She sued them for patent infringement, but the first judge for her case would not believe that Mary Hallock-Greenewalt, a woman, could have invented so complex and difficult an electrical device as the *rheostat.* His opinion was overturned on appeal, and Hallock-Greenewalt won this suit.

She sued Wilfred following her success with her first suit, for infringing her patent (no. 1,345,168/revision 16,825) that described a system for connecting light and music (i.e. Nourathar) filed in 1916 and received in 1927. This first device employed a hand-painted film that would be viewed in much the same way as one of Edison's Kinetoscopes—by looking directly down, into the machine, at the film strip itself as it passes over the light—and did not involve projected imagery at all. As in her later scoring system, the notation and timing on these film strips is musical, 4:4 time, rather than the intermittent sampling of 24 frames per second common to motion pictures. The light that would come out of the machine, playing across the wall above it, would have resembled the unmodulated play of light common to later examples of Nourathar. She lost her suit with Wilfred, primarily

because his Lumia developed from a different aesthetic than hers did, one based in imagery. Her patent was amended in 1934 to include a disavowal of the "use of stereoscopically focused images such as are known as painted pictures and the like, projected between lenses as distinguished from the substantially shapeless flood of light,"[19] direct evidence of her lost suit against him.

Thomas Wilfred (1889 – 1968)

The other major early visual music inventor whose work has directly impacted motion graphics was Thomas Wilfred who developed his own visual music he called "Lumia." He was originally a lute soloist who performed throughout Europe before emigrating to the United States. His invented art he named "Lumia," he produced not only detailed scores for his compositions (rendering them performable by others, at least in theory), but also wrote several essays on the aesthetics; however, unlike many of the other artists working in this period and later who would move between their electro-mechanical visual music system, painting and other static forms of abstraction, and motion pictures, Wilfred was singular and specific in his rejection of Lumia-on-film as a valid aesthetic form and adaptation of his ideas. The reasons for this rejection of motion pictures have to do with the nature of his technology, and the distinctions between Lumia, other varieties of color and visual music (such as Rimington's Colour-Music or Hallock-Greenewalt's Nourathar), and the basis of motion pictures in sampled photographs for its projected imagery.

While Wilfred's optical system of projection and image manipulation seems like it would naturally lead to work with film and motion pictures, he specifically rejected the photographic medium because the sampling rate—24 frames per second—was not capable of showing the full subtlety of the speed and motions he could achieve with the electro-mechanical technology he invented. The motion picture camera operates through a process of fragmentation, creating its motion effects through the rapid projection of discrete images, and exploiting human perception to create the apparent motion; Lumia does not rely on apparent motion in its motion effects and movements, but on the modulated and controlled use of actual motion—the light moving on the screen in a Lumia performance or recording presents a continuous, physical movement. The rejection of motion pictures devolves from this fundamental technological difference between these technologies.

> Here the technician takes over and transforms the picture book and by projecting its images on the screen in rapid succession—but not nearly fast enough! The standard projection speed of twenty-four static pictures per second does not permit the showing of rapid movement; beyond a certain velocity a moving object becomes a blurred flicker. No capable director permits this speed limit to be exceeded and we are therefore rarely conscious of the shortcoming in the motion photograph.[...]
> In Lumia, the art of light, no such problem exists; the Lumia composer may freely write a rapid passage with the assurance that the interpreting artist at the Clavilux keyboard commands the uninterrupted flow of motion at any velocity, the motion being effected by the player's own hand at the time it is

seen by the spectator. We have so far used rapid motion sparingly in Lumia, but it is there at our command![20]

According to Wilfred, it is this capacity for extreme speed is a potential, although he admits it is not one that he has employed. A Lumia composition contains details and subtleties that the gaps introduced by the sampled nature of *24fps* inherently lose in the process of transfer to the motion picture medium. The distinction between the continuous movement and form of the light composition vs. the sampled fragmentation of film is analogous to the debates among audiophiles over the relative qualities and differences between digital recordings and analog ones.

Where other inventors and color/visual music experimenters focused on the play of color without form, in Lumia compositions, color is always tied to specific shapes and forms developing over time. His Lumia compositions, and the Clavilux instrument he patented to present them, are fundamentally analog projection technologies that generate their visual forms though a process of reflection, distortion and filtering to add color. The visual forms projected in these devices are optically derived from the shape of the filaments in the lamps, modified by gobos and other masks to produce a variety of distinct shapes that were set in motion using electrified clockwork mechanisms that ran on complex, interlocking cycles. The Clavilux was designed in two distinct types:

(1) the instrument where the viewer/performer could manipulate and change the display, and which could be used in a live performance

(2) the performance box (or "recording") where the machine would cycle through a set sequence of visual forms before repeating

These devices were documented through the technical specifications required to patent that with US Patent Office; however, the actual machines he constructed diverge from the filed patents in a variety of ways, depending on the composition the piece was designed to present. The nature of his Clavilux design meant that each distinct composition—whether performed live or as a performance box—would require physical changes to the optical elements, the timing of the clockwork mechanisms and the number, intensity and relationships between the different lighting elements and their filters. The performance boxes run through a complex series of permutations of color and form before repeating any specific combination. These works were organized to recycle their elements and compositions, returning to the beginning of the sequence in a continuous loop.

Hallock-Greenewalt's suit against Wilfred for infringement is not surprising given the technical design of his instruments. The desire for primacy of invention is a common feature of all these inventors, both in their claims and in their responses to critics looking at what they have built and recognizing similarities between it and those of others. Wilfred's objections to his Lumia being identified as a type of "mobile graphics" makes the similarity between the Clavilux and the Sarabet clear; (at the same time, his using on a dictionary definition as the basis for rejecting a general description of Lumia with the term "mobile graphics" is, almost by definition, an example of sophistry):

We may aptly apply Mr. Blake's new term "Mobile Graphics" to the motion painting process—the abstract and non-objective film and the animated cartoon—but the term does not apply to Lumia if we are to accept Webster's definition of the word Graphics, because the Lumia composer neither paints nor draws his composition—he records it in a special notation, akin to musical notation. This notation—letters and numbers on vertical staffs—is placed on the rack over the Clavilux keyboard and the player then performs the composition by moving the sliding form, color and motion keys as the notation indicates. He has the same latitude for personal interpretation of the composer's work as the pianist has in music. Optical elements are actuated in a battery of projectors, and the composition takes visual form for the first time as the rays of light from the projectors reach the screen surface. [21]

The description of the Clavilux reveals the technological overlap with Hallock-Greenewalt's Sarabet: his instrument consists of a series of lamps that are controlled from a central board composed, not of "keys" as Wilfred calls them, but slider bars. The control systems for these devices are remarkably similar, differing only in what they project: the lights are fully remote controlled from this central board, and the composition is written out as a series of discrete instructions based on a model derived from musical notation! While Wilfred's system and Mary Hallock-Greenewalt's are examples of a convergent process—both share a common foundation in orchestral performance, and their devices are a response to the same context that produced other abstraction generally and color music variants in particular—the lawsuit against Wilfred also has an inevitable quality to it since he was directly competing with Hallock-Greenewalt for concert venues. [22]

In spite of Wilfred's rejection of motion pictures, part of the significance of Lumia for the history of motion graphics, and the development of all types of kinetic abstraction, not only in film, but video and computer graphics as well, lies with his recognition that color requires form in order for its motion to become apparent.

In 1965, Wilfred chose to broaden his definition of Lumia to include other work not done with a Clavilux, encouraging its adoption,[23] with some success. His name for a new "art of light" was embraced by other artists, notably by artist-programmer Fred Collopy, and inventor George Stadnik, both of whom employ computer technology in the production of their work. This link between mechanical and digital is logical: Wilfred's technical method for reproducing Lumia compositions recalls the rendering of digital video from a given file, adjustable to whatever device happens to play it:

A Lumia composition may be recorded and mechanically rendered, either full screen size, or reduced to almost a miniature, by means of playing devices corresponding to the phonograph in music. The compositions in this exhibition are such recordings. [24]

Unlike every previous attempt to create a color or visual music, the central feature of Wilfred's work is the creation of visual forms in motion over time; the rendering of the piece happening as the device "plays" the "recording." It is a mechanical

result of the distortion, and transformation of the source material. The technical basis of these compositions is entirely physical: the manipulation of reflectors, colored glass disks, and the lights according to a set sequence of actions run on an electrical, clockwork mechanism. The foundations of this art form, while reminiscent of motion pictures, developed independently of film. Wilfred's visual music developed between 1905 and the first public performance in New York, 1922 as a mechanical system for performance; the "recordings" appeared later, during his a recital tour of live performances between 1922 and 1943.

The influence of the visual forms Wilfred used in his Lumia compositions comes from the second variety of work, the self-contained autonomous recordings, or Lumia boxes. The Museum of Modern Art in New York exhibited five of Wilfred's Lumia compositions in the groundbreaking 1950 exhibition *15 Americans* that introduced the Abstract Expressionist painters Jackson Pollock, Mark Rothko, Clyfford Still to a broad, general audience. One of his compositions in this exhibition, *Vertical Sequence, Opus 137* (1941), became part of MoMA's permanent collection and was on view outside the gift shop for many years before finally being put in storage. The result of this exposure has been to make Wilfred's visual ideas paradoxically highly visible, but largely forgotten. Following their high profile presentation in a pair of exhibitions of visual music, one organized by the Hirshorn Museum in Washington DC, and the other in Paris by the Centre Pompidou, both in 2004, the influence of Wilfred's work on motion graphics emerges in unexpected places; for example, in fourth and final season of the NBC television show, *Heroes*.

Heroes (2006–2010) was a fantasy program drawing from the innovations of Marvel comic books in giving realistic, often average characters special, even magical, powers. In season four, the program introduces a deaf woman who apparently has some variety of synaesthesia—she sees sound as moving, colored veils of light. These veils look almost exactly like the types of visual forms used by Wilfred in his Lumia compositions. The specific forms adopted by the "sound" in reveal all the characteristics of visual music: it is both tinted and connected to specific notes, and the veils of light that move through the air spin and evolve in the same way at Wilfred's compositions. The influence of visual music can be found in these relationships: not just the ideas about what music should look like when it appears visually, but how those forms ought to be synchronized to the music and the way their visual development proceeds. It is the underlying assumptions about what sound should look like if we were to see it that are the direct heritage and significance of visual music, and especially Lumia, for motion graphics.

KINETIC TYPOGRAPHY

Motion graphics emerged from a combination of two major historical factors: the aesthetics that developed around synaesthesia in both color music and abstraction, and from the translation of typography into motion—kinetic typography. Each of these sources for motion graphics depended on the invention—in the case of visual and color music quite explicitly—of new technologies. Like motion pictures and visual music, motion graphics also depended on the development of specific technologies beyond just the motion

picture camera; the available technology has always constrained the aesthetics of motion graphics. The ease of combination that digital technology brought to compositing live action, animation and typography has enabled a reconsideration of typography as an essential, active element within the motion image, and is responsible for the consolidation of different fields into contemporary motion graphics.

The aesthetic development and particular narrative uses for kinetic typography in motion pictures depends on the specific technology used in its integration with other filmed material: different technologies offered distinct potentials; with the advent of digital compositing, the range of uses for typography within the film narrative radically expanded, in the process reanimating early film's experimentation with image, typography and their combination. It is a continuous aesthetic issue in motion design. The development of technology to combine different pieces of pre-photographed material was a major area of advancement and innovation throughout the history of motion pictures. The history of motion graphics—most visible in title design and kinetic typography—is one of continuous invention, where new machines to optically combine different types of material, with consequently distinct aesthetic potentials depending on the technology enabled distinct approaches to motion graphics.

Understanding the relationship between typography and its role in a narrative depends upon the context of that use—how it figures in relation to the "story space," or diegesis, of the fictional world shown in the film. This concern with the construction of fictional spaces, what the characters recognize as existing within their "world," and how the typography figures in relation to that screen space are essential to understanding the nature of the narrative function of typography in the context of any particular film or television program. At the most basic level of construction, the role of text-on-screen is determined by the ability to characters to interact with, and be aware of, those typographic elements.

The issue for all kinetic typography is one of application: how the type is inserted into the narrative 'space' of the film. The design of intertitles provided the first integrations of typography into the narrative of the film itself. The relationship between typographic and photographic elements in later feature films reflect the dynamic nature of the visualization of narrative in the silent era. The relationships between text, image and narrative established with the first feature films can be broken into three broad categories based on the kinetic typography's narrative function in that fictional world.

Early film developed three several distinct narrative uses for typography that correspond to the relationship between these titles and their role in the fictional narrative—the relationship they have to the diegetic narrative space. Both varieties of text on screen in the silent era—titles that identified the name of the film and its credits, and the intertitles that contained narrative, dialogue, and informed the action on screen—were produced apart from the main production of the film itself. In these early films, the intertitles received more emphasis since they were the means used in actually telling the story, apart from the action seen on screen. The writers of intertitles were credited for their work on these early films, while the designers who produced the titles (sometimes the same person, sometimes not) were not often credited. Their organization in relation to the narrative space on

screen—the story enacted by the actors—creates the role for the typography; it is only in the specific context of how a given title functions within a particular narrative that its relationship to that diegetic space becomes apparent. These initial conventions for engaging text within the visual and narrative elements of the filmic space established the parameters for how typography would function after the introduction of sound in 1927. This use of typography would gradually be adapted in television as TV production shifted from live performances to the filmed-shows-for-television made in Hollywood starting in 1954.

All three of these functions are apparent from almost the beginning of title cards' use in film. Even the animated title sequences created by Saul Bass, Maurice Binder and other designers can be contained by this descriptive system: in the 1950s, it is typically a non-diegetic element, set apart from the fictional world being presented in the film narrative itself. The ways that it has developed beyond this initial foundation describes the evolution away from being title sequences and towards a preamble to the fictional film that follows. These three categories had all emerged by 1919, and limit the role of kinetic typography throughout the history of motion pictures as a whole.

(1) Diegetic Typography

Diegetic Typography depends on the audience being able to recognize that the moving type shown on screen is a part of the narrative world; characters are aware of it and its presence functions within their world. It is part of the story space the characters experience and encounter.

It is the most immediately obvious use for intertitles and other insert-shots of written material: it appears in early films as insert shots of letters, diaries, books and other texts that characters on screen read or discuss with each other. Non-diegetic typography clearly exists outside the narrative space of events shown on screen, unconnected to the actions shown on screen or to the consciousness of the characters' world within the story. Both *diegetic* and *non-diegetic typography* are developments that were fully established internationally in the formal language of feature films by 1920.

(2) Non-Diegetic Typography

Non-Diegetic Typography presents moving type that is not a part of the character's world, but is instead being presented as a comment, illustration, or function of the narrative, but is not accessible to the characters who act within the fictional world.

It was common in the so-called silent era films, appears as the intertitles which present a character's dialogue. These title cards, inserted into the narrative typically employed a static graphic design distinct from that used for other intertitles—so the audience watching the film would be able to identify the dialog as separate from other inserted typography. Often these intertitles contain, in separate cards from the dialogue, other non-diegetic elements such as statements about time, place, as well as providing narrative linkages that might be given using voice-over in later film productions.

(3) Extra-Diegetic Typography

Extra-Diegetic Typography functions within the (narrative) story space, giving information that is part of the story and expresses something a specific character experiences *internally*, but is not a visible part of the story space itself; the other characters are not aware of this typography and do not interact with it.

This use of typography is more complex than the others.

The Cabinet of Dr. Caligari is one of the earliest examples of kinetic typography functioning within the narrative 'space' of a fiction film in a way that is clearly distinct from the more prosaic applications—such as a character reading a letter where the letter itself is shown to the audience, or the appearance of signage within shots. This integration of kinetic type into the drama appears within the visual space of the climactic scene where Doctor Caligari's reaction to the typography is central to the action. It is a highly unusual moment in an already unusually experimental feature. The use of diegetic and non-diegetic type is extremely common in the "silent" era film precisely because it did not have the technical capacity for synchronous sound; however, the extra-diegetic typography in *The Cabinet of Dr. Caligari* is of a different character entirely than those commonly used. It appears in the film not in the form of a letter or book, but as a visualization of madness—a presentation of an internal mental state—as the dramatization of the film's climax.

The moment comes at a crucial point in the film, literally the central discovery at the heart of the drama: the head doctor, the man running the insane asylum, is himself insane. Cesare has been brought in, the doctor has recognized him as a somnambulist, and runs from his office; outside, literally written around him on the trees and the curving wall next to the path are the words *"Du Musst Caligari Werde"* ("You Must Become Caligari"). The language is mapped onto the tree branches, appearing letter by letter in a stop-animation process. It is historically exceptional, and this type of integration into a fictional narrative remained uncommon until digital technology fundamentally altered the production process.

This early example of kinetic type was produced using an innovative combination of techniques that would become one of the two most common methods for titling by the 1930s, and which would remain in use until digital technology completely altered the production process in the 1990s: using the photographic shots of the scene for reference, the type was shot with an animation stand, with the lettering registered to the photograph, and animated into the shot using the standard single frame technique. This shot of white (clear film) typography against a black background was then superimposed over the photographic shot during the printing process—in the answer print, the type shows up white (as overexposed film) within the scene. It is fundamentally a special effects shot where the special effect is the typography appearing on screen. Because the actor, Werner Krauss (Dr. Caligari), responds to the type, the illusion of its presence is complete. It is the external projection of his madness, the visual enactment the shows his excitement at the arrival of Cesare leads not to the grand scientific discovery, but through the doors of madness. The diegetic typography appears to both the doctor and to the audience, but it is simultaneously apparent to the viewer

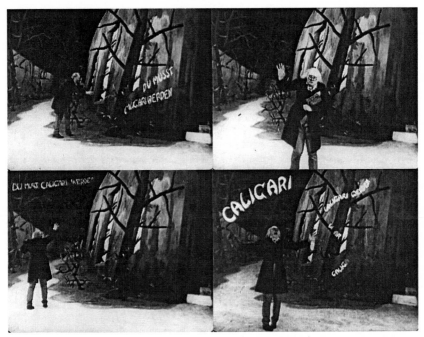

Stills from *The Cabinet of Dr. Caligari* (1919) showing extra-diegetic typography.

that these words are a hallucination, a mental projection onto the world around him, much as the distorted sets and design suggest a contorted and unstable reality.

The invention of extra-diegetic typography in *The Cabinet of Doctor Caligari* remained significantly unexplored until much later in the history of motion pictures: early examples of this contemporary revival appear in the film *Zentropa* (1991) as rear-screen projection of giant words seen on screen, and in *Fight Club* (1999) where the use of typography is limited to one scene where Narrator, played by Edward Norton, talks about buying his identity from IKEA: this is a single shot that transforms Narrator's apartment into a page from the IKEA catalog, complete with item names and prices, composed to follow the style and design of the catalog it simulates. While these intrusions of text into the story space are indexed by the narrative action, and in the case of *Fight Club* signaled by Narrator's voice over, as in *The Cabinet of Doctor Caligari,* they are not a feature of the visible story space, existing in an intermediate position between being diegetic and non-diegetic in the historical uses of motion typography established by the silent era, thus: extra-diegetic.

TV commercials offer enormous opportunities for experimentation with typography and innovative animation, as they have since their introduction in the 1950s; however, typography has always played a role in the TV commercial—but it is in the narrative fiction film and TV program that typography has begun to have a more significant presence than simply within the title sequence. It is these, essentially new, sites for typographic integration that digital technologies allow. However, digital technology only became available for motion graphics on a commercial basis during the 1980s; prior to that time, the creation of motion graphics and kinetic typography required other, more physical, techniques.

Understanding these technologies is essential to the history and aesthetics of motion graphics done before digital technology.

B-Roll

The simplest technique for adding typography to live action has been available almost since the beginning of motion pictures in the 1890s—to over-expose selected parts of the final release print shown in movie theaters. The addition of typography in this way depends on the printing process used to create a finished print from several different shots: when motion picture film negative is conformed to match the edited work print, it is typically cut into two rolls—A-roll and B-roll—with the different shots alternating in a checkerboard fashion between these rolls. Thus, when there is a shot in the A-roll, in the B-roll there is only opaque black leader. This allows the printing of a motion pictures without showing the glue edits used to hold the different film strips together with the black leader film. B-roll titles are also called "Burned-In" because they appear in place of the black leader that normally would be used in the roll opposite a shot from the film. When printed, these titles burn-in the white text, creating a superimposition. Because the B-roll titles typically only include typography, the text appears on screen combined with whatever the opposing shot contains.

Diagram showing A-roll and B-roll for superimposed titles in production of an answer print. Grey areas indicate photographic content; black areas are opaque film leader.

B-roll titles are typically shot on an animation stand, allowing for a high degree of control over their registration frame-to-frame, a fact that enables the titles produced as B-roll to be animated and as complex as designer-animator wants to make them. However, there are some constraints. Since B-roll titles replace the black leader that is normally used in the B-roll to hide the glue edits, the conventional approach to creating B-roll titles is to superimpose them over a long take—a shot that runs for the full duration of the sequence without editing, thus resolving the issue of glue splices showing in the finished answer print. This approach also means that adding B-roll titles to a feature film can be relatively inexpensive to produce, a factor that has historically conditioned that available options for producing title sequences. The resulting type, because it is a superimposition, also means that it is generally only possible to produce white lettering; type that includes color is commonly a sign that it was produced with an optical printer instead of as B-roll.

THE PROJECTION PRINTER

The creation of improved technologies for the production of motion pictures by engineers was a significant part of the early history of film. Like the visual music inventors, Freeman H. Owens (1890 – 1979), a prolific inventor of motion picture and camera technologies, (11,812 inventions and 200 patents, including the A. C. Nielsen Rating System used by the television industry), was exceptional. After dropping out of high school, by 1910 he had developed his own motion picture camera that he used to cover news events: he filmed the Chicago Stock Yards Fire (1910) and the Charleston, South Carolina Hurricane and Flood (1911). Starting in 1926, he patented several versions of the projection printer, each designed for greater control over the resulting composite film. His work is part of a trajectory towards ever greater precision and control over the combination of multiple images into a single moving picture.

Developing from a technical need to greater control over the superimposition process used in B-roll printing, the projection printer was an intermediate technology that combined the direct compositing of B-roll with the compositing effects possible with the technology that replaced the projection printer known as optical printing; the projection printer was in common use by the 1920s. This machine allowed the combination of two separate images onto a single film strip, but did not allow precise masking and compositing of different elements—it used mirrors to reflect the image of two distinct film strips onto a third, creating a composite image through superimposition. These production machines did not employ a camera in the reproduction of its imagery, instead an array of mirrors and lenses transferred (and optically mixed) the film frames on two different strips of celluloid onto a single negative. The early abstract animator Hans Richter used a projection printer to produce both of his abstract films *Rhythmus 21* and *Rhythmus 23* (discussed in Chapter 2). He explains how these machines enabled the production of complex animation from only a limited number of basic elements:

> My first film was *Rhythm 21*. I did the shooting partly on an animation table, partly in the printing machine shop, by stop motion, and forward and backward printing. The printing machines at that time were not fully automatic and you could use them like a camera.[25]

The "printing machine" Richter refers to is the projection printer, whose ability to optical combine and remix a small group of components into longer, more complex pieces reflects the basic nature of this technology as a mechanical analog to the optical printer and, later, the digital computer. However, the ability to selectively manipulate different film strips was limited due to the nature of the technology: the film strips would be refracted and focused onto each other using mirrors, and the machines were designed to run at high speed—they were designed to enable specific types of reproduction, including automated print transfers between different sized film stocks (35 mm to 16 mm). Their ability to combine imagery enabled the creation of superimpositions and other early special effects in post-production. The replacement of the projection printer by the more precise optical printer came as a logical elaboration of the technology towards greater range of effects and a higher degree of control over the result.

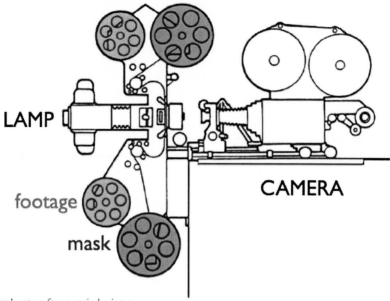

LAMP

footage

mask

CAMERA

Simple set-up for an optical printer.

OPTICAL PRINTING

The origins of optical printing technology lie with refinements of an earlier machine, the "projection printer" that enabled it to become useful for creating various types of special visual effects, and is one of the foundational technologies for motion graphics as it developed after World War II. Linwood G. Dunn (1904 – 1998) constructed the first modern optical printer by combining a projector and a motion picture camera in 1929, used in the feature film *Ringside* (1929). Complex visual transitions from scene to scene, such as wipes, push-offs, and various kinds of image modifications and distortions that appear in films starting in the 1930s were enabled by this technology.[26] He patented an optical printer design in 1946 that was the first mass-produced system, the *Acme–Dunn Printer*, produced by Hollywood Film Enterprises in Los Angeles.[27] These machines use a camera that rephotographs film on a frame-by-frame basis as it passes through the 'projector' or printer head. Technically there is no 'projector' in an optical printer since the only lens is attached to the camera that rephotographs the existing film, which is not projected—it is backlit. Both the camera and the printer head's mechanisms must be perfectly aligned to each other to insure proper reproduction of the existing film passing through the printer head. Unlike standard projectors, the optical printer does not need a shutter: all the optical effects, including exposing the film, as well as dissolves or wipes are a function of the camera, and would be redundant in the projector.

Both camera and printer head are mounted on rails allowing their positioning to be controlled precisely. The position of camera and projector can be moved laterally, vertically and horizontally, enabling tilts, zooms and pans within existing—stationary—footage. The entire device is typically motorized, allowing precise, repeated control over the camera, and in some cases, the printer head's

position as well. As with other animation technology, an optical printer enables repeated exposure of the same filmstrip multiple times, allowing the creation of complex imagery drawn from several sources within the singular frame. It is through optical printing that the history of motion graphics and special visual effects overlap, most especially through the combination of animated and kinetic typography with live action in title sequences.

Because optical printing is fundamentally a process of rephotography, the materials being optically printed can be subjected to a range of transformations that effect, the image as a whole, as well as its motion, duration, and contents. The potential changes to motion pictures that optical printing (and compositing generally) makes possible can be summarized as follows, based on whether it is the full image, the duration or some combination of elements being altered by this post-production technique:

(1) **Full Frame-Based Transformations**
 Hold
 Superimpositions / Dissolves / Fades
 Horizontal / Vertical Flips

(2) **Time-Based Transformations**
 Loop
 Speed Ramping
 (slowing/accelerating the speed of the movement)
 Resequencing
 (Forward / Reverse, interlacing shots, flicker)

(3) **Image-Based Transformations**
 Pan
 Zoom
 Compositing (including the addition of typography)
 Reframing and Cropping

This collection of potentials is divided according to how the contents of the frame are treated in the optical printing process. Both full frame-based and time-based transformations simply reproduce the entire film frame without alteration; image-based transformations involve the ability of optical printing to change what is actually seen on screen in the frame itself—through either using mattes to combine different shots, or by employing the potential implicit in rephotography to take an existing image and alter the framing of that shot through cropping it, moving in to pan across it, or to zoom in on a particular detail within the larger shot; in each case the Image-based transformation creates a new framing of the existing shot. Optical printing takes what is photographic material and enables the treatment of photographic imagery as being a plastic medium, able to be changed and combined in the same ways that graphics can be manipulated in standard animation. This ability to manipulate and combine photographs was an essential tool for the integration of photographic materials with animation and typography, bringing into the motion image many of the same combinatory potentials available in graphic design.

Most historical motion graphics employ a mixture of techniques including materials shot on an animation stand, optical printing, superimpositions, and B-roll (which is added when the final answer print of a film is being made). Special visual effects photography also uses the optical printer's ability to composite; it is through this application that motion graphics and special effects overlap since optical printing enabled the combination of elements filmed separately into a single finished work.

The optical effects produced with a printer can be grouped into two types: variations on superimposition, and variations on masking. Superimposition is the most basic of these effects: the overprinting of two different images in the same frame; fades and dissolves are a variation on this process. A fade is, fundamentally, one half of a dissolve: in a fade-out the exposure of the footage is reduced in precise stages over a set number of frames, resulting in a picture that grows steadily darker; the fade-in reverses this process. A dissolve works by combining a fade-out on one piece of footage with a fade-in on another—resulting in a constant exposure of the new film strip, but a graduated change in its visual contents as the various exposures of each original strip changes.

Masking is related to this process, but where superimposition works with entire frames' contents, travelling mattes cover part of the frame, and leave the remainder visible. This process involves threading two spools of film through the print head at the same time—an essential part of compositing several shots together—so that part of the image is entirely hidden (hence, "masked") by the second film, leaving only the parts desired visible. Raymond Fielding, the special effects cinematographer who wrote the primary textbook for producing visual effects with optical printers and other, more complex technologies explains this elaborate process:

> An entirely different process [than superimposition] must be used to 'jigsaw' the moving figure of the actor into the background image and to produce a convincing composite, in motion. What is obviously required is a type of matte which changes in position, size, and shape from frame to frame—a 'travelling matte,' whose silhouette conforms exactly to the shape and movements of the actor, allowing him to move anywhere within the picture. Two entirely different classes of travelling-matte processes are available to produce this kind of composite. The first is a self-matting technique which is applicable only to black-and-white photography. The second—suitable for either black-and-white or color—is an optical printing process which employs strips of motion-picture film, bearing photographic silhouettes which alternately obscure and reveal foreground and background images during successive printing operations.[28]

In compositing with masks, at least two different matte films are needed: one for each part of the final film being created. The 'first technique' (used only in black and white films) Fielding mentions was developed in the 1920s by C. Dodge Dunning and Roy J. Pomeroy: similar to later chromakey, it was done "in-camera" during live filming as a way to create composite shots. Two film strips would be threaded through the camera at the same time: unexposed film stock, and a second strip with a film positive (a print of whatever was to be combined with the live action). The

combination of these stocks depended on differences in the wavelength of colored light: the positive was dyed orange, and the new live action parts of the scene being filmed were lit the same color; any background elements were lit in blue. As the bipacked film strips were exposed in the camera, the orange-lit action passed through the film strip, while the blue-lit areas did not. The effect would combine both elements——live and filmed——onto the same black and white negative, producing a composite.

In some ways optical printing required more planning, but also corrected the limitations of the Dunning–Pomeroy system: it could only be done with black and white film, did not allow camera movement or a moving background, and could not be corrected after it was shot. Its replacement by other means with greater control was therefore inevitable given the historical development of Hollywood studios towards ever greater control over the finished motion picture image. However, elements of this combination of live action with other footage by posing actors in front of a colored background remain in use: chromakey in video, which enables the creation of an "alpha channel" in video and digital compositing, functions in the same way as these historical processes, but with radically different technology. The later video process of chromakey used a similar procedure——the selection of a color to "remove" from a shot (typically blue or green)——that would then facilitate the combination of the remainder into a new composite. It is the separation of one part of the image from the rest that is significant to these production processes, whatever the method that might be used in achieving that result.

The ability to combine different types of material into a single image——animation, typography and live action——brings the work of motion graphics into close proximity with both traditional character animation and special visual effects. It is a symptom of digital technology's impact on the techniques of narrative story telling, expanding them to include typographic elements not commonly seen since the silent era. These relationships develop precisely because all these disciplines share a common basis in the individual still images arranged in sequence that are the foundation of all motion pictures, whatever their pictorial contents might be: in effect, all motion pictures proceed from a foundation as animations, and this fact enables the various combinations and transformations made possible in motion graphics and its related brethren. The distinctive features of motion graphics, however, lie with its specific history beyond the boundaries of motion pictures in both graphic design and the fine arts, and it is this particular history of abstraction, visual music, video art that merge with design in the middle of the twentieth century to produce the distinct field of motion graphics.

02

INVENTING THE ABSTRACT FILM

Abstract film is the origin of motion graphics and provides the foundational conventions of how images relate to sound, the formal shape of the field, and the most basic elements of visual technique and technological application. The history of abstraction in motion pictures includes a set of interlocking concerns with synaesthetic form, the painterly and graphic organization of space, and the use of technology, especially optical printing and computer technology, in the production of imagery. Within this broad scope, the abstract film and its relationship to visual music occupies a central position in the invention of motion graphics.

In tracing the development of abstract motion pictures over the course of the twentieth century, it is possible to identify three distinct phases to its emergence and consolidation as a specific genre of animation that correspond to its engagement with the art world. The first phase begins with the invention of motion pictures and ends with the *Art in Cinema* exhibitions organized by Frank Stauffacher at the San Francisco Museum of Art in 1946. This screening series marks the beginning of the second phase, which was characterized by the consolidation and the development of organizations devoted to the presentation of film as an art, independent of commercial cinema (Hollywood) distribution. The third phase, characterized by a historical focus, emerged at the beginning of the 1970s as the abstract film and video were institutionalized by the art world that selected canons of major artists in avant-garde film generally; abstraction based on synaesthetic concerns was relegated to a minor position within this history. The reassessment of abstract film and video began much later, in the mid-1990s, as digital technology made the abstract heritage of commercial media obvious, forcing a reconsideration of the larger history.

Where the first two periods are concerned with supporting, exhibiting and promoting the artists making films in a variety of genres collectively termed "avant-garde," "underground," or "experimental film," what specifically defines the third period is the shift to a group of concerns about writing and teaching its history, inherently leading to the formation of a "canon" of particular films and filmmakers that are of greater and lesser importance. Works produced in this third period are generally marked by a greater historical awareness, self-conscious quotation of earlier work, and an orientation to the new fields called into being by

their movement into the academic environment. The nature of criticism during the third period is specifically academic, primarily focused on the established canon of film artists.

What unites the first generations of abstract cinema innovators, experimenters, and inventors—those artists active prior to the *Art in Cinema* shows of 1946 at the San Francisco Museum of Modern Art—is an interest in creating films that provide a kinetic analogue to then-recent developments in avant-garde art and painting—the abstract results of these experiments were called the "absolute film." The attempt to create a systematic, universal language based on abstract form, a focus of some abstract painters such as Vassily Kandinsky and Kasimir Malevich in Russia, was also a direct goal of the experimental animations (called *absolute films*) produced by Hans Richter and Viking Eggeling in 1920s Germany. Other concerns with dynamism, movement, and visuals predicated on an analogy with music also provided subject matter and an aesthetic for these early works. By the mid-twentieth century, these concerns were assimilated by second generation of film artists as the foundations for the language of abstract film, and by century's end, had become one of the foundation for motion graphics' use of music.

The development of abstraction in motion pictures throughout the entire twentieth century was simultaneously caught between two related concerns: the commercial deployment of motion graphics in advertizing, and the entirely independent creation of an art origins lie within painting, visual/color music and the esoteric spiritualism of the fin de siècle, such as the mystical writings of the Theosophists. The abstract film began specifically as an avant-garde experiment in creating a new art, one that is also a variety of visual music. However, during the first period of invention there are examples of artists who used commercial support to produce what are more commonly regarded as independent abstract films—both Mary Ellen Bute and Oskar Fischinger produced their films for general theatrical distribution. There are many examples of these same artists creating abstract films as advertisements for cigarettes or early TV (both Fischinger and Len Lye) and even postage (Lye and Norman McLaren) as a way to secure funding needed to make the films. This commercial basis also provided a venue for their presentation to a general public that would otherwise remain unaware of their existence. It is the connection between the avant-garde aesthetics of abstract film and the commercial concern with being 'modern' that brought these sources of funding to the early abstract filmmakers.

THE FUTURIST ABSTRACT FILMS (1909 – 1912)

Bruno Corra (1892 – 1976) and Arnaldo Ginna (1890 – 1982) were Italian Futurist painters whose concerns with creating a new art for the new Modern world they saw as embracing speed and powerful kinetic movement, naturally lead to experiments with adapting this ideal to motion pictures; in the process they made the first known abstract films, now apparently lost. The only surviving record of them is the description in the Futurist manifesto, *Abstract Cinema – Chromatic Music,* describing both their experiments with hand painted films and their (also lost) color organ. The description of these films gives a sense of what the compositions were

like, but little is said about the tempo of the movement, or how the forms developed and evolved visually on screen:

> We turned our thoughts to cinematography, and it seemed to us that this medium, slightly modified, would give excellent results, since its light potency was the strongest one could desire. The other problem concerning the need to have hundreds of colors at our disposition was also resolved, since, by exploiting the phenomenon of the persistence of an image on the retina, we would indeed have been able to make many colors merge, in our eye, into a single hue. To achieve this it was sufficient to pass all the component colors in front of the lens in less than a tenth of a second. In this way with a simple cinematographic instrument, with a machine of small dimensions, we would have obtained the innumerable and extremely powerful effects of large musical orchestras, the true chromatic symphony. This was the theory. In practice, the results, after we had acquired the camera, procured many hundreds of meters of film, removed the gelatin and applied the color were, as always, mixed. To achieve a harmonious, gradual and uniform sequence of chromatic themes we had removed the rotating switch and had managed to get rid of the shutter action, too; but this was exactly the reason for the failure of the experiment, and meant that in place of the expected marvelous harmony there exploded over the screen a cataclysm of incomprehensible colors. It was only subsequently that we understood the reason. We replaced all the parts we had removed, and decided to consider the film to be colored as divided into bars, each one as long as the space between four perforations, which corresponds at least in films of the Pathé gauge, to one complete rotation of the switch.[1]

This description is filled with useful information about what they produced, even though their first experiments with film were a complete disaster: by removing the shutter, they not only disabled the projector, their alterations eliminated the potential for motion on screen. Their work used a standard 35 mm film strip—what they call the "Pathé gauge"—and they have an awareness of how the film strip was divided into individual frames. Thus, while the first experiments proceeded from a complete lack of knowledge about the technology or how motion pictures move, it is clear that they must have started with some piece of exposed film, and then bleached the images off it, or been very thorough in their examination of how the mechanics of the projector worked; possibly both.

Corra and Ginna's stated interest in creating a continuously modulated, changing range of hues—*color music*—without the imposition of specific forms or shapes, is common to color organ inventors. That the Futurist films should have begun with this stated goal is thus not surprising; it was the formal feature in common to both A. Wallace Rimington's and Mary Hallock-Greenewalt's color music inventions done just before and just after the Futurist's experiments. What is striking about Corra and Ginna's transition from color organs to film is how quickly they included animated forms moving on screen, rather than simply modulated color fields. This change may be evidence of the impact from their failed first experiments with modifying the projector and the lack of imagery in their first films:

Before describing, since I cannot do otherwise, the most recent successful color symphonies, I will attempt to give the reader some idea of this, though it will be far from the effect of the encounter of colors extended in time. I will place under the reader's eyes a few sketches (here to hand) for a film planned long since. This will precede public performances, accompanied by suitable explanations. (It will consist of fifteen or so extremely simple chromatic motives, each about a minute long and each divided from the next. These will serve to communicate to the public the legitimacy of chromatic music, to help it grasp its mechanisms and put it in the right frame of mind to enjoy the color symphony which will follow, simple at first, then little by little more complex.) To hand I have three chromatic themes sketched in on strips of celluloid. The first is the simplest one could imagine. It has two colors only, complementariness, red and green. To begin with the whole screen is green, then in the center a small red six-pointed star appears. This rotates on itself, the points vibrating like tentacles and enlarges, enlarges until it fills the whole screen. The entire screen is red, and then unexpectedly a nervous rash of green spots breaks out all over it. These grow until they absorb all the red and the entire canvas is green. This lasts a minute. The second theme has three colors—pale blue, white and yellow. In a blue field two lines, one yellow, one white, move, bend together, detach themselves and curl up. Then they undulate towards each other and intertwine. This is an example of a linear, as well as chromatic, theme. The third is composed of seven colors, the seven colors of the solar spectrum in the form of small cubes arranged initially on a horizontal line at the bottom of the screen against a black background. These move in small jerks, grouping together, crashing against each other, shattering and reforming, diminishing and enlarging, forming columns and lines, interpenetrating, deforming, etc..[2]

The limited animation and color palette described in this first film leaves a sense that their first attempt was composed from short experiments, rather than being a complete work. That the first film was not given a title, but the later films they described have titles reinforces the possibility that what was attempted was less a complete work than a collection of studies. The discussion suggests a systematic examination of how their colors worked in combination on screen, what the process of animation required, and how to organize the development of a longer hand painted film.

There are two mutually exclusive approaches to making hand painted animations, and both of these potentials are developed in the Futurists' descriptions of their experiments. The distinction in these approaches depends on the process used to create the imagery and the artists' concern for the break-up of the film strip into frames:

(1) works that are specifically registered to individual frames

(2) works that ignore the frame, relying on the projector to create framing

Because the projection of a hand drawn film will create individual frames whether the animation has been registered to those frames or not, concern with the frames in creating the animation is a choice of the artist, rather than a necessary technical

requirement. In the later Futurist films there is only a tentative suggestion of the initially identified concerns with color blending and the orchestration of fields of modulated color. Their initial ignorance of the intermittent shutter became a clearly described interest in the creation of colored, abstract frames where the animation is allowed to develop and move in a fashion common to photographic cinema. What appears in these descriptions is a summary of the temporal development of what are clearly elaborate abstract animations, comparable to the work of later hand-painted films by Len Lye, Norman McLaren or Harry Smith:

> And now it only remains for me to inform the reader of our most recent experiments. These are two films, both of about two hundred meters. The first is entitled *The Rainbow*. The colors of the rainbow constitute the dominant theme, which appears occasionally in different forms and with ever-increasing intensity until it finally explodes with dazzling violence. The screen is initially grey, then in this grey background there gradually appears a very slight agitation of radiant tremors which seem to rise out of the grey depths, like bubbles in a spring, and when they reach the surface they explode and disappear. The entire symphony is based on this effect of contrast between the cloudy grey of the background and the rainbow, and the struggle between them. The struggle increases, the spectrum, suffocated beneath the ever blacker vortices which roll from background to foreground, manages to free itself, flashes, then disappears again to reappear more intensely close to the frame. Finally, in an unexpected dusty disintegration, the grey crumbles and the spectrum triumphs in a whirling of catherine-wheels which disappear in their turn, buried under an avalanche of colors. The second is called *The Dance*, the predominant colors being carmine, violet and yellow, which are continually united, separated and hurled upwards in an agile pirouetting of spinning tops.[3]

Their "recent" works, in having titles and apparently a complex sequence of abstract animation, is an indication that the Futurist films were not only employing the techniques of hand painting to produce works whose direct references are suggestive of their color music heritage—titling these abstract films *The Rainbow* and *The Dance*—have distinct overtones of synaesthetic meaning. The development and apparent organization of the pieces reveals distinctly graphic concerns with how the imagery appears, moves and transitions from one section of the film to another. The Futurist's film work offers a clear connection between the concerns of painting, the synaesthetic performances of color organs, and their elaboration and transition to motion graphics.

The invention of these hand painted films is not as surprising as it might seem. Throughout the nineteenth century the practice of hand-coloring black and white photographs was common, and early films employed several techniques to add color to their black and white compositions: hand-coloring, where colored aniline dyes would be painted by hand onto black-and-white film; stencil coloring replaced hand-coloring, but still involved a labor-intensive process of making separate stencils for each color to be applied; tinting, which applied color to the whole frame uniformly, including those parts of the film outside the frame; toning where the processed film strip would be immersed in a chemical bath that would replace the

silver in the emulsion with a colored dye, making the dark areas of the film a color, but leaving the white parts uncolored.[4] Tinting was the most common of these two techniques primarily because it was easiest and cheapest to do—the film would be run through a dye bath, picking up the color as it passed through. This technique quickly became part of the language of early film: since the stock was not very responsive to light, all scenes were brightly lit to ensure a correct exposure; by the 1910s, tinting frames blue for night and yellow-orange for candlelight had become a common part of narrative film. The materials and techniques for adding these colors to motion pictures would have been readily accessible to artists, such as Corra and Ginna, looking at motion pictures as a potential medium for experiment.

Few of the early films survive, but experiments with both technology and the production of hand-painted films are features of this first period leading up to the German films produced after 1920 which have survived to the present. The oldest known surviving hand-painted "film" was produced in the United States around 1916 by Mary Hallock-Greenewalt whose work with visual music was discussed in detail in Chapter 1. These films are stored at the Historical Society of Pennsylvania in Philadelphia. They could only be played on a special, custom-built machine of her invention, a device lacking the basic conceptions of frame and projection common to typical motion pictures; her machine is fundamentally alternative to the development of abstraction in film. However, what is significant for our consideration is the technical means of their production: the imagery incorporates repeating patterns in a variety of colors, and was applied using stencils and a paint sprayer. This same technique would be reinvented by both Len Lye in the 1930s and Harry Smith in the 1940s. Fully abstract films, without reference to representational content, are rare in this first period of experimentation.

LÉOPOLD SURVAGE (1879 – 1968)

Called "the glistening bridge" by poet/critic Guillaume Apollinaire, the Russian émigré painter Léopold Survage proposed an abstract film, *Rythme Coloré*, to the Gaumont Company in 1914. The designs for this project survive as a series of sequential paintings meant to show the key stages in the development of this motion picture. His discussion about the (apparently) planned production of his film, accompanied by some examples of the imagery, was published in the July-August 1914 issue of Apollinaire's avant-garde magazine *Les Soirées de Paris*, but the film would never be produced, possibly because of the intervention of World War I.

The publication in *Les Soirées de Paris* contained a lengthy analysis of Survage's conception of "colored rhythm," the focal point of his aesthetic theory. He makes a series of claims: that the fundamental element of music was sound rather than harmonic tones, and argues for an analogy between abstract visual form and music. Film provided the ideal medium for the execution of these relationships because of its specific connection to elaboration over time, and ability to organize visual material through projection. He argued for the establishment of film not only as an abstract medium, but specifically as a vehicle for the production and projection of abstract, visual music to an audience. His conception of *Rythme Coloré* is explicitly as a motion graphic work:

An immobile abstract form is still not expressive enough. Round or painted, oblong or square, simple or complicated, it produces an extremely confused SENSATION; it is only a simple graphic notation. Only when it begins to move, when it transforms itself and meets other forms is it able to arouse a FEELING. Through its role and its destination it becomes abstract. In transforming itself over time, it sweeps through space...[5]

Survage's analysis recognizes the addition of motion to his designs is not simply a matter of making a painting dynamic—it utterly transforms the character and meaning of the work as well. These works are not simply paintings where he would animate the various pieces, instead they are designs where all the visual forms would be engaged in a continuous transformation over time. These recognitions about the nature of motion graphics were radical for 1914, revealing a complex understanding of the fundamental difference between the static images of painting, where motion is implied through composition and technique, and the production of actual animations where the motion is transformative of the visual forms shown. These transformations are an essential part of how a work of abstract motion graphics must evolve for the imagery to move in more than two dimensions; i.e. to move spatially, and not simply graphically on a flat plane.

The description of the planned production process for *Rythme Coloré* contains a number of significant details about how he planned to produce the film that bear a closer examination. Survage's explanation reveals an understanding of the paintings he produced between 1911 and 1914 as being the keyframes in his project, leaving the "tweens" for technicians to execute according to his instructions:

> The technical difficulties reside in the realization of cinematographic films for the projection of colored rhythm.
> For a three-minute piece, one must consider the registration of one thousand to two thousand images. That is quite a lot! But I do not propose to execute them all myself. I will provide the essential steps. From these, the draftsmen, with a little good sense, will know how to deduce the intermediary images, of which I have indicated the quantity, hence the cadence. When the plates are finished, they will be passed in succession before the lens of a three-color cinematographic apparatus.[6]

The understanding of the production process involved in the creation of his film described here is familiar, even if his terminology is quaint: he has produced the storyboards for a 2-3 minute film, indicating the timing of the tweens for the animation department to execute on plates of glass (the forerunner to the general adoption of acetate cels). The production line envisioned in this description is identical to the breakdown found in animation studios of the 1920s and 1930s, where the designs, timing and storyboards are elaborated and executed by the animators following the director's orders.

Guillaume Apollinaire recognized in Survage's work the connection between painting and abstract film; his naming Survage the "glistening bridge" (le pont chatoyant) was a direct reference to the connections Survage was making between painting and the (potential) development of kinetic abstraction through motion pictures. However, there is an additional connection made by the designs for *Rythme Coloré*: the linkage between color music, abstraction and abstract film is specifically

apparent in the forms Survage chose to devise for this project, a linkage contained in the imagery.

The central forms that develop in the 54 individual storyboard-paintings owned by the Museum of Modern Art in New York shows the encounter between a white ray and a prismatic form, resulting in a spectrum of colored bar-forms that modulate and evolve over the series of panels. These images depict optical refraction, followed by the production of a spectrum whose transformations resemble the arcing and banding common to the "*disks of newton*" that appear in the work of many abstract painters of this period (1910–1914) also active in Paris: *The Synchromists,* (Stanton MacDonald-Wright and Morgan Russell), paintings by color music inventor Daniel Vladimir Baranoff-Rossiné, and painters Robert Delaunay, Sonia Delaunay, and František Kupka among others. Their name comes from the color disk or wheel Isaac Newton provided in his book *Opticks.* The transfer of these forms into the designs for his proposed abstract film makes the linkages between the synaesthetic tradition of color and visual music, the concerns of synaesthesia in abstract painting and the meaning of early abstract films explicit. Survage's work, as Apollinaire noted, bridges the aesthetic and conceptual gaps between painting, film and color music with his conception of how to adapt these concerns into the creation of a film.

The significance of Survage's accomplishment lies with his early recognition of what was required to make an abstract film. While *Rythme Coloré* was never produced, the promotion of Survage's theories about color, rhythm and motion by Apollinaire and, in 1919, by Blaise Cendrars, who wrote a discussion and analysis of the unproduced film, *The Birth of the Colors* that provided a narrative of forms development. Cendrars' description of *Rythme Coloré* gave an organic character to the organization and elaboration of the colored forms—"Frondlike, this blue extends its branches in all directions and grows little trembling leaves on the red..."[7]—transforming the austere abstraction into what suggests a naturalistic, even representational, story expressed in colored geometric forms. This analogy between abstraction and the movement of natural, living things, will reappear in the abstract films produced after World War I by Walther Ruttmann in Germany during the 1920s.

THE DADA/CONSTRUCTIVIST CINEMA (1919 – 1929)

Dada films have a collection of features in common with the movement of the same name. Their focus is on the disruption of conventional mores, logic and aesthetics, while at the same time offering nothing in their place. Nevertheless, the definition of a "Dada film" is historically problematic, a fact elaborated upon by Thomas Elsaesser in his chapter "Dada/Cinema?" where he explained the problem is that the history of Dada does not discuss films, for reasons of chronology. Most Dada films were made after Dada ended:

> If one takes a generous view, one can start with 1920, the year Richter and
> Eggeling applied for facilities and funds to the UFA Film Company in order
> to carry out work which resulted in *Rhythmus 21, Rhythmus 23* and *Symphonie
> Diagonale.* In the same year Duchamp and Man Ray conducted the first and
> almost lethal experiments with revolving glass disks and 3D stereoscopes,

out of which grew *Rotating Demisphere* and *Anémic Cinéma*. It is not until 1923 that *Le Retour à la Raison* appears, and in 1924, *Entr'acte*. *Ballet Mécanique* follows in 1925, and in 1926 comes Hans Richter's *Filmstudie,* Man Ray's *Emak Bakia* and Duchamp's *Anémic Cinéma*. Finally, in 1927 Richter completes *Ghosts Before Breakfast* and *Two-Penny Magic*, and in 1928 Man Ray's *L'Etoile de mer* is shown. No chronology of Dada stretches that far.[8]

Paris Dada ends in 1923, and half of the films Elsaesser designates as Dada appeared in the final event of that group, the *Soirée du Coeur à Barbe* (The Bearded Heart) on July 6, 1923: Man Ray's *Le Retour à la Raison* (Return to Reason); Hans Richter's *Rhythmus 21* and *Rhythmus 23*; and Viking Eggeling's *Symphonie Diagonale* (Diagonal Symphony). While the other films were produced after the "end" of Dada, one of these, Rene Clair's *Entr'acte,* was produced for Eric Satie's Dada ballet, *Relâche*. (Man Ray's later films, *Emak Bakia* and *L'Etoile de Mer* are generally regarded as Surrealist, not Dada; nevertheless, these distinctions often depend on who is writing the history).

In general, the grouping of films as "Dada" by film historians has been based on the relationships between the artists who made them and their affiliations with the Dada movement and its ideals, rather than the presence of these films within a Dada performance/exhibition, or the limited periodization of Paris Dada. Film historian Patrick de Haas elaborates on this problematic in his examination of the different ways the aesthetics of these films suggest connections to larger aesthetic movements:

> If we take the terms 'Dada' and 'Constructivist' for their aesthetic meanings, we quickly realize that a formal analysis of the works overturns these easy classifications. Some films by the Dadaists answer to Constructivist principles (*Rhythmus 21,* by Richter for example) and if we take this qualification in a broader sense, a number of films could be called Constructivist (*Ballet Mécanique* by Fernand Léger, or *Impatience,* by Charles Dekeukeleire). In most cases, however, we are looking at combined works, that sometimes invoke the Constructivist aesthetic and sometimes the Dada one.[9]

Neither name—*Dada nor Constructivism*—was employed to describe these films at the time of their production; they were simply "avant-garde films" or "art films." Their break-up into more coherent descriptive categories came later as part of their historical consideration. Since their production was not necessarily under the banner of a specific movement or singular avant-garde aesthetic, the lack of a primary aesthetic on view in these films is not surprising. The range of years in which they were produced also straddles the transition from Dada into Constructivism; the transition appears gradually as different artists moved towards what in retrospect was clearly a common destination.

Further confusing the "Dada" designation is the heterogeneity of techniques and aesthetics on view in the films. Thus, the typical historical focus has been on what watching these films was like for an audience, as film historian Rudolf Kuenzli does in his introduction to the anthology *Dada and Surrealist Film*:

Dada-related films have several characteristics in common: they disrupt the viewer's expectations of conventional narrative, their belief in film as presenting reality, and their desire to identify with characters in the film. Dada films are radically non-narrative, non-psychological; they are highly self-referential by constantly pointing to the film apparatus as an illusion-producing machine. Through their cinematic defamiliarization of social reality, they attempt to undermine the norms and codes of social conventions, and thus of conventional filmmaking, which has as its goal to reproduce that conventionality.[10]

The difficulty with this description of Dada films is its inability to fully accommodate abstraction except as a sequence of negations more logically applied to live-action films. It is hard to accommodate Richter or Eggeling's work to this description. Yet, this discrepancy makes the distinction between a work such as Rene Clair's *Entr'acte* that employs actors, suggestions of narrative (always undermined and thwarted) and the fully-abstract animation in Hans Richter's *Rhythmus 23,* clear since both films are commonly identified with the Dada movement. The distinction between these fully abstract works, and the more representationally-oriented Dada films lies with their source: of all the Dada films, only those not produced in Paris are fully abstract, (Marcel Duchamp's film *Anémic Cinéma* with its spinning disks is the exception to this rule); the fully abstract Dada films by Hans Richter and Viking Eggeling were produced in Germany.

The relationship between the Dada and Constructivist movements is mainly one of succession: those artists involved with Dada in the 1910s and early 1920s who did not become involved with Surrealism often became involved with the Constructivism. The difference in trajectories having to do with how deeply involved they were with the Paris Dada group; Richter and Eggeling were already working within the early stages of Constructivism by 1923. As the Dada groups in other cities across Europe moved towards the rationalism of Constructivist design and formal innovation, the Parisian Dadas became more involved with the systematic irrationality of automatisme that marks the Surrealist endeavor. In Germany these concerns—shared by Walther Ruttmann, Hans Richter, Viking Eggeling and Oskar Fischinger—would coalesce into the first fully abstract, "absolute films," a name that reveals the influence of Constructivist thought.

The term "absolute film" differentiates fully abstract animations by Walther Ruttmann, Hans Richter and Viking Eggeling produced in Germany from other Dadaist abstractions, such as *Le Retour à la Raison* or *Ballet Mécanique* produced in Paris. While all three filmmakers lived in Germany and produced their films at around the same time, they did not constitute a "group" or movement. The first of these films was made by Walther Ruttmann: *Lichtspiel: Opus I* (1921) is the oldest fully abstract motion picture known to survive. However, he does not always receive credit for his work. After World War II, Hans Richter engaged in historical revisionism, placing his work at the forefront and diminishing Ruttmann's contributions: he does not even appear in some histories of abstract film; once Richter arrived in the United States he rewrote the history of this period, making his own film, *Rhythmus 21,* the first abstract film ever produced.[11]

MAN RAY'S *LE RETOUR À LA RAISON* (1923)

Man Ray (1890 – 1976) produced *Le Retour à la Raison* (The Return to Reason) for the *Soirée du Coeur à Barbe*; it was only screened once during his lifetime. He reused parts of the original film in his later Surrealist film work; *Le Retour à la Raison* was recreated as part of a restoration project by the Centre Pompidou in 1998. This film used a variety of techniques: some sections were shot with a motion picture camera, but the majority of the footage was created by placing physical objects—tacks, nails, etc.—directly on unexposed film stock, switching the lights on for a second, then developing the film. This action created a cinematic version of the photogram process Man Ray named the "*rayograph*." He also laid a number of negatives across a few frames, printing his still photography into the film in a way that precludes it being visible to the audience.

The resulting motion picture contains a series of comparisons between rayographic materials, photographic materials and live action motion picture material. Some of the shots are filmed normally, but have been selected to resemble the rayographs, while others are animated still images, or images of light/shadow in motion. Much of what happens in the film is not actually visible to the audience. Man Ray's account of how he produced this film is informative of this procedure:

> Acquiring a roll of a hundred feet of film, I went into my darkroom and cut up the material into short lengths, pinning them down on the work table. On some strips I sprinkled salt and pepper, like a cook preparing a roast, on other strips I threw pins and thumbtacks at random; then turned on the white light for a second or two, as I had done for my Rayographs. Then I carefully lifted the film off the table, shaking off the debris, and developed it in my tanks. The next morning, when dry, I examined my work; the salt, pins and tacks were precisely reproduced, white on a black ground as in X-ray films, but there was no separation into successive frames as in movie films. I had no idea what this would give on the screen. Also, I knew nothing about film mounting with cement, so I simply glued the strips together, adding the few shots first made with my camera to prolong the projection. The whole would not last more than about three minutes. Anyhow, I thought, it would be over before an audience could react; there would be other numbers on the programme to try the spectator's patience, the principle aim of the Dadaists. I arrived at the theater a few minutes before the curtain went up, brought my film to Tzara and told him that he was to announce it, as there were no titles or captions I called the film: *The Return to Reason.*[12]

This apparently transparent description of the production of Le Retour à la Raison is unreliable. Man Ray's claim that it was random, simply a bunch of different pieces of film glued together without any planning or organization is belied by the actual film itself, and the unreliability of his description becomes clear on even a first viewing—the camera-made shots are not simply attached to the beginning, but reappear throughout the film, arranged into sequences with editing that suggests an orderly procession of juxtapositions. His description, and the implication that the only purpose to the film was to shock and promote outrage (or at least, try the audience's patience) is a product of critics believing his deliberate misinformation.

Film historian Deke Dusinberre has elaborated on the discrepancies between Man Ray's description of *Le Retour à la Raison* and the actual evidence obtained from a careful examination of the film strips themselves, noting that "such 'contentless' analyses were symptomatic of two tendencies: the general one of avoiding the very real difficulty of analyzing the content of abstract films, and the specific one of accepting Dada's claims of nonsense or 'meaninglessness.'"[13] The problems posed by abstract films for interpretation result from the eschewed narrative and representational characterization—the absence of those literary interpretations normally used when considering commercial, fictional cinema as a whole. In their place, works such as *Le Retour à la Raison* substitute a visual construction based on sequence and similarity. Dusinberre explains:

> despite the diversity of images, there clearly emerges a motif of black-and-white dots and shapes that tread a thin line between representation and abstraction. The [opening] sequence is woven together by the swift pace of the cutting and the repetition of certain images, whether rayographed onto the filmstrip (salt-and-pepper, thumbtack) or filmed with a movie camera (white fairgrounds at night).[14]

This opening montage offers a glimpse into the organization and suggests a meaning for the whole in how these shots were juxtaposed: salt-and-pepper intercut with a shot of flowers in bloom, where the framing and movement of the representational shot renders it almost indistinguishable from the abstraction of salt-and-pepper. The thumbtacks create a visual rhythm that repeats in the swirling of the carousel lights at the fairground. In each instance, the cut initially created confusion about whether the new shot is abstract or camera-based, blurring the distinctions between what has been photographed and hand-generated.

Following this opening is a superficially still shot of Man Ray's painting *Dancer/Danger* (1920) with puffs of smoke billowing in front, catching the light and creating a direct contrast between the stillness of the image and the mobility of the air—that which is normally invisible becomes seen. Similar contrasts of stillness and motion, seen and unseen, appear in the film: the rotating torso of Kiki de Montparnasse where the moving body contrasts with the speckled light passing through a window. The blacked out caption that appears on screen for only a few seconds is coupled with an apparently abstract roll of paper that unspools in a cone stretching vertically through the frame, but like the illegible caption, this "cone" is marked with punch holes—it is a player piano score that unspools silently through the frame. The subject of *Le Retour à la Raison* is this hidden content, invisible to the audience—embedded subliminally on screen—which, as Dusinberre has noted, only becomes intelligible by looking at the film strip itself on a light table. This consistent interplay of seen and unseen indicates the film is not a Dada exercise in non-sense. Man Ray's film presents a self-referential commentary on the nature of the motion picture apparatus and the apparent movement of the film when projected. The illusions of continuity, motion, and reality in motion pictures are discursively addressed through the combinations of seen and unseen, visible and invisible, legible and hidden that run throughout the film.

MURPHY & LÉGER'S *BALLET MÉCANIQUE* (1924)

Ballet Mécanique produced by Cubist painter Fernand Léger (1881 – 1955) in collaboration with American filmmaker Dudley Murphy (1897 – 1968), presents an attempt to create a visual analogue to Léger's paintings in film: a "motion painting." The production was a close collaboration where Léger developed the initial script-plan, Murphy handled the shooting, and they collaborated on edited the resulting footage.[15]

Even though Léger's paintings are not regarded as belonging to the Dada movement, *Ballet Mécanique* is typically grouped with the work of the Dadaists. This connection to Dada is not simply rhetorical: *Ballet Mécanique* follows the common desire of Dada art to attack its audience, confrontationally undermining conventional logic, organization and expectation. This desire to "try the spectator's patience" was conceived not simply as a component of the film, but systematically explored in the preparation of the finished film, as Léger notes about the editing and loop printing done with a projection printer:

> in "The Woman Climbing the Stairs," I wanted to amaze the audience first, then make them uneasy, and then push the audience to the point of exasperation. In order to "time" it properly, I got together a group of workers and people in the neighborhood, and I studied the effect that was produced on them. In eight hours I learned what I needed to know. Nearly all of them reacted at about the same time.[16]

Léger's claim that the woman climbing the stairs—one of the film's most famous sequences—was the product of careful calculation is supported by the sequence itself. It appears twice in close succession; the woman never actually reaches the top of the stairs. Both sequences are loop prints of the same footage, but their editing differs subtly. In the first sequence, the starting point grows closer to the top of the stairs on each repetition of the loop, moving the woman slightly closer to the end of the staircase; in the second sequence, this relationship is reversed, moving her further downstairs, and making her progress slightly longer each time it repeats. This sequence is a Dada "inside" joke—a reference to Marcel Duchamp's famous 1913 *Nude Descending a Staircase*—the woman is clothed and ascends the stairs, never actually arriving.

The distinct Dada character of this "trying the spectator's patience" is only a contributory effect in the organization of the whole. Like the other Dada films, its non-narrative, disruptive techniques focus on the materiality of the film, and the breakdown of conventional film language and structure—features common to all Dada films as Kuenzli has observed. Léger explains the conception of *Ballet Mécanique* in the notes for its 1946 exhibition in the *Art in Cinema* series in San Francisco:

> A series of fragments, a ciné-poem with a certain optical sequence make up a whole that still remains a fragment. Just as one can much better appreciate the abstract beauty in a fragment of a classical work than in its entirety, so this film tries to indicate the essentials in its contemporary cinematography.[17]

The focus in this explanation is on the decision to employ a variety of optical techniques to fragment and produce repetitions of the imagery: including

kaleidoscopic mirrors, double exposures, masks, variable speed ramping (under and over cranking), tinting, toning, animation and rhythmic editing. What is absent is the connection between these visual devices that break the image into multiples and simultaneously present them on screen and the Cubist procedures Léger employed in his paintings. The relationship between the various abstract imagery of disks, cones, and other patterns in his paintings made just before the production of this film and the use of visual analogues—funnels, pots, pans, colanders, etc.—set into motion approximate the formal shape of elements visible in paintings such as *Composition* (1918), *Mechanical Elements* (1918–1923), or *The Builders* (1920).

Ballet Mécanique is an early attempt to fragment the screen into discrete "windows" whose imagery was manipulated separately, allowing for complex visual juxtapositions and rhythms on screen, something not technically feasible until after optical printing was developed in 1929. (Chapter 6 contains a more in depth discussion of windowing.) The solution to this aesthetic demand for multiple imagery was the optical prism. Held over the lens and manipulated, it resulted in the faceted, kaleidoscopic imagery seen on screen. Coupled with the use of simple geometric forms, it produces a physical abstraction on screen using common household objects—Christmas ornaments, pots, pans, colanders—whose motion is a combination of optically moving the prism, spinning the object on a string, or the limited pixilation of stop motion animation. *Ballet Mécanique* was an attempt to translate painterly forms into motion pictures using physical materials. This use of geometric objects as an analogue for abstract geometry is a common technique among abstract films during the first, experimental period—an approach also used by American Mary Ellen Bute in the 1930s.

WALTHER RUTTMANN (1887 – 1941)

Walther Ruttmann was initially trained as an architect and painter; he served on the Eastern front during World War I, suffered "shell shock" (what is now known as post traumatic stress disorder), and on being released from the hospital abandoned painting to make films. He made the oldest known abstract film, produced between 1919 and 1921. As he was the son of a wealthy mercantilist, he had the financial means to become a filmmaker after his release from the hospital. Ruttmann's first two abstract films date to the years following the end of World War I, during the lead up to the onset of the German hyperinflation following the collapse of the Reichsmark in July 1922, which delayed his continued work. Unlike both Eggeling and Richter, Ruttmann worked independently of the German studio Universum Film AG (UFA). His first productions were abstract animated films, and he also made the first fully animated cartoon produced in Germany.

As he worked on his first film, *Lichtspiel: Opus I* from 1919 to 1921, Ruttmann wrote a manifesto/statement on his endeavor titled "Painting with the Medium of Time" where he explicitly identified a series of links between abstract film, painting, and music:

> Not a new style or anything similar. Rather a new method of expression, one different from all the other arts, a medium of time. An art meant for our eyes, one differing from painting in that it has a temporal dimension (like music), and in that its artistic foci are not to be found (as in the picture) in

the rendition of a (real or stylized) moment in an event or fact, but rather precisely in the temporal unfolding of its form. As this art form centers around the dimension of time, one of its most important elements will be the temporal rhythm of visual events. This new art form will give rise to a totally new kind of artist, one whose existence has been only latent up to now, one who will more or less occupy a middle ground between painting and music.[18]

The emphasis on time as a precondition for the development of movement provides the basis for Ruttmann's concern with rhythmic organization and the serial organization. His first film, *Lichtspiel: Opus I,* employs a limited number of visual forms whose development follows a musical structure. This connection to music also appears in Ruttmann's titles, indicating their relationship to the synaesthetic heritage of painting and music. The first of his abstract films premiered in April 1921, and was released for German theatrical distribution in 1922.[19] It is the oldest fully abstract motion picture using only animated geometric forms, known to survive. Graphically, they were arranged and shown without reference to any representational imagery; the first abstract experiments by Viking Eggeling and Hans Richter were not exhibited publically until 1923.

He followed it with *Lichtspiel: Opus II,* a second animation developing his visual ideas from Opus I, and refining the animation technique, but did not immediately move on to a third abstract film. Instead, the impact of the Weimar hyperinflation appears in the production gap between *Opus II* that premiered in April, 1922, and the his two final abstract films. During this period of hyperinflation he worked as an animator on commercial feature film projects for Fritz Lang, where he designed and filmed the dream sequence in *Die Niebelingen* (1924), and for Lotte Reininger's film *The Adventures of Prince Achmed* (1924–1926), and the sequence called *"Lebende Buddhas: Eine Phantasie aus dem Schneeland und Tibet"* in the film *Living Buddhas* (1925) directed by Paul Wegener. He returned to making abstract films with *Lichtspiel: Opus III* produced from 1923-24, and *Lichtspiel: Opus IIII,* produced in 1925 as the German economy began to stabilize. Both premiered on May 3, 1925. This pattern of production interrupted by the 1922 period of hyperinflation appears in the work of Richter and Eggeling as well, but since they worked at the UFA studio, in a much less pronounced way.

Both *Opus I* and *Opus II* share a laborious paint-on-glass technique, employing oil smudges on plate glass, and supplemented by cut-out animations of angular forms. This technique is used to a lesser degree in *Opus III*, and *Opus IIII* was made using paper cutouts and wax elements rotated and backlit to create oscillating forms on screen. Another German filmmaker who would become closely associated with abstract film during the sound period, Oskar Fischinger (see Chapter 3), sold experimental animation equipment (a wax animation slicing machine) to Ruttmann, but he did not use it in his films, employing it instead in Reininger's *Prince Achmed.*

Lichtspiel: Opus I (1921) used a projection printer to loop the animation, allowing Ruttmann to lengthen and repeat earlier motifs over its 12 minute duration. Composer Max Butting produced a score for *Opus I* that is closely synchronized to the action of the curves, triangles and bars that move around the screen. There are two sets of animated forms—one set are softly drawn, and their

shape and movements are organic, the others are triangular, hard-edged shapes that jut into the screen, forcing the organic shapes to flee. The dramatic structure in Opus I is based around this interplay between organic and geometric form. The organic forms are hand animated using an oil-on-glass technique where each frame is hand-painted, photographed, then altered to become the next stage in the movement. The smudges of paint left over after he wiped away previous movements are visible throughout the film. Unlike cel animation, this labor-intensive process is more closely related to stop-motion animation of objects; the geometric forms are cut-outs. It was literally a "motion painting."

All of Ruttmann's *Opus* films employ color to some degree. *Opus I* had the most complex use of color, with different sections being tinted an overall color, or showing individually toned forms. Coloring the geometric shapes and the background, to reflect both the action and the mood, also enabled him to break *Opus I* into distinct movements that correspond to Butting's score. The toned background follows the standard meaning for tinted film in the silent era, enabling the second movement, tinted blue, to be a nocturne. Hand coloring individual animated elements was both time consuming and expensive. The coloring in his subsequent films was simpler—single overall colors tint everything on screen.

Lichtspiel: Opus II (1922) expanded the formal innovations in *Opus I*, again employing a mixture of angular and organic forms done with the oil-on-glass technique. Although shorter, it is also faster paced, and is clearly a more developed version of the motifs and structure from his first film. However, it also included the use of kinestasis—still images animated through camera movement—and was animated on multiple planes of glass, allowing two sets of curved animated forms, one white and the other black, to interact on screen, wrapping around and masking each other against a grey background. The animation is a mixture of curves, squares and rectangles, arrayed into compositions that reference the shape of the frame, which are all in motion at the same time. Different sections were toned different colors—blue, then later, red. Individual forms were not hand colored as in *Opus I*.

Lichtspiel: Opus III (1924) is composed from squares, rectangles and other straight-edged forms animated in overlapping, kinetic compositions. The shapes in this film are not solid colors, but graduated tones, and the development of each sequence is built around asymmetrical compositions that break the frame into harmonious sections. The result is dynamic, active: the moving shapes suggest the rapid movement of machinery, pistons. Then in the middle of the film there is a shift towards a bifurcation of the frame and oscillating patterns that rotate around this central axis (the physical forms modeled in wax and rotated), before a return to the asymmetry of the machine-like motions. The compositions employed in this film are unique in the 1920s, resembling the later work of Joseph Albers, or, the more contemporary paintings of Peter Halley in the 1980s.

Color serves a dramatic purpose in *Opus III*. Short sections of red and blue alternate towards the end, creating a contrast, but as in *Opus II*, the whole frame is tinted, and there is no hand-painting. His alternation of monochromatic, colored compositions at the conclusion produces a dramatic resolution that was missing in his earlier films. This use of color for emphasis is repeated in his last abstract film,

Lichtspiel: Opus IIII (1925): the first half the film is black and white, then it is tinted blue for one minute-long sequence of curved forms, (again, modeled with wax), oscillating on screen. After them, the black and white forms reappear from the opening, superimposed with the curved forms—a synthesis of his motifs, resolving the curved-linear opposition that appears in all four *Opus* films. Finally, the last two shots are bright red.

The organization and imagery in *Lichtspiel: Opus IIII* has even fewer parallels in the abstract painting of the 1920s. Composed in several sections, the first is made from bands of white and black that stretch horizontally across the screen, and "roll" between being white bands on black and black bands on white. These are interrupted by an ascending white blocks that moves outwards from the center, but does not empty the screen. Instead, these vertical bars move horizontally across the bands, creating graphic compositions. The closest parallel in film is *Lines Horizontal* or *Lines Vertical* by Evelyn Lambart and Norman McLaren, done in the 1960s; however, the imagery of *Opus IIII* resembles nothing else so much as the abstract video works of the 1970s by Gary Hill and the Vasulkas produced at the Experimental TV Center.

Lichtspiel: Opus IIII was the last fully abstract film Walter Ruttmann made; he would employ short abstract sequences in some of his other films: symmetrical abstract shapes like those in *Opus III* and *Opus IIII* appear as short graphic elements and transitions in his cartoons *Das Wiedergefundene Paradies* (1925), *Dort wo der Rhein* (1927) and in the opening of his documentary, *Berlin, die Sinfonie der Großstadt* (1927).

In considering all four of Ruttmann's abstract films in sequence, what emerges is a development away from the organic, soft-form animations of *Opus I* towards increasingly rectangular grid compositions and geometric forms. The adoption of a geometric abstraction demonstrates the shift towards non-referentiality and Constructivism that happens as the 1920s develop, a feature of abstract painting as much as abstract art: Vassily Kandinsky, whose paintings of the 1910s were soft and organic became progressively more geometric and planar as the 1920s progressed.

The influence of Ruttmann's work on later abstract filmmakers comes primarily through the impact his work had on Oskar Fischinger who attended the first screening of *Lichtspiel: Opus I* in 1921. Fischinger began making his own films during the 1920s, but did not produce fully abstract films until after optical sound was adopted as the standard in 1927. Prior to that he made a number of experimental animations using machines of his own design, including a wax-cutting animation device that Ruttmann bought, but apparently never used. (Fischinger's involvement with abstract film will be considered in more detail in Chapter 3.) Fischinger used this machine to make several films: *Wax Experiments* (1921-26) shows a variety of abstract and impressionistic of imagery; *Seelische Konstruktionen* "Spiritual Constructions" (ca. 1927) follows a dreamlike progression of distorted, but representational imagery. The graphic nature of both films is striking, but when Fischinger used it for a finished film, the results were not particularly abstract, instead creating a fluid, "surreal" cartoon.

VIKING EGGELING (1880 – 1925)

Between 1918 and his death in 1925, the Swedish painter Viking Eggeling collaborated with the German Hans Richter to develop a geometric, formal language for art; starting 1920 they attempted to translate their invention into film. This focus separates their work from Ruttmann's films. When Richter and Eggeling met in 1918, they were working on similar problems and arriving at similar solutions; however, Eggeling was the leader of their theorization. He had made more progress systematically developing his grammar of abstraction[20] he called *Generalbass der Malerei*, (1918, "Bassline Painting"). A more formal version, published with Richter as co-author, was published in a pamphlet titled *Universelle Sprache* (1920, "Universal Language"), now apparently lost. In spite of their joint authorship of the pamphlet, Eggeling may have been the "senior" partner in the project. Bauhaus professor and Constructivist artist Laszlo Moholy-Nagy discussed their relationship in his book *Painting Photography Film* written in 1924, and published in 1925:

> In Eggeling's hands the original color-piano became a new instrument which primarily produced not color compositions but rather the articulation of space in motion. His pupil Hans Richter has—so far only theoretically—emphasized the time-impulse even more strongly and has thus come near to creating a light-space-time continuity in motion.[21]

The connections between the synaesthetic dimensions of abstraction, the geometric work of Constructivism and its transition from being a live instrument to being an animated creation shown on film are explicit in Moholy-Nagy's comments. It is also significant that his contemporary description, produced at the time when Eggeling was completing *Symphony Diagonale* (and Richter was working on *Rhythmus 23*), recognizes that Eggeling's film closely resembled the theory they had developed and Richter's did not. It suggests their collaboration, begun by 1919 and ended by 1921, and the *"Universelle Sprache"* (Universal Language) pamphlet from 192022 may have been more Eggeling's work than Richter's. Since Eggeling died in 1925, leaving Richter to promote and disseminate their work, the true nature of their collaboration is unknown.

There are no copies of the 1920 *Universelle Sprache* pamphlet known to survive, but Richter produced several variants of this text over the span of his career developing and reiterating its ideas, including a version published in his Constructivist magazine *G*.[23] The role of time in this construction is effectively independent of the movement of the forms—it is instead the duration (length of time) required to look at the completed piece that is the focus. This separation of the conception of time from the running-time (duration) of the motion picture presents the overlap between the static imagery of the painted image and kinetic imagery, evolving through apparent motion, in their films. Richter explains their system:

> This pamphlet elaborated our thesis that abstract form offers the possibility of a language above and beyond all national language frontiers. The basis for such language would lie in the identical form perception in all human beings

and would offer the promise of a universal art as it had never existed before.[24]

The appendix to Stephen Foster's anthology *Hans Richter* includes a facsimile of one version of this proposed formal language written out and diagramed on a collection of papers and scraps. It closely resembles the one published under the title *"The Badly Trained Soul"* by Richter's magazine *G* in June, 1924; foreshadowing how Richter would rewrite history after World War II, this version of the *Universelle Sprache* used his film *Rhythmus 21* as an illustration of its principles.[25] Their graphic system was based on relative scale of forms, their repetition/variation over time, and their organization in time. The individual diagrams present blocks and lines organized iconically, as are the forms clustered and linked together in the scroll-paintings that helped shape this theory. The role of color receives consideration within this construction as a means to organize groups of forms, (thus reinforcing their iconic aspects), but does not play a major role otherwise. Of the four films that applied their language, only Richter's *Rhythmus 25,* now lost, was in color.

The synaesthetic dimensions noted by Moholy-Nagy are apparent in Eggeling's initial creation: in both the name—bassline painting, a reference to the basso continuo in music—and in how the elements of his visual language show the common influence of the synaesthetic forms common to early abstraction.26 Its focus was on painted imagery, not motion pictures. These works were created as scrolls where individual images would repeat different elements in a sequence down the length of the sheet. It employed a limited vocabulary of simple, planar geometry arranged in a visual syntax modeled on language, connecting their theoretical work to that of the Constructivists, whose graphic work this imagery resembles.

In Richter's description, when music appears as a reference, it is via analogy—principally rhythmic and structural, not synaesthetic. The "movement" he described is based on an analogy to "movement" in music, where the organization of a complex work is broken into sequences that are self-contained:

Each movement must be able to exist in itself, i.e. it must be completed, a world of its own...and open for the next/imply the next[27]

The "exist in itself" of this notion of movement shows a different conception, one that necessarily evokes the musical analogy; thus, it was not simply the motion shown by film. This dimension of the universal language is a reminder of its basis in graphic drawings and painting produced prior, during, and after Eggeling and Richter's experiments with film. While the synaesthetic dimension may be unclear, the impact of the system's foundations in Richter and Eggeling's scroll-paintings is clear: their *Universelle Sprache* is first a graphic language, then secondarily a language of kinetic graphics.

The visual form of the scroll paintings resembles the laid-out frames of the motion picture, where each drawing implies the individual, sampled movement contained on film. Their transition from scroll painting to cinema was a natural progression. In 1920 both artists began working on films based on earlier scroll paintings as a means to put their *Universelle Sprache* into actual motion, but the initial works chosen to animate—Eggeling's *Horizontal-Vertikal Orchester* (aka Horizontal Vertikal Mass) and Richter's *Praludium* (both 1919)—presented a novel problem the

static medium of painting did not have: movement. They moved from a painterly question to a cinematic one of movement that incorporated time. Their painted work was concerned with the relationship between the space of the image and the time needed to look at it: "movements" were organized by linking forms across the sheet in a gradually cumulative process.

Problems of film production immediately confronted their animation of their graphic sequences, and both Eggeling and Richter encountered difficulties in translating their formal language to motion.[28] Eggeling's first attempt, based on his scroll-painting *Horizontal-Vertical Orchester* was abandoned by 1921 when his collaboration with Richter ended and he moved to Berlin; this first attempt at animating a scroll-painting is now lost. Produced over a four year period from 1921 to 1924, Eggeling adapted another scroll-painting *Symphonie Diagonale* into a film of the same title; similarly, Richter's attempt to animate his scroll-painting, Praludium, was also abandoned without being completed; however, for his second attempt, Richter did not adapt a scroll-painting to film, and instead used a different approach to animate *Rhythmus 21*—he would later reuse parts of his first film in *Rhythmus 23*.

Eggeling worked on his film from 1920 to 1924, attracting the attention of Werner Graff while Graff was still a student at the Berlin Bauhaus, (a meeting that eventually lead to his writing two pieces for the *De Stijl* magazine inspired by Eggeling's work). Graff introduced Eggeling to another Bauhaus student, Erna Niemeyer, who left the Bauhaus to assist with the film production of *Symphonie Diagonale* in 1923; the film was completed in 1924. The film was made using reversal black-and-white film stock, so white would become black, and black, white in the final print. The animations were made with a compas and ruler; when the film was shot, a white card was moved to reveal the already-finished drawings. Once it was processed, the blacks and whites reversed, leaving white forms appearing over a black field.[29] This technique worked well for Eggeling since his imagery was composed of linear elements: lines and curves, not solid planes. This organization of linear elements produced a dynamic where shapes could develop and oppose one another both graphically and rhythmically.

Symphonie Diagonale (1924) is structured to resemble the musical sonata,[30] and in spite of the initial difficulties he encountered, Eggeling's film shows a clear translation of his formal language into film: composed from a collection of elaborate black and white linear forms whose appearance on screen follows a rigid design, the meaning of the finished film is suggested by its title: in music, a symphony is an extended composition in four movements, the first of which is the sonata. While Eggeling's film has four distinct sections, as film historian Gösta Werner and musicologist Bengt Edlund observed about it's organization:

> *Diagonal Symphony* starts with an "exposition," in which several episodes establish the various pictorial themes or motifs, and in which the dialectical opposition between first and weaker second theme, basic to the sonata form, is replicated by means of angular and rounded shapes. Then follows a "development," characterized by complex, multi-motivic pictures undergoing several changes simultaneously—a kind of visual polyphony. The material of the exposition appears in compact form as a "recapitulation," and finally there is a fairly extended section with further metamorphoses of

complex pictures, corresponding to the "coda," the (optional) closing part of the sonata scheme.[31]

The musical patterns established in the opening continue throughout the film. These pictorial themes are based on the repetition and opposition, what he called "pairing," and the symmetry it produced was a feature of how his graphic theory developed around the diagonal as a central structural principle. The geometric shapes following the design of the scroll paintings are gradually revealed on screen at a steady, uninflected pace, their motions structured around oppositions: movement in one form would be mirrored on screen by another element moving in the opposite direction; however, these linear shapes transform rather than move, the alterations appearing on screen as the revelation of iconic forms, not the kinetic action of forms moving in or through space: it is a static animation. These opening themes develop in opposition, unfolding without suggestions of motion through space. This film is graphic, yet does not entail an interplay between positive and negative space, or even motion on the screen, so much as the gradual revelation of composed designs: striations, grids, and radiating lines built around simple, symmetrical base-forms (circle, square, triangle). Following the opening's simple forms, they become more complex, creating a visual polyphony where multiple and compound groupings of forms interact, arranged into composite structures whose groupings resemble graphic crescendos and decrescendos; the film concludes with a reiteration of the opening formal elements. The forms shown are iconic, and the structure follows the drawing of each unit, then moves on to the next.

The final, completed *Symphonie Diagonale* first screened on November 5, 1924 at the *Gloria Palast* in Berlin to a private audience of thirty that included Laszlo Moholy-Nagy and film critic Paul F. Schmidt, who reviewed it; the first public screening was organized by the Novembergruppe six months later, on May 3, 1925; Eggeling died sixteen days following its public premiere. This public exhibition included many of the other "Dada films"——*Ballet Mécanique, Entr'acte*——and works by Ruttmann and Richter.

HANS RICHTER (1888 – 1976)

In the first part of Hans Richter's career, he worked as an artist, making both paintings and films; during this period he collaborated with Viking Eggeling. Their relationship was predicated on similar interests, and developed, at least initially, from Richter's desire to work together. The second part of his career, following his escape from Germany in 1939 to the United States was as an educator and historian. He brought prints of European avant-garde films by Fernand Léger, Man Ray, Marcel Duchamp, Walther Ruttmann, Germaine Dulac, Viking Eggeling and Oskar Fischinger with him. Both the Museum of Modern Art and the Museum of Non-Objective Painting (later renamed the Solomon R. Guggenheim Museum) purchased prints from his collection, making these films readily available for screenings in the 1940s. This availability and institutional support end of the first, experimental period in abstract film production and exhibition. From 1942 to 1956 he was the director of the Film Institute of the City College of New York, a position he used to promote a revisionist history of avant-garde and abstract film.[32]

In the summer of 1919, he invited Eggeling to visit his family's estate in Klein-Kölzig, Nieder Laustiz, Brandenburg in Germany. This marks the beginning of their formal collaboration, and art historian Martin Norden has noted the parallels and connections between the abstract language Eggeling and Richter produced, and similar attempt to create a formal language by other artists.[33] After 1920, Richter worked to promote their *Universelle Sprache* using his relationships with other abstract artists: De Stijl in the Netherlands, the Dada/Constructivists in Berlin, and the Russian artist Kasimir Malevich's Suprematism. Norden's recognition of the formal relationship between Suprematism, the geometric painting of Piet Mondrian and Theo van Doesberg (both De Stijl artists), and the *Universelle Sprache* created by Eggeling and Richter is not simply a coincidence. Their collaboration developed because of Richter's associations with these groups and mutual friends they shared in them.

Theo van Doesberg introduced Richter to Eggeling in 1918 during a visit to Zurich, Switzerland,[34] and in 1920, van Doesberg was promoting their work with the abstract scroll paintings to the De Stijl group, which included Mondrian[35]; van Doesberg's 1921 discussion of abstract film was illustrated using images by Richter and Eggeling.[36] The formal language developed and proposed by Richter and Eggeling found publication in De Stijl, and reflects their participation in the larger aesthetic developments of the 1920s.

Richter's relationship with Kasimir Malevich was equally direct: he organized the Berlin exhibition of Malevich's paintings in 1927, and was appointed curator of these works, stored in Hannover.[37] During this visit they planned an abstract film to demonstrate the translation of the principles of Suprematism into motion.[38] The planned film was never produced, remaining instead a collection of notes and sketches for how the work would develop.

The transfer of the formal language proposed by their *Universelle Sprache* into motion pictures was problematic for Richter. The attempt to adapt structures and form-sequences from his scroll-paintings are apparent to varying degrees in Richter's *Rhythmus 21* (1921/23), *Rhythmus 23* (1923/25) and in stills of *Rhythmus 25* (1925, apparently lost). *Rhythmus 21,* Richter's first completed film was originally titled *Film ist Rhythmus,* (Film is Rhythm), and may not have been completed until 1924, but parts of the unfinished film were shown starting in 1921.[39] It developed the ideas of their *Universelle Sprache* in a new direction, largely independent of the designs and aesthetic employed in his scroll painting *Praludium* (1919); his abandoning this first project may have led to the arguments and the end of his direct collaboration with Eggeling in 1921. The difficulty in producing the animation lay with the complexity of forms: as a result, the UFA animator assigned to animate them took longer than Richter wanted, an issue discussed at length in his memoir about these films *Easel–Scroll–Film* (1952), and apparently was not very supportive of the project Richter had conceived. His completed film was not based on the designs and technique employed in creating of the scroll paintings:

> I wanted to understand better what I was doing and decided, very much
> against Eggeling's arguments, to start from scratch again—using the
> principle of counterpoint to guide me. This time I did not concentrate upon
> orchestrating form—but time, and time alone.
> The simple square of the movie screen could easily be divided and

Hans Richter, stills from *Rhythmus 21,* (1921/23)

"orchestrated." These divisions or parts could then be orchestrated in time by accepting the rectangle of the "movie-canvas" as the form element. Thus, it became possible to relate (in contrast-analogy) the various movements of this "movie-canvas" to each other—in a formal as well as a temporal sense.[40]

Richter's organization of *Rhythmus 21* follows a harmonic division of the screen, with different parts being animated using squares in white and black. The full duration of the film employs superimpositions and loop printing of his animation in both positive/negative and forward-reverse. This repetition of animated elements gives the finished piece a structure where the transformation from positive to negative, and the reversal of animated actions, as in Eggeling's work, suggests the harmonics of musical scales, crescendos and decrescendos. As Richter's description of the idea of "a movement" posed in their *Universelle Sprache* states—"it must be completed, a world of its own"—each revelation of a form stands largely apart from the forms that follow it. In the sequences created by this arrangement, the harmonies and elaboration of visual motifs happens through the variations these compositions reveal. In *Rhythmus 21* and *Rhythmus 23,* each "movement" is a complete unit unto itself, leaving the modulations and patterning of moving forms to a different work.

Animated at an even pace, Richter's organization of "time," as Moholy-Nagy noted in his discussion of Eggeling's work with film, is distinctly limited to shifts of graphic relationship on screen, not to modulations of how fast or slow the squares and rectangles move. The structure is one where the frame of the screen is referenced by animated bands that slide horizontally and vertically across it; there are no curves, circles or rounded elements in this film. These are followed by a square diminishing in size. Each of these actions is repeated a few times before the next sequence of animation begins. Running only around 3 minutes, the finished work depends on the fragmentation and restoration of the full frame projected on screen. These movements are a realization of the precise syntax and structure of the language Richter and Eggeling proposed, based on the geometric and didactic presentation of its principles: this is claim that "each movement must be able to exist in itself" shown in actual practice. The elaboration of these basic units of

division and motion over the duration of the film follows from the compartmentalized foundation of the formal language. The isolation of each animated block where the reference is the screen's shape follows from the analogy between the screen and the surface of the painting: *Rhythms 21* is an animated painting, its abstraction follows from and develops the potential and implied motions of static art using animation. The sense of fragmentation felt in the experience of watching this film is essential to its meaning and design—a reflection of the iconic aspects of their *Universelle Sprache*.

The interplay between light and dark produced by the negative loops and the reverse sequences offers an opportunity to consider the shape of the screen as a positive and negative field upon which these rectangles and squares shift between being filled, solid space, and empty space. These graphic relations between figure and field are the subject of his animation, and are what he means by "counterpoint" in discussing the result.

Rhythmus 23 (1923/25) is markedly more complex both in its execution of the movement, and in the varieties of forms. It premiered in Paris during the film program of the *Soirée du Coeur à Barbe*. Again, Richter's design did not include curves or ellipses, focusing only on the use of rectilinear elements and straight lines. His earlier film experiments with adapting his 1919 scroll painting *Praludium* were incorporated into the finished film that primarily employed diagonal motifs in its organization. Where *Rhythmus 21* was built from the figure/field dynamics of solid planes and shapes in motion, the reintroduction of linear elements made in his initial film experiment allows a dynamic exploration of the relationships between solid and linear forms, and shows a construction of the differences and similarities between them. The different graphic potentials of these forms becomes apparent: as in the Richter's first completed film, *Rhythmus 23* employs positive and negative loop printing to reverse the figure/field relationships of his forms, but with the additional factor posed by the linear elements as a mediating force in their spatial relationship on screen.

In *Rhythmus 25* (1925) Richter returned to working with a scroll-painting as the foundation for a completed film: *Orchestration der Farbe* "Orchestration of Color" (1923). Unlike his earlier abstract films, *Rhythmus 25* employed tinting to add color to different forms, following the design of his painting. The coloring Richter used in the film works to group the forms in similar ways to the scroll-painting they are modeled on. His color theory was based on a red-green opposition:

> Between green and red are all the colors, as between black and white is all the light. The scientifically denominated elementary colors, blue, red, and yellow, do not have, aesthetically speaking, an absolute distance from each other. Red and yellow are nearer (warm); blue is opposite of yellow as well as of red; whereas green and red are incomparably unequal to each other… All other colors I consider more or less variations.[41]

Perhaps because of the difficulty and expense with producing the hand-colored print of *Rhythmus 25*, Richter only produced one copy, now lost. His use of this particular pair of opposites, in contrast to the yellow-violet of Impressionism,

reflects the more dynamic thinking of avant-garde painters starting with the Fauves, in particular, Henri Matisse, whose works extensively employ a red-green opposition to create their dynamism. It premiered in the same film program as Eggeling's *Symphonie Diagonale* sponsored by the Novembergruppe in 1925.

Taken together, his surviving films *Rhythmus 21* and *23*, are a demonstration of the visual potentials of the language Richter and Eggeling developed as Richter understood it. This distinction is significant, since in the production of these films he has acknowledged that he chose to deviate from how they proposed the *Universelle Sprache* for graphic forms—it was modified for use in his films, thus the actual parameters of this system do not entirely correspond to their application within these films. That the parameters imposed by working in black and white were limiting can be recognized in the use of hand-coloring for *Rhythmus 25*. The aspiration to demonstrate the possibility of an abstract, universal language based in perception that Richter's films reveal is particular to the Constructivist aesthetics developed in the 1920s. It is the element of these works which places them beyond the scope of being purely Dada provocations, contrasting as it does with the provocations and nihilism common to that movement.

MARCEL DUCHAMP'S *ANÉMIC CINÉMA* (1926)

Marcel Duchamp (1887 – 1968) produced only one film, *Anémic Cinéma* (1926). It shares some of the concerns with creating an abstract visual language, but stands apart from the translation of the implied movement shown in abstract painting to the apparent motion of cinema. This film, shot by Man Ray, creates a visual comparison between a series of risqué French puns and a number of kinetic optical illusions that oscillate between convex and concave when spun. The relationship between the visual and verbal elements of this film is intricate; the complexity of meaning contained by this formulation is belied by the simplicity of the film itself. Understanding it requires a consideration of how this film and its subjects can be related to the rest of Duchamp's oeuvre. This process reveals the abstract language Duchamp proposed in this film and his other works.

The oscillating disks so obviously on view in *Anémic Cinéma* are what Duchamp called "*precision optics*"; his name for the specific illusions used in the film was '*rotoreliefs.*' These early examples of kinetic art were originally designed for exhibition on the spinning turntable of a phonograph. Once set in motion, they visually pulse between positive and negative space. Duchamp has identified this apparent movement as "cinematic blossoming"; he directly connects it, so literally visible in *Anémic Cinéma,* with the role of desire in his painting-on-glass, *The Large Glass* (1915-23). This note from his publication *The Green Box* documents his process in the design and uncompletion of the painting:

> The bride basically is a motor. ... The whole graphic significance is for this cinematic blossoming. This cinematic blossoming is by the electrical stripping (see the passage of the bach. machine to the bride) ... The last state of this nude bride before the orgasm which may (might) bring about her fall graphically, the need to express in a completely different way from the rest of the painting, this blossoming.[42]

The "blossoming" cannot be presented; what the depicted machinery in this painting does cannot be shown. Yet, the completely different way he mentions can be recognized as a demand for actual motion—making his use of the cinema, and the appearance of the 'rotoreliefs' (with their blossoming action) not coincidental. The connection of the 'rotoreliefs' to *The Large Glass* is appropriate if only because the pulsating movement so visibly resembles "blossoming," but at the same time is an effect beyond the ability of painting to produce: without movement, there is no illusion in the 'rotoreliefs.'

Yet, the verbal elements are essential to interpreting the significance of the rotoreliefs: the apparent sexual meaning of the film comes not from the puns or the optical disks, but from their interaction. However, the puns composed and put in motion by Duchamp are difficult to translate because, as film historian P. Adams Sitney explains:

> Something else happens when we begin to allow the puns to have their play. The figurative meaning of "*la moelle de l'épée*" and "*la poele de l'aimée*" over powers the literal (non)sense. The reference to sexual intercourse could hardly be more evident. Furthermore, once we recognize its figurative character, our reading of the other disks begins to reveal sexual allusions. ... Suddenly the abstract gyrating shapes which rise from and sink into the plane of the screen come to resemble the igloos, breasts, welts and genitalia evoked by the words. The sexuality is neither in the literal meaning of the words, nor represented in the optical illusions, seen by themselves.[43]

Sitney recognized that sexuality is the subtext to this film, but it is a subtext which requires the interpretation of the viewer looking at the juxtaposition of rotorelief and the text. However, as Katrina Martin has noted in her essay on the problems with translating the text in *Anémic Cinéma*, these statements are untranslatable; Duchamp's statements are built from alliteration and puns that are a fundamental reflection of the differences between spoken and written French—simply translating them to their English equivalent necessarily loses the word play that is so important to their affect, effectively denuding this use of language of its peculiar quality.[44] The sexual interpretation of Duchamp's puns are an overlay from verbal to visual, applied to the image; the puns, in order, are:

> *Bains de gros thé pour grains de beauté sans trop de bengué.*
> *L'enfant qui tète est un souffleur de chair chaude et n'aime pas le chou-fleur de serre-chaude.*
> *Si je te donne un sou me donneras-tu une paire de ciseaux?*
> *On demande des moustiques domestiques (demi-stock) pour la cure d'azote sur la côte d'azur.*
> *Inceste ou passion a coups trop de famille, à coups trop tirés.*
> *Esquivons les ecchymoses des Esquimaux aux mots exquis.*
> *Avez-vous déjà mis la moëlle de l'épée dans le poêle de l'aimée?*
> *Parmi nos articles de quinquillerie par essence, nous recommandans le robinet qui s'arrête de couloir quand on ne l'écoute pas.*
> *L'aspirant habite Javel et moi j'avais l'habite en spirale.*

These "word plays" act through a double meaning which becomes apparent to French speakers, even though the statements are nonsense, when read aloud. The structure of these statements depends on the sound than the (normal) referential meaning.[45] The precise nature of this verbal nonsense is essential to the construction and meaning in Duchamp's film. Sitney further explains this organization:

> At first sight *Anémic Cinéma* would seem to underline the difference between optical and verbal images. The two modes of representation are held together by the figure of the spiral. Yet we automatically apprehend them differently. The eye grasps the eccentric circles as if they were geometrical wholes. … While the view sees one set of disks as creating depth, he "reads" the other set as flat because of his reflex to the familiar orthography of the Latin alphabet. Thus, the viewer is the victim of an automatic response at odds with the ontological "sameness" of the shots.[46]

Duchamp used the rotoreliefs as half of the visual material in *Anémic Cinéma,* the French puns were also placed on a spinning disk, the text arranged in spiral that moves from the outer edge towards the center. If we also recognize that as with a record, the 'rotoreliefs' have a hole in the center which is registered on a pin centered on the turntable, the mounting of the disk recalls the sexual metaphor which is repeated throughout the iconography of this film.

The doubling of the puns parallels the doubling of the *'rotoreliefs.'* The gyrating shapes' movement originates in the inconsistency of human perception which optical illusions exploit. It is the interpretative shift of the *"precision optics"* which moves the experience of looking from the purely visual into the mental realm. The rotoreliefs and their use in *Anémic Cinéma* recall Duchamp's famous claim that:

> Painting should not be exclusively visual or retinal. It must interest the gray matter; our appetite for intellectualization.[47]

The objection Duchamp has to "retinal art" does not lie with the optical experience, but with the issue of mental engagement in what that visual experience signifies; this bias suggests an art where the semiotic organization of visual elements is the focus. The optical component of this film is an illusion: what we see in looking is different than what the rotorelief is physically. While the retinal effect of the texts and rotoreliefs in *Anémic Cinéma* have a different perceptual character, their meaning is en effect of our interpretation—a result of intellectualization.

Sitney is correct that "the sexuality is neither in the literal meaning of the words, nor represented in the optical illusions, seen by themselves," the semiotic conversion of a retinal impression in *Anémic Cinéma* into sexuality is connected to the system of construction Duchamp presented in *The Green Box* (1914). His system creates a linguistic formalism derived from the abstract system of mathematics. It allows his introduction of a 'formal' component into the work provided that the viewer is aware of the system he employs:

Conditions of a language:

The search for "prime words" ("divisible" only by themselves and by unity).

Take a Larousse dict. and copy all the so-called "abstract" words. i.e., those which have no concrete reference

Compose a schematic sign designating each of these words. (this sign can be composed with the standard stops)

These signs must be thought of as the letters of the new alphabet.[48]

The invention of new "signs" for an abstract language corresponding to terms in a dictionary without concrete reference divests language of its meaning, allowing its manipulation in purely technical terms. The function of the puns and word-play of this film can be recognized in his system of *"prime words."* Each pun replays the action of the *'rotoreliefs'* linguistically, translating them from language to visual form. Yet for the translation of terms to be comprehensible requires an awareness of the systems of substitution for them to become legible. Alternation in the sequence of the film demonstrates their interchangeability. This transformation of abstraction into a complex web of meaning based upon an internal set of referents—the other works by Duchamp—the equivalences involved in the movement of oscillating visuals and punning text, instead of simply being a juxtaposition of *"neutral"* content, is logical within Duchamp's system; it is evidence of the semiotic organization of his material. The formal system Duchamp devised is representational; the meaning of the rotoreliefs, while apparently comparable to the works of pure abstraction comparable to those of Ruttmann, Richter or Eggeling, nevertheless have a specific meaning, thus the sexual context transforms how we understand these figures, shifting them from the realm of pure abstraction to something more closely related to the sublimation and substitution common to the works of Surrealism.

It is a transfer that renders the work difficult, opaque to easy examinations. Art historian Anne d'Harnoncourt explains the problem with looking at another of Duchamp's difficult works:

The Large Glass and some of its studies are, of all Duchamp's creations, the most accessible (to the point of being literally transparent) as well as the most abstruse. We see through them more than we see them. The viewer becomes part of the view.[49]

Her description of *The Large Glass* could easily be a description of Anémic Cinéma as well. The difficulty of this film lies with ways the transparency of the work is also its opacity: what we see and what it means are separated by a gap which must be filled with careful attention to the details not of the work immediately before us, but its relationship to prior knowledge of Duchamp's other works. This complex relationship appears in the title *"Anémic Cinéma"* which is a near-palindrome, almost spelled the same forwards as backwards. There is a self-similarity in the organization not only of his film, but of his other creations.

Duchamp's attempt to create such a language of visual form unites his film with in the development of all the early abstract films; the differences between his work and that of other artists lies with how he worked to create his abstract language, a matter of technique rather than goal. The role of language, both verbal and visual, in the construction of motion graphics is one of the essential concerns of

the field as it develops. Duchamp's film can be recognized, as with Ballet Mécanique, as a tangential development, offering a glimpse of an alternate way the integration of text and image could have developed. But at the same time, his use of cinema as a medium for the construction of a semiotic system where the visual achieves a linguistic function should not be discounted. The transformation of graphic element to meaning bearing sign is the essential feature required for the development of a visual language. Duchamp's work is especially notable in the history of motion graphics because it achieves this transfer so effectively, communicating a complex meaning that is not present in either his optical disks, the spiral texts, or their juxtaposition alone: it emerges from the relationship they also have with the rest of his work.

LASZLO MOHOLY-NAGY (1895 – 1946)

The "film" sections of Laszlo Moholy-Nagy's book *Painting, Photography, Film* were concerned with the "absolute film"; his observations about the importance of Viking Eggeling's work begin his analysis. His focus was on the ability to create an abstract work where light and movement appear on screen separated from the confines of theatrical, literary cinema. Moholy-Nagy called these works light-space articulation; an idea he developed initially in the form of the *Light-Space Modulator*, a kinetic sculpture produced in collaboration with Stefan Seboek at the Bauhaus in Berlin. This sculpture, and his theory about film, was the product of a highly synaesthetic context at the art school. His concerns were shared by other artists at the Bauhaus in the 1920s, including Vassily Kandinsky whose interest in color music had already been highly influential, and Kurt Schwerdtfeger who experimented with his own variety of "visual music" called *Reflektorische Farblichtspiele* (1922, "Reflecting Color-Light-Play") using a color organ of his own design. *The Light-Space Modulator* was in development for most of the 1920s, an on-going project of Moholy-Nagy's starting in 1922 when he created the first version, until his final version done in 1930. It is this last version that appears in *Ein Lichtspiel schwarz weiss grau* (1930).

Between 1929 and his death in 1946, Moholy-Nagy produced a number of films, but the majority of these are documentaries of work done at the Bauhaus or employ actors and a scenario; however, one of these films, Ein Lichtspiel schwarz weiss grau, is both a "documentary" and an abstract work independent of its subject. This film is significant, not for its development of sound-image relationships, but for the ways it employed the standard photographic technique and apparatus of the motion picture camera to create an apparently abstract film using physical materials and light—as reflection, distorted by prismatic lenses, and as projections through an abstracting device; it is simultaneously an abstract film in itself and a documentary of the visual and optical phenomena produced by the *Light-Space Modulator*. Camera work and the framing of the shots in the film incorporated the movements of the reflectors, balls and rods. The carefully framed shots blending projected light and physical objects created a visual composite, providing a bridge between *Ballet Mécanique's* use of objects and the absolute animations by Ruttmann, Eggeling, Richter, and Fischinger. This manipulation of physical material was an important innovative development from the initial

experiments done in *Ballet Mécanique* by Léger and Murphy. His film anticipates motion pictures done using the combination of live action, optical printing, and/or image processing that appears in both later abstract films and video art.

If Moholy-Nagy's *Ein Lichtspiel schwarz weiss grau* had been produced without reference to his sculpture, it would immediately be recognizable as being a fully abstract work; instead it is generally regarded as simply a documentation of his sculpture's operation. There are several factors that suggest this documentary aspect is not the primary focus of the film: that the title does not reference the Light-Space Modulator, instead recalling Walther Ruttmann's abstract films, *Lichtspiel: Opus I – IIII* in its proposal of "lightplay"; the organization of the visuals within the six minute running time; and the clear relationship between the film and Moholy-Nagy's film theory.

The Light-Space Modulator offered the opportunity to visually demonstrate the potentials of cinema he described in 1924. The focus of this work is the translation of his ideas about visual form from sculpture to film. Because the subject matter of his film is already visually abstract, the motion pictures transferred those kinetic abstract forms to film, but with a series of key differences between what he produced and simple documentation of the machine's operation. The images are framed in a careful, painterly fashion producing compositions—rather than documentary records—where it can be difficult to separate the moving elements from their reflections, shadows and projected patterns. His 1924 call for a new type of cinema, not concerned with representation could describe the result produced in 1930:

> Film practice has so far been largely restricted to reproducing dramatic
> action without, however, fully utilizing the potentialities of the camera in an
> imaginatively creative manner. The camera as a technical instrument and the
> most important productive factor in film-making copies the world around us
> in a manner that is 'true to nature'. We must be prepared for this; but we
> have hereto been too fully prepared, with the result that the important other
> elements in film-making have been insufficiently refined: formal tensions,
> penetration, chiaroscuro relationships, movement, tempo.[50]

This collection of visual phenomena separated from dramatic narrative and conventional representational content—the abstract patterns of circles, projected light and simple geometric forms on view in *Ein Lichtspiel schwarz weiss grau* provides a moving analogue to the photograms and Constructivist paintings Moholy-Nagy was producing during the 1920s. Originally planned as a six part project, only the last section was actually produced. The first five sections were planned around different types of light-effects: a match, automobile headlights, reflections, moonlight and the refractions created by prisms and mirrors, culminating in the existing section produced with his sculpture.[51] Incorporating a mixture of positive, negative and superimposed images throughout its duration arranged into approximately fifteen distinct sequences, the development of the film is towards increasingly complex kinetic compositions of lines and planes.

Ein Lichtspiel schwarz weiss grau (1930) opens with a fast whirling ball that gradually slows enough to read *"moholy=nagy zeigt ein lichtspiel"* (moholy-nagy presents a lightshow). The title is followed by a shadow hands manipulating a film strip, then another shadow hand pulls title cards into place: *"schwarz"* (black card with white text), *"weiss"* (white card with black text), and *"grau"* (dark grey on lighter grey). The opening image of the film itself has a foreground-background instability: it is initially uncertain how to read the circular image: as a cut-out or as an object set against a field of softer grays. The ambiguity of visual space in this opening image provides one of the primary themes developed throughout the film. The opening sections present the visual motifs of the film: spatial ambiguity, the transformation of lines to planes, the confusion of shadows cast with the forms casting them, and the contrast of light to dark forms in motion using both positive and negative printing. These sequences develop their material singly, then in combination, to systematically confuse the relationship between what is a positive and what is a negative. Following these explorations are a series of sequences built around increasingly complex multiplications and superimpositions arranged and edited carefully to create the illusion of continuous movement.

Of particular interest are the sequences that use a prism to repeat and kaleidoscopically merge the movements on screen. As in the superimposed sequences that follow, the compositions and camera movements are designed to minimize the sense that what is shown is a rotating sculpture: imagery emerges out of the grey background and slides back into invisibility. As white circles are superimposed into these sequences, the distinctions between different shots begin to breakdown, hiding the edits even further.

At no point does *Ein Lichtspiel* give a coherent sense of what the animating sculpture actually looks like. This film is not a document of the device; it is a translation of the aesthetic animating that sculpture into a film, with a series of distinct, particular effects appearing in it that are only possible because *Ein Lichtspiel* is a film. The kinetic motion of the whole follows a circular, clockwise movement, with individual shots having been composed to emphasize the graphic, painterly dimensions of the image over the creation of a coherent, photographically real space. Much of the film's images emphasize the chiaroscuro effects of light and dark—both through superimpositions and camera set-ups that enable light flares to reflect off the mirrors and glass surfaces within the *Light Space Modulator*. As the elements move, lines become planes and then abruptly vanish.

Moholy-Nagy has employed the sculpture as an abstract image generator, a tool for creating the kinds of flat, planar geometry that is so apparent in his paintings from c. 1930, when the film was produced. It presents a transfer of the geometric, Constructivist forms in his paintings that only imply movement to the apparent motion of cinema. Dwinell Grant will attempt a similar translation of Constructivist geometry to film at the end of the 1930s using stop-motion animation and glass rods to create animated compositions.

TOWARDS A UNIVERSAL LANGUAGE OF MEDIA

The desire to create a universal, visual language was a common goal of avant-garde artists working between the end of World War I and the beginning of World War II. This aspiration is shared not only by artists working with the traditional media of painting and sculpture—it includes artists such as film theorist and director Sergei Eisenstein whose conception of montage was also principally an issue of creating a language-effect through the combination of imagery, discussed in the next chapter. Where Eisenstein's language proceeded through the elaboration of editing, the linguistic systems proposed by other artists focused on different formal procedures. The reduction of visual form to simplified, planar, geometric forms did not directly lead to the establishment of a common visual language; however, the range of potentials these early graphic works elaborated upon do have relevance for the development of computer graphics and the formal organization/production of imagery generated by vector graphics.

At the same time, throughout the "silent" era, the element that the abstract film most needed to develop as the inheritor of those synaesthetic traditions elaborated by color and visual music—the ability to fully synchronize sound to visual—could only be approximated through the production of scores and their annotation to enable a synchronous performance. This tactic was a central part of the early and continued successes for Ruttmann's films during the silent film period. With the development of a commercially viable technology for recording and presenting sound in 1926, the abstract film underwent a dramatic, almost immediate transformation.

All of the surviving abstract and near-abstract films from the 1920s have some connection to the aesthetics of Dada/Constructivism, and bear the imprint of the avant-garde aesthetics of fragmentation, disruption and speed. In this earliest period the concerns of abstract painting generally dominate the resulting films: of the surviving works, only Ruttmann's films were constructed and designed as animations. Eggeling, Richter and Duchamp produced abstractions that were governed by their interests developed in other media, and then adapted to film. The transfer of existing concerns explored in painting and theoretical ideas about abstraction, motion, and color were heavily constrained by the limits of motion picture technology in the early 1920s, forcing these artists to adjust their thinking not only to the differences between a motion medium and a static one, but also to the much more limited technologies available at the time. As the decade progressed, improvements in film stock, camera and lens design, and the ability to reproduce sound radically altered the field as the 1920s drew to a close.

However, the underlying concerns with making a visual art comparable to music—whether in painting, film, or with light—remained a unifying principle that links the various developments in these media. At the same time the Germans were developing their 'absolute' films, in the United States, Mary Hallock-Greenewalt and Thomas Wilfred were perfecting their visual music devices. The interchange between the paired fields of visual music—motion pictures would become more pronounced with the development of the optical soundtrack synchronized to the motion picture image.

03

THE SOUND FILM

The films of the "silent era" before the advent of optical sound in 1927 were *rarely* silent. Instead, they would use familiar classical music whose timing was organized on cue sheets to match the film, enabling musicians to play in synchronization with the film.[1] By the 1920s the studios were commissioning original scores written specifically to accompany the film. However, commercial film producers would not employ Modernist composers to write scores for the various films made during this period, or even use popular music such as Jazz. The Modernist composers who did want to score films were compelled to collaborate with their friends who were making avant-garde films: this is why George Antheil scored *Ballet Mécanique*, *Entr'acte* was produced for Eric Satie and used his music, and Ruttmann's *Lichtspiel* films had a scores composed and synchronized to them by Max Butting, Timothy Brock and Hanns Eisler, and lead to screenings of these abstract films at the *International Music Festival at Baden-Baden* in 1927. This connection between avant-garde composers, experimental musicians, and abstract filmmakers is one of the common features of the tradition as it developed in the twentieth century outside of commercial distribution—during the 1930s there was a brief period where abstract film enjoyed commercial success as a visual accompaniment to popular music set into motion.

During the "silent era," film scores would generally be produced after the film was made to facilitate synchronization and counter-point of music and image. The introduction of optical sound reversed this production method—the score would come first: after recording it with the new film sound technology, the resulting optical sound track enabled the production of films with very tightly synchronized music and visuals. This ability to create an immediately apparent link between sound and image is the most important heritage of the abstract film for the field of motion graphics; with the arrival of optical sound, and its widespread use after 1927, the issues of synchronization between sound and image became much more pressing for all film artists working at the time. The development of visual music through the technology of motion pictures comes to dominate over alternative approaches to kinetic abstraction once the wide spread adoption of optical sound assures the ability to synchronize images with a soundtrack: it offered the potential

to directly connect musical tones to specific colors and forms in motion—to create a visual synaesthesia—the historical context for the synchronization of image and sound that developed in the abstract film.

After its commercial adoption by the film industry, the question of what and how to manipulate sound in relation to the image became a formal issue of concern not just to abstract filmmakers. In the decade leading up to the adoption of optical sound as the standard after the success of *The Jazz Singer* in 1927, filmmakers produced a wide range of theories about synchronizing sound to image and the synaesthetic form apparent in visual music was only one potential being proposed. The various types of synchronization can be reduced to three variations based on how the sound and image are linked:

(1) **Synchronous form** (direct synchronizatization)
 which attempts to create a "natural" phenomenon similar to "talking pictures" in the linkage of sound to image

(2) **Asynchronous Form** (random synchronization)
 where any relationship is purely accidental and the sound-image relationship changes with each screening

(3) **Variable Form** (counterpoint or structural synchronization)
 where the relationship between sound and image depends on rhythm or musical phrasing

A careful consideration of how Oskar Fischinger, Mary Ellen Bute, Len Lye and Norman McLaren worked with abstract film and at the same time produced commercial graphic animations reveals the direct connections between the artistic experiments of the 1920s and their transfer into the commercial realm during the 1930s. The synchronization of image and music, coupled with innovations in technique (color film) produced works that are immediately recognizable through their impact on later developments in motion graphics. Yet, at the same time, this period is also marked by experimentation and innovation—the artists active during these years were literally inventing their art, and in the process defining the basic parameters of motion graphics.

There was a fortuitous convergence of factors that enabled these artists to work: the needs of the studio system in the 1930s led to a steady demand for new screening material, enabling both the most banal pastiche to show along side what would have been radically experimental in the 1920s. The commercial funding available for commercials and the short animations that were part of the typical theatrical program gave Mary Ellen Bute, Oskar Fischinger to a lesser degree, and other independent producers the ability to continue making their films. Success as a filmmaker required both technical and business skill—since to sell a finished work to the Hollywood studios was a virtual guarantee of never receiving a royalty for the finished work. Self-distribution, a path followed by Mary Ellen Bute, would provide a prototype for the distribution organizations (primarily *Canyon Cinema* and The *Anthology Film Archives*) that identify the second phase in the history of abstract film.

MONTAGE

The development of sync sound was the exciting, new effect in motion pictures during the late 1920s and early years of the 1930s. Following the success of Warner Brothers' musical *The Jazz Singer* in 1927, the "talkies" were filled with speech, singing, and music—simply because seeing these in a film was a novel experience for their audience at the time. Animated cartoons by the Fleisher Brothers and Walt Disney quickly adopted direct synchronization sound, crafting visual fantasies around rhythmic action, singing mice and dancing creatures of all types. During this period the dominant theory for organizing and interpreting "serious" or "art" cinema was the Russian technique of montage—a theory primarily concerned with the structure and sequencing of what were essentially silent films—motion pictures where the soundtrack would be performed live, giving only limited ability to construct elaborate relationships between sound and image.

Soviet filmmakers began systematically developing theories about film structure in the early 1920s. These theories, collectively termed "montage" (editing), develop a variety of approaches to the structure and organization not only of edited sequences in finished films, but include the organization and development of action within the individual film frames. This work was promoted in the United States from 1930 to 1934 by the film magazine *Experimental Cinema* published in Philadelphia by avant-garde filmmaker Lewis Jacobs and David Platt. In the first issue, published in February 1930, it proclaimed itself:

> *Experimental Cinema,* published by the *Cinema Crafters of America,* is the only magazine in the United States devoted to the principles of the art of the motion picture. It believes there is a profound need at this time for a central organ to consolidate and orient those individuals scattered throughout America, Europe and U.S.S.R. that are working to liberate the cinema from its stereotypes symbolism.[2]

The American connection between the idea of an "experimental cinema" and the avant-garde lies with this publication. At the same time, it draws together a variety of distinctly American ideas about individual, artisanal production—the *"Cinema Crafters"* presents a motion picture analog to the various "crafters" guilds organized twenty years earlier through the American Arts and Crafts movement. This connection between popular art making (the craft guilds) and the European avant-garde is less surprising than it might seem: Gustav Stickley's magazine *The Craftsman* included articles about a wide range of subjects—including essays by members of the avant-garde such as Walter Arensberg who would become the preeminent collector of Marcel Duchamp, and Constantin Brancusi—and not just the endless decorating tips, plans for building houses or furniture, and the variety of do-it-yourself ideas now associated with the magazine.

The primary focus of *Experimental Cinema,* however, was the promotion of montage and Soviet theories about cinema as a tool for social change. For the leading theorist, Sergei Eisenstein, montage was a direct analogue to the Marxist dialectical process. The first issue's feature article was a discussion of montage theories summarized by Seymour Stern, the Hollywood editor, called "Principles of the New World-Cinema." This article was primarily concerned with presenting and

explaining Sergei Eisenstein's montage theories in a formal, rather than theoretical fashion. Subsequent issues would include further discussion of montage, and print some of the first translations of Russian montage theory to English.

Sergei Eisenstein (1898 – 1948)

Sergei Eisenstein proposed a series of techniques in his montage theory that provide a complete system for motion pictures. His theory was concerned with communicating the Marxist ideas directly to their audience, both through the stories told, and in the construction of the films themselves. His conception of montage attempted to present the Marxist conception of dialectic—the synthesis of antithetical materials—through the formal organization of both the materials shown on screen and in the selections made for any particular edit of two film strips. In practice, this 'visualization of the dialectic' appeared through visual contrasts (what Eisenstein termed "conflicts") of, for example: *class* (rich/poor), *scale* and *size* (near/far, big/small), or through *graphic oppositions* of light/dark contrast and *movement* within the frame and between shots cut together. In his theory, *this combination of oppositions presented the dialectical process through the montage* (and even within single shots), thus connecting the formal organization of the film to the ideological content of its story.

As optical sound became the dominant technology, his theories shifted, becoming concerned with the organization and relationship between sound and image. Concerned more with the editing of sequences than the graphic animation of imagery, montage nevertheless does have a direct relevance to the synchronization of sound and image. Eisenstein proposed a special type of montage form, chromo-phonic montage. This conception emerges from his critical engagement with the color-sound relationships surveyed in his article on "chromo-photic montage," *The Synchronization of the Senses,* a fact that reflects the pervasive influence synaesthesia on art before World War II.

The foundations of Eisenstein's *chromo-phonic montage* theory depend on a synchronization that is not only a matter of rhythmic connection between the editing and the music, but would also include and be determined by color. This specific montage formulation emerges from an analysis of the linkages between color and sound created by color organs where Eisenstein concludes from his analysis that:

> The decisive role is played by the image structure of the work, not so much by employing generally accepted correlations [of color to sound], but by establishing in our images of specific creative work whatever correlations (of sound and picture, sound and color, etc.) are dictated by the idea and theme of the particular work.[3]

The construction of color-sound relationships is arbitrary, dependent on the needs and 'desires' of the work itself, and should not reflect any other concern than those internal and specific to the work being made. Reaching this conclusion, Eisenstein rejects the foundations of color music to embrace the more variable construction common to artists engaged with visual music. While his discussion at a theoretical level is concerned with a full range of sensation, on the technical level his interest is in the relationship between sound, color, and image; this expansion of montage

theory in the 1930s builds on the five earlier, primarily visual, montage techniques he developed starting in the 1920s.

Eisenstein's five varieties of montage build towards greater complexity, based upon the weight given to the image's contents: *metric, rhythmic, tonal, overtonal and intellectual* (or the *montage of attractions*). The basic unit for this system was the "*shot*"—the individual film strip with moving imagery on it—and their organization in the montage sequence was to be based upon collision or conflict in a literally visual joining of the dialectical process of thesis|antithesis. The resulting new meaning that would be synthesis, spontaneously appearing from these juxtapositions. For Eisenstein, this was a theoretical translation of the dialectical process, leading him to claim the montage construction was an inherently Marxist method for film production:

> According to Marx and Engels the dialectic system is only the conscious reproduction of the dialectic course (substance) of the external events of the world.

Thus:

> The projection of the dialectic system of things
> into the brain
> into the process of thinking
> yields: dialectic methods of thinking;
> dialectic materialism— PHILOSOPHY

And also:

> The projection of the same system of things
> while creating concretely
> while giving form
> yields: ART.[4]

Eisenstein's claim for montage is simple. It is the transformation of mere images into a visual construction that is functionally identical to the dialectical materialist process. This shift causes the artwork itself to become an example of Marxist theory at the level of praxis in a direct movement from theoretical construction through to application in particular media work. The theory of montage, being based in the visual collision of opposites dramatizes this dialectical procedure inherently in itself. Thus, within Eisenstein's argument, montage is not only inherently Marxist, it is also immune to being used for purposes that would conflict with its dialectical nature—montage would always assure that the resulting film bears the imprint of Marxist analysis.

However, a closer consideration of the various types of montage suggests an alternate potential—a formal one rather than dialectical one. The essential element that produces the dialectical dimension of Eisenstein's theory depends on the actual, visual contents of each shot—that the different visual materials present a conflict. This factor becomes clear from Eisenstein's enumeration of various types of visual conflict: *motion, scale, size, apparent volume*; he also includes *contrasts of light/dark,* and *conceptual relationships such as young/old.* Such a recognition of the importance for context, implicates the context of the montage with the larger work

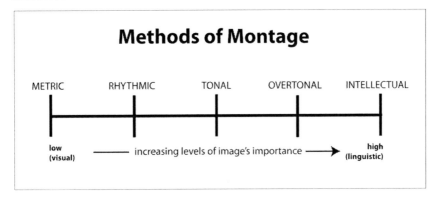

as well. The various montage structures he describes do function without the dialectical element, even if in his own films constructing a dialectic was essential to their meaning.

The various "lower" levels of montage, specifically metric and rhythmic, have immediate and obvious analogues in musical form. In metric montage the cut comes based on a specific frame count, no matter what is happening within the image (i.e. the image's content is of low importance), while in rhythmic montage the visible content does begin to matter: when there is a rhythm visible in the shot, that must be taken into account in deciding how to cut following a variable meter—hence, the "rhythm" in the name. Both types of montage treat the montage sequence musically, creating patterns and effects through the visual tempo of the editing—incorporating elements of metric cutting into the fabricated rhythm. Yet neither type is necessarily concerned with the actual content of the image, unless the motion contained therein affects the rhythm of the cut.

The visual qualities and contents of the image becomes increasingly important in the remaining three types of montage. Tonal montage is based on the graphic tone of the image—black and white levels, for example. Overtonal montage is concerned with the emotional tone or affect of the image, a factor dependent on the subject matter shown and the graphic character of depiction. Different styles of photography produce radically different emotional feelings, independent of what those images portray. Similarly, rhythmic and metric elements influence the emotional sense that a given sequence of shots has, impacting what kinds of feelings the montage sequence produces. All of these types of montage are concerned with the elicitation of feeling and organization of the sequence around creating a specific emotional tone.

Only intellectual montage approaches the assembly of the sequence in a linguistic fashion, as if each shot were also a word so that the sequence can be regarded as analogous to a sentence, or paragraph in its meaning and effect. It is intellectual montage that most specifically produces the thesis+antithesis combinatory effect: the juxtaposition of two images creates a meaning that is not present in either image when seen by itself. This last type of montage is the one most often simply, generically, identified as being "montage."

However, the "lower" levels of montage are more important to the history of how sound and image can be synchronized than the intellectual montage that Eisenstein championed in his writing and films. The concerns of intellectual

montage, with its aspiration to semiotic construction of filmed sequences comparable to language, have a different character entirely than the other methods he described. When confronted by the issue of sound, Eisenstein proposed a variety of synchronization between image and sound where both would contribute to a composite effect:

> Everyone is familiar with the appearance of an orchestral score. There are several staffs, each containing the part for one instrument or a group of like instruments. Each part is developed horizontally. But the vertical structure plays no less important a role, interrelating as it does all the elements of the orchestra within each given unit of time. Through the progression of the vertical line, pervading the entire orchestra, and interwoven horizontally, the intricate harmonic musical movement of the whole orchestra moves forward.

> When we turn from this image of the orchestral score to that of the audio-visual score, we find it necessary to add a new part to the instrumental parts: this new part is a "staff" of visuals, succeeding each other and corresponding, according to their own laws, with the movement of the music—and vice versa.[5]

Eisenstein's recognition about the organization of sound to image necessitated the development of techniques to handle their synchronization. That the sound and image can be linked in a technical fashion to achieve a direct, permanent connection is the central factor that enabled the theorization of a specifically audio-visual variety of montage.

In his discussion of the "Battle on the Ice" in *Alexander Nevsky*, Eisenstein considered the visual dramatization of music. His conception of how this synchronization would work reveals an approach to visual structure closely related to the concepts of visual music:

> It was exactly this kind of "welding" [of the demands imposed by the actual photographic films strips to the initial plan], further complicated (or perhaps further simplified?) by another line—the sound-track—that we tried to achieve in Alexander Nevsky, especially in the sequence of the German knights advancing across the ice. Here the lines of the sky's tonality—clouded or clear, of the accelerated pace of the riders, of their direction, of the cutting back and forth from Russians to knights, of the faces in close-up and the total long-shots, the tonal structure of the music, its themes, its tempi, its rhythm, etc.—created a task no less difficult than that of [a] silent sequence.[6]

Central to this orchestration of sound, movement and montage is the recognition that sound and picture happen simultaneously—that there is no delay between how sound and image are understood: they are perceptually superimposed one over the other.[7] The issue for his audio-visual montage was the coordination of sound-to-image[8] where the problem posed by music was not so much a matter of locating comparable elements in music, but of rendering the relative movement in visual terms:

> Musical and visual imagery are not actually commensurable through narrowly "representational elements. If one speaks of a genuine and profound relations and proportions between music and picture, it can only be in reference to the relations between the fundamental movements of the music and the picture, i.e. compositional and structural elements.[9]

Eisenstein's solution to these problems is to create visual analogues to the audible elements in a translation of musical arrangement to visual appearances on screen; his conception for relating the sequence of notes in music to the graphic organization of the frame was not based on the individual graphic presentation of tones. It is the relative structure of a sequence of notes, heard simultaneously with a particular image that was his focus. This organization anticipates the counterpoint synchronization that John Whitney would propose and develop under the name "digital harmony." However, unlike other experiments and theories of synchronic and contrapuntal structure, the underlying material used in Eisenstein's montage theory is representational, live action photography—and not abstracted forms or absolute animation.

OSKAR FISCHINGER (1900 – 1967)

Oskar Fischinger is the artist most closely associated with the production of motion graphics using a direct synchronization of note to form. Much of what is currently understood about Fischinger depends on historical research done by William Moritz, who was Fischinger's biographer, a family friend, and the foremost scholar on his work. Moritz's close association with the Fischinger estate, and his work to preserve Fischinger's work starting in the 1970s, is partly responsible for the survival of these abstract films. Most of what is understood about this filmmaker depends on research done by William Moritz.

Fischinger arrived at the connection of abstraction-in-motion and sound after almost a decade of experiments with automating and reducing the labor required to produce animations. His early works involved demonstrating new technologies he invented that could reduce the labor-intensive aspects of frame-by-frame drawing and painting—precisely to avoid the laborious procedures used by other abstract animators such as Walther Ruttmann in making his *Lichtspiel* films.[10] Of these early tests, *Wax Experiments* (1921–26) is composed from various kinds of imagery—abstract and impressionistic—produced using a wax-cutting machine developed based on the slicers used in delicatessens to cut lunch meat; he would use this device for the fantasy *Seelische Konstruktionen* "Spiritual Constructions" (ca. 1927). The fluid transformations and dreamlike space of the animation clearly required a level of preplanning comparable to what would be needed with traditional cel animation.

Another set of experiments are preserved in the fragment *Spirals* (ca. 1922–26). In this film Fischinger employed moiré patterns and other types of graphic interference effects to generate mandala-like swirls and spirals. This imagery was created using rotating sets of graphic lines that, when spun, would interact to produce kinetic imagery on screen. All these early works reveal a series of attempts to arrive at technical means for generating abstract animations without the

need to the labor-intensive animation process. It is a concern that reappears among artists throughout the first period of abstraction, and continues into the second. With the development of video art and the digital computer, these mechanical attempts were replaced with electronic, then digital, technologies. These early experiments with abstraction demonstrate various physical processes that other artists, such as Jordan Belson, would rediscover later in the century and use in their film work.

But the primary influence of Fischinger's films is not these early attempts at abstraction, but his later works done using commercial funding: he called these works "Studies"; *Studie no. 3* (1930) and *Studie no. 4* (1930) employed sound synched to the animation. The remaining films have a formal orchestration of form and synchronized design: *Studie nos. 5 – 12* (1930–32). In each of these surviving films the formal design and organization of forms follow precisely from the orchestration of the soundtrack. These films are the earliest examples of the synchronous form in abstract film. Their design depends on the individual dynamics of each note and the progression of the musical phrasing as it can be tied to the movement and animation of form on screen.

Studie no. 5 (in Jazz) (1930), originally titled *R-5, Ein Spiel in Linien* (R-5, A Play of Lines), presents black and white animation of simple abstract forms moving on-screen synchronized to an instrumental version of "*I've Never Seen a Smile Like Yours,*" a piece of popular Jazz from the British film *The Perfect Alibi* (1930) directed by Basil Dean. Unlike his later films in this series, *Studie no. 5* was initially synchronized to a record rather than the optical sound Fischinger would use starting with *Studie no. 6*.[11] However, this work represents a breakthrough that enabled the commercial survival of abstract film—of the other three filmmakers involved with abstraction in Germany, Eggeling had died and both Ruttmann and Richter had moved on to more commercial projects. Fischinger's connection of his abstract animations to popular music enabled their commercial distribution, allowing a degree of formal experimentation while still retaining the essential commercial audience required by the expense of production.

The other study films, *Studie no. 6, no. 7* and *no. 8* (as well as the last films in the series, *Studie nos. 9—12* that were made by his brother Hans) were synchronized precisely through the use of the standard optical soundtrack, developing the direct synchronization of tone-to-form. The forms in all these films are linear, but have the same soft, tonal quality as the forms in Walther Ruttmann's first two *Lichtspiel* films; the relationship between Fischinger's film and Ruttmann's forms could not be more apparent, differing only in speed of motion, size and—most clearly—their tight synchronization to the soundtrack. Forms synched to horns glide around the screen, pairing up and moving in tandem; a cymbal crash is a short burst of concentric circles. The shapes dance on screen, following the melodic phrasing up the screen in a visualization of the harmonic ascent of the music. The organization on view in these films is simultaneously guided and limited by the musical notes: duration and volume set the parameters of his work, while their placement on screen does not otherwise appear to be determined by the music.

The influence of the tight synchronization of abstract form to music that Fischinger pioneered cannot be underestimated. The synchronous form is the most common variety of visual music, at least in part, because it is the most commercial. Moritz has noted that Fischinger's initial decision to adopt the tight synchronization in the *Studie* films was a result of demands imposed by his clients, the record companies:

> [He adopted] tight synchronization partly because of his commercial ties with record advertising and partly because he found that audiences would more easily accept abstract visual art if it were linked to known music (abstract auditory art) they already approved of.[12]

The implication of this comment is clear: that abstract visuals present particular difficulties for audiences, so in order to ensure the commercial viability of his films, Fischinger was forced to make tightly synchronized films. However, this also implies a subservience of image to sound.

Kreise (1935, "Circles") was initially produced as a commercial for the German advertizing company Tolirag as an animation around the slogan that appears at the end of the film: *Alle Kreise erfasst Tolirag,* "Tolirag reaches all Circles in Society." The repurposing of existing commercial work as independent "art film" is something Fischinger would repeat with his later work done at Paramount. William Moritz has suggested this film was the first 3-color process film produced in Europe,[13] an indication of the commercial success of Fischinger's work and his connections with the advertizing industry. This close relationship between commercial application, experimental/avant-garde design aesthetics and motion graphics is a constant element in the history of motion graphics

He would produce several more abstract films as advertisements in Germany before leaving for Hollywood in 1936. These color films produced between 1933 and 1935 enabled his escape from NAZI Germany to work for Paramount on a seven year contract; it would be over after only six months.[14] It was the only full studio contract he would have, even though he would also work with MGM and Disney on individual projects under contract. The only project he did at Paramount used the Ralph Rainger piece *Radio Dynamics* (1936), but was never completed at the studio.[15] It originally was designed to be an animated opening sequence for the feature film *Big Broadcast of 1937,* a star vehicle for various well-known radio comedians—Jack Benny, George Burns and Gracie Allen. Had it been used in the film, it might have been the first animated title sequence of its kind, something that would only become common in Hollywood features after the mid-1950s.

Even though Fischinger produced the *Radio Dynamics* animation in color, and shot it with the Gasparfilm three-color separation process, the feature was in black-and-white, thus creating usability problems with Fischinger's animation. Because it was designed to be shown in color, the chromatic differences between the graphic elements became indistinct once the color was removed—the dark reds and greens simply became a dull and indistinct gray. Fischinger proposed adding various representational images—cars, toothpaste, cigarettes—superimposed over the graphic elements to solve the aesthetic problems using black-and-white

caused.[16] He ran behind schedule in adding these elements, leading to his firing; and the sequence he created was not used.[17]

An Optical Poem (1938) premiered on March 5, 1938, but it was actually shot and animated in 1937. It was his first film completed in the United States. Almost six months after losing his contract with Paramount, Fischinger signed with MGM to produce a seven minute animation independently of the studio in the style of his earlier film *Komposition in Blau* (1935).[18] The new film elaborated on the final sequence where colored circles fly through space. To achieve this effect Fischinger rented a space across the street from the MGM studio and built a scaffold to allow the manipulation of flat colored paper circles moving through a three-dimensional space.[19] While Fischinger was contracted to receive royalties from his production, the studio accounting system applied very high administrative charges to the film; Fischinger never received a royalty for it.[20]

The third film and final studio project Fischinger had in Hollywood was with Disney as the original director for *Fantasia* (1940), a film he left before completing the first sequence—Johann Sebastian Bach's *Toccata and Fugue in D-minor*—over disagreements about the degree of abstraction in the animation: Fischinger's designs were highly abstract and Disney added figurative elements to make the abstraction more accessible to the American public.[21]

The Guggenheim Foundation funded several of Fischinger's projects during the 1940s. Baroness Hilla von Rebay (1890 – 1967) the Foundation's director, met Fischinger in 1938 and purchased a print of *An Optical Poem* from him for the museum collection for $250.[22] His correspondence with the Guggenheim Foundation includes requests for funding ranging from $200,000 to make a feature film, which was beyond their ability to provide, to $750 to complete a short, which they gave him. In 1942, the Guggenheim Foundation provided the $1,300 Fischinger needed to buy the color negative for his unused animation (the original opening for *The Big Broadcast of 1937*) from Paramount so he could release the film as a three minute color work under the new title *Allegretto* (1936–1943)[23]; he discovered the original negative had shrunk and could not be printed, forcing him to reshoot the entire animation.[24] He sold prints of his German films to the Guggenheim Foundation which were used in screenings during the 1940s. Rebay would also fund his films, *An American March* (1941) and *Motion Painting no. 1* (1947). During the 1940s and 1950s he would also produce various fragments and experiments that would remain incomplete after his death in 1967.

Fischinger's influence is coupled with much earlier assumptions about direct sound-image linkage (i.e. synaesthesia) technologically enshrined in various visual music instruments where depressing a key results in the projection of a burst of color or image. This framework leads to a restrictive understanding of sound-image relationships where the only "acceptable" one is the tight synchronization adopted by Fischinger in the 1920s. His commentary in the 1946 *Art in Cinema* catalog suggests an awareness of the synaesthetic heritage informing the early development of film:

Now a few worlds about the usual motion picture film which is shown to the masses everywhere in countless moving picture theaters all over the world. It

is photographed realism—photographed surface realism-in-motion ... There is nothing of an absolute artistic creative sense in it. It copies only nature with realistic conceptions, destroying the deep and absolute creative force with substitutes and surface realisms.[25]

An echo of the universal, hidden reality shown by synaesthetic forms and early abstract art appears in this statement. The idea of "realistic conceptions" can be understood as a critique of his own works as well, since this general statement about the failures of motion pictures due to their superficial realism conditioning everything about the work could also be directed at the tight synchronization of his own work. Immediately before he makes these observations in his article, his concern is with the future development of his own work:

The color film proved itself to be an entirely new art form with its own artistic problems as far removed from black and white film as music itself—as an art medium—is removed from painting. Searching, for the last thirteen years, to find the ideal solution to this problem, I truly believe I have found it now, and my new, forthcoming work will show it.[25]

The "new, forthcoming work" that Fischinger was making when he wrote this article is likely to be his final film, *Motion Painting No. 1*, the last of his projects funded by the Guggenheim Foundation; portions of this *Art in Cinema* essay repeat in the statement "True Creation" published in the catalog for the *1949 Knokke-le-Zoute Film Festival*. The "ideal solution" he identifies is not the closely synchronized relationship of all his work being screened, but rather a contrapuntal structure where the organization of the work and the organization of Bach music on the soundtrack exist as tangential elaborations that come into contact only at major points of structural change. The adoption of a counterpoint structure in this final film comes without precedent in his earlier film works, suggesting an entirely new direction his work could have taken had he produced more films after *Motion Painting No.1*. The implication this change has for his work is direct: that the closely synchronized works, while commercial, also recreate an illusion of surface realism—the connection of tone-to-form and tone-to-color; it establishes the idea of synaesthetic abstraction as a variety of formal realism. The transformation from direct synchronization to variable synchronization, implied by his statement and apparent in *Motion Painting No. 1,* becomes a locus of attraction for abstract film and visual music works over the next fifty years.

MARY ELLEN BUTE (1906 – 1983)

Mary Ellen Bute was originally trained as a painter at the Pennsylvania Academy of Fine Arts in Philadelphia. After graduating in the early 1920s, she moved to New York and became involved with the same concerns with movement, rhythm and synaesthetic form that were common to the European avant-garde before World War II. Her engagement with these issues is apparent through her associations: she was closely involved with the community of visual music inventors and musicians in New York in the 1920s and early 1930s. During this period, she worked in the studio of Leon Theremin, and it is likely that through this connection she encountered Joseph Schillinger who was collaborating with Theremin on the

development of the electronic musical instrument that bears his name; Bute read the paper about this instrument while Theremin demonstrated it to the New York Musicological Society.[26] She would later also work in Thomas Wilfred's studio, learning to perform on the Clavilux.

Her movement between live performance of electronic and visual music, the aesthetics of abstract painting influence and her work with adapting Joseph Schillinger's mathematical model for synchronization of sound-image draws all the various threads of the history of motion graphics together in her film work, which she termed—in a direct reference to both visual music and the American abstract painter Stanton MacDonald-Wright's avant-garde art "movement" of the same name—*Synchromy*; she would produce ten abstract films between 1936 and 1959. In these films, the organization of visual material is provided by the music, whose structure is systematically translated into the visual composition: the musical form is taken as given, and determines the development, arrangement, and in many cases the form of the visuals accompanying it. The effect of this connection of sound to image creates a compelling illusion that the orchestration of sound and form is "natural." This connection is compounded by the common use of already-popular music in these early films, a factor that aided in the acceptance of the abstract visuals when the film screened for a general, popular audience. This strategy for achieving a "success" was common throughout this period—the 1930s and 1940s—and was noted by Cecile Starr who discussed Bute's films in 1952: "*Familiar acceptability of the music is a good basis for audience and theater approval.*"[27] The synchronization hides the arbitrary nature of the constructed relationship, implying that the only appropriate presentation of synchronized sound and image is one where they are locked into an absolute relationship: the music and the image appear to correspond to each other exactly creating an illusion of a natural linkage.

Bute's activity as an abstract filmmaker began as an attempt to produce a visual demonstration of music theorist/mathematician Joseph Schillinger's system for synchronizing music and image. Understanding Schillinger's musical system is essential to comprehending the formal development of Mary Ellen Bute's films; it occupies a central position in the aesthetics governing her film works. The earliest of these are directly relatable to the theoretical work produced by Schillinger. Her first attempt at an abstract film, *Synchronization* (1933), was never completed, but was meant to be a logical demonstration of Schillinger's ideas.

Schillinger's music theories have many points of contact with the tactics of avant-garde artists working in the visual arts: he would attack and ridicule established conventions, arguing for a new model for music that he was proposing.[28] The musical system is part of Schillinger's larger system of art that is principally modeled on the permutation of Aristotle's five senses. Music historian Warren Brodsky explains Schillinger's invention in his survey of the theorist's work: This permutational approach to the arts (forty years before the computer era) defined eighteen different art forms involving sound, mass, odor, flavor, light, pigment and surface relation to general components of time and space. He spoke of synthetic and multisensory associations, as well as about the fusion of sensations, which were referred to as "colored hearing," "sound seeing" and "kinesthetic

temperature / texture reactions" of tone quality. Schillinger also raised the question of transformation and coexistence of optical forms based on musical patterns.[29] All of Bute's films show the influence of Schillinger directly: many have titles that state *"A Seeing-Sound Film,"* or *"Synchromy."* They are examples of what Joseph Schillinger identified schematically as *"Art Form Number Eight (sense of sight): Kinetic art of visible light projected on a plane surface"*[30] whose description identified both color music and abstract film as examples. The connections between synaesthetic abstraction, the production of a *"universal language of form"* and both visual music and film could not be more explicit. Art based around the synthesis of discrete senses, and the fusion of sensation as *"colored hearing,"* was a common theme among artists involved with the synaesthetic tradition.

In working out the potentials of his system, Schillinger proposed several approaches to the synchronization of music to visuals, patenting devices of two types: the *Graphomaton* that produced linear designs, and the *Luminaton* that employed projected light.[31] The development of machineries to demonstrate the theoretical connection between sound and image, as well as the free movement between various types of "color organ" and film experiments, is one common feature shared by a majority of artists working in the first period of abstract film. Bute's work and close connections to Schillinger, Theremin and Wilfred has a visible impact on how she develops and experiments with creating visuals for her abstract films; central to this work are Schillinger's theories about synchronization.

Joseph Schillinger's Method

Schillinger's approach conceptualized both film and music as similar problems where their structural organization and development was to be based on rhythm. In his model the rhythm of events (plot), actions (actor's movements), and color (or chiaroscuro) are all coordinated to the music to create a single rhythmic effect. Bute's first finished film, *Rhythm in Light* (1934) simplified the earlier visual design of Synchronization and replaced the hand-animated forms with live filming of physical objects, thus allowing the production of the finished film much more quickly than what would have been required for the animation. Unlike Fischinger's direct synchronization of form-to-tone, Bute's design follows an elaborate synchronization of composition, musical phrase, visible motion on screen and editing to create its linkage of sound and image. It is an almost literal adaptation of Schillinger's description of synchronization from his February, 1934 article "Excerpts from a Theory of Synchronization" published in the Marxist film journal *Experimental Cinema:*

> Synchronization of the visual-audible does not necessarily mean one to one correspondence. Different components can be correlated through all the infinite variety of their different powers and different modifications of the same powers. Different parameters of the same component follow the same principle. This means that the continuum of one or more components can be represented through a system of parabolas, where the location of points expressing different parameters can be determined.[32]

Schillinger's brief article presents a mathematically-based theory for cinematic construction of synchronous relationships between music and image. The

foundation for this construction is the rhythmic cycle based in an assumption that the audience already knows the development and progression of the piece itself; this element of past experience and conscious anticipation of the work's development is a crucial, but unacknowledged element in his theory:

> There are different ratios of correlation serving different purposes. For instance the rhythmic center for an image on a given area will be more dynamic or dramatic at the ratio of 4:3 than at 1:1. The same is true referring to time for a whole composition: the suspension of a climax will be more effective at the ratio 3:2 than at 4:3—as it develops later, it will seem tenser.[33]

The distinction between an image where the whole totality is perceived instantly, and the elaboration of a work across a duration is absent from this construction; this lapse is significant to understanding the theory Schillinger proposes. It is a conception where the organization of the whole, and its comprehension after viewing. In this theory, the full elaboration and the desired emotional effects of that construction, require a complete apperception of the totality once it is complete.

Bute's Adaptation of Schillinger's Theory

Filmmaker and historian Lewis Jacobs, whose magazine *Experimental Cinema* was engaged in promoting a politically-engaged film practice derived from Soviet work with montage, described Bute's films as being "*more concerned with complementing rather than corresponding to the visuals.*"[34] His observation about her films is appropriate: Bute's films do not engage in the same kind of synchronization of note/tone to form that Oskar Fischinger's films do; however, this is not to say that there is not a variety of counterpoint synchronization clearly evident in these films. Their structural organization, editing, rhythm, and tonal qualities are all carefully fitted to the music, so the imagery serves as a response and a visualization of the music, but without displaying individual notes tied to specific forms throughout the entire film. The degree to which each film is synchronously connected to the music varies. Some, such as *Tarantella* (1940), have close synchronous relationships with forms, while others, such as *Synchromy No. 4: Escape* (1938), do not.

Rhythm in Light (1934) was Bute's first completed film, appearing the same year as Schillinger's discussion of synchronization in *Experimental Cinema*. It had been preceded by several studies and an earlier attempt to film Schillinger's ideas using standard animation techniques that was abandoned because the imagery was too complex for standard production with hand animation. *Rhythm in Light* reflects this shift from the painterly and cel animation techniques employed by the absolute filmmakers (Ruttmann, Eggeling, Richter) in the 1920s in favor of the same procedures of abstracting from reality by using already-abstract subjects employed by Laszlo Moholy-Nagy. Running just under three minutes long, following the opening credits it proclaims itself a "*A Pictorial Accompaniment in abstract forms*" followed by the explanation that "*It is a pioneer effort in a new art form – It is a modern artist's impression of what goes on in the mind while listening to music.*" The explanatory element in Bute's film is a common feature of American abstract films of the 1930s

produced for commercial distribution—an element also shared by Fischinger's *An Optical Poem*.

Her use of commercial distribution links the independent production of Bute's abstract films to the more contemporary independent production companies that create motion graphics. Bute retained ownership and control over her films, distributing them herself; they would screen in commercial distribution as the animated short before prestige features such as *Mary of Scotland, The Barretts of Wimpole Street* or *Hans Christian Anderson*.[35] Bute's early commercial distribution of her films directly to "prestige" venues, including New York City's Radio City Music Hall, helped establish Modernist, abstract art as part of elite American culture.

Like Fischinger, Bute chose classical music that was already familiar to her anticipated audience for *Rhythm in Light*. The abstract forms are organized in counterpoint to Edvard Grieg's "Anita's Dance" from his *Peer Gynt Suite*. To achieve the effect of an "absolute" animation, Bute filmed various objects that already has a geometric character in such a way as to render them abstract: sheets of crumpled cellophane, an egg-cutter, prisms, toy pyramids, ping-pong balls, velvet sparklers, and bracelets.[36] Their framing, movement and editing are responsible for creating the abstract effects seen in this film. Fully recognizable shots are kept to a minimum, and the elements seen only betray their actual, physical identity in a few shots—the majority of the material appears completely abstract, but has a sensuous quality produced through the lighting effects possible with tangible objects.

Synchromy No. 2 (1935) develops and explores the potential for using physical materials, editing and lighting effects to create abstraction with actual objects. Unlike her first film, the materials used allowed a consideration of the range between representational materials abstracted through film, and geometrically abstract objects. The lighting effects and kaleidoscopic distortions that abstract her physical source materials converged with the same kinds of effects Laszlo Moholy-Nagy employed in his earlier *Ein Lichtspiel schwarz weiss grau* (1930). However, the visual materials, however abstracted they are, retain their representational content: gothic arches, staircases, rippling star patterns abound throughout the five minute film. These recognizable materials are linked to the soundtrack in obvious, direct ways: as illustrative materials drawn from the musical content and matched to the lyrics.

The soundtrack for *Synchromy no. 2* is exceptional not only among Bute's abstract films, but also among abstract films generally: it used a vocal performance of Richard Wagner's *The Evening Star,* sung by Reinnald Werrenrath, instead of a purely instrumental score. This difference brings her film closer to the music videos of the 1970s and 1980s in its effect—a visual performance that illustrates the soundtrack in a way that Fischinger's tight tone-form synchronization does not. The illustrative dimension of this film appears through the fully representational subject of the film: a small statue of the *Venus de Milo,* whose role is as the "evening star" from the song. This close relationship between content of the imagery and the lyrics of the song overshadows the loose synchronization of music and image. The points of contact provide a referential framework for the elaboration of the film-as-illustration.

Parabola (1937) is the last of Bute's films to be built from careful manipulations of physical objects to achieve chiaroscuro effects in black-and-white. It employs a translucent sculpture by Rutherford Boyd whose abstract arcs and curves—supported by internal ribs—give visual form and rhythm to the film. As with Moholy-Nagy, Bute incorporates both the sculpture itself and the light patterns it produced on a wall into the finished film. The imagery of this third film is the closest to the descriptions for musical structure posed by Schillinger: his *"continuum of one or more components can be represented through a system of parabolas"* becomes literally visible in Bute's film, appropriately titled "Parabola." This connection between her work and Schillinger's ideas is a constant feature of all the abstract films she produced.

Synchromy No. 4: Escape (1938) introduces a series of new elements to Bute's visual vocabulary developed in her previous films: color, kinetic light effects (the influence of Thomas Wilfred), and subsumes all these to plot set to Johann Sebastian Bach's "Toccata" from *Toccata and Fugue in D-minor.* The narrative drama is simple: it is the story of a red triangle in a black prison, and shows it breaking through a series of grids and bars in its process of escape, as it leads other triangles to freedom. This story synthesizes the developments of her previous films, yet does not leave the realm of visual abstraction because the various "actors" are themselves simple abstract forms. This dramatic narrative element would become more pronounced in her collaboration with Norman McLaren on *Spook Sport* (1940) where his hand-drawn animations tell the story of ghosts and other spirits cavorting in a graveyard after dark, appropriately synchronized with Camille Saint-Saëns' *Danse Macabre.*

Tarantella (1940) was a second collaboration with Norman McLaren, however, unlike *Spook Sport* it is less a narrative than an abstract dance where hand-drawn elements contrast with hard-edged geometric forms. The synchronization of tone to form is more precisely timed and achieves a visible synaesthetic effect similar to the synchronization employed by Fischinger. Her other films of the 1940s would develop these effects further.

Like *Spook Sport,* but unlike *Synchromy No. 4,* ghostly, highly-saturated color effects appear throughout the film—a product of the film being printed with a two color process. Because the film uses a pair of negatives—one that produces red and another that produced blue—when there are different animation elements in each printing negative strand, the resulting colors are brightly saturated and highly graphic. (McLaren would use this color separation process in his other films from the 1940s made under a Guggenheim grant.)

In the early 1950s, Dr. Ralph K. Potter, director of the Department for Transmission Research at Bell Telephone Laboratories in New Jersey, who came to her studio interested in seeing her films; in the later 1950s he wrote the "TV-Film Roundtable" column, often discussing the innovations being produced by the avant-garde, for the magazine *Art Direction,* which focused on promoting creative and innovative advertizing design. Connections such as Potter's between avant-garde film and commercial production were common during the 1950s.

Bute called the films she made with the electronic image-generator produced by Potter *"Abstronics"* for *abstract electronics*. This collaboration/development resulted from her explanation of the animation process and its labor-intensive process to Potter. He designed the circuit for an oscilloscope which allowed the generation and animation of Lissajous curves and other wave forms that could then be filmed live and combined into finished films. The first of these films, *Abstronic* (1952) employed imagery that moved in three distinct "spaces"—a foreground, middle ground and background—where lively animated Lissajous curves appear against geometric backgrounds, synchronizing forms to specific instruments in the soundtrack by Aaron Copeland. A similar approach appeared in *Mood Contrasts* (1953) with music (*Hymn to the Sun* and *Dance of the Tumblers*) by Nikolai Rimsky-Korsakov. *Mood Contrasts* was her last abstract film. She compiled existing footage for an RCA TV commercial and as a short made for broadcast on the *Steve Allen Show* in 1957.

The importance of the electronic instrument created by Potter was its dynamic, live ability to simplify the animation process. It provided a means to "draw" directly on screen, and animate the drawing at the same time. Bute explained its importance in "Abstract Films," an unpublished article:

> We got the pattern so that we could make it come forward or backward on the screen and move around and come in any side of the screen so that you also have horizontal and vertical control.[37]

As an animation tool, her device anticipates developments in both video art—the Paik/Abe video synthesizer also used oscillators to create imagery—as well as other experiments with creating digital computer animations such as John Whitney's work as artist-in-residence at IBM in 1966. Because it offered the ability to change the size of the form (creating the illusion of a z-axis movement), and both x and y coordinate movements, the oscilloscope controller enabled the first direct animation of abstract materials that did not require some type of physical object prior to filming—a requirement present even in the experimental wax and moiré patterns generated by Oskar Fischinger in the early 1920s. This transition from a physical object to a generally variable, artificial electronic source provides an important precedent for developments of electronic imagery in computer films and video art; the generation of imagery within a specific set of parameters is a common feature of all digital imagery.

LEN LYE (1901 – 1980)

Within the history of motion graphics Leonard Charles Huia Lye (known to the world simply as "Len Lye") occupies an unusual position. He worked as an animator, then as a director of newsreels for the *March of Time* from 1946 to 1951, and finally as a kinetic artist. Even though he had informal training as a painter and worked with various types of sound-image synchronization in abstract film, his works exhibit a distinct conception of abstraction as a kinetic art, rather than an art constructed upon a musical analogy as was typical for the other artists drawn to create abstract motion pictures during the first phase of their history. This emphasis appears in his theorizing shortly after his first hand painted film had achieved a wide-spread critical success in Europe. Writing with a collaborator, Laura Riding, in

1935 for the essay "Film-making," Lye proposes a tentative framework to think about motion as form:

> 1. Form in movement-compositions is the total effect of accidental design created by cross-movements, perspective movements, timing, accenting—all the varieties of action whether in natural juxtaposition or not.
>
> 2. There is a possibility of isolating a movement-consciousness by reverting to such reflex-spontaneities as hereditary instincts are composed of. It might even be said, perhaps, that this gift of physical immediacy, which is the gift of a consciousness of movement, is discoverable through the brain in blood, organs, tissues, nerves: that a physical time-sense can be physiologically cultivated.
>
> 3. Consciousness of movement may be purely receptive, as a passive sensing of the vibration-pattern: so we might speak of a sense of movement just as we speak of a sense of telepathy, meaning a receptive intuition of other people's thoughts, or a theosophic sense, meaning a receptive intuition of things unknown.[38]

The proposal being made in these three axiomatic propositions is that motion and movement are autonomous sensory phenomena based in our ability to recognize the passage of time (time and movement are equivalent here), and our perceptions of movement happens as a recognition of something present in the world around us, but at the same time absent in itself: movement only become apparent through the pattern of its action—where it has been and where it goes as we watch. This understanding of the apparent motion of film is fundamentally perceptual, a construct that necessarily combines the perception of movement with the recognition of duration. However, even as movement is a natural component of the physical world, the concern Lye has is with its perception:

> 4. Or we might say, speaking in terms of light, colour, sound, atoms, that nothing physical exists in a static state. But at the same time, we should have to say that by movement we meant not external or mechanical movement, but movement as our own physical existence projected outside the mind and seen as living. And further, that when the mind is movement-conscious it is conscious of nothing else: in fact, is something that precedes what is strictly called consciousness, as physical precedes mental.[39]

The ability to see something move does not depend on a conscious decision by the viewer, it is an innate, autonomous process outside of conscious control—yet, in a startling recognition, Lye's theory understands movement as an internal interpretation of the viewing mind that is then assigned to perceived external stimuli. The recognition of movement, however innate, is a construction reflecting some mental activity.

Lye concludes this set of axiomatic proposals with a comment about the role of film—motion pictures—in relation to the distinctly perceptual-kinetic framework he has proposed. These foundations, considered in relation to his film work, leads towards the creation of works that converge with the audio-visual concerns of visual music:

6. Film is technically the best method for the isolation of visual movement.
As sound and visual movement are equal in timing they can be balances with
accents and silences in film.[40]

However, his concern with movement is a qualitative distinction that separates
Lye's films from those of other artists active in the 1930s. The relationships
between the visual forms and the soundtrack that are produced by his films move
between organization around specific note-form (as in Fischinger) to the
counterpoint relations of form to soloist performance, and the rhythmic break up
of the film into sequences corresponding less to specific parts of the music than to
the mood or tone of a sequence. This difference probably originates with his
background, unique among artists of this period: an autodidact, he learned the
forms and approaches of Modernism at one remove, via books and magazines at
the library in Christchurch, New Zealand—a location distant from the
conversations, arguments and debates shaping the emergent abstraction at the start
of the twentieth century. Instead of developing his ideas of abstract form within the
cultural horizons of the European avant-garde (and its relatives in America), Lye
developed autonomously: thus, where music provides the aesthetic reference point
for the synaesthetic abstraction developing in the Euro-American tradition of
abstract film, Lye's aesthetic begins with a concern with motion—the idea of a
kinetic art that he would develop graphically with the apparent movement of
cinema, then later employing the actual, physical movement of motorized, kinetic
sculpture in a gallery setting.

However, the conceptual basis of his work as kinetic, (vs. the more common
musical analogy), does have parallels to musical form. Joseph Schillinger noted the
relationship between movement and music in his 1937 discussion of music, *The
Destiny of Tonal Art*.[41] The recognition that movement is a foundational principle of
reality informs both Schillinger and Lye's conceptions of motion as central to the
organization and development of musical arts; the distinction between them lies
with how that idea informs and develops in their otherwise independent aesthetic
systems. A concern with motion does not preclude interest in or concern with a
music-like organization for a film.

While his work develops from an aesthetic of movement attached to specific
forms—his "figures of motion"—Lye's work in both film and kinetic sculpture lie
along twin, successive trajectories, each with their own distinct audiences and
particular histories that do not generally overlap.[42] Roger Horrocks, Lye's former
assistant-turned historian, explains the connection between this conception of
movement and Lye's films:

> The term 'figure of motion' had the advantage of being applicable to films,
> kinetic sculptures, or any movement in nature. Familiar examples included a
> wave rolling in and breaking, or a graceful 'figure skater' making patterns on
> the ice. One of Lye's favorite examples was a child waving fireworks on Guy
> Fawkes Night: "When a . . . sparkler described a figure eight, the persistence
> of after-image isolates its motion as design." Lye was, however, less
> interested in the 'after-image' than in the pattern-making implied by the
> word "describes."[43]

Len Lye, title card for *A Colour Box,* 1935

It is this element of form created by a specific, particular movement spread over time that defines the concept of "figure of motion." Thus, what is of concern to Lye as a theorist is not the perceptual form created in optical perception, but the visibility of motion that optical trace enables. This distinction is significant for how this aesthetic develops its forms and the ways in which those forms are put into motion.

Lye's work as a filmmaker proceeded through a combination of experimentation on his own projects combined with practical on-the-job training working at film production companies that specialized in creating animated films. His first completed film, produced in London over a two year period, *Tusalava* (1929) was done using standard animation techniques: individual hand-drawn artwork was photographed on an animation stand during his off hours at work.[44] The Samoan title, translated by Lye as *"Everything eventually goes full circle"* employed vaguely Surrealist, primitive drawings related to the work of Hans Arp.

A Colour Box (1935) produced during 1934, proceeded from an entirely different basis than his first attempt; it is the oldest surviving hand-drawn motion picture. (At the time of its production, earlier work by the Futurists was essentially unknown, and Mary Hallock-Greenewalt's experimental hand-painted "films" were only playable on an idiosyncratic device of her own design, and were not "motion pictures" except in a generic sense that they moved intermittently.) This basis made *A Colour Box* a topic of much discussion, and it screened widely in Europe, eventually winning a special Medal of Honor at the *1935 International Cinema Festival* in Brussels.

A Colour Box was Lye's first project done under the sponsorship of John Grierson and the GPO Film Unit. This organization was a division within the United Kingdom's General Post Office, begun in 1933 as a reorganization of the earlier Empire Marketing Board Film Unit that was responsible for creating advertizing films for the government. Under John Grierson, the GPO would become an instrumental organization in the development and production of socially-engaged documentary films. Lye's first work with them was created to be shown in color in a program of black and white films; after its initial success, Grierson would commission three more animated films from Lye—one per year—with the only requirement imposed on *A Colour Box* that it end with a message advertizing postage for the post office. Ultimately Lye would only produce three animated films for the GPO; the fourth was the live-action film *N or NW* about the dangers of misaddressing a letter.

His rediscovery of hand-painted (direct animation) film became the foundation of the animation techniques Lye would develop over the remainder of his career making abstract films. However, his production of hand-painted films was not entirely limited to working with direct-on-celluloid techniques: *A Colour Box* used a series of title cards for the opening credits, over which he applied his painting, using a combination of stencils to create repeating shapes across the strip without concern for the individual frames, and scrapers to "cut" lines into the wet paint before it dried. The subtractive process introduces the common element that reappears in almost all Lye's films: a 'figure of motion' in the form of a vertical line that modulates in response to the music. These different graphic elements are roughly synchronized to the music—different elements are on screen at the same time as different instruments take up solos. This linear form runs throughout *A Colour Box*; it appears across Lye's entire body of work, visible both in his films and in his kinetic sculptures. His next film, produced as a tobacco advertisement, would refine these stencil and subtractive techniques further.

Len Lye's Kaleidoscope (1935) was sponsored by the Imperial Tobacco Company, and featured music by Don Bareto and His Cuban Orchestra. Following the design of his earlier film, Lye shot the titles using an animation stand, but painted color fields and wipes over them, integrating the traditional animation into the hand-painted. *Kaleidoscope* presents improvements and shows a clear development of his stenciling technique: where graphic patterns dance without great concern for the individual frames of *A Colour Box*, this second film incorporates carefully registered stencil animations of spinning disks, star shapes, and subtractively, dancing rectangles that represent cigarettes. Further unlike his GPO film, the animation is not simply an abstraction with advertising message at the end—the films nature as an advertisement structures and organized the imagery throughout. The spinning disks recall cigarette labels, the stars suggesting the burning coals of the lit cigarettes themselves.

As with both Fischinger in Germany, and Bute in America, Lye worked with familiar, popular music. The choice to employ Cuban music reflects a mid-1930s European fad for Cuban performers of various types—both dancers, singers and bands. The combination of abstract animation and popular music is a common

feature of pre-World War II abstraction generally once the sound film and optical sound track replaced the live performers of the silent era.

 Rainbow Dance (1936) was Lye's second GPO Film Unit sponsored production. As with his first GPO film, this one also ended with a message from the post office: *"The Post Office Savings Bank puts a pot of gold at the end of the Rainbow."* Unlike his first production where the relationship between the advertizing message and the rest of the film is uncertain, in *Rainbow Dance* their connection is obvious, if also literal. He employed a new type of color film that Oskar Fischinger had also used to make his color films starting in 1932. The Gasparcolor film created a full color image from three black and white color separation negatives that would be printed together to produce a single finished print. In making *Rainbow Dance* Lye employed both live actors with sets and hand painted elements that were combined in the printing process; his use of this film stock was fundamentally different from how this stock would normally be used. The colors that appear in the finished film result from how Gasparcolor employed separations: each element of film was produced from a black and white original—no color was used in the sets or graphic elements in the film. Lye discussed this process at length in his essay "Experiment in Colour." It developed a different approach to the creation of color:

> The difference in colour technique for this film as compared with the shooting of a straight colour film is that all colour records were taken as separate films. No colour was used in the sets, where every object was painted in terms of black and white. For instance, a green hill (a 'prop' hill) was painted white and photographed continuously for the red record, painted dark grey and photographed for the yellow record, painted a light grey and finally photographed for the blue record. This meant the film was split into three records for the required densities of the pink, yellow and blue dyes of the Gasparcolor film stock.[45]

The creation of color via the printing process meant that the final color effects of the film would have a translucence and brilliance unrelated to the actual colors of the material filmed, while at the same time breaking the visuals on screen into a spectrum of hues—the "rainbow" described by the film's title. It has the effect of separating the colors shown from the forms seen on screen—as different moving elements overlap, their colors interact and combine independently of their shape or motion. This exploration of the physical potentials of color in film would lead to his final animated film done at the GPO, one that developed the combination of live and animated elements, as well as the orchestration of color in a laborious production process that anticipates commercial motion graphics produced in the 1980s and 1990s that employ video and computer graphics.

 Lye's continued involvement with the GPO allowed him the opportunity to further develop his techniques combining filmed material with direct, hand-painted animation. The results of these experiments are visible in *Trade Tattoo* (1937), a documentary of "the rhythm of work-a-day Britain" that was made with outtakes from other GPO films which were carefully combined with hand-animated elements. As in all Lye's hand-painted films, the synchronization of

sound to animated forms becomes increasingly acute, partly an effect of montage, where as instruments change, there is a cut to a new piece of animation. The difference between this film and his earlier ones, however, is immediately apparent in the "Fires are lit" sequence where a the mixture of hand-drawn words, representational animation of flames, Lye's familiar animated dots, and extremely high contrast—rendering only black and white with limited grey scale—footage of a smelting furnace pouring out molten metal. The dots, flames and lines in the animation dance, while the live action footage follows the music in a rhythmic montage. This combination highly abstracted, yet still recognizable live action with highly synchronized animation is an extension of the potentials present in Lye's first direct film, but also a movement towards the highly synchronized animation employed by Fischinger at the start of the decade. This shift towards closer audio-visual relations and easily recognizable subject matter may be the impact of audiences hostile to highly abstract art, a constant issue present since the first abstract films were commercially distributed in the 1920s.

When John Grierson left the GPO in 1938 to set up the National Film Board of Canada, Lye lost his primary supporter at the GPO, ending his involvement with the organization. He would continue making direct animations, producing three more before World War II as advertising. The first, *Colour Flight* (1938), was made for Imperial Airways (later renamed British Airways) where the visuals were built around an animation of the company logo. *Swinging the Lambeth Walk* (1939) was made for TIDA, the Travel and Industrial Development Association, and *Musical Poster #1* (1940). In 1941, Lye joined the Realist Film Unit and began making propaganda films for the Ministry of Information, ultimately directing six live action documentaries. This work lead to a job with the American newsreel company *The March of Time* from 1944 to 1951, employment that ended when the newsreel ceased production. This position enabled him to travel to New York during World War II, where he would remain for the rest of his career.

While living in New York he only made a few films on his own. He collaborated on film projects with the younger filmmakers: Lye added the color effects to Ian Hugo's *The Bells of Atlantis* (1952), a film adaptation of his wife, Anaïs Nin's poem of the same name. Lye's own work during this period is limited. *Color Cry* (1953) employs many of the familiar direct animation techniques developed in the 1930s, but because it has a soundtrack performed on harmonica by Sonny Terry, the animated forms have a dramatically different character: while synchronized to the vocals and harmonica, their impact is less one of a visualization of sound than a counterpoint to that sound. The shifting relationship between the visuals and the soundtrack is a feature of Lye's later scratch films as well.

Yet, in spite of his involvement in the New York art scene following his arrival in 1944, and continuing throughout the 1950s, (he was a regular at the Cedar Tavern and "The Club" where the Abstract Expressionist painters—Jackson Pollock, Mark Rothko, Willem DeKooning, et. al—gathered), Lye's films during this period were never linked to the broader concerns of action painting, even though the language Harold Rosenberg developed to discuss this type of new American painting apply equally well to Lye's work.[46] Instead, Lye's theorization anticipates and follows other avant-garde developments outside of motion pictures or

painting. In his essay *"Is Film Art?"* (1958) he ultimately declares he will "go on strike" and not make any more films without institutional support. In this essay he considers the relationship between the New York School's development of action painting and his own film work, noting about the relationship between movement, stillness and perception in a description that is distinct from the concerns with painterly surface, gesture and the traces of movement common to discussions of Abstract Expressionism:

> The increasingly pronounced kinetic quality of 20th Century art evokes a sensory rather than an intellectual involvement. It would seem that the sensation of being—of actually existing—can become an underlying involvement with the imagery of art without a work literally depicting aspects of everyday realism. 'Action Painting' is a notable U.S. contribution to art.
>
> We infer the supreme orienting power of bodily kinetic sensation when we say we must pinch ourselves to see if we are awake.
>
> Some of our activities have been cultivated purely for kinesthetic enjoyment, such as dancing and sports. It follows that immobility, stillness, quietude have a contrapuntal effect on our sense of motion as silence emphasizes sound.[47]

The opposition Lye proposes of *motion vs. stillness,* on a parallel to the idea of *silence vs. sound,* evokes the musical theorizations of composer John Cage who arrived at a similar reduction in his late compositions: the rendering of silence as a counterpoint to the creation of sound. This theory brings his last film works specifically into a musical context, but on strictly visual terms.

Free Radicals (1958) was produced as a result of an invitation by the *International Experimental Film Competition* at the *1958 Brussels World Fair* in Belgium; it won the second prize at the festival, an award that included $5,000 in prize money.48 Unlike all of Lye's earlier direct animation films, *Free Radicals* was not hand painted; instead it was an adaptation of his subtractive painting process, done on optically black leader where the only imagery visible on screen is a result of his scratching away the black emulsion. In an interview with Gretchen Berg for the magazine *Film Culture,* Lye explained his scratch process:

> I made *Free Radicals* from 16 mm black film leader, which you can get from DuPont. I took a graver, various kinds of needles. (My range included Indian arrowheads for romanticism.) You stick down the sides with scotch tape and get to work with scratching the stuff out. You spit on or dampen the celluloid with a sponge. Now the question is register. You've got sprocket holes to guide you. When you hold the needle, you dig it in through the black emulsion into the film and then start doing kinds of pictographic signatures. You hold your hand at the right height and act as if you were making your signature.[49]

The on screen result of this process is a transformation of his forms from lines and colors into pure white shapes set against a completely black field, but the visual language remains the same as in his earlier film work: Lye's common motif of vertical lines dancing to the music appears throughout this film, at times apparently

rotating in space, while graphic patterns and dots provide accompaniment. The closely synchronized to the drum and vocal music by the Bagrimi Tribe, the abstract forms simultaneously suggest a physical landscape of waving grass and distant hills or mountains. This was the last film Lye would produce without outside support and funding, resulting in his shift from film making to kinetic sculpture. The central motif of his film work—the vertical line and its organization in groups—appears in his kinetic sculptures, demonstrating his shift to a new medium did not involve a break with the concerns of his earlier film work.

Lye's last films, *Particles in Space* (1979) and *Tal Fallow* (1980), both developed from short experiments and studies produced in the 1950s and 1960s using the same technique as *Free Radicals*. They were completed with the assistance of the United States National Endowment for the Arts and the New Zealand Queen Elizabeth II Arts Council. Both explore the visual potentials of scratched imagery discovered in *Free Radicals* and are closely synchronized to their musical scores. In many respects these final films were analogous to his 1930s direct animation films where the potential to combine hand painted elements with live action provided the aesthetic "space" for his explorations, moving towards a logical elaboration of the potentials of his invented technique.

NORMAN MᶜLAREN (1914 – 1987)

Norman McLaren is best known for his many years spent working at the National Film Board of Canada (NFB); however, his career passed through several distinct phases prior to his arrival in Canada where he did most of his work with animated film. McLaren's innovations in creating animated film all proceed from a singular recognition about the nature of the apparent motion seen in motion pictures: that it proceeds from a leaving out—the apparent motion is a result of the way we perceive the moving image as a reconstruction of actual motion seen in the real world. The motion image creates movement not based on what we see on screen, but based on the differences between succeeding frames: what is left out of the still film strip is the actual movements happening between the individual frames.

His earliest work in film was done while still a student at the Glasgow School of Design where he worked on six independent productions while studying interior design. One of these films, *7 'til Five* (1933) was a "city symphony"—a documentary film presenting a 'day in the life' of the Glasgow School of Design—arranged using the principles of Soviet montage. McLaren entered it into the *1935 Glasgow Amateur Film Festival* where he won an award whose prize enabled him to make another film, *Camera Makes Whoopee* (1935) that he entered along with an abstract film, *Colour Cocktail* (1935) now lost—made using the direct animation process of Len Lye's *A Colour Box* that had received wide distribution and popular acclaim throughout the British Empire—into the *1936 Scottish Amateur Film Festival* where John Grierson was judging. McLaren won the Best Film award for his direct animation, and Grierson hired him to work in the editing department at the GPO Film Unit.

Between 1937 and 1939 McLaren made four films for the GPO, directing live action documentaries that do not resemble the later animated films he is known for

producing: *Book Bargain* (1937) and *News for the Navy* (1938) show McLaren was learning how the film making process works. McLaren acknowledged the importance of Len Lye's experimental work at the GPO, but denied the influence of the direct animation technique on his 1935 film *Colour Cocktail*. He claimed his development and use of direct animation happened independent of Lye's film:

> Although I did not work in close proximity to Len Lye when at the GPO Film Unit, and although I started direct drawing on film independently of him, his films have always put me in a state of dithering delight and therefore should be counted as a formative influence.[50]

The type of animation McLaren employs in his direct animations do have an entirely different character and organization than Lye's films: where Lye's animations proceed kinetically in a graphic form that only slightly references the breakdown of the film strip into individual frames, McLaren's hand drawn animations are cartoony, based firmly within the standard frame-by-frame animation process, only done on the film strip itself rather than individual cels that are then photographed. This adaptation of standard animation techniques to direct animation are apparent throughout McLaren's career.

Love on the Wing (1938), McLaren's third GPO film, was never released; the Postmaster–General considered it too erotic and Freudian: *Love on the Wing* offers a suggestion of how McLaren's later work done at the Canadian Film Board would develop, with some minor differences. His later work cannot be as readily connected to any particular art movement in the same way that Love on the Wing can be. Its opening titles boldly announce its adaptation of aesthetics drawn from the French Surrealist movement of the same period using a series of biomorphicly abstract figures with a totemic character standing in a peculiar landscape for each of the title cards. Similar figures reappear in a simplified, liner form in McLaren's later direct animation *Blinkety–Blank* (1955). The main part of the film was animated using Surrealist-inspired backgrounds that resemble the work of Salvador Dalí, Yves Tanguy and Giorgio De Chirico combined with boldly drawn, hand animation of simple linear shapes that tell the story through continuous metamorphosis: a series of love letters en route back and forth from The Hero to The Heroine. These animations were synchronized to Jacques Ibert's *Divertissement*.

From 1939 to 1941 McLaren was in New York city working on five short, direct animation films produced with a grant from the Museum of Non-Objective Painting under Hilda Rebay. Like Oskar Fischinger, McLaren used this money to support himself while he worked on five direct animation projects where he experimented with hand-drawn optical soundtracks, (what he called "synthetic sound"), produced by directly marking in the space on the film strip: *Loops* (1939), *Scherzo* (1940) and *Dots* (1940). These synthetic sound experiments were followed by *Stars and Stripes* (1940) and *Boogie–Doodle* (1941) that use familiar, popular music; all of these films were distributed by the NFB after he began working there.

In 1940 he collaborated with Mary Ellen Bute on two of her films: *Spook Sport* which was entirely animated by McLaren, and on *Tarantella* which employed a collection of hand animated looping figures clearly adapted from his earlier film

Loops. All of his films done while in New York also experimented with using color separations employed in a two-color printing process to create bright, intense color not present in the original strips themselves. This technique was invented by Len Lye, for *Rainbow Dance* (1936) using a three color separation; McLaren first saw it while working at the GPO and his work done in New York is a variation on Lye's process.

Then, in 1941 John Grierson hired McLaren for a second time: to organize the animation department at the National Film Board of Canada, where he would remain for the rest of his career, except for a pair of one year sabbaticals spent working with UNESCO in China (1949) and India (1952). His first hires were Guy Glover and Evelyn Lambart with whom he would collaborate on film projects in the 1960s. His time as director of the animation department was divided between making his own films, training the animators he hired, and administration. The security of his position encouraged his experiments and enabled a thorough exploration of the possibilities of direct animation, as well as the development of entirely new animation techniques and procedures—it is these innovations produced while at the NFB that are associated with McLaren's film work: the fragmentation of movement that is the focus throughout his career. His interest in this understanding of film appears in a short syllogism he posted on his animation stand that logically argues for an understanding of animation based on the sampled nature of photographic motion pictures:

The Philosophy Behind this Machine

Animation is not the art of Drawings-that-Move but Movements-that-are-Drawn.

What happens between each frame is much more important than what exists on each frame.

Animation is therefore the art of manipulating the invisible interstices that lie between frames.[51]

The analytic consideration of motion pictures as a dynamic result not of what appears on screen, but of the implicit "evidence" of change—movement—that happens not on screen, but as a result of how the differences between two succeeding images become movement. The techniques he invents, specifically "pixilation" and the "pastel technique," depend upon the intermittent nature of the motion picture film strip's imagery. McLaren's understanding of the apparent motion in cinema is essential to the kinds of experiments he makes during his tenure at the NFB: explorations of how apparent motion can be used as the material of motion pictures. McLaren's theorization of animation developed from a binary description of animated movement: *tempo* and *modulation*. Tempo describes the kinds of movement done within the film frame; modulation is a description of how those movement change over the course of any given movement, from being at rest (static) to increases in, decreases of, or maintenance at a constant speed. This close engagement with rhythm and musical form is a basic element of the animation process when using recorded music:

To summarize the technical process: Music is first recorded. Music track is run on a movieola [editing machine], and each note, phrase and sentence marked with a grease pencil. Track is put on a frame counter and the notes measured cumulatively from zero at start. Measurements are put against the notes on a dope sheet, which is usually a simplified musical score, and by subtraction, the length of each note in terms of frames is written in. The grease penciled sound track is run through a two-way winder, along with a clear machine leader called a "dummy." The notes are copied and identified with India ink on the dummy.[52]

These various steps enable the careful identification of each note in the score, its duration, and its place in the development of the film as a whole. It is a technique that enables production of a finished work that can be synchronized at any level of musical structure—ranging from the individual notes to the melodic organization, the break up into individual sections—with a high degree of precision in both the timing of animation actions and their corresponding sound and music from the score. This production process allows for direct synchronization of notes to form, as well as the creation of audio-visual counterpoint. Selecting appropriate movements in McLaren's aesthetic depends on how the music can be complemented by the motion's character (erratic, energetic, etc), which depends on the combination of tempo and modulation, balanced against the lack of motion, or "staticness" giving rest as silence does in music. It is fundamentally an organization of the movement and animation according to musical design.

The pixilation technique that McLaren developed in the early 1950s in the short film *Two Bagatelles* (1952), and in several longer films, *Neighbors* (1952), *A Chairy Tale* (1958) and *Opening Speech: McLaren* (1960). It developed from his recognition that the stop motion technique normally applied to inanimate objects could also be adapted for use with living actors. His explanation of the pixilation process illuminates both the design process that resulted in this technique, and the importance of the sampled nature of motion picture imagery for McLaren's animation aesthetic:

> Once it is assumed that the actor being photographed by a movie camera can stop between any or every 24th of a second [between each shot frame], a new range of human behavior becomes possible. The laws of appearance and disappearance can be circumvented as can the laws of momentum, inertia, centrifugal force and gravity; but what is perhaps even more important, the tempo of acting can be infinitely modulated from the slowest speed to the fastest.[53]

This description proposes the transformation of live action into the fluid and dynamic control of motion to create dramatic effects common to the cartoon and animation generally. His application of the term "pixilation" to this technique is thus both descriptive (it employs a non-standard camera speed to film live actors) and deceptive (it is not simply live action filmed at a non-standard camera speed, but stop-motion animation with live actors), as McLaren defined it: "applying the principles normally used in the photographing of animated and cartoon movies to the shooting of actors."[54] The implications of this transfer from animated cartoons

to live actors is the central characteristic of how this animation technique enables the exaggeration of motion, the violence and speed of action, as when the two neighbors fight and destroy each other's houses in *Neighbors* or the increasingly strident attempts to control the microphone in *Opening Speech: McLaren*. Pixilation allows the violation of normal physics as well as offers the potential to create entirely new forms of human motion, or to imbue the inanimate with life. The potentials of McLaren's pixilation technique overlap with the magical aspects of visual effects in transforming photographic reality into the plastic space of animated film.

A similar engagement with the sampled nature of motion pictures informs McLaren's other technical "inventions" used in his films. Because film is based on the successive exposure and projection of 24 individual images per second, the variation not only of the interval between when each frame is exposed (as in pixilation), but their display on screen creates the potential for modulations of how much animation is actually required to create any given sequence. The "pastel technique" belongs to a class of animation procedures generally termed "motion painting"; McLaren's development is similar to, but distinct from, other motion painting work by Oskar Fischinger. Where in Fischinger's film *Motion Painting No. 1* the animation is single frame-based, in McLaren's "pastel technique" films, the animation proceeds by dissolving each frame shot into several frames that follow, resulting in a motion based not on single frame animation, but on the continuous, short-duration merging of a series of short frames, with the result that instead of needing 24 unique frames per second, McLaren's films could use only many fewer frames, spread across brief dissolves where the duration on screen of each frame is stretched into the frames following (each frame overlaps 50% of its on-screen duration with the frame before and 50% of its on-screen duration with the frame after) enabling fluid animation with only a fraction of the movements typically required: this process softens individual movements and blurs the outlines of the animated elements, creating a gradual transformation of the image, rather than the more common motion of animation; it also reduces the amount of labor needed to produce any given animated film.

Pas de Deux (1968) approaches the same issues of motion-based sampling as McLaren's earlier technical experiments with pixilation and his variation on motion painting; however, where these earlier methods began as animation, *Pas de Deux* began with live action (dance) and then subjected this material to the transformative action of optical printing. Because optical printing is fundamentally a process of rephotography, the materials being optically printed can be subjected to a range of transformations that effect, the image as a whole, as well as its motion, duration, and contents. The imagery in *Pas de Deux* was produced by step printing the two dancers against a black background to produce an "echo" effect that reflects the multiple images contained in the film strip itself. McLaren explained his technique, which employed a series of underexposures to create the final images on film:

> To create the multiple image, we exposed this high contrast [film of the dancers] many times successively on our new optical negative. The same shot was exposed on itself, but each time delayed or staggered by a few

frames. Thus when the dancers were completely at rest, these successive out-of-step exposures would all be on top of one another, creating the effect of one normal image; but when the dancers started to move, each exposure would start moving a little later than the preceding one, thus creating the effect of multiplicity.[55]

The individual points in the development of each motion are repeated on screen, creating fluid movements that chase the dancers as they perform the choreography. Because each repetition is underexposed, the more distant repeating figures are darker, fading into the background. The repeating imagery is only possible by using the optical printer to introduce an offset (a delay) that becomes apparent in the film as the figures move on screen. These delays between different repetitions in *Pas de Deux*—between when one image starts moving and the next—results in a visual effect that resembles Jules-Etienne Marey's chronophotographs from the nineteenth century, but with their arrested motion restored.

* * *

The establishment of a standard technique for sound reproduction in motion pictures in 1927 transformed cinema from a medium where synchronization was only possible if the live performance that accompanied the projected film were able to maintain the precise timing required for those relationships to one where sound and image are always organized together as a singular presentation. With the commercial adoption of recording and the use of the optical soundtrack integrated into the film strip itself the potential for precisely controlled, synchronized sound became not just a potential, but rather than norm in motion pictures. The "natural" effect of directly synchronized sound and image is the baseline condition for cinema; the production of alternatives, such as the counterpoint structures and parallels between musical and visual form employed by Mary Ellen Bute are exceptional.

The immediately apparent synaesthetic effects that emerge from animations employing a direct synchronization of form to tone (or note) represent the dominant tradition of how kinetic abstraction (and animated films generally) have addressed the technical and aesthetic problems posed by the musical soundtrack. The accessibility of direct synchronization is simultaneously the reason for its dominance and its ties to commercial success: it is no accident that the films commercially distributed in the Unites States by Fischinger and Bute begin with explanations that what follows is an interpretation of what the sound of music looks like to the eyes. This audio-visual relationship defines both the visual music tradition, whether in painting or in motion media of all types. This specific heritage of synchronization, visualization of sound and music, and the organization of imagery in relationship to a soundtrack that comes first in the production process that reveals the close links between commercial motion graphics, title designs, and non-narrative animations of all types—and the earlier avant-garde films.

MODERNIST TELEVISION

After World War II, the pre-war cultural fight over Modernism and abstraction in the United States ended with an embrace of highly abstract art. The avant-garde design styles that developed in parallel under the influence of European designers and educators who fled NAZI Germany in the 1930s, such as Herbert Bayer (1900 – 1985) who taught at the Bauhaus and arrived in New York in 1938 were already in use by the 1940s, although not in everywhere in the United States—only the major, progressive markets such as New York fully embraced the new design before the war. The impact of these "foreign influences" became obvious by the end of the 1950s: the transformation from a traditional, even academic, approach to art and design was being discarded and was replaced by the Modernist forms developed at the German Bauhaus, in France and in England—most especially visible in changed response to abstract art. It is this connection between European Modernism and the distinctly American adaptation that gave form to the first motion graphics on television starting at CBS in 1951. The importance of TV for promoting and encouraging acceptance of Modernism is evident through both the sets and content of programming, as well as in the design of show openings, network logos and program advertizing.

While television would provide one of the strongest distributors of this newly accepted Modernism, it was the avant-garde film that provided the techniques and aesthetics used by that televised modernity. The movement of avant-garde film (including the abstract film) from marginal activity of artists to materials for a mass audience watching television is the central historical factor in the emerging "film culture"—built around periodically screenings of foreign and independent productions—that grew in both San Francisco and New York. The first of these screening programs, *Art in Cinema,* was initially conceived as a museum-based historical survey of the "fifty year history" of cinema. Its effect was to help create both an audience and venue for the work of then-contemporary avant-garde filmmakers, thereby beginning the complex process of organizing filmmakers and community-building that defines the expansive second phase of the avant-garde film in America.

The *Art in Cinema* symposium and screening series organized at the San Francisco Museum of Modern Art in October 1946 (curated by Frank Stauffacher, Richard Foster and George Leite) marks an important transition point for the development of abstract film towards contemporary industry: the shift from being the occasional commercial production or rarely seen avant-garde experiment to a specific genre of film-as-art whose style and form appeared both unique and "modern." It was this appearance—unique and modern—that initially attracted commercial designers and producers to it as a source of ideas for their ads. This curated program of films marks the beginning of the second historical phase, characterized by the consolidation of the artist community around particular screening programs that led to the creation of organizations (film societies) devoted to the presentation of film as an art, independent of commercial cinema distribution. Out of its 1946 museum exhibition beginning, *Art in Cinema* became a screening series, programmed at irregular intervals, until Stauffacher's death in 1954. Innovations in the first phase were promoted through historical screenings and through the commercial work done by both industry technicians and by these filmmakers' work for the advertizing industry; other, even more direct connections (avant-garde artists working for commercial production) between the abstract film and commercial motion graphics emerged during the second phase.

Stauffacher's 1946 series was accompanied by a symposium catalog that is a valuable document in the transition from disparate artists to historically significant art. His project was possible because of the collaborative efforts of the artists shown and the ability to borrow films from the Museum of Modern Art in New York, which had been collecting and preserving film since its founding in 1935 as the "Film Library." The catalog provides one of the first histories concerned with the "experimental film"—a loose collection of works that range from the psychodramas of Maya Deren, to the anarrative work of Hans Richter (who abandoned abstraction after making *Rhythmus 25*). Within the ten programs of "experimental film" there are only a few abstract works, and the organization of the shows is based around thematic and national origins rather than an aesthetic or art historical foundation. Historical Surrealist, Dada/Constructivist, and abstract films are screened with documentaries and short, commercial narratives in no particular sequence, suggesting a consciously eclectic programming—so visitors would see a cross-section of the history in any particular show. Abstract films are largely dispersed: Viking Eggeling's *Symphonie Diagonale* was included in "Program One: Precursors," and the "Fourth Program: Non–Objective Form Synchronized with Music" is principally a retrospective of Oskar Fischinger's films; Mary Ellen Bute's *Rhythm in Light* (1936) comes at its end. The early films of John and James Whitney were included in the "Sixth Program: Contemporary Experimental Films in America," coming in between psychodramas by Maya Deren (*Meshes of the Afternoon, A Ritual in Transfigured Time,* and *Choreography for Camera*), and *The Potted Psalm* by Sidney Peterson and James Broughton. It is a roster of film artists who would establish occasional relationships with the commercial world, in the process bring their concerns with synaesthetic form and montage to broader, popular audience.

Despite its limitations as a coherent history of the "experimental film," *Art in Cinema* established the filmmakers shown in this series as the first set of canonical artists in the post-war American avant-garde film, initiating a process of historical

consolidation and selection that continued into the 1970s. This significance of the screening and the catalog that accompanies it was suggested by historian Scott MacDonald in his book about the series:

> One can only conjecture what the impact of the *Art in Cinema* [catalog] was on the *Art in Cinema* audience, but since Stauffacher's book was the only guidebook to the new field of avant-garde film, its publication must have convinced many in the audience that these screenings were at the forefront of developments, were the avant-garde.[1]

Staffaucher collected a range of important documents about the aesthetics of film and published brief artist's statements from Man Ray and Oskar Fischinger. Hans Richter contributed a short history of avant-garde film in Europe before World War II. In constructing this book, there was a clear attempt to put the films shown into a historical context and to interpret their significance and relationships to one another. It is these factors, perhaps as important as the retrospective of Oskar Fischinger's films, that contribute to the consolidation of abstract film into a specific genre with the "experimental film" as it developed during the 1950s. Lawrence Jacob's essay on experimental film, published in the magazine *Hollywood Quarterly* in 1948, and later reprinted as an appendix to his much longer Rise of the American Film (first published in 1939, then reprinted in 1948 and 1967) presented a similar historical narrative, reinforcing Stauffacher's choices by covering the same films programmed, amplifying their historical significance, and then adding other films and filmmakers later screened by *Art in Cinema* to the discussion. Several abstract filmmakers would attend these shows and begin making their own works following their encounter: Harry Smith,[2] who would assist in organizing some of the later screenings, and Jordan Belson began making their abstraction films after attending this key exhibition in San Francisco.

The connection between advertizing and abstract film that would become increasingly clear during the 1950s was already emerging with the sixth *Art in Cinema* series. The last day of the screenings included "A Short Program of Rejected Television Spots" with TV commercials by John Whitney, Denver Sutton, Frank Stauffacher, Dorsey Alexander, Charles Maddux, Keith Monroe and other filmmakers uncredited in the program. At least some of these unaired TV commercials were abstract, but all were attempts to bring the avant-garde aesthetic to the new medium of television. The description in the program says they "display a wonderful dynamic visual vitality that is, unfortunately (and apparently) years ahead of its time."[3] There was some truth to this comment: by the end of the 1950s, television would routinely be using styles and ideas drawn from experimental film—as well as employing avant-garde filmmakers. This screening came after a failed attempt to arrange for exhibition of experimental films by filmmakers in San Francisco who had shown in the *Art in Cinema* series on ABC.[4] The fusion of art films and TV commercials in the same screening series would remain a common practice until the 1970s. Part of the difficulty confronted by television by avant-garde films was the primitive state of broadcast technology in 1949; the use of filmed programs would only become common after 1954, entirely replacing live broadcasting for anything but sports by the end of the 1960s.

JOHN (1917 – 1995) & JAMES (1921 – 1982) WHITNEY

John Whitney who was initially interested in composition and had traveled to Europe to study composer Arnold Schoenberg's atonal system, and his younger brother James Whitney, who had trained as a painter, grew up in Hollywood, California. In 1941 they built an optical printer and machine to create "synthetic sound" to use as an accompaniment to their 8mm films. By 1944 they had collaborated on several abstract films, and contacted the Guggenheim Foundation and it's director, Hilla von Rebay seeking funding. She sent them a check, and commented on the sample films they had sent with their request:

> If you take my advice, it is: wait. I would like very much to speak to you and explain to you that you must know more about art itself, motif itself, and space rhythm itself to create Art with films. ... If I were you I would paint for a while, to learn form and space relationship to a greater degree.[5]

Apparently the Whitneys cashed her check and ignored her instructions, continuing to work on their films, screening them in "Program Six: Contemporary Experimental Films in America" during the first *Art in Cinema* series in 1946. Their later works, both collaborative and those made independently, showed in subsequent series. These early abstract films established the working parameters that John Whitney would adapt to his work with the computer animations he produced at IBM in 1966—taking a limited amount of footage and procedurally altering it with optical printing. The interrelationship between optical printing and abstract film becomes increasingly prominent during the 1950s and into the 1960s with the work of other filmmakers such as Hy Hirsh and Pat O'Neill who also used optical printing to reconfigure and recompose their work in a manner similar to the Whitney's films (see Chapter 5). During the 1950s John would apply his experience with producing and animating abstract film commercially, in the process helping create the new field of motion graphics.

Their abstract films used a limited quantity of abstract footage filmed with a live action technique, and then manipulated with an optical printer, thus avoiding the time and labor intensive process of single frame animation. Their desire to avoid hand animation was not unique among abstract filmmakers—it was shared by almost all of the first generation working in the 1920s as well. Their optical printer enabled highly complex structures in their films, and gave them the ability to precisely control the color, independently of the forms shown.

The films in Series One, later known as *Five Film Exercises,* were broken into sections that were organized around a music presentation of a visual theme and its variations. This musical foundation is made explicit in both the construction of the films and in their explanations, as the Whitney's catalog entry for *Exercise Four* (listed as "Fourth Film; Completed Spring 1944" in the catalog) shows:

> Entire film divided into four consecutive chosen approaches, the fourth being a section partially devoted to a reiteration and extension of the material of the first and second sections.

> Section One: Movement used primarily to achieve spatial depth. An attempt is made to delay sound in a proportional relationship to the depth or

distance of its corresponding image in the screen space. That is a near image is heard sooner than one in the distance. Having determined the distant and near extremes of the visual image, this screen is assigned a tonal interval. The sound then moves along a melodic line in continuous glissando back and forth slowing down as it approaches its point of alteration in direction. The line would resemble slightly a diminishing spiral as viewed on a flat plane from the side. The section concludes with a frontal assault of all imagery with an interlacing tonal accent.

Section Two: Consists of four short subjects in natural sequence. They are treated to a development in terms alternately of contraction and expansion or halving and doubling of they rhythm. Sound and visual elements held in strict synchronization. Color is directed through a blue to green dynamic organization.

Section Three: A fifteen second visual sequence is begun every five seconds after the fashion of canon form in music. This constitutes the leading idea, a development of which is extended into three different repetitions. This section is built upon the establishment of complex tonal masses which oppose complex image masses. The durations of each are progressively shortened. The image masses are progressively simplified and their spatial movement increasingly shortened.

Section Four: Begins with a statement in sound and image which at its conclusion is inverted and retrogresses to its beginning. An enlarged repetition of this leads to the reiterative conclusion of the film.[6]

Their discussion only suggests the process used to create these films. Beyond the temporal organization of the sections, this description tells little about what and how such a sequence was produced. These films were a complex mixture of live action photography, traditional animation and optical printing. Their procedure began with black-and-white photography. Overlapping paper cutouts were placed on a light box, allowing differences in translucency to determine the light-to-dark values in their image. Filming was done at live speed, rather than as single frame animation. The papers were attached to paired pantographs: one held the paper, while the other gave the Whitney's control over its position, movement, and speed, which allowed the precise animation of their cutouts by tracing patterns with the controller. This black-and-white film then became source material rephotographed with their home made optical printer onto color film stock using filters and using the optical capabilities of the printer—superimpositions, repetitions, changes of scale, etc.—to expand and transform their initial footage into something much more complex. This use of optical printing to create abstract films would become a standard part of their working process, even when using early digital computer technology.

The soundtrack for *Film Exercises* was produced in a similarly novel fashion. It was a variety of "synthetic sound" created by directly manipulating how the film recorded the optical soundtrack. The sounds were generated from a machine that used swinging pendulums to create individual tones on the track. By setting up a collection of twelve pendulums suspended at the end of wires whose lengths

corresponded to the 12-tone scale of the standard musical octave. These pendulums were connected to the cover over a light beam, and as they swung, their motions were translated into variations in the light, thus "recording" those motions on the optical soundtrack would make tones when projected. The nature of the device allowed them to vary the notes, their duration and sequence, resulting in "electronic music" directly created to accompany their films.[7] This use of artificial soundtracks—more commonly electronic—would become a standard part of the 'abstract film.' While John and James would work independently later in their career, these first abstract films show the direction of their later work: made with a complex mechanical apparatus where optical printing played a central role, the imagery their films was neither a direct product of animation, but rather generated through the manipulation of source material. Their completed *Film Exercises* are suggestive of the hybrid processes that would create the first computer films in the 1960s, where digital technology and optical printing would combine in transforming a limited quantity of material into a more complex, finished work.

HARRY EVERETT SMITH (1923 – 1991)

Like Len Lye, Harry Smith had other interests than film. Both men were in New York during the 1950s, yet remained mostly apart from the experimental film making community there; however, this separation from other avant-garde filmmakers is where their similarities end. Lye did regard himself as an artist, while Smith did not; he regarded himself as an anthropologist, which he had studied in collage before dropping out.[8] His peers recognized him as an artist, and that career stretched across several distinct and otherwise largely unrelated fields: musicology, anthropology, art and filmmaking all were impacted by his work. His influence on postwar American culture was considerable, if at the same time, indirect and unknown to a wide audience.

Smith premiered several of his abstract films (*Nos. 2, 3,* and *4*) in the third *Art in Cinema Series* in September 1947. By this time he was working to help organize the shows, and visited Los Angeles to secure prints for the screening. Also shown were European films from the 1920s that ran in the first series, Oskar Fischinger's *Motion Painting No.1*, and new films by the Whitney Brothers.

However, in spite of his careful observation and recognized work as an anthropologist who studied the Native American tribes in the Pacific Northwest, Smith was at the same time a notoriously unreliable source of information about his own life. Over the course of many years he claimed, as his biographer Darrin Daniel has noted, variously: to be the mystic Aleister Crowley's illegitimate son; that his mother was the "missing" Romanov Czarina, Anastasia; and that he smoked marijuana for the first time with Woodie Guthrie in the back of the Sun studios in Memphis, Tennessee—none of which were true.[9] The various myths he created, and encouraged, about his childhood and life before 1946 do little to render his claims about when he began making abstract films credible.

All his false biographical claims share a certain self-aggrandizing feature; when considered in this context, his claim that he began making his abstract films in 1939—which would be when he was 16 years old—a statement accepted by the historian P. Adams Sitney without question, is highly suspect.[10] These dates appear

in his 1965 description for the *Filmmaker's Cooperative Catalogue,* the artist-run distribution company formed in New York:

> My cinematic excreta is of four varieties:—batiked abstractions made directly on film between 1939 and 1946; optically printed non-objective studies composed around 1950; semi-realistic animated collages made as part of my alchemical labors of 1957 to 1962; and chronologically superimposed photographs of actualities formed since the latter year. All these works have been organized in specific patterns derived from the interlocking beats of the respiration, the heart and the EEG Alpha component and should be observed together in order, or not at all, for they are valuable works, works that will live forever—they have made me gray.[11]

Hyperbole is a good characterization of this description; while it was essentially advertizing the rental of his films, at the same time, this is a peculiar description: in the progression of his films from geometric, abstract patterns through to hallucinatory photography—coupled with the instruction to see them all, in order—implies their organization along the same hallucinatory progression from abstract films to distorted, realist shapes and people noted by Heinrich Klüver's study of hallucination in 1932.[12] What such an organization implies is a calculating series of choices meant to place Smith's films in a separate category from the other works distributed by the *Filmmaker's Co-op,* suggesting the hyperbole is not part of a sales pitch, but should be seen as another example of the same self-aggrandizement as the other myths he circulated about his origins; given the clear synaesthetic dimensions of abstraction so apparent in the first *Art in Cinema* series, and the close relationships produced in his own later works—both paintings and films—his claims become even less credible.

The unreliability of Harry Smith's dates for his films is reinforced by Jordan Belson, a fellow filmmaker, met Smith in 1946. He includes in his account of the batik process used to make the hand-colored films a brief discussion of what Smith's small apartment was like before he began working on the films.[13] (While it is conceivable that Belson might be lying about when Smith started work on these films, from a historical perspective, one must question: why would Belson do so, especially in a book meant to celebrate Smith's accomplishments? On the other hand, Smith is already known to be a myth-maker and unreliable source of information.) This suggests that Smith began making his hand painted films after seeing the synaesthetic films by Fischinger, the Whitneys and the European avant-garde screened at the *Art in Cinema* series in 1946. The extended range of their more probable dates, 1946 – 1950 collectively, recognizes the process of revision and editing, as well as the time required to make these films. While they are not silent—always being shown with a musical accompaniment—their organization is basically asynchronous. His elaborate process of coloring both sides of the film strip employed a number of spray and speckling techniques that apparently made a mess of his home; as Belson's description makes clear, the variety of techniques worked to hide the hand-applied nature of Smith's color:

> He would have the clean film, with a thin coat of emulsion on it so that it would hold they dye, and a lot of colored inks, and with a mouth atomizer—artists use for spraying fixative on their drawings. He used it for

painting, which was a good trick. ... He would block out certain areas of the frame with pressure-sensitive tape, gummed labels that were cut in circles or squares and things of that sort, and stick them onto the film. And then he would spray the ink on it, the parts that were not covered, so it would soak up the color and texture. And then he would spread petroleum jelly all over the film. Then remove the tape and that would allow him to spray another color there, inside the areas that had been previously covered, without affecting the areas that had the jelly on it.[14]

Belson's description is illustrative: it reads almost precisely as an inversion of the techniques created by Len Lye in 1934 for the production of *A Colour Box*. Where Lye's films used templates that he could overspray and repeat, with color only being applied through the openings of his stencils, Smith's films used objects—stickers, cut outs, etc.—that would cover different parts of the film strip, thus preventing different areas from being colored. Where Lye's process resulted in colored shapes on screen, Smith's produced empty spaces surrounded by color—the shapes seen on screen are the negative areas not filled by painting; this difference produced dramatically different results.

The three hand painted films Smith made were done over several years: *no. 1*, also called *A Strange Dream*, (1946), *no. 2*, or *Message from the Sun*, (1946–48), and *no. 3*, also known as *Interwoven*, (1947-49); the titles to these films were provided by Jonas Mekas, (1922 –), Village Voice film critic, filmmaker and promoter of Harry Smith's work—Smith himself had used numbers to identify his films.[15] In a letter to Baroness von Rebay, director of the Museum of Non-Objective Painting, Smith explained his decision not to title his films:

Originally they were not titled, and I still feel that giving them specific titles is destructive because it tensions them to specific emotions, and for these particular films are as out of place as a chemest (sic) naming his experiments according to the colour they produce, rather than the purpose.[16]

Whether they are titled or not, these are not random abstract patterns, nor are they simply decorative geometric forms arranged on film. The specific relationships they establish with their original Jazz accompaniment, as well as the syncopation and orchestration of movement and formal similarity to other abstract art of the 1940s reveals the influence of his trip to Los Angeles in 1947 where he met with Oskar Fischinger and the Whitney Brothers, seeking to arrange for them to come and present work in person at later *Art in Cinema* screenings.[17]

His films belong to a visionary tradition in experimental cinema, a connection further demonstrated by their descriptions:

(*no. 1*) Hand-drawn animation of dirty shapes—the history of the geologic period reduced to orgasm length. (Approx. 5 min.)

(*no. 2*) Batiked animation, etc., etc. The animation either takes place inside the Sun, or in Zurich, Switzerland. (Approx. 10 min.)

(*no. 3*) Batiked animation made of dead squares, the most complex hand-drawn film imaginable. (Approx. 5 min.)[18]

Their descriptions are both playful and fantastic, collectively drawing from Surrealist fantasy to produce an "explanation" that echoes Allen Ginsberg's poetry; Smith's listed durations, if correct, are considerably longer than the versions now in circulation. These films were exhibited in later *Art in Cinema* programs, and reflect a systematic engagement with the process of abstract animation, working from within the tradition defined by both Fischinger and the Whitney brothers. Initially synchronized to Dizzy Gillespie's Jazz music, the motion and counterpoint of the animations following and visualizing the syncopation of Gillespie's trumpet. His paintings followed an even closer connection to Jazz by developing compositions based on a note-by-note translation of musical to graphic form.

Smith developed close relationships with the other abstract and avant-garde filmmakers in California, both in San Francisco, where he lived, and in Los Angeles. It was through these connections that he met the Baroness von Rebay who was a major patron of abstract filmmakers, providing financial support for the production of their films. This word of mouth referral was common—the Whitney brothers had received a similar referral to von Rebay in 1944. In 1951, Smith used his grant from the Solomon Guggenheim Foundation to move to New York, the other "center" for experimental film in the United States. However, there was only minimal awareness among New York filmmakers of what was happening in California, since the west and east coast of the United States developed in isolation. The distance and limited communication between avant-garde filmmakers was common during the first period; Lewis Jacobs saw it as the primary feature of American experimental film. This isolation, as well as the commercial distribution of her films, may be part of the reason Mary Ellen Bute only screened one film at the 1946 *Art in Cinema* series; she would show more in *Series Two.*[19]

Even though Harry Smith worked steadily on film through the 1950s, he remained apart from the other filmmakers then clustering in New York. Instead of becoming closely involved with the filmmakers collecting there during the 1950s, Smith contacted Moses Asch, president of Folkways, a record label specializing in folk music, about selling the company his extensive collection of American vernacular music. Instead, Asch hired Smith to curate a six album anthology in three volumes. During the 1950s, the revival of vernacular or folk music was part of a general reappraisal of naive, and "outsider" art by Modernists. The collection, composed of recordings released between 1927 and 1932, and containing 84 tracks, helped create the folk music revival of the 1950s and 1960s. Smith's distance from the rest of New York's film avant-garde reflected his decision to live, as curator Andrew Perchuk described, as an "angry bum":

> The bum was a figure much in the popular imagination during Smith's
> depression-era childhood, very distinct from the homeless of our own era. ...
> He interacted with and frequently used, those he needed to carry off a
> particular project, and he never seems to have been especially grateful or
> particularly sorry when he did things like pawn a borrowed camera. And if
> the avant-garde was parasitic on the bourgeoisie, tied by that umbilical cord
> of gold, Smith was parasitic off the avant-garde and bohemia alike, as Cohen
> decried: "You've bothered me, my friends, and others in the sense that you
> don't accept the fact that you have to earn money to be a fruitful part of

society." Part of their displeasure was no doubt that Smith's angry bum caricatured bohemia ideas—"art as life," "life as art"—just as bohemia caricatured the bourgeoisie.[20]

Smith's position as an outsider to the art and experimental worlds in New York changed when he met the Beat poet Allen Ginsberg in 1960; it was through Ginsberg that Jonas Mekas became aware of Smith's films and began the program of exhibition and promotion as part of the New American Cinema.[21] This confrontational position—the parasitic dimensions of the "angry bum"—brings the various mythic stories Smith into focus as part of his position on the margin of both the avant-garde in New York and as an outsider to the typical organization of American society: the various untrue stories, and grandiose claims transformed Smith from the vagrant to the displaced aristocrat, a tactic for excusing (and allowing) the behaviors Perchuk identified.

AVANT-GARDE FILM IN PARALLAX

The east and west coasts of the United States developed independent, parallel organizations in support for their respective avant-garde filmmaking communities after World War II, attracting the attention of different film making communities in the process. The west coast institutions found interested audiences among the intellectuals and Hollywood film industry; on the east coast, these audiences also included the advertizing designers, copywriters and executives. In San Francisco the support organizations were created by filmmakers: Frank Stauffacher, who organized and ran *Art in Cinema* until his death in 1954 was also a filmmaker; Bruce Baillie, another filmmaker in San Francisco created both *Canyon Cinema* (1960) and the *San Francisco Cinematheque* (1961) as organizations to support experimental film. In New York, the relationship between filmmakers and organizations was more varied. Amos Vogel, a film programmer, incorporated *Cinema–16* (1947) as a screening and distribution company; later organizations in New York would more closely follow the model in San Francisco of being artist-organized. *The Filmmaker's Cooperative* (1962) was founded by a group of filmmakers including Jonas Mekas, Stan Brakhage, Shirley Clary and Gregory Markopoulos (the "New American Cinema") as a way to archive and distribute their work. The creation of the *Anthology Film Archives* (1970) by the filmmakers Jonas Mekas, Stan Brakhage and Peter Kubelka, along with historian and critic P. Adams Sitney marks a transition point between this earlier phase of production-exhibition-distribution since unlike the earlier organizations, *Anthology Film Archives* was conceived as a way to screen experimental film, collect and preserve that work, and publish books about it—an essentially historical project, unlike the more commercial organizations designed to promote and distribute films.

The development of these alternative networks of distribution and exhibition enabled the filmmakers emerging after World War II to not only places to exhibit their work, it also provided them with encouragement (and sometimes rental fees). The changes that began in the post-war era created an entirely new context for the experimental film, one that was apparent as early as 1948, as Lewis Jacobs, the founding editor of *Experimental Cinema* recognized about the pre-war period:

Lack of regard became an active force, inhibiting and retarding productivity. In the effort to overcome outside disdain, experimental filmmakers in the United States tended to become cliquey and in-bred, often ignorant of the work of others with similar aims. There was little interplay and exchange of ideas and sharing of discoveries. But with postwar developments in this field the old disparaging attitude has been supplanted by a new regard and the experimental filmmaker has begun to be looked upon with respect.[22]

The dramatic transformation Jacobs' describes is symptomatic of broader cultural shifts underway after World War II, most especially a shift to embrace American Modernism, as well as a steadily expanding consumer market as industrial production shifted from a war basis to a consumer market. Historian Scott MacDonald discussed the importance for exhibition and distribution in the production of the American avant-garde film in his introduction to a history of the West Coast avant-garde film distributor, *Canyon Cinema*:

> Whatever social or aesthetic influences now seem formative, it is important to remember that the evolution of alternative cinema was determined not simply by the quantity and quality of the films that were produced within any given moment and set of circumstances, but also by the extent to which whatever films did get produced were seen by audiences, and by the nature of these audiences.[23]

The importance of the organizations founded between 1946 and 1970 to the development and organization of the American avant-garde film should not be underestimated. It was through these organizations and the screenings they enabled that artists became aware of each other's work, developed mutual support networks and began establishing an on-going dialogue about the nature of their medium as an art form, rather than simply as commercial entertainment subject to review by censorship boards. It was also through the programmatic screenings organized around these filmmaker's work that television advertizing and the emergent field of motion graphics would draw from a deeper history in the production and organization of their productions.

Of particular importance to this development was *Cinema–16*, a private film club organized in New York to screen and distribute, the new films being produced in the United States and Europe. Writing for the advertizing industry magazine *Art Direction* in 1961, Ralph K. Porter, who had been involved with the development of Television at Bell Laboratories as the Director of Transmission Research, and collaborated with abstract filmmaker Mary Ellen Bute, designing the device she used to make her abstronics films, explains the link between commercial and art films was a matter of "inspiration." Potter had written about the avant-garde film, visual music and new technologies before[24] and he brings his expertise to the promotion of the avant-garde film to advertising designers:

> Of all the film societies in the country none has influenced the creative television artist more than *Cinema–16*. Their experimental, avant-garde and new art forms pop up with amazing regularity. ... While many of [Vogel's] highly volatile films evaporate into nothingness or obscure points of aesthetics, most are excellent visual barometers for the graphic artist Agency

Art Directors and film producers flock to view these private showings. Much of what they see eventually finds its way into TV commercials.[25]

The title of Porter's article, "Sources of Stimulus: TV Commercials Often Draw on Avant-Garde Films," makes the connection even more explicit. The newly emerging avant-garde film community whose works were being screened by the periodic shows at *Art in Cinema* in San Francisco found a strong supporter in New York's *Cinema–16*. Unlike the west coast exhibitor, *Cinema–16* was organized as a business, and sought to distribute many of the new American films it programmed. Stauffacher would encourage the connection between east and west, sending films to New York, and arranging for personal and business connections linking the two coastal centers for experimentation.

 Cinema–16 in New York was founded by Amos Vogel (born Amos Vogelbaum, 1921 –), with his wife, Marcia, his father, her brother, two close friends and a lawyer during 1947 after an extensive correspondence with Staffaucher about his program at *Art in Cinema.*[26] Between 1947 and 1963, when the club disbanded, *Cinema–16* would become a major promoter of the new American avant-garde film, and would be responsible for premiering films from Europe in America, including films by Alain Resnais, Agnes Varda and other members of the *Nouvelle Vague*—known in the United States as the "French New Wave." Vogel organized his programs, and the cinema as a commercial enterprise from the beginning, and was involved with distributing many of the films that premiered at his screenings. *Cinema–16* was conceived and marketed as an alternative to the standard, public movie houses that were subject to censorship review in New York: by being an independent cine-club with a membership fee, Vogel was able to program films without first having them pass the censor's review, thus allowing him to exhibit works that challenged the conventionally accepted mores of the period.

 The club took its name from Eastman Kodak's smaller gage film stock, (marketed to amateur filmmakers starting in 1923), because many of the films he programmed and the avant-garde artists who came to show their films, worked in the cheaper, non-professional 16 mm size. This particular film size—and the equipment marketed for home, amateur use—became the standard equipment of the American film avant-garde after World War II. In 1963 Vogel ended the *Cinema–16* series, founding the *New York Film Festival* as its successor. The transition from a cine-club to a more film festival is logical given the range of films screened at *Cinema–16*. Programs were composed from a mixture of contemporary, experimental work, foreign films, older "classic" films from the 1930s and silent era, as well as educational films and documentaries. These screenings offered variety, and were focused on the promotion of cinema as a Modern, aesthetically and socially challenging medium, reflecting the ascendant values of the Modernist avant-garde during this period.

AMERICAN MODERNISM

 Russell Lynes' article for *Harper's Magazine,* "Highbrow, Lowbrow, Middlebrow" published in 1949 makes a specifically American Modernist argument

for dividing culture into domains of significance and insignificance. Addressed to a middle class audience with aspirations of social advancement, Lynes' essay provides a manifesto for the particular evolution of Modernism in the United States during the 1950s:

> The old structure of upper class, middle class and lower class is on the wane. It isn't wealth or family that makes prestige these days. It's high thinking. ... For the time being this is perhaps largely an urban phenomenon, and the true middlebrow may readily be mistaken in the small community for a genuine highbrow, but the pattern is emerging with increasing clarity, and the new distinctions do not seem to be based on money or breeding. ... [The highbrow] is most frequently found in university and college towns, a member of the liberal-arts faculty, teaching languages (ancient or modern), the fine arts, or literature. ... The highbrow does not like to be confused, nor does he like to have his authority questioned, except by other highbrows of whose seriousness he is certain.[27]

Clement Greenberg is one of the art world examples Lynes' provides for the highbrow intellectual—this choice is a visionary one since Greenberg's work as an art critic will help bring the Abstract Expressionist painters to prominence, and his essay "Modern Painting" will define the parameters of Modern art in America. In opposition to the highbrow is the "middlebrow"—the broad audience for art and culture in America. For Lynes, the middlebrow corresponds to:

> Philistines—those who through viciousness or smugness or the worship of materialism gnaw away at the foundations of culture. And the highbrow sees as his real enemy the middlebrow, whom he regards as pretentious or frivolous man or woman who uses culture to satisfy social or business ambitions. ... The fact that nowadays everyone has access to culture through schools and colleges, through the press, radio and museums, disturbs [the highbrow] deeply; for it tends to blur the distinctions between those who are serious and those who are frivolous.[28]

Lynes opening claim that the distinctions between these groups is not a function of class or social position serves the purpose of his manifesto in promoting the democratic ideal of social mobility in the United States. While this transformation of avant-garde aesthetics into the markers for a social elite, the "highbrow" connoisseur, can be recognized as an explicit component of the debate over Modernism. The elitism of his construction, however, reaffirms the social distinctions he began by attacking—the people who become the "highbrow" connoisseurs he describes came from the ranks of the upper classes, groups whose social prestige was threatened by the cultural aspirations of the middle classes who were gaining access to the traditional signifiers of social rank: advanced education and a concern for the arts. By disavowing this historical condition, Lynes makes his argument not to the upper classes, but to the groups most directly under attack in his manifesto: the middle classes who have "discovered" art and whose interest threatened its traditional role in defining the American elite.

The last of Lynes' groups, the "lowbrow," receives a condescending embrace in his construction, as does the idea of "folk culture." It is this dimension of

"lowbrow culture" that emerges in the financial and cultural significance of Harry Smith's anthology of vernacular music for *Folkways* in 1952:

> The highbrow's friend is the lowbrow. The highbrow enjoys and respects the lowbrow's art—jazz for instance—which he is likely to call a spontaneous expression of folk culture. The lowbrow is not interested, as the middlebrow is, in pre-empting any of the highbrow's function or in any way threatening to blur the lines between the serious and the frivolous.[29]

The lowbrow knows their "place" and stays there, offering no threat to the elite cultural status claimed by the highbrow (that there is a racial as well as economic dimension to this hierarchy is self evident—jazz developed as an outgrowth of traditional black culture, and its "stars" such as Dizzy Gillespie were African-American). Even as the manifesto asserts the dissolution of cultural distinctions, it asserts them—in an identical form to the established order Lynes acknowledges throughout this essay. The decline of cultural authority described by *Highbrow, Middlebrow, Lowbrow* is simultaneously offered, democratically, to his readers: the distinction between the highbrow and the middlebrow is not an issue of taste or cultural interest, but of engagement.

Lynes makes clear that one can move from being "middlebrow" to "highbrow" status through a "serious" engagement with art—an element left purposefully undefined, but whose meaning is recognizable in the seriousness of the "highbrow." This engagement is with formal concerns, demonstrating the "highbrow" connection to the realm of significant culture, high art and historical importance; a concern for subject matter is prosaic, a "middlebrow" engagement with the realm of kitsch and historically insignificant art. His essay presents an open conception of the cultural elite that, one that allows for the expansion of this elite culture without necessarily surrendering its social distinction. His understanding of "highbrow"—especially its embrace of folk art—reflects the Modernist art promoted by the Federal Works Progress Administration's Federal Art Project during the 1930s, most especially the American Modern art movement called Regionalism. [30]

THE RISE OF POST-WAR ABSTRACTION

Modernism in the Unites States had been a highly contested issue since the International Exhibition of Modern Art held at the National Guard 69th Regiment Armory ("The Armory Show") brought the latest works of the European avant-garde before the eyes of an unexpecting public in 1913. This conflict between a conservative, traditionalist public and the foreign artists centered in Paris was never fully resolved. Instead, it continues to be an active component in the American culture: the opposition to Modernism (along with the distinction between it and the avant-garde) as a corrupting, decadent influence from Europe came into sharp focus around this exhibition, in particular the painting by Marcel Duchamp titled *Nude Descending a Staircase, No. 2* (1912). It is this work—Julian Street, an art critic for the New York Times, called "an explosion in a shingle factory"[31]—that became the standard-bearer for avant-garde art in the United States, and brought Duchamp to international prominence as a result.

The Armory Show came at a particular moment in the development of the American art center in New York, and can be recognized as the dividing point between the period before the "culture war" over Modernism began and the war itself. It marks the division between an internal-to the art world conflict between academic art (anti-Modernists) and reformers of various types (the Modernists)—but which also included foreign, mainly French, art—and the general battle over Modernism in American culture generally;[32] prior to this moment, there was little concern with which side of the debate about Modernist art and American culture a writer or artist was on: it was an issue of whether they were in favor of artistic and cultural "reform" or more focused on maintaining the established traditions. The general confusion and equation of the avant-garde with the Modern in the United States is the most visible, continuing aspect of the debate between the Modernists and anti-Modernists.

After The Armory Show, this fluidity of "reformers" vanished and became instead an ideological division based on the acceptance of the (abstract) avant-garde or its rejection. This transition point is visible in publications such as Gustav Stickley's *The Craftsman* magazine which published articles on artists such as Maurias de Zayas and writing by a range of international and Americans, including Samuel Bing, Maxim Gorky and the art collector Walter Arnsberg who would become one of Marcel Duchamp's principal patrons. This mixture of designers, decorators and avant-gardists were commonly a part of its program to bring "reform" to American taste; after The Armory Show, this mixture abruptly changes, focusing on more directly useful decorating advice, and less so on the earlier "reform" program.

The reformist movements of nineteenth century England, following art historical John Ruskin's critiques of industrial production, sought an equal standing for craftsmen-as-artists. His writings codified the anti-industrial, pro-craft ideas that would spread in the English Arts and Crafts movement via William Morris, and later in America as the "Mission style" proposed by Gustav Stickley, and promoted in his magazine has an importance to American Modernism that was identified by historian Jane C. Milosch:

> *The Craftsman,* published between 1901 and 1916, disseminated the reform
> philosophy of the British Arts and Crafts Movement to the American public:
> to re-establish harmony between architect, craftsman and designer and to
> promote handcraftsmanship in the production of well-designed, affordable
> everyday objects.[33]

The "arts and crafts movement" reforms begun by John Ruskin and William Morris in the nineteenth century had a lasting impact on the American conception of art and design: one need look no farther than the various "gothic" typefaces produced during the twentieth century to recognize both the elimination of decoration (these typefaces are all highly streamlined, avoiding even serifs in their construction) and a direct acknowledgement of Ruskin's proclamation that the Gothic was the highest form of European art. The pervasive presence of gothic references, from architectural designs to the naming of Modernist, sans-serif typefaces, attests to Ruskin's impact.

In the United States the primary promoter of this view of art and culture was Gustav Stickley, whose furniture company fused the attention and concern for

hand workmanship championed by English reforms with the distinctly American application of industrial procedures and machine tools,[34] in the process paradoxically discarding their rejection of industrial and machine-tool production central to their initial critique; Ruskin's objection to industrialization was based in the same Romantic rejection of the industrial factory apparent in William Blake's poems about demonic mills.

The American use of machinery allowed the movement to market its products to a broad, popular audience, an audience beyond the reach of the British craft workshops whose limited production required high prices—and rich, elite customers to pay them. The importance of the American changes to this European workshop model allowed these "craft" aesthetics to become part of the emerging, industrial culture of the United States. Machine tools and assembly line production were necessary to meet the demands and efficiencies required for popular production. French art dealer and designer Samuel Bing whose gallery, *L'Art Nouveau*, was provided the name for this Modernist reform movement in France recognized the importance of the American transformation of these ideals in 1895:

> The machine can propagate beautiful designs intelligently thought out and logically conditioned to facilitate multiplication. It will become an important factor in raising the level of public taste. Through the machine a unique concept can, when sufficiently inspired, popularize to infinity the joy of pure form.[35]

How the distinctly anti-industrial critique of The Arts and Crafts Movement in the United Kingdom was adapted to American production on an assembly line is typical of the transformations of European Modernism that would follow in the twentieth century. The sudden dominance of that American Modernity at midcentury came after decades of preparation. The work of a head designer, guided by the ideals of Ruskin/Morris, would be produced by a shop of workmen, instead of each being the designer as well as the fabricator (as in Morris' own factory). Instead of focusing on the details of how Ruskin's critique was developed by Morris, Stickley embraced the ideology it suggested—especially the refusal of distinctions between high art and low craft, and the use of structural forms as decoration. A similar adaptation of the "craft workshop" model to advertizing design would enable William Golden at CBS to reinvent advertising design in the 1950s.[36] In practical terms, this denial emerged as a fusion of design and art, apparent in the convergence of avant-garde writing and homespun advice that ran through his Craftsman magazine. In spite of the "culture war" that followed the Armory Show these connections become explicit in the postwar period as the art world's center shifted from Paris to New York and Modernism (and avant-garde art) became part of how the United States' CIA used art to present a vision of the US as both "Modern and Free" to the rest of the world.

Both the rise of Regionalism and the later shift to Abstract Expressionism[37] served specifically political ends: in the 1930s Regionalism's apparent accessibility made it the focus of official support by the WPA whose goals were primarily to create a social role for art and artists in America.[38] Holger Cahill, Director of the WPA, curated several exhibitions of American Folk Art at the Museum of Modern

Art in New York, and his discussion of Industrialization in his book *Art for the Millions* echoes the critical position of the Arts and Crafts reformers:

> I do not think that we have weighed sufficiently the meaning of the change from a handicraft to a machine method of production, probably the most revolutionary change in the history of human society. Its effect upon the arts has been catastrophic. It has divorced the artist from the usual vocations of the community and has practically shut off the average man from the arts.[39]

Cahill's criticism matches that of Ruskin, revealing the pervasive influence of the Arts and Crafts movement in the United States. To the extent that industrial production and art existed in opposition, the reformers sought initially to raise craft production to the level of art, or in a reverse proposition, the avant-garde reformers such as the German Bauhaus, or American Regionalists such as Grant Wood, tried to transform art into a variety of craft; this second desire is evident in the various disavowals of the "precious art object" in favor of reproduction made possible by industrial production techniques. Lynes' denial of "middlebrow" having an appropriate understanding of art is closely related to the rejection of industrial production techniques; his embrace of Folk Art is entirely consistent with this Arts and Crafts aesthetic foundation. The disruptive aspects of avant-garde Modernism, when confronted by an alternative, populist Modernism (the WPA and Regionalism) reveals the class bias of Lynes' divisions, and their relationship to the historical patrons of art: in choosing to foster an adversarial relationship to the general audience, avant-garde art was able to establish itself as a symbolic marker for the upper classes.

The association between Modernist art and the upper, social elites in American society is not accidental; a concern for avant-garde European painting is apparent even in the nineteenth century—the main patrons for French Impressionism were Americans. The first museum concerned with Modernist art to open in New York was the Museum of Modern Art in 1928. It was created by members of this social elite: Abby Aldrich Rockefeller, and art collectors Libby P. Bliss and Mary Quinn Sullivan. Both Sullivan and Bliss were early promoters of avant-garde Modernism in the United States; some of the works shown at the Armory Show were lent to the exhibition by Bliss. The establishment of MoMA was an important part of the acknowledgement that Modernist art was, in fact, art—and that it was not simply an European import, alien to American society and culture.

The Museum of Modern Art was followed by the Museum of Non-Objective Painting in 1938 (later renamed the Solomon R. Guggenheim Museum) organized by artist Baroness Hilla von Rebay, who would become its first director. She was responsible for building the iconic museum in New York designed by Frank Lloyd Wright. Included in the original plan for Rebay's museum, but dropped from the final design, was a film center that would provide production equipment, screenings of abstract films, and work to promote abstract film as an art form. During the 1940s she sponsored screenings of abstract films and worked to make abstraction generally more accessible to the public. After Solomon Guggenheim's death in 1949 she left the museum board and her involvement with the foundation and its programs ended. The importance of her work at the museum in promoting and supporting abstract film is clear from the range of artists and projects she supported

either through grants or by employing them at the museum—including Oskar Fischinger, Norman McLaren, Jordan Belson, the Whitney Brothers, Harry Smith, Dwinell Grant and Marie Menken (perhaps the best known artist who worked at her museum was Jackson Pollock); she also played a crucial role in helping Hans Richter escape NAZI Germany for the United States. The importance of these filmmakers, and Rebay's support, for the development of motion graphics in the Unites States is immediately apparent in the embrace of their synaesthetic concerns in the design and organization of both title sequences and television advertizing.

The shift to abstraction and avant-garde Modernism was prepared for by the conjunction in the 1920s, and especially in the 1930s, of a range of trends promoted by the Modernist critics: Folk art, nineteenth century design reform (the Arts and Crafts movements in the US and UK, Art Nouveau/Art Deco in France, and Jugendstyl/Bauhaus in Germany), and finally American Scene Modernism, (of which Regionalism was the most prominent example). These trends received official sponsorship through the Federal Art Project under the WPA that reveals the close association of Modernism and American popular culture. Jonathan Harris' history of the Federal Art Project documented these overlapping concerns:

> The activity of art making would help revive racial traditions and knowledge in a new democratic culture, while the Community Art Center would become a locus for the state's construction of a new social rigor. ... The centers were intended to be "living" refutations of the "average museum," seen by the Federal Art Project as an alienated and alienating institution that had "severed fragments of the past" from contemporary social meaning.[40]

Where the European Futurists famously called for the destruction of museums, the WPA attempted to replace them with something entirely different—and for the same reasons as the Futurists: that the museums were no longer relevant to the Modern world. It is this specific context, one where the intellectual foundations are in place for a shift to abstraction, that allows the Abstract Expressionists and American Modernist design to become the dominant style of the 1950s; it was a shift that was developing as early as 1928 with the founding of MoMA, the institution responsible for solidifying Abstract Expressionism as a major American art movement with the 1950 exhibition *15 Americans*. The "highbrow" art of the 1950s was distinctly Modernist and avant-garde in nature.

However, in the 1930s it was Regionalism that "highbrow" culture embraced, in the 1940s, the culture which Russell Lynes, and the other "highbrows" he directly identifies—such as Clement Greenberg—promote is the American avant-garde / Modernist hybrid developing in New York: Abstract Expressionism (Jackson Pollock, Mark Rothko, Willem De Kooning, and the other artists shown in the Museum of Modern Art's *15 Americans* exhibit in 1950). Lynes' connection of Modernism to the 'elite,' and then explaining the preconditions for "membership"—embrace of jazz, Modernism, abstraction, etc.—provided a model for middle class aspirations to social advancement, even as Lynes denied the importance of these social dimensions in his understanding of art. This separation of social from aesthetic concerns was a major part of how American Modernism defined itself; the recognition of the social dimension to art and culture is part of the

shift to Post-Modernism during the 1960s. That these are values promoted in an on-again off-again fashion by television suggests an ambivalent relationship driven in part by an uneasy embrace of this modernity by the mass audience TV courted.

Yet the adoption of Modernist art and design in the post-war period was wide spread. The cultural shift was an on-going process, moving from the realist art dominant in the 1930s—Regionalism and "American Scene" painting—to an abstraction which shared the same general goals articulated in the 1910s by the Modern artists in New York city responsible for organizing The Armory Show.[41] The meaningful differences between abstract artists (the Abstract Expressionists) and their realist counterparts (the earlier Regionalists) depends not on what their goals were, but on how their work was deployed in a larger debate over Modernism. (The misperception of Regionalism as anti-Modern, and the misrepresentation[42] of its forms and goals as fascist derive from inaccurate accounts of the work and poor historical writing by authors following the art historian H. W. Janson, author of the art history textbook, *The History of Art.*[43])

In the United States, the subtle distinctions between European Modernist and avant-garde art were elided into a simpler opposition between academic art and Modern art. The various complexities and nuances of different movements and positions within this pairing progressively became less important in the evolution towards the all-or-nothing conflict of the 1920s and 1930s. Regionalists, like the Federal Art Program sponsored by the WPA, found themselves on the "wrong side" of this political sea change in the battle between a realist Modernism and an abstract Modernist avant-garde. Identifying Regionalist art with specific subject matter, and then denying that such subjects exist for European Modernists is easily disproved, as the art historian James M. Dennis described in his book on Grant Wood, Thomas Hart Benton and John Stewart Curry, *Renegade Regionalists*:

> Published writings on Grant Wood's art and on Regionalism as a whole have concentrated primarily on subject matter. Feature writers, critics and art historians alike have tended to proceed from the initial pronouncements of the Regionalist movement. The depiction of people and places in Wisconsin, Iowa, Kansas and Missouri and elsewhere in the Heartland has been praised as the seedbed or damned as the backwater of contemporary American art, and has been viewed as either stylistically indigenous or hopelessly provincial. Either way, Regionalist Art has been evaluated vis-à-vis European academicism, or more commonly, in confrontation with the Paris-based, pre-World War I avant-garde and what was accused of being its American counter-part, the Stieglitz *291* group of painters in and out of New York City.[44]

The reception of Regionalism in the 1930s and later continues to condition the reception it still receives. The focus on subject matter in the critical reception of this defiantly American-oriented movement has served to obfuscate a more complex understanding implicit in its historical context. A similar subject matter is evident in work by Matisse and the European Modernists—to focus instead on formal concerns is a rhetorical slight-of-hand that hides the art world politics in action during the 1940s. What this history suggests is that while the debate in the European art world was between three groups: (1) academics who sought to

support an earlier, hieratic social system; (2) the Modernists who worked to transform the conventions and limitations of that academic art, while accepting its premises; (3) the avant-gardes who sought a more radical redefinition of society in a democratic, if not populist fashion.

The direct impact of the populist art and design movements of the 1930s on the following generation demonstrates how much this transformation of American culture reflected, at fifty year's distance, the reorganization of European popular culture between 1890 and 1920 along a similar reductive, geometric, and abstract trajectory starting with Art Nouveau, and Jugendstyl and progressing through Art Deco. The visual forms of the first motion graphics used this abstract 'grammar' established in graphic design. The transformation of the United States was related to the ex-patriot status of many leading European artists, educators and designers starting with the rise of European Fascism in the 1930s and continuing through World War II. Designer William Golden who was the Creative Director of Advertizing and Sales Promotion at CBS in the 1950s, recognized this shift:

> Under the twin impact of the functionalism of the Bauhaus and the practical demands of American business, the designer was beginning [in the 1930s] to use the combination of word and image to communicate more effectively. Under the influence of modern painters, he became aware (perhaps too aware) of the textural qualities and color values of type as an element of design.[45]

American Modern's development in television and broadcast design links the vernacular forms, familiar subjects, and a tightly-drawn realism of Regionalism to the emergence of Pop Art in the 1960s—a development that demonstrates the network of connections between Modernist design, television advertizing, experimental / abstract film and fine art: these sources combined on TV to become broadcast design and motion graphics. It was a transposition of elements already familiar in print design from before the war, but which had never been translated into popular forms and presented to a wide, national audience in a systematic fashion. The innovation Golden brought to CBS, enabled by both network chairman William S. Paley, and president Dr. Frank Stanton, was the consolidation of the public appearance of the network behind a singular, consistent and visually modern facade.

The Regionalist movement was the most visible sign of an American, popular Modernism not based in a confrontational engagement with a "mass culture." The rise of experimental film after World War II was part of this shift away from the rigidly defined, traditional, art towards the more fluid avant-garde abstraction and Modernism. However, this transformation was gradual, and entailed twenty years of confrontations between the established political and cultural authorities and the new abstract, Modernist art of the post-war era. During the 1950s, the "new" modernist designers found their closest supporters in the broadcasting corporations and motion picture companies, rather than among the established advertizing and design agencies of New York. The transformation of graphic design following a Modernist paradigm received its greatest support and promotion through television.

DESIGN ON TV

The commercial expansion of television after World War II served as the disseminator of this Modernist design to a broad public, and the role of early television as the promoter in this transformation of American culture cannot be underestimated. The development of broadcast design starts at the end of the 1940s and continues through the 1950s—the foundational period for broadcast (network) television: it is during this same period that a collection of different groups concerned with Modernism converged to bring it into a central position in the United States—in both art and design. At the same time as the San Francisco Museum's screening and lecture series on film as an art form was creating a canon of American "experimental" films and filmmakers, the Museum of Modern Art in New York was organizing and promoting the new generation of Abstract Expressionist painters, a process that culminated in the *15 Americans* exhibition in 1950, (the same exhibition that established Thomas Wilfred as the central visual music artist in the United States). The embrace of Modernist approaches to art, especially those employed by the avant-garde, were also engaged by graphic designers during this period as a way of demonstrating a collective embrace of modernity.

Television was always a medium where Modernist design, fine art (both literally and as an aspiration), and popular, commercial entertainment converged. After the war, television underwent enormous expansion both of its audience and in terms of programming; it was a period of consolidation as the networks based in New York worked to expand their reach by establishing relationships with local broadcasters—affiliated stations—in smaller markets across the country. The initial hostility of Hollywood studios to network television in 1950 developed into a parallel world of production for television by 1955. This transition moved TV production from the live studios of New York to sound stages specially constructed in the Hollywood studios and dedicated to shooting on film for later TV broadcast.

The programming originating in New York, and provided to the network affiliate stations consisted of more than just material to show on air: it included print advertizing materials, graphics and support packages to promote those shows locally. CBS was the leader in this development of uniform advertizing materials, and was the first network to employ Modernist design throughout their designs for both on-air and print ads promoting their shows. Since there was little difference in the content of the programming between CBS and NBC (their direct rival), the significance of graphic design and publicity art in packaging the network as more prestigious becomes immediately apparent. CBS used modern design as a vehicle to brand themselves as *"the Tiffany network"*—the source for more prestigious programming—a strategy that melded the business concerns of television executives with the design strategies of modernism. This decision was also an issue of competitiveness, as Gilbert Seldes, (1893 – 1970), head of the television department at CBS starting in 1937, and one of the first critics to engage with American experimental film, explained in MoMA's 1962 exhibition *Television U.S.A.: 13 Seasons* that

> The natural connection with radio—that TV transmits sound as well as
> images—was reinforced by the industrial connection: the greatest investment

in laboratories where the new apparatus was being developed was made by RCA, parent of the National Broadcasting Company [NBC]. Westinghouse and Philco, both interested in radio, were also carrying on experiments. A non-manufacturing network, like CBS, was compelled to buy equipment from its corporate rivals.[46]

CBS was forced to buy its broadcast equipment from competing television networks who would have access to improve technology at the experimental stages of its development, it was forced to develop an alternative strategy to attract customers—one based on the content of their programs, rather than the purely technical issues of picture and sound quality. Their need to distinguish themselves from the three other television networks—NBC, ABC and DuMont—created a need for innovative solutions that was met through the adoption of Modernist design and the organization of an internal design and marketing department within the network.

William Golden (1911 – 1959)

William Golden was appointed *Creative Director of Advertizing and Sales Promotion* in 1951, making him more than just the designer and art director responsible for CBS' print and on-air designs—his role at the network was unprecedented in broadcasting; he invented broadcast design as it was practiced at TV networks. Golden was put in charge of setting up an in-house design and production office for all CBS advertising; prior to this moment, outside ad agencies were hired to create promotional materials, resulting in wide variations the style of the network. He developed the *entire* corporate image for CBS TV, including its iconic eye logo launched in October 1951. Yet the department he created was organized as a "craft shop"—following the organizational model of the arts and crafts movement:

> Once he stops confusing Art with design for Business and stops making demands on the business world that it has neither the capacity nor obligation to fulfill, [the designer will] probably be all right. In fact I think he is pretty lucky. In the brave new world of Strontium-90—a world in which craftsmanship is an intolerable deterrent to mass production—it is a good thing to be able to practice a useful craft.[47]

Golden's view that design was not art, but a specific variety of craft, is apparent in the organization of a small department of thirty-nine employees that embraced innovation and functioned autonomously within the corporate structure of CBS.48 This organization depends simultaneously on a view that Art and craft are distinct fields, but at the same time borrows innovations and approaches from the art world as techniques for improving the designs produced by his department; while he claims the designer and artist are entirely different, his department behaved with the autonomy and independence commonly associated with artists. The separation of His department from the other "masters" at CBS was essential to its success. He explained the quality and consistency of his designs at CBS as resulting from the separation of his department from the rest of the corporate structure:

> [Their designs] were for the most part kept clean and powerful because they were made by a consistent policy, by one department with the approval of

one agency of management. They were never shown to anyone in advance of publication.[49]

This independence enabled Golden to oversee all dimensions of the design and production process, including the selection of paper stocks, typefaces, packaging and shipping of their promotional materials to ensure a high level of design quality that even extended to the ink color used to meter the postage.

Golden's transformation of CBS was enabled by the interest in Modern art of both the chairman William S. Paley, and president Dr. Frank Stanton, who had a doctorate in the psychology of audience retention of media messages. Stanton explains the decision to embrace Modern design as a marketing tactic to distinguish CBS from other networks:

> Everything we produce at the Columbia Broadcasting System, including our own printed advertizing, reports, documents, and promotion is carefully considered from the viewpoint of the image we have of ourselves as a vigorous, public-spirited, profitable, modern enterprise. We give the most careful attention to all aspects of design. We believe that we should not only be progressive, but look progressive.[50]

The audience that mattered the most to the network were the advertisers: creating the impression that CBS was the premiere network translated into the ability to charge more for advertizing on air. This Modernist transformation began immediately in 1951. Golden's designs for CBS succeeded in promoting it as the "prestige" network, making it the top network throughout the 1950s and into the 1960s. His department produced material for two distinct audiences: directly to prospective advertisers, and to the general public through designs for on-air and in print. These designs, distributed to the affiliate stations nationwide, gave a more uniform style and appearance to CBS, even though there were local differences outside New York since the individual affiliates would produce some of their own print designs using materials provided by Golden's department.

This embrace of Modernist design in a highly commercial medium where business concerns determined the aesthetic forms chosen is symptomatic of the transfers between the art world and commercial world that surrounded television production in the 1950s; by the 1960s this engagement would be primarily limited to advertising, but prior to 1955, the overlap extended to the content of television productions as well. The rise of television commercials—a shift from the early, live shows that had a single sponsor who was more important than the actual program shown to multiple sponsors who buy "time" during the commercial breaks—was due to this change in production method: entire shows could be paid for and filmed by the studios without the need for an outside partner, thus enabling the shift from sponsored shows to commercial programming that has dominated TV ever since.

At the same time as this transformation of advertising was happening, Hollywood studios who (literally) had decades of feature films in storage began distributing their "back catalog" to network TV: CBS began running the "*Late Show*" featuring B-grade feature films from independent studios in 1951; by 1955, the major Hollywood studios were releasing their pre-1948 features to television.[51] These first "midnight movies" helped establish a demand for film screenings and

exhibitions in theaters as well, and its influence on artists active during the 1950s and 1960s is apparent in the parody of Hollywood B-movies in films by members of the New American Cinema that included the Kuchar brothers, Jack Smith, Robert Frank, as well as Andy Warhol's superstars such as Mario Montez, a drag queen who modeled herself on B-movie starlet Maria Montez. The emergent "film culture" fostered by television's need for programming became part of a visually sophisticated, knowledgeable audience for feature films. Combined with the rise of studio production on film for broadcast changed relationship between advertisers and television programming forced the advertizing industry to evolve; it did so by adapting the styles and techniques of film to the demands of creating ads.

Starting in 1961, NBC introduced "*Saturday Night at the Movies,*" a program that showed recent films with major Hollywood stars; it was a successful programming decision, and by 1968 both CBS and ABC were also scheduling features in the Saturday night time slot—and at least two hours of primetime programming showed a feature film every night of the week. Hollywood feature films were an essential part of the television schedule by the end of the 1960s.

The arrival of the French New Wave in the early 1960s found an audience prepared by the repertory screening of Hollywood films on television, and the development of the American avant-garde, especially the New York-centered New American Cinema of the 1960s, followed from this familiarity with the history of Hollywood cinema. The techniques adapted by advertisers in the production of their commercials drew from this visual resource for both inspiration and technical innovation: the avant-garde filmmakers, by nature, were inventive and highly knowledgeable about cinema's past—the two elements required by advertizing in the production of TV commercials.

Unlike motion pictures that had only a passing engagement with avant-garde film art, early television was a site of direct crossings from the independent productions of artists to the corporate productions of television. Those artists who found themselves placed in a central position by the *Art in Cinema* series in San Francisco, and subsequently promoted first by *Cinema–16,* and later by *The Filmmaker's Co-op* in New York that influenced (and in some cases, worked in) the commercial world to varying degrees.

THE "TELEVISION PROJECT"

The Museum of Modern Art in New York used television to attract a wide, general audience to their exhibitions and galleries, in the process establishing the museum as the preeminent institution of Modern art in the United States. The head of CBS' experimental television department in the 1930s and early 1940s, critic and playwright Gilbert Seldes' history explains the early limitations of the technology:

> Television was licensed only for experimental purposes at that time, so there were no sponsors, no commercials, and almost no money for talent or materials. ... [In his predecessor's report on their experiments] there was a memo written by the same man who later said there was no place for dancing in television, noting that the Metropolitan Museum of Art would be a natural source of program material. ... A member of the museum staff spoke about whatever we showed—and we showed costumes as well as the

front of the Parthenon, etchings, which came across perfectly, as well as oils, which didn't. On the night we were closing down—because of the war—Taylor [the museum director] came on the program. He said, "the invention of television is as significant for the arts as the invention of printing was for literature."[52]

This direct engagement with television with the concerns of art and its history and interpretation in the short period before the advent of commercial production, literally at the at the dawn of broadcast television, contradicts the later rejection of broadcast programming in favor of the "video art" produced by artists independent of the commercial industry. That the first museum to become involved with television was not the Museum of Modern Art, but the more traditionally-oriented Metropolitan Museum, has an element of historical irony to it, but the role that MoMA had in the development early television programs quickly expanded in the 1940s. Since the earlier programs had focused on historical art, Seldes organized a new series, focused on discussion of Modern art done in collaboration with the museum:

As soon as the Metropolitan's series was set, I approached the [Museum of Modern Art]. Obviously neither I nor they wanted "equal time for reply"—we were not engaged in battle. I had put on a discussion of modern art ... this was [the] only one that came near to bloodshed: one of the hostile critics of modern painting had proved his point by saying that Picasso (around 1940) was a collaborator and the owner of a gallery (which happened to be showing the great master) objected.[53]

The argument Seldes describes revealingly presents the conflicted nature of how Americans still responded to Modernist painting—especially the Cubism Picasso created, and abstract varieties generally—even through it was 27 years since The Armory Show. However, MoMA recognized the potential for television as a means to promote Modern art generally, even though there was almost no audience for television until after World War II.

The museum's ascent in the popular imagination was aided by the high visibility achieved through their engagement with television and the relationships established with television during this early period: William S. Paley, chairman of CBS, was on the museum board, and from 1944 to 1946 it hosted the *American Television Society's* monthly meetings, building relationships with network presidents Dr. Frank Stanton from CBS and Allen B. Dumont from DuMont TV.

The linkages between the museum, museum exhibitions, and the television industry became explicit with the "Television Project" at MoMA that ran from 1952 to 1955. Organized by Douglas Macagy, special assistant to the museum director, and avant-garde filmmaker Sidney Peterson (1905 – 2000), whose film The Potted Psalm (1946) screened after the Whitney brother's work in 1946, the three-year "Television Project," at MoMA was run under a grant from the Rockefeller Brothers Fund. This program explored how the museum could directly use television to promote itself to a broader audience. Under Peterson's guidance, began a series of in-house film productions for eventual broadcast on television. In *The Dark of the Screen*, Peterson explains his time at the museum:

I don't think anyone could argue that MoMA was not *une institution sérieuse.* And besides, there was all that money to be spent. And what better way to spend money than to make a movie? So I made two, one about manhole covers and the other, in anticipation of what would come to be called post-modernisticism, about the tops of building, called Architectural Millinery. They were supposed to be pilots for a possible Museum series viewing the city as a museum without walls, how it might look to someone with an eye to see it.[54]

His description is misleading: *Architectural Millinery* (1954)[55] was produced first as the pilot for the series with narration by Henry Morgan; his second film of manhole covers may not even have been completed. Neither film was well-received by the museum administration. *Architectural Millinery* uses montage to compare skyscrapers to hats, and employed a range of unusual angles—especially aerial photography—to show New York through a comparison with the headgear of its residents. The museum administration felt the film was a failure, but showed promise for the idea. The manhole cover film begins with a low angle shot of the museum, then cuts to a movie camera emerging out of the sewer as the narrator says *"And there is another museum, which is the city of New York itself."* While the juxtaposition of museum with sewer is amusing, the subjects were not appropriate to promote the institution; manhole covers were not a good choice since they prompted thoughts of sewers, and the content of the narration drew the audience away form the museum's exhibits, defeating the purpose of using television to promote the institution's collection.

While Peterson's initial vision of a series of programs focused on New York as a living museum produced very little, in adapting to what the administration actually wanted, he developed the characteristic mode that television would use in presenting art to a general public. Peterson's recognition that the general audience in the United States was suspicious of art experts shaped the scripts he wrote for MoMA:

The audience should be represented in the person of an innocent bystander able to ask questions which might embarrass the emcee.[56]

The problem that Modern art (the then-contemporary art of the 1950s) posed was its newness; Peterson's recognition was that the "culture war" begun by The Armory Show in 1913, in spite of the Modernist's apparent victory in the art center of New York, was still very much an issue. By giving the suspicious audience a "voice" within the structure of the show, Peterson enabled these dissenters an apparent opportunity to question the validity of the work, while at the same time directly addressing and answering those objections. It simultaneously gave the appearance of questioning the work's status, and resolved those objections in a controlled, scripted fashion. This use of television as an educational medium mirrored the design efforts by Golden at CBS.

The television audience presented a paradox for the museum: the broad, general audience that watched television was seen as "distracted" and passive, while the museum attendee was seen as a connoisseur, "contemplative" and attentive to the art. These different types of engagement meant that the audience addressed in the museum appeared to be mutually exclusive to the audience addressed by

television in the home—it is a problem that the art world would not resolve until the emergence of video art, and its embrace by MoMA in the 1970s—a problem resolved by eliding television from video as an art medium, marking the emergence of a new art medium that did not have a pre-existing relationship to television.

COMMERCIALS & THE EXPERIMENTAL FILM

In the Anglo-American tradition, even before World War II there was a relationship between the avant-garde film and commercial concerns: Len Lye's films were produced by the GPO as advertising vehicles, Mary Ellen Bute employed commercial distribution to enable the production of her films, and even Oskar Fischinger made abstract films as commissioned advertising pieces, most evident in *Kreise* (1932). However, after the war, the new embrace of Modernist design by television offered opportunities for experimental filmmakers to support themselves by working commercially.

The Whitney brothers, like Harry Smith, are transitional figures between the earlier avant-garde films of the first experimental period, and the consolidation characteristic of the second period. John Whitney himself provides a direct link between the abstract, synaesthetic films produced by the European/American avant-garde and the commercial productions of the 1950s and 1960s: he worked as an animation director at the UPA studio in the 1950s on several animations for the first fully-animated TV show, *UPA Cartoon Parade,* and then directed several musical shorts broadcast on CBS. Whitney met Saul Bass through the UPA studio, the seminal figure in the emergence of the "title designer" in Hollywood film, and Bass' title design for *Vertigo* (1958) prominently features animated spirals generated by Whitney's analog animation "computer" (see Chapter 6).

The concept of "motion graphics" emerged during the 1950s as a result of both the feature film title sequence and the demands for short, animated commercials by television that combined photography, typography and abstract design in a single film with a standard running time of 15, 30, 60, 90 or 120 seconds. But the best of these shorts were not simply animated graphic design, as Whitney explains in his talk at the *Catalina Design Conference* in 1962:

> When a film title in the tradition that Saul Bass has done so much to establish, has an interesting articulation, it usually succeeds as a title. On the other hand, if it is lacking effective motion or articulation, it as well have been a book jacket, at best, perhaps like those that Alvin Lustig made. This matter of articulation is what I refer to as Motion Graphics and it is distinctly a new problem in the field of design; so little explored in fact that designers must approach it with caution and the proper sense of adventure. Film titles have been sold to clients; sold, approved and paid for, that must have looked superb in the storyboard layouts. But the storyboard would by at best a series of static drawings ostensibly to suggest or imply the motion that was conceived. If in production this action is not realized, or was unimaginative to begin with, very, very impressive storyboards from the point of view of graphic design may be still graphic design when they reach the screen—we say the work is not dynamic. It may be good graphics—it is not good Motion Graphics.[57]

The specific demands imposed by the translation of graphic design to motion graphics was a function, not of animation, but of the creation of abstract films; Whitney's conception of motion graphics was equivalent to abstract film, and both emerged from the same historical foundations. His conception of good motion graphics is distinctly a Modernist one, based on the correspondence of an art form to the ideas of the period which produced it:

> Sir Kenneth Clark of the London National Gallery has to say "Art and not, as used to be supposed, two contrary activities, but draw on many of the same capacities of the human mind ... Artist and scientist alike are trying to give concrete form to dimly apprehended ideas. ... they still depend on humanly comprehensible images, and the valid symbols of our time, invented to embody some scientific truth, have taken root in the popular imagination." Here in a nutshell is background for abstract art. But notice that we can also perceive the timely validity of the abstract image in motion. The nuclear scientist will agree readily that he is concerned with dimly apprehended ideas of forces and energies and particles in motion. His artist contemporary should (and does not) have any great facility to create image in motion. To repeat: our concepts of the universe have become overwhelmingly dynamic.[58]

Whitney's claims about art, its relationship to science and the direct need for dynamism would almost certainly be greeted with cheers of enthusiasm by the historical avant-gardes from before World War II, especially the Futurists whose work was directly concerned with the kind of energetic, dynamic imagery Whitney's speech calls for: his development of abstract film and motion graphics—as well as their use in popular media—suggests the intimate connections between art and commerce that enabled his movement from the margins of film into a highly visible, if uncredited, position translating the formal structures of abstract film into the commercial designs of television advertizing and film title sequences.

The connections between musical form as synchronized sound and image were for Whitney a matter of direct theory—the invention of a conceptual approach with immediate, practical application in the design of motion graphics, a concern of his since 1944, when he and brother James' *Five Film Exercises* screened at the first *Art in Cinema*:

> This new audio-visual-music image, whether animated frame by frame or created by other means for screen or television, must adapt its basic temporal structure to the frequency of the frame projection rate. As a general principle, both sound and image should have a common time unit which would be the frequency of the projected frames. Music notation, where it is used, would thus be converted from metronomic time values to frame-unit values. The fact that movement is not continuous actually limits rhythmic possibilities in the visual domain relative to that of sound. ... Color structure united with a graphic-time structure is comparable to the relationship between orchestration and these structure of a musical composition: the two contribute to a unified whole.[59]

The organization that he describes is one based in the specific technological potentials and limits of the medium used—the addition of sound and music to a motion graphics piece imposes changes on the music in order for it to "match" the action shown in the animation. This linkage is an amplification of the constraints already imposed by the production process for these synchronized works of visual music: as Norman McLaren explained, the soundtrack must be recorded first, and then a timing sheet created for to enable the connection of music to image. Whitney's recognition takes this limit further—only those notes and rhythms which fit within the time-span of the projected frames can be synchronized—any note whose duration is less than $1/20$ of a second (the projection time of a single film frame) cannot be synchronized in any precise way. These notes are too brief for a connection to any individual note. Early television with its low resolution and interlaced image fields simplified this relationship further: major connections, based on rhythm and musical phrasing, were the dominant types of synchronization—the direct linkage of note-to-form was less common, especially on television because of the technical constraints.

John Whitney and Sidney Peterson were not the only established avant-guardists to find support and employment by using their knowledge and aesthetics developed in experimental film and applying it to motion graphics. Whitney's work at UPA in the 1950s, and at his own company, "Motion Graphics, Incorporated," founded in 1960 brought the concerns and structural connections of visual music directly into the construction and design of both film titles and television advertizing. By the mid-1960s the relationship between TV commercials and avant-garde film was critically recognized in both screenings and museum exhibitions. This convergence of commercial and art worlds happened because the production process for television began to shift after 1954 from broadcasts of live performances to presentations filmed in Hollywood for television distribution.

Stan VanDerBeek (1927 – 1984)

Stan VanDerBeek (1927 – 1984) made animated films which had a lasting impact on the development of broadcast graphics. while at the same time working on the CBS children's show *Winky Dink And You,* (1953 – 1957) an "interactive" program that ran Saturday mornings where children would "help" Winky Dink and Woofer, his dog, complete key parts of the story by completing a connect-the-dots picture on screen using a vinyl sheet and crayons. (The product tie-in to these shows—the screens and crayons—used a marketing model where the children's program was also an extended sales-pitch, suggesting how later programs, such as Transformers in the 1980s or *Pokémon* in the 1990s, would integrate their toys and other merchandise into the children's program itself.) He made his first animations using the equipment at the CBS studio afterhours.[60]

However, it was not this program that VanDerBeek was known for—it was his avant-garde animated films, produced independently, but enabled through the financial security (and initially through off-hours access to equipment) provided by the show. These films combined stop motion, live action, collage animation to produce political satires of the television industry and American mass culture that employed him. In discussing the changing role of the film avant-garde in relation to

the commercial world with fellow filmmaker Jonas Mekas in 1967, VanDerBeek notes the demand for experimental work coming from the commercial world:

> We can see evidence of this in Hollywood's appropriating the new techniques of the Underground. The new processes are undergoing a dissolve into commercial forms. The explorations of the language of image and idea that's being done by the so-called Underground makes it a kind of research area for industry. *Hard Day's Night* [a vehicle for The Beatles from 1964], for example, could not have been made had there not been any number of films made as far back as, say, the twenties. The whole structure of film is changing. And so are the means of distribution. Films can come to you by means of educational television. And there's talk of Ford funds putting up an ETV satellite. Also, when they expand the electro-magnetic wave transmission process we'll have as many television stations as we now have radio stations.[61]

The potential for many more television stations VanDerBeek mentions was the expansion of television to include a second band for broadcasting—UHF—which allowed for more local stations unaffiliated with the major networks of CBS, NBC and ABC. Educational television—that variety of TV explored by MoMA in the 1950s—was in 1967 the main province of public broadcasting. It is in 1967 and 1968 that the first experiments with television as an artistic medium were about to begin the evolution from commercial medium to video art. His comments, made on the cusp of this transformation, reveal the intimate connections between the avant-garde (what he calls "Underground") film and the commercial media broadcast on television, and shown in mainstream movie theaters around the United States. The overlapping of popular and avant-garde during the 1960s was essential for the transformation from isolated artists making films seen only by a limited audience of their peers and friends to 'industrial' and commercial productions made for a broad general audience. Motion graphics emerged from this period as the largest, most visible (yet paradoxically, the most unrecognized) application of this Modernist heritage in media.

MAINSTREAMING THE AVANT-GARDE

The emergence of motion graphics as a commercial field happened gradually; the transition from live broadcasts to filmed programs led to innovative solutions to the difficulties of television and film design—and by 1959 these solutions had matured to a point that their consideration and evaluation was becoming an issue for both groups, industry and artist alike. *The Ninth International Design Conference in Aspen* (IDCA), Communication: the Image Speaks, held June 21-27, 1959 deserves special attention because this is the moment when designers, filmmakers and artists converged to give talks and present their work, in the process making the ties between the avant-garde and commercial industry VanDerBeek mentioned apparent. The group who came together dramatically reveal these connections: film title designer Saul Bass, who showed his titles for *The Man With The Golden Arm* (1955) chaired a session about the film image that included the abstract and experimental animator Norman McLaren, leading experimental filmmaker Maya Deren (1917 – 1961), Gerald (Jerry) Schnitzer (1917 –) who the first film producer

to recognize the value of television for a film studio's back catalog of older films, and who produced TV shows (including *Lassie*) during the 1950s. Schnitzer's presentation argued for a more dynamic TV commercial, one whose point of reference is clearly the experimental film:

> The filmed commercial can, as it must, tell its story with dynamic movement. Emulating from still photography, it has often failed; witness those commercials whose only action takes place between the nose and chin of the announcer.[62]

"*Dynamic movement*" was the chief concern of the Futurists in 1909—the visual presentation of an energetic, powerful motion specific to the Modern era they found themselves living in. The transfer of this particular term to advertizing implies the general transfer of this entire Modernist ideology to television, itself a new medium whose emergence at midcentury appeared specifically reflective of a "space age" populated by astronauts, orbiting satellites, and moving images broadcast through the air. The production of static images—still photography—when the new historical moment seemed to demand something more kinetic demonstrates the shift of this Modernist ideal from the realm of avant-garde art to the most mundane of media: TV.

The other presentations made during the IDCA were similarly focused on the use of these avant-garde ideas in relation to then-contemporary design issues. McLaren's presentation showed his experiments with synthetic sounds made by drawing directly on the film strip (*Penpoint Percussion*), exhibiting of the hand-drawn films he made under a Guggenheim grant in 1940 featured that approach.

This conference brought the connections between avant-garde film and television production—especially advertizing design—into an explicit dialogue, making the well-known connections between the commercial and avant-garde media worlds a subject for discussion and consideration by leading members of both communities. The linkages formed between them gave formal definition to the emerging motion graphics field, just as the commercial nature of that field enabled the avant-garde to assume a specifically non-commercial (if not an entirely anti-commercial) position in relation to the emerging norms and industry practices that *Art Direction* and *Print* magazines developed through their articles and coverage of both contemporary Hollywood film production and the avant-garde.

The movement between commercial film, television and avant-garde worlds was common for the artists who emerged into active production during the post-war period, and while the implied dynamic of their movement might suggest a mutual respect, (as might the presence of TV commercials in screenings and exhibitions of avant-garde films during the 1950s and 1960s), to make that characterization would be to oversimplify and misunderstand the dynamic itself: commercial production was looking at and borrowing from avant-garde work as a means to an end—the demands for both novelty and being "up to date" that motivate the commercial assimilation of the styles developed in art films are entirely different than the aesthetic motivations artists have in their choices and methods. William Golden described the problem confronted by TV when it engaged with the avant-garde simply as "in an era of mass-marketing, controversy is assumed to be bad for business, for no potential customer must be offended."[63] The discrepancy

between the personal demands of artists and the conformity of mass production reveals the parasitic aspects of the advertizing industry in relation to the avant-garde: the new, innovative developments made by artists were transformed by their use in commerce; the threatening, taboo aspects of films being shown at *Cinema–16* and elsewhere—what Amos Vogel called "*subversive*"—has no place in a TV commercial selling soap (or anything else). As Ralph Potter observed in 1959:

> Most newspapers are still characterized by relative policy freedom from advertisers and retain their tradition of assuming editorial positions. In this sense it is unfortunate that TV developed in an atmosphere of conformity and authoritarian fear ... programming and policy virtually determined by sponsors, and "public taste" (in the form of ratings and letters) dictated by the thinly veiled voice of conformity.[64]

Potters' description anticipates another critical description of TV rendered by FCC Chairman Newton N. Minow, who called it a "vast wasteland" in his first speech to the National Association of Broadcasters in 1961. Minow observed that "*when television is bad, nothing is worse*,"[65] describing an endless procession of boring, identical programs whose content and form all conformed to a narrow view of what the audience would accept and watch; the limited number of channels broadcasting nationally meant the Nielson ratings used by the networks to track "viewership" only identified who had their TVs turned on, and to which channel, but not whether the shows were actually being watched, or what might happen if there were more options available to them. Instead of insuring quality, the ratings system created a pressure to conform. The programs were consistent—generic—programs of types the competing networks also ran; it is the conformity Potter also describes. Any successful development was quickly copied and used in every program being run, rendering the content, style and form of TV programming uniform across all three major networks. Conformity and replication were even more common in television advertising than in the shows themselves. To change from marginal art production to mass media sales pitch required the removal of the artwork's content so only its surface, formal appearances would remain—and this transformation of avant-garde to mass aesthetics made the eventual rejection of the commercial link by the avant-garde artists inevitable.

With the development of "*ETV*"—later known as public television—and the institutional support that solidified around the avant-garde film canon and video art during the 1970s, the shift towards a more antagonistic relationship between the avant-garde media makers and television would become increasingly common. The dissent that is apparent within the industry at the start of the 1960s was shared by artists and critics working outside it as well—the promotion of higher standards and recognition of innovation via museum exhibitions and in the pages of industry magazines (*Art Direction, Print*) can create a retrospective illusion that TV produced higher quality programs than it actually did. The rejection of Hollywood and the television industry that had been a part of the avant-garde stance towards commercial media production would change into direct confrontation and critique as the 1960s progressed towards the 1970s. The transition from the second phase to the third reflects both the dominance of this adversarial stance and the institutionalization of the avant-garde.

MUSEUM VALIDATION

Starting at the end of the 1960s and fully emerging during the 1970s, is the third period of abstract film that emphasized the shift from marginal activity to one fully recognized and embraced by art-world institutions. It coincides with the creation of the *Anthology Film Archives* in 1970, the elevation of "Video Art" by the Museum of Modern Art in 1975, and the development of the Film Studies program in American colleges and universities. The shift is from a focus on new production, experimentation and invention to one where specific artists were elevated to being historically important and the various activities of artists were organized into a linear, historical narrative: this period proceeded with the institutionalization and canonization of certain artists, films, and the differentiation of video art from television—as well as the dominance of a media-critical practice that adversarially engages with both television and Hollywood cinema. It was marked by the institutions supporting the avant-garde shifting from a promotional and presentational mode to a primarily historical understanding of artists and avant-garde media. This historical invention was a side-effect of the embrace of the avant-garde film by academic and museal institutions.

However, the early phases of this period in the mid-1960s moved in contradictory directions: while some artists worked towards a formal medium-specificity for both video art and avant-garde film that followed the theorizations of Modernism proposed by the art critic Clement Greenberg; at the same time, other artists were working in the hybrid, overlapping spaces between video, film, and television—often using elements of all three technologies in the creation of avant-garde "movies" that exceeded the limitations of the various media used in their production. The development of installation art (both film and video), and experimental presentations based in manipulations of projection or using multiple projectors can be recognized as part of this hybridization known during this period as "expanded cinema."

Clement Greenberg's essay, *Modernist Painting,* appeared in 1960 as a pamphlet in a series published by the Voice of America, then reprinted in 1966, implicitly conditions how artists understood the idea of 'formal' during the beginning of this institutional period for the avant-garde film. His article was initially published as the art world was in transition, coming as the highly reductive, abstract Minimalist

movement was being recognized by the Museum of Modern Art and artists' direct engagement with popular culture was becoming more common—a collection of trends called "Neo–Dada" at the start of the 1960s, but which would later be known as Fluxus and Pop art. In constructing his argument about the essential features of Modernism, Greenberg adapted ideas from philosopher Immanuel Kant to claim the historical development of painting as a continual purification of the art, stripping away all excess conceptual baggage:

> The essence of Modernism lies, as I see it, in the use of characteristic methods of a discipline to criticize the discipline itself, not in order to subvert it but in order to entrench it more firmly in its area of competence. Kant used logic to establish the limits of logic, and while he withdrew much from its old jurisdiction, logic was left all the more secure in what there remained to it.[1]

In this "self-critical" procedure Greenberg proclaims the foundation of Modernism: it provides a logically consistent explanation for the historical changes in painting, beginning with the Impressionists' shift from the highly rendered realism of academic painting to the more loosely drawn modeling of light effects where individual brush strokes and the physical handling of paint is visible, progressing through Seurat's reductive pointillist technique where color became an optical mixture composed of individual specks of color into the physical appearance of both brush work and blank, unprimed canvas in Cezanne's major paintings to the reductive abstraction of Cubism, which in turn spawned the geometric flatness of the various abstract movements—Suprematism, de Stijl, Constructivism, etc.—until reaching the American Abstract Expressionists. It was a historical account that linked post-war American abstraction to the earlier European Modernists, without acknowledging the existence—or role—of a native American Modernism in the emergence of abstraction after World War II.

The various avant-gardes which did not fit into his paradigm for Modern art, such as the Dada movement, or Surrealism, were simply left out of Greenberg's conception. The 'self-critical' procedure he identifies with Modernism is his own creation, derived from how for Greenberg Modern artists are engaged in a pseudo-philosophical activity that assumed a definition for "art" based on a clearly defined boundaries between different media:

> Each art, it turned out, had to perform this demonstration on its own account. What had to be exhibited was not only that which was unique and irreducible in art in general, but also that which was unique and irreducible in each particular art. Each art had to determine, though its own operations and works, the effects exclusive to itself. By doing so it would, to be sure, narrow its area of competence, but at the same time it would make its possession of that area all the more certain. ... The task of self-criticism became to eliminate from the specific tasks of each art any and every effect that might conceivably be borrowed from or by the medium of any other art. Thus would each art be rendered "pure," and in its "purity" find the guarantee of its standards of quality as well as of its independence. "Purity" meant self-definition, and the enterprise of self-criticism in the arts became one of self-definition with a vengeance.[2]

Within such a conception, there is no quarter given to hybrid works, or to works whose formal qualities challenged the clear boundaries Greenberg's theory erected between different media. The newly emergence media, such as television, whose formal character was evolving, or motion graphics—which used two very different technological media to create the same kinds of effects (film and television)—could not be Modernist within the paradigm Greenberg proposed. In fact, Greenberg has no interest in popular, commercial media, since it has no place within his theory of modernity, and the reception his discussion received both in the 1960s, and later, prompted his partial retraction of its implications in 1978:

> Nevertheless, a close reading of what he [Greenberg] writes will find nothing at all to indicate that he subscribes to, believes in, the things that he adumbrates. (The quotation marks around pure and purity should have been enough to show that.)[3]

His desire to distance himself from his own work is most visible in his writing about his own work in the third person, as if he, Clement Greenberg, had not written the essay; of course, he did begin his discussion with the statement "as I see it"—making his later disavowal less than credible. His distancing himself in 1978 from the proposal he made in 1960 lies with two factors: the almost complete ahistoricality of his account, which is based on a collection of value judgments about what was the "good" art of the past, and was not entangled with, and only supported by, the theory he proposed in an example of circular logic (the "good" art supported and demanded explanation in the theory he posed, which in turn was valid because it enabled the identification of that "good" art); secondly, because the further development of the art world in the 1960s worked to fully contradict his theory: Pop art, with its embrace of commercial imagery and production techniques, the Minimalist art that seemed to take his theory literally, but which he rejected, and the emergence of Conceptual art, where the various boundaries between art media required and assumed in his theory collapsed into hybrid forms using multiple media simultaneously.

Yet at the same time as Greenberg's theorization was being challenged by the new developments happening in the art world, it exerted a powerful, almost gravitational pull, on artists and critics engaging with art during this period: whether to embrace and logically develop the implications of his theory, or to fully reject its conception of art, Modernism and American culture. In this respect, Modernist Painting is the central post-war explanation of American art and its relationship to European Modernism, one whose influence established the parameters for how television, the avant-garde film, and video art would be theorized and historically contextualized in the third period of abstract film. It is a theory that found a parallel in the Film Studies program developed at Harvard University by Stanley Cavell, whose book *The World Viewed* (1971) drew on Greenberg's theory as elaborated upon by art critic Michael Fried, but where Greenberg and Fried's concerns were with contemporary art and painting, Cavell was primarily concerned with Hollywood, and feature-length feature films, and his philosophical basis for film study relied on the realism of the photographic image used to create fictional worlds and present stories. It is a foundation that necessarily had only limited application to abstraction and motion graphics because of its focus on an apparent, physical

connection between the actors seen on screen and the actor's presence in front of a camera.

This institutionalization of film and media art generally was accompanied by the canonization of artists and films who emerged during the second period as representative of the alternative to commercial, Hollywood cinema. It is a shift that begins in the 1960s with the publication of critical studies focused on the specifically experimental film that become increasingly academic as the decade ends: Sheldon Renan's *An Introduction to the American Underground Film* published in 1967, Parker Tyler's *The Underground Film: A Critical History* in 1969, David Curtis' *The Experimental Cinema* from 1971, and P. Adams Sitney's *Visionary Film* in 1974. Sitney's book developed from various articles published during the 1960s. They demonstrate the close connection between Sitney's elaboration of a film avant-garde, and the role of filmmaker and programmer Jonas Mekas' magazine *Film Culture,* in the critical dissemination, organization of artists, and creation of a particular history for the avant-garde film that happened in parallel to the development of the exhibition and distribution (discussed in Chapter 4). That both men collaborated in the creation of the *Anthology Film Archives* in 1970 is not incidental in the creation of the particular history contained in Sitney's book: it is a demonstration of the shifting from the expansive second period to the hierarchical third. This transformation impacted the development of motion graphics—instead of there being an ad hoc group of films (what happened to be showing at any particular moment in the "art house" cinemas), the emergent canon provided a coherent, uniform collection of significant filmmakers and films—thus stabilizing the field and creating shared foundations for an aesthetic; this new basis also had the effect of banishing the commercial work from the serious consideration along side the art film. In the process, it codified the "standards of excellence" that were being promoted in *Art Direction* and *Print* magazines by critics such as Ralph Potter in the 1950s.

INTERMEDIA

In contrast to the canon that was being formed around avant-garde films in New York, and which followed a trajectory towards greater "purification," were the alternative developments of inter-media, which can be grouped into several overlapping trends that sometimes appeared together in a single work:

(1) the creation of multiple projection environments
(2) the fusion of projection and various kinds of performance
(3) the combination of different image technologies—film, video, and the theatrical, optical projectors of various types used in concerts and other live stage performances

Of these, only the first and third are of direct relevance to the development of motion graphics in the 1970s and 1980s. Unlike the "pure" formal works that engaged film as film, these productions worked to blur the boundaries between still imagery and motion, as well as moved fluidly between film and video, and explored alternatives to the standard theatrical projection of films on a single screen. (The development of the "computer film" was closely related to these works, but will be

examined in detail in Chapter 6.) Called both "intermedia" and "expanded cinema," it was a vein of production that developed in the convergence of commercial and artistic interests—and often used corporate and commercial funding for what were essentially experimental, avant-garde media works. This idea of "expanding cinema" was posed in the opening credits of Bute's films in the 1930s and returned in the 1960s around a range of formal approaches to both the production and exhibition of avant-garde films. The term, "expanded cinema," was proposed by Stan VanDerBeek in his contribution to a special issue of *Film Culture* on "*Expanded Arts*," but the use of multiple projectors, combinations of slides and film, and the use of environmental projections was known under a variety of names during this period; expanded cinema and intermedia were the most common. *Film Culture* magazine's editor, filmmaker Jonas Mekas recognized the shift that "expanded cinema" was bringing to film:

> For what is cinema if not really images, dreams, visions? We take one more step and we give up all movies and we become movies: we sit on a Persian or Chinese rug smoking one dream matter or another and we watch the smoke and we watch the images and dreams and fantasies that are taking place right there in our eye's mind.[18]

The cinema of mind Mekas describes is one where the distinction between the hallucinatory and the real collapses. In its evocation of the 1960s counter-culture's use of psychedelic drugs of various types he reminds his readers of the relationships between the spectacular experiences of watching visual music and the spiritual meanings attached to early abstraction. The emergence and transfer of these meanings into an "expanded" conception of cinema is part of this heritage.

Hy Hirsh (1911 – 1961)

Hy Hirsh worked as a photographer throughout his career, and like the Whitneys, he constructed his own optical printer to allow him a high degree of control over the composition and layering of imagery essential to his films. Optical printing enables a physical transformation of existing motion picture material into something new, a combinatory process where live action material can become abstract, and limited quantities of source material can be built up into a much longer, more complex and more dynamic film. This transformative process is the essential role that optical printing plays in the Whitney brother's films. The approach to image processing enabled by optical printing can be readily transferred and adapted for use with digital technology precisely because digital approaches were developed as a way to create optical printer effects without the time and expense of actually using an optical printer. Both analog and digital compositing treats all visual materials as graphic elements for manipulation: chromakey, in analog video, blue or green screen in film, the alpha channel that digital images can store, and the paired mattes (holdout and travelling) used in optical printing all function in the same way: they enable the combination of two or more discrete units into a composite, final movie; hence, the name, "compositing." Because all these distinct technologies share a fundamental conceptual basis—the isolation of one visual element for combination into a new image—the approach to imaging created

by optical printing can be applied to any type of media that employs a compositing technique in the production of motion images.

Hirsh began working in Hollywood at Columbia Studios in 1930, working as a camera operator and editor before leaving in 1936; before moving north to San Francisco, he acted in Roger Barlow's experimental film *Even as You and I* (1937). It was while at Columbia Studios that he began working as a still photographer. Photography remained a constant part of his work; he worked at the M. H. de Young Art Museum in San Francisco as their staff photographer from 1937 to 1954.[8]

During his time living in San Francisco, he occasionally collaborated with the avant-garde filmmakers there, but exhibited primarily as a photographer working in the "straight" realist style of the *Group f64* that included Edward Weston, Ansel Adams, and Imogen Cunningham, teaching in the photography program at the California School of Fine Arts in San Francisco in 1947. While there, he collaborated with Sidney Peterson on *The Cage*. Peterson described Hirsh's engagement as fundamentally experimental:

> Together, in one way and another, we did everything either could think of
> to do with a camera. We tried animation. We tied the camera to a
> contraption and rolled it down a hill. We reversed the action and shot it
> upside down and then reversed the film in accordance with the rule, since
> made explicit by Jasper Johns, about taking an object, doing something to it
> and then doing something else to what had been done.[9]

This working process is fundamentally a combinatory one—it builds from a limited quantity of materials, handled in a variety of ways, and uses the resulting "loop" to move the footage away from a mimetic photographic realism—the result of this procedure is to violate the premise of "straight" photography in favor of near-abstraction. Hirsh would work with Sidney Peterson on several more films: *Horror Dream, Clinic of Stumble,* and *The Lead Shoes,* but Hirsh would not begin producing his own films until the 1950s. These abstract films were made using an optical printer. Without the recombinatory ability provided by the rephotographic process of optical printing, he would not have been able to create the complex assemblages of imagery on view in his films that combine of live action and oscilloscope patterns.

The first of these, *Divertissement Rococo,* (1951) was followed by *Come Closer,* (1952) and *Eneri* (1953).[10] All three were produced with an optical printer, enabling the transformation and rearrangement of both live action footage (birds in flight) and the abstract patterns produced by an oscilloscope in to a new composition; it employed the same transformative potentials of optical printing developed in the Whitney brother's *Five Film Exercises.* The synchronization between the images and the Caribbean steel drum carnival music in *Come Closer* moves between a synchronization and a syncopation suggestive of a dancing counterpoint where the connections between sound and image are carefully chosen, yet at the same time not directly linked. This looser approach to synchronization creates an uncertain relationship between the sound and image, one where their linkage is highly ambiguous.

Expanding Cinema

"Expanded cinema" was revised by other artists and critics to describe a range of artistic and technical practices, following the idea of "expanded consciousness" rather than the formal expansion suggested by both Stan VanDerBeek and Mary Ellen Bute. The exhibitions produced under this name did not meet the standard expectations for film screenings—Mekas' description of watching these films seated on a Persian or Chinese rug is not the description of a show in a movie theater, but of some other model for screenings, less formal, less recognizable as part of a commercial presentation. While this difference in exhibition was accompanied by other formal innovations—multiple projection, curved, domed or shaped screens, the mixture of slides with moving images, combinations of film and video—these formal differences were not the primary focus of expanded cinema.

Gene Youngblood, a critic who moved between film and video in his theory and history, produced the primary historical account of this period of overlapping and convergent media in his book *Expanded Cinema* published in 1970; Youngblood's book is closely linked to the cultural context of its production. With an introduction by the architect and designer Buckminster Fuller, the book promotes a utopian view of technology, one where new technology serves the avant-garde purpose of breaching boundaries between distinct fields to create a holistic, unified paradigm, explained in Preface to his book:

> When we say expanded cinema we actually mean expanded consciousness. Expanded cinema does not mean computer films, video phosphors, atomic light, or spherical projections. Expanded cinema isn't a movie at all: like life it's a process of becoming ... One can no longer specialize in a single discipline and hope truthfully to express a clear picture of its relationships in the environment. This is especially true in the case of the intermedia network of cinema and television, which now functions as nothing less than the nervous system of mankind.[19]

The understanding of media implied by this opening statement becomes more explicit when Youngblood begins his discussion of intermedia. This idea of expanded consciousness, expressed through the collection of formal devices ("computer films, video phosphors, atomic light, or spherical projections") proceeds from a changed conception of the relationship between media productions and the conception of reality: the shift during the 1950s and 1960s was to a recognition of reality as incorporating media into it; i.e. a 'media-reality.' Youngblood explains "the intermedia network of cinema, television, radio, magazines, books and newspapers is our environment."[20] This understanding has received a range of distinct terms that all describe essentially the same changed relationship between experience, media representations and knowledge, when understood in positive terms it is the "global village" of theorist Marshall McLuhan or "expanded cinema"; considered negatively, it is Situationalist Guy Debord's "society of the spectacle," or Post-Modern theorist Jean Baudrillard's concepts of "simulation" and "hyperreality."

The media-saturated environment was a topic of international interest during the 1960s. It is a focus that became apparent when Montreal, Canada hosted the *1967 International and Universal Exposition* or *Expo '67*. It was a world's fair dominated

by media presentations and screening/performances of various kinds. Complex, large and multi-screen projections were in several of the pavilions: the Czechoslovakian pavilion held the *Diapolyceran Screen,* a thirty-two by twenty foot wall made up of 112 rear-projection screens, each with its own slide projector holding eighty images. It allowed the manipulation of the entire wall as a collection of different pictures, or as a single large image. Roman Kroitor from the National Film Board of Canada produced *Labyrinthe,* a pair of giant films projected on forty-foot screens, using a horizontal-carriage 70mm film (this technology is the direct ancestor to IMAX). As with early television (discussed in Chapter 5), there was a mixture of avant-garde artists also presenting: the pioneering feminist performance artist and filmmaker Carolee Scheneeman showed *Night Crawlers* (1967) a combination of film and live performance that moved off the stage, physically assaulting the audience.[21]

These exhibitions used large, (and often curved or domed), screens to fill the audience's entire visual field with images in a rejection of the standard proscenium-style projections typical of film and television, and inherited from live theater. Projection on these screens creates an immersive, all-encompassing environment was a concern shared by a range of media artists; the contemporary IMAX theater is a descendent of these developments in the 1950s and 1960s. As with the idea of "expanded cinema" it was not an invention of this period: Mary Hallock-Greenewalt's proposed theater for Nourathar was to employ a curved screen; Thomas Wilfred used a curved screen in the theater for Century Dairy Exhibit Building that showed his Lumia compositions at the *Chicago Century of Progress World's Fair* in 1933; Oskar Fischinger proposed a similar design to Hilla von Rebay in correspondence about the design and form for the Film Center she planned as part of the Guggenheim museum that was then being designed. Fischinger suggested a theater that was

> half-spherical, like a big planetarium. The Machines [projectors] at the center. The spheric projection surface of a planetarium produces a perfectly clear feeling of endless space.[22]

This proposal, while never constructed at the Guggenheim (the final design did not include any screening rooms of any kind), closely resembles what was used by the *Vortex* concert series at the California Academy of Science's Morisson Planetarium in San Francisco. The creation of visual performances that exceeded the parameters of typical film presentation became a common concern of artists engaged with intermedia production; these multimedia productions were designed to create "sensory overload"—a reflection of the understanding of media saturation and simultaneity present in the media environment.

THE *VORTEX* CONCERTS

Vortex, (also known as the "Vortex Concerts,") produced by filmmaker Jordan Belson (1926 – 2011) and composer Henry Jacobs (1924 –), was a series of five concert programs that began on May 28, 1957 and ended on January 28, 1959. There were thirty-four performances done at the Morrison Planetarium. It was a highly successful, popular series, and was organized more formally for the start of

their fourth series. The program notes for *Vortex 4* explains the development of their conception of *Vortex* as more than just a space to play music and show motion pictures:

> *Vortex* is a new form of theater based on the combination of electronics, optics and architecture. Its purpose is to reach an audience as a pure theater appealing directly to the senses. The elements of *Vortex* are sound, light, color, and movement in their most comprehensive theatrical expression. These audio-visual combinations are presented in a circular, domed theater equipped with special projectors and sound systems. In Vortex there is no separation of audience and stage or screen; the entire domed area becomes a living theater of sound and light.

> *Vortex* had its beginning in 1957 as an audio-visual experiment under the joint sponsorship of radio station KPFA and the California Academy of Sciences. Founders Jordan Belson and Henry Jacobs ascertained the Morrison Planetarium with its extensive loudspeaker system ideal as a demonstration laboratory. With the thirty-eight high-fidelity speakers, actual movement and gyration of sound was made possible by means of a special rotary console.

> Utilizing the elaborate Planetarium lighting system along with special projectors, coordinated full-scale visual effects gave promise of an exciting new form of theater. The premiere of *Vortex* on May 28, 1957 to a capacity audience established this audio-visual experiment as a true theater of the future with a potential for directly reaching an audience with unique sensory experiences not based on the customary story, music, or entertainers. *Vortex* is direct. There is no age, linguistic nor aesthetic barrier to experiencing *Vortex*.

> On the basis of the success of thirteen performances of *Vortex* to audiences totaling over 5000, the Audio-Visual Research Foundation was established in 1958 as a basis for interchange of information and to gain support from composers, artists and scientists throughout the world who are working with the experimental aspects of audio-visual phenomena. Already interest in the *Vortex* project has come from Canada, Switzerland, Belgium, Germany and Japan.[23]

These concerts began as presentations of ethnic and experimental music from Jacob's collection; they were an outgrowth of his KPFA radio program concerned with the same material. The presentation was based on the specialized loud speaker arrangement in the planetarium theater where forty high-fidelity speakers were evenly placed at twelve locations around the edge of the dome and in the center, allowing the sounds to surround the audience, and rotate around them creating a 'whirlpool' that provided the name for the series—*Vortex*. As the history in the fourth concert series program explains, the organization of these concerts was around the systematic, synchronized development of "sound, light, color, and movement" within the immersive arena-theater offered by the domed planetarium screen. Jacobs later described these shows in the Folkways LP record released with music from these performances:

Unfortunately, the most significant and valid aspects about this project cannot be revealed in print. It is a kind of new sensory communication which allows the receiver to create even more excitingly than the communicator—a rare, but stimulating opportunity in these days of the million dollar cliché on television, films and videotape is admittedly non-intellectual, non-educational and non-reformational, *Vortex* occasionally takes its audiences to areas hitherto unimagined and there is a purely accidental aesthetic experience which is so overpowering that even memory is obliterated by the dominance of that moment. Because of this, people cannot disregard *Vortex*, it does provoke irrespective of all else, this provocation in a cultural context of pre-fabricated dreams, pre-fabricated houses, and indeed pre-fabricated lives, is self-justifying and necessary.[24]

The "visionary" nature of this collaboration is reflected by the later development of Belson's film work which employed techniques and imagery developed at the *Vortex* concerts. He and Jacobs collaborated on these performances, with Jacobs curating the music and Belson organizing the visuals. There were six series of concerts in total, five at the planetarium plus one series at *Expo '58*—the *1958 World's Fair* in Brussels, Belgium. These concerts were organized around programs of experimental music produced with the then-new Ampac audio tape; as part of later shows (*Vortex 4* and *5*). For the fourth series, they sold a stereophonic tape of the highlights from *concerts I, II*, and *III* produced by Musical Engineering Associates of Sausalito for $11.95[25]; after the final series, Jacobs organized an LP record for Folkways. The first three series had been popular enough that in the later series they ran two shows per night and expanded their exhibition dates for *Vortex 4* (May 12, 13, 19 & 20, 1958 at 8:00 and 9:15 pm), and the final series *Vortex 5* (January 12 & 13 19 & 20 26 & 27, 1959 at 8:00 and 9:00 pm); the break between the *Vortex* 4 and *Vortex* 5 concerts in 1958 and 1959 was for *Expo '58*.

As the *Vortex* concerts progressed, the visuals and the acoustic potentials of the space become more complex. The ability to control the sound played by the ring of speakers spaced around the dome enabled Jacob's to "spin" the sound around the circumference of the room—the source of the "vortex" in the series' title. Belson supervised the installation of special interference pattern projectors that played on the sixty-foot domed ceiling-screen. The importance of the visual part of the show was emphasized in the program notes for *Vortex 5*:

The *Vortex* demonstrations are sponsored by the Audio-Visual Research Foundation with the cooperation of the Morrison Planetarium. The Foundation is organized to explore the esthetic possibilities of technological developments in auditory and visual media. Our first project, *Vortex*, stems directly from this approach.

Technically *Vortex* utilizes all known systems of projection, along with one of the most highly developed sound playback systems extant. Yet, it is a live creation of sound and image, being performed for a specific audience. Vortex is based on a mutual complement of aural and visual elements, in which they reveal unspoken meanings about one another which exist in neither alone. Having presented successful *Vortex* series in San Francisco

and Brussels, the Foundation hopes to give demonstrations in Tokyo and Moscow in 1959.[26]

While these concerts were initially conceived as experiments with new technology, these performances involved the assistance and work by a large number of artists, including visual work by avant-garde filmmaker Hy Hirsh and James Whitney who are credited in the *Vortex 4* program notes as responsible for "Special Visual Effects." Because of this unusual screening situation, the programs offered an immersive visual experience that would become an important part of the developing "expanded cinema" and psychedelic films of the 1960s. They provide a direct link between the earlier work done with visual/color music, abstract film and the installation-performance hybrids of expanded cinema.

Jordan Belson (1926 – 2011)

Jordan Belson, responsible for the visual parts of these concerts, was initially trained as a painter at the California School of Fine Arts (later renamed the San Francisco Art Institute) and then the University of California at Berkeley, graduating in 1946, and attended the first screening series at the San Francisco Museum of Modern Art where the films by Hans Richter especially influenced his formal development; he began making scroll-paintings as Eggeling and Richter had in the 1920s. His first film, *Transmutation* (1947), premiered in the Third Series at *Art in Cinema*. This early film is no longer known, but it and his second film, *Improvisation No. 1* (1948), which premiered in the Fourth Series, distributed through *Cinema–16* in New York.

In the late 1940s Thomas Wilfred exhibited his Lumia works at the San Francisco Museum of Modern Art, and gave a series of performances with his Clavilux. This exhibition influenced Belson's development, and may be a contributing factor in his involvement with doing live performance using abstract films at the *Vortex* concerts at the California Academy of Science's Morisson Planetarium suggests the significance of this exhibition to Belson's developing aesthetic:

> We could tint the space any color we wanted to. Just being able to control the darkness was very important. We could get it down to jet black, and the take it down another twenty-five degrees lower than that, so you really got that sinking feeling. Also we experimented with projecting images that had no motion-picture frame lines; we masked and filtered the light, and used images that didn't touch the frame lines. It had an uncanny effect: not only was the image free of the frame, but free of space somehow. It just hung there three-dimensionally because there was no frame of reference.[27]

The discovery that abstract imagery that was not cropped by the edges of the film frame would appear not as a film image but as a free-floating visual form recalls the kinds of visual forms that appear in Wilfred's Lumia. Belson would use the imagery and techniques he developed for the concerts in his later films, including *Allures* (1961). In a similar fashion, the creation and modulation of the viewing experience changes the nature of the presentation. The images and music were arranged in counterpoint rather than a direct synchronization. While the concert series did not

show any completed films, one of the original compositions Jacobs created became the soundtrack for James Whitney's film *Yantra* (1959).

Allures (1961) opens with the films' title rippling on screen. The imagery which follows was produced using a range of mechanical devices that generate abstract patterns through a combination of spinning masks that create interference patterns, superimpositions and composites of different footage, and kinetic geometric shapes on screen. While the imagery in *Allures* resembles that produced by an oscilloscope, it was generated mechanically, not with electronic technology: forms rotate around the center of the screen, moving towards the edges in a radial motion that gives the visuals a constant rhythm of circles, spirals and tunnel-shapes composed of moving diamonds. Belson has identified the forms in Allures with the same mental, internal cinema Mekas described:

> I was able to produce externally, with the equipment what I was seeing internally. ... The mind has produced these images and has made the equipment to produce them physically. In a way it's a projection of what's going on inside, phenomena thrown out by the consciousness, which we are then able to look at.[28]

The conception Belson presents is fundamentally a matter of "inner vision" made manifest through film and the devices he built to create this imagery. As with John Whitney's mechanical computer being constructed in Los Angeles at the same time (see Chapter 6), Belson's machines are custom-built to produce abstract imagery, and generate a variety of images based on spiral forms (as Whitney did with Saul Bass for the *Vertigo* title sequence in 1958).

The abstract imagery on view in Allures belongs to a consistent, recurring visual interest in circles, spirals, and web patterns that suggest lattices, tunnels or kaleidoscopic forms set in motion. They provide the basic vocabulary employed in most abstract films and are commonly associated with hallucinatory forms as well. This connection between the abstract, hallucinatory shapes of these films and their production in the 1950s and 1960s is reflected in the label "psychedelic" that is commonly used to describe and identify them.

While Belson used mechanically-generated imagery in the production of his work, by the mid-1960s other artists were also investigating the electronic imaging potentials of television. The combination of video art image/signal processing techniques with the technological overlap between television exhibition and film production enabled the development of a hybrid "videographic cinema" where film, video and television would combine in the creation of "live" production with television studio equipment for final exhibition as a film, rather than as video. These early works suggest the later combination of film and digital technology.

Pat O'Neill (1939 –)

Pat O'Neill studied art and industrial design at the University of California, Los Angeles and was one of the founding dean and faculty member of the film and video program at the California Institute of the Arts (CalArts), teaching there from 1970 to 1976. His transition to film making came during the 1960s, an era of hybridity and interdisciplinary artistic practice.[11] He was occasionally provided film

material for performances[12] done by *Single Wing Turquoise Bird*, a group of artists active from 1967 to 1975, who produced light shows in Los Angeles, California, and the influence of these live visual performances is apparent in O'Neill's films which are focused on optical/kinetic aspects of the moving image.[13]

O'Neill's work with film is based around a combination of imagery through rephotography. His transition to films based on reproduction of existing motion imagery instead of direct animation reveals the influence of John Whitney, whose films employed optical printing as a way of controlling and manipulating a limited 'library' of material into a longer, more complex film in O'Neill's process.[14] However, unlike Whitney's films where the image remained a singular, unitary form on screen, O'Neill's work shows the equal impact of his design training:

> I went to UCLA where I was sort of all over the place and finally wound up in the art school doing design. It really wasn't until I had been there about three years that I began working in photography and encountered a couple of teachers that were very helpful. But it was still photography that got me interested in moving images. It was John Neuhart at UCLA who showed me the Whitneys' films for the first time. I was Neuhart's TA in the summer of 1962. John Whitney came and set up his pendulum-actuated device and also showed some of his early work. And soon after that John Whitney was working on his piece for the US pavilion at the New York World's Fair and he showed *Catalog*. That one in particular was quite a revelation, the first time I had seen anything completely original in abstract film.[15]

John Whitney's films and approach to film making presented a technical model based on optical printing and the manipulation of existing imagery. The use of live action imagery, in combination with abstraction, or transformed into abstraction is an inherent potential in this engagement with reproduction and recomposition of existing footage; these are the features of this technique that Pat O'Neill developed in his work, and it unites the approach he developed with those of early video art. This convergence between electronic and chemical imaging technologies also appears in Scott Bartlett's *Off/On* (1968) and links these avant-garde films to later digital technologies.

7362 (1967) was made using high-contrast film and an optical printer, enabling the production of imagery in several layers on screen simultaneously. As in Bartlett's *Off/On, 7362* is concerned on a formal level with the creation of abstract imagery from what began as live action footage of a highway, machinery (what appears to be oil rigs pumping), a nude woman, and other material whose origins are less apparent in the finished composite; *7362* refers to the code number for Kodak's high-contrast film stock employed in creating the masks for optical printing. The film O'Neill produced uses double exposures and horizontal flips (to create the symmetrical effects) and is organized around the rhythmic motion of the images' contents O'Neill's description of his film focuses on these optical phenomena:

> A bilaterally symmetrical (west to east) fusion of human, biomorphic and mechanical shapes in motion. Has to do with the spontaneous generation of

electrical energy. A fairly rare (ten years ago) demonstration of the *Sabatier* effect in motion. Numbered after the film stock of the same name.[16]

The "spontaneous generation of electrical energy" O'Neill mentions is generally recognizable as either lightning or more commonly, 'static electricity.' Given that there are no apparent images of either in his film, this "electricity" is metaphoric—given the overt sexuality of his imagery—it may be sexual in nature. *7362* proceeds by accumulating imagery where the screen space gradually moves from simple symmetries toward increasingly complex layerings of both machine and human in which the two seem to merge into a composite machine-body. Presented as neither horrific nor as a celebration, the film presents its content in a "blank," matter of fact fashion, without apparent comment through editing or counterpoint.

O'Neill's work reveals the influence of design applied to motion pictures, showing the influence of commercial adaptations of Modernism on artists working in the avant-garde; this reversal indicates the transition from the first generation of American avant-garde filmmakers—those who emerged around World War II and shortly afterwards, and those who emerged during the 1960s. The convergence of his design training and interest in film making is apparent in the formal organization of his films which resemble collages of image fragments arranged into on-screen photo-montages in motion. This complexity was only suggested by 7362, a film that works with compositions based around the entire image-in-combination:

> I finished my first film in 1962. Then I started doing abstract or composite films. I began to use the camera as a sort of gathering device to provide elements for manipulation through rephotography. This led to 7362 which was done in 1967.[17]

Photography of live action collected specifically for combination and reproduction. The innovations of *7362* are essential for the later development of his work which employed increasingly complex combinations of imagery. The next film he made after *7362, Runs Good,* reveals the influence of his design background even more strongly: the film serves as a collage of discrete imagery, building towards denser collections of representational imagery, a significant difference between it and the earlier *7362* where imagery becomes increasingly abstract.

Runs Good (1970) develops imagery that is partitioned, breaking the screen into a grid of frames whose contents enable a juxtaposition of imagery on screen reminiscent of both Robert Rauschenberg's combine paintings and James Rosenquist's large scale panoramas of collaged imagery. The combination of discrete image pieces both within the frame as a whole and through a break-up of the screen into discrete windows is a distinctly post-modern aesthetic tactic for creating juxtapositions of imagery; this approach is one of the most direct sites of overlap between the visual forms of graphic design and Modernist advertizing and the avant-garde film. However, the inset imagery in O'Neill's *Runs Good* works against establishing a stable meaning, working instead to create a shifting series of relationships that undermine the stability of meaning common to these forms in the advertizing context.

The combinatory nature of O'Neill's films, like those of John Whitney, present a parallel to the development and production of composite imagery and the use of reproductive processes to transform existing footage. In modulating between realism and abstraction, the formal structure of O'Neill's films creates the appearance of indeterminacy—a balance between being recognized and unknown—that thwarts the simple 'transparency' of the design aspects of commercial production. However, this linkage between commercial and experimental practice enabled him, as with Whitney, to establish a commercial business, which he began in 1976 after leaving CalArts, based on his expertise with optical printing, and employing an aesthetic built around that technology he developed working as an artist.

'STRUCTURAL' FILM STUDIES

The institutional period was fully underway when the American Federation of the Arts produced their circulating film exhibition, *A History of the American Avant-Garde Cinema* in 1976 that included thirty-seven films by twenty-eight artists whose work had previously been established as important by the organizations and publications active during the second historical phase. This exhibition followed similar work at consolidating and organizing a collection of central works that had been underway since Gregory Battcock's anthology featuring many essays previously published in *Film Culture* magazine, *The New American Cinema* (1967), and film critic Parker Tyler's lengthy, but not particularly academic survey of the American avant-garde as distinct from the earlier European films called *The Underground Film*, following the model of Renan's earlier book. There had been previous books on this subject that attempted to create a history for the avant-garde, such as Stauffacher's catalog for *Art in Cinema*, and Lewis Jacob's essay "Experimental Cinema in America, 1921–1947" in *The Rise of the American Film: A Critical History*, but it was the context emerging at the end of the 1960s which proved crucial for the emergence of a canon of important films and filmmakers: these books were published at the same moment that American colleges began to look at and seriously consider film as a historical subject. The introduction of Film Studies programs created a new academic department charged with the historical and critical understanding of film—including the avant-garde. This additional element changed the context for the assessment and study of motion pictures.

Following the lead taken by film historian P. Adams Sitney in Visionary Film, American films from before World War II were excluded from this new canon, even when later films by the same artists were part of the screening series. The abstract film received almost no consideration: only James Whitney's *Lapis* (1966) appeared in the program, and there is little suggestion of any relationship between the avant-garde and commercial industries. The central feature of this film series was the reconception of the history of avant-garde film as a linear progression from realism into a formalist abstraction based around the film technology. It was a trajectory proposed by Clement Greenberg as fundamental to a serious Modernist work, and paralleled David Antin's "manifesto-like" history of video art. The films consolidated in this screening series presented a history that emphasized film's material basis as photography (the same basis chosen in Cavell's book), and in the

process broke with giving consideration to the commercial adoption and parallel to experimental film techniques in advertizing: unlike the exhibitions of the 1950s and 1960s that included TV commercials, *A History of the American Avant-Garde Cinema* made no reference to these connections.

Central to this reconception of the American avant-garde along the self-critical lines of Greenbergian Modernism was the emergence of the 'structural film,' a tendency identified by Sitney as a specific, new development in the American experimental / avant-garde film. Its origins in *FluxFilms* that experimented with the physical apparatus of motion pictures (camera, screen, projector) would become standard parts of "structural film." These films formal organization resembled a filmic application of a self-critical reduction towards a formal 'purity' specific to motion pictures produced with live action rather than animation. Sitney's description of structural film based on four formal characteristics had an important role in the emergent canon of "experimental film"; his designation of "structural film" was based in a physical engagement with the material basis of film as a photographic process in a transposition of Greenberg's Modernist aesthetic to film:

> fixed camera position (fixed frame from the viewer's perspective), the flicker effect, loop printing, and rephotography off the screen. Very seldom will one find all four characteristics in a single film, and there are structural films which modify these usual elements.[5]

This is a description that makes the differences between film and video essential to the definition of 'structural film.' It is an organization where the actual, visible content of the images is less significant than the ways that content has been transformed on film through production, post-production and exhibition. While this designation, and its historical pedigree, were a contested subject during the 1970s, it enabled a breach between commercial production, television and video that distinguished art films from other media productions. This formal range emphasized the materiality of the photographic basis of film, and emphasized the specific technology of film as distinct from the electronic medium of video. This is Greenberg's self-critical model, one where the essential features of film selected as the "pure" elements—the four features of Sitney's designation—focused on the same element: the intermittent projection of frames, and their photographic reproduction, i.e. the photo-chemical dimension of film rendered via optics. Within this construct, there is only limited potential for abstract, hand-painted and electronic hybrids of film and other media.

This emphasis on the technology of film imaging and projection provided a response to the newly developing field of video art, distinguishing the work of Michael Snow, Hollis Frampton, Paul Sharits, Tony Conrad, Ernie Gehr and other American structural filmmakers from video art that was being produced in the same period. It provided a medium-specific understanding of film that showed the influence of Greenberg, and suggested a similar foundation to what Cavell used in *The World Viewed*: the photographic nature of what was projected on screen. However, instead of focusing on the realism created by that photography and its apparent mimetic creation of a fictional "world" on screen,[6] structural film developed the potentials of flattened, graphic imagery through a self-reflexive use of media. It draws attention to the fact the film image is a still photograph projected

at high speed. The loop printing, inclusion of dirt, scratches, light flares and film grain that becomes apparent through rephotography serve to make the images seen in these films announce their photographic basis to their audiences.

A History of the American Avant-Garde Cinema, the catalog published in 1976 for that exhibition, traced an explicit trajectory beginning in the 1940s that culminated in the highly reductive, formal 'structural films.' It was a history without Mary Ellen Bute, and only minimally even included abstract films oriented towards visual music; it's central concern is with the development of structural film from the earlier, more narrative foundations of avant-gardism. Art historian John Hanhardt, in his philosophical consideration of avant-garde film, quickly moves into a discussion of structural film:

> Structuralism attempts to locate the "universals," the "distinctive features," common to all of man's social and cultural expressions. In order to locate the distinctive features of film, the structuralist has modeled his approach on that of linguistics, which offers the model of linear, narrative forms.[7]

The approach Hanhardt employs in his consideration takes Cavell's argument about the photographic foundation as a reference point, reflected by his article's title, *"The Medium Viewed: The American Avant-Garde Film."* The establishment of structural film as an historical 'end' to the development of the American avant-garde film is an internal guide to his reconstruction of film history along reductive lines towards establishing the inherent, foundational principles of film as an art form. It is a specifically photographic 'purity' based on the roles of the camera in creating films and the presence of a "live" in front of that camera—even if the finished, projected film in the theater constitutes an entirely distinct experience. The resulting history proposed by Sitney and elaborated by Hanhardt and the American Federation of the Arts exhibition and touring film program canonized a particular history and group of artists in the mid-1970s. These artists and the particular, adversarial relationship that appeared to have with commercial media, became the foundation for understanding those works. This transformation is the essential feature of the third, institutional period of the American avant-garde film; in the process, it obscured the direct and important mutual relationships between film, video and commercial production.

THE INVENTION OF VIDEO ART

A crucial factor in the emergent institutional period of the 1970s was the increasing critical attention of film as an art form, and the authorization of that work as serious, and worthy of critical attention—the extensive opening section in Cavell's book, *The World Viewed,* addresses this question for the academic field, using Michael Fried's Greenbergian view of Modernist painting as a reference point, constructing a philosophical basis for the serious critical examination of Hollywood film. In the art world, this validation was provided by museums hosting exhibitions of films, then later television and video art. The transition from marginal activity to significant art happened during the second period; in the third period the wholesale recognition of motion pictures as art worthy of both collection, exhibition and serious, scholarly study was an accepted fact. It is this

final shift that defines the boundary between the expansion and consolidation of the second period and the institutionalization characteristic of the third.

The Museum of Modern Art's involvement with moving images began in 1935 when it created the museum's Film Library, a department that provided film prints and other material to the San Francisco Museum's 1946 *Art in Cinema* series. When the museum launched the "Television Program" in 1952, the Film Library was openly opposed to the collection of television programs, a hostility that continued throughout the 1960s. Understanding the acceptance of video art by MoMA with the 1974 conference of artists, curators and critics called "Open Circuits: An International Conference on Television." Despite the presence of "television" in the conference title, the focus was on the establishment of video art as an independent, fine art medium separate from the more common television. It marked a shift in focus for the museum, and the art world, from commercial, broadcast productions for a general audience to the more limited audiences of the museum and art gallery.

The construction of video art as an art medium was premised on the devaluation of television using explicitly sexist language. Since the 1950s, television had been associated with femininity and the home audience; MoMA's "Television Project" (1952-55) explicitly assumed a feminine audience, no matter what their actual gender might be—a feature of MoMA's understanding of the television, as historian Lynn Spigel has noted in her history of television, *TV by Design*:

> As early as 1948, a museum report stated that MoMA had "participated in many daytime programs aimed primarily at housewives." By speaking directly to housewives about homemaking concerns, the museum hoped to "educate" women about art's relevance to their daily lives.[4]

The Museum of Modern Art used early television as a way to establish itself as a dominant cultural institution in the popular imagination by appealing directly to television audiences and arguing for their relevance to that audience's daily life. By the 1970s, MoMA's position in the popular imagination was firmly established, and this earlier audience had become a liability for the art world aspirations of television, an issue that was resolved by re-imagining both the technology and the audience as male.

The "Video Art" that would be canonized in the mid-1970s had its origins with artists connected to Fluxus. This intermedia festival developed from an avant-garde approach that violated the medium-specific 'purity' of Greenberg's Modernism. George Maciunas (1931 – 1978) worked as the organizer and programmer for Fluxus—a collection of performances and art events that began in New York at the AG Gallery in 1961, and then continued in Europe in 1962. This "movement" developed from the association of artists and composers whose initial connections were through their involvement in composer John Cage's experimental composition classes at the New School for Social Research in New York; Maciunas provided organization and the *Fluxus Festivals* created a public outlet for the experimental art and music by a diverse group that included La Monte Young, Jackson Mac Low, Dick Higgins, Yoko Ono, Nam June Paik, Paul Sharits and George Brecht among others. The experimental and open-ended frameworks created by Fluxus anticipated later developments in the art world, including the

structural film, video art and conceptual art, as well as developed performance art and provided one of the first venues for Minimalist music.

Fluxus created a wide range of publications and editions—often cheaply produced—and would commonly employ everyday materials in their productions, but one of its direct engagements was with media production. This development happened within the a context that embraced both radically new types of "musical" performance and engaged with experimentation with media—film, video, and even early computer works.

Nam June Paik (1932 – 2006)

Nam June Paik was originally trained as a musician, but changed media from composition to video. His pioneering work with television and video is regarded as the beginning of video art. In 1963 his exhibition titled the *Exposition of Music-Electronic Television,* transformed the private residence (which also served as a gallery) of architect Rolf Jährling into an installation where the difference between the private areas and the gallery spaces disappeared. This show was the transition for Paik from music to media, and marks the beginning of his engagement with television and video art. The show contained both sculptural works and avant-garde music—including four 'prepared' pianos, mechanical sound objects, record and tape installations—and in their own exhibition room were twelve TV sets modified by powerful magnets that distorted the cathode ray, creating swirling abstract patterns on screen that distort the TV programming as it was broadcast; these televisions present an obvious parallel to the modified pianos also shown, linking Paik's music composition directly with his invention of video art.

Exposition of Music-Electronic Television was only open to the public for two hours a day (from 7:30 to 9:30 pm) over its ten day run. These limited hours reflected the importance of the modified television sets to Paik's show: in 1963 Germany only had one TV station, and it only broadcast for a limited time each day; in order to have the broadcast programming distorted by the magnets, the show could only be open to visitors during the hours when TV was being broadcast. Paik's manipulation and distortion of the television signal would become the basis for the effects created by the Paik/Abe video synthesizer. (The first model was created in 1970 and installed at the public TV station WGBH in Boston.) Completing Paik's gallery installation, the head of a freshly slaughtered ox hung over the entrance. The modified TV sets opened a new approach to both video imagery and technology, one that Paik would continue developing throughout his career.

Writing about Paik's exhibit of modified TV sets at his 1968 exhibition in the Humanities Art Gallery in Stony Brook University, Norman Bauman noted how these modified TV sets invited a specifically visual performance:

> Some of his [Paik's] more complicated machines such as *Tango Electronique,* are more like musical instruments than art works. You don't watch it, you play it. ... If we paint with paint, and get one set of shapes and paint with light, and get another set of shapes, and paint with sound, if the analogy may be extended, to get a different set of shapes, why not paint with magnetic fields, the working stuff of our technology, to get a completely new and completely different feel?[29]

Paik's work with TV sets and the physicality of the electronic medium presents an approach to technology that converges with that of the direct filmmakers of the 1930s and 1940s whose engagement with the physicality of film—the film strip itself—enabled their production of imagery and visual works that exploited the particular nature of their medium. Len Lye's manipulation of color separations to create a new type of 'colored' film in *Rainbow Dance* is united in approach with Paik's manipulation of the electronics of particular TV sets, either by hacking their internal circuitry or through his use of magnets to distort the imagery appearing on screen. This type of direct engagement is a hallmark of the avant-gardes in general; the hybrid nature of Paik's works—especially their invitation to "play" and interact with his machines is common to Fluxus especially.

The creation of *FluxFilms* between 1962 and 1970 developed in parallel to the emerging video art. These films anticipate the formal features of structural film: *fixed camera position, flicker, rephotography, and looping.* They are also directed simultaneously towards conceptual art and that movement's use of photography for documentation (films by Nam June Paik, Dick Higgins and Yoko Ono all anticipate these uses), and to graphic animation (especially apparent in the FluxFilms by abstract filmmaker Paul Sharits). Some of the earlier Fluxus artists would become part of the New American Cinema: Paul Sharits was included in the American Federation of the Arts screening series. His film *T,O,U,C,H,I,N,G* (1968), shown in the American Federation of the Arts exhibition in 1976, employs the formalist strobing and registration of his imagery to create after-images he used in *FluxFilm no. 29, WordMovie (1966).*

The definition of '*video art*' as a distinct medium, apart from both the '*experimental film*' and television was a central topic of theoretical and critical concern during the early years of video art's existence; of greatest concern to these first writers on video was the ways it differed from television—much more than the relationship it had with the avant-garde film community, many of whom had shifted from film to video as lower cost cameras and video tape recorders became readily available.

Shigeko Kubota (1937 –), a Japanese filmmaker who was part of *Fluxus,* along with Nam June Paik, her husband, recognized the innate relationships between film images and video images. In her chronology of video screenings and exhibitions at the *Anthology Film Archives* in 1974 and 1975, she notes that the differences between the two are a matter of technology more than aesthetics:

> Film and video are not mutually competing media, but mutually complementing ones. Film is superior in projection, shooting and editing; video is more versatile in transmission, post-production image mixing, and sound-sync matching. Harmonious interfacing of these two media would therefore be very beneficial for the future development of video and film art.[30]

The fusion of video and film that Kubota hypothetically considers in the 1970s, becomes a reality in later decades as video technology improves and combines with the powerful computer technology. By the end of the twentieth century, even theatrical Hollywood feature films would be produced as digital video and exhibited on film. The differences between video and film she identified—projection,

shooting, editing vs. exhibition ("transmission"), post-production image mixing, and sound-sync matching—are relevant to the history of motion graphics precisely because the initial problems posed by film's production limitations were readily resolved with video's ease of combination, and then entirely eliminated through computer graphics. The evolution towards the greater precision offered by digital technology thus depends on both the developments of abstract filmmakers and the technical innovations of video art.

Within this trajectory, the art world's need to differentiate video art from television has features that closely link the emergence of video to the earlier developments within television—not of entertainment programming, but through the aesthetics of TV commercials. David Antin (1932 –), an avant-garde poet and critic, discussed the problematic relationship pose by television for video art because of the common technological basis they shared. His catalog essay, "Video: Distinctive Features of the Medium," for the Institute of Contemporary Art in Philadelphia's exhibit *Video Art* (1975), that blends criticism with history, is more concerned with a lengthy explanation of how broadcast television developed than with what the essentials of video are; however, he acknowledges the connection between TV commercials and video art:

> It would be so much more convenient to develop the refined discussion of the possible differences between film and video if we could forget the Other Thing—*television*. Yet television haunts all exhibitions of video art, though when actually present it is only minimally represented, with perhaps a few commercials or "the golden performances" of Ernie Kovacs (a television "artist"); otherwise its presence is manifest mainly in quotes, allusion, parody and protest.[31]

Television, because of its powerful, dominant position as a mass medium lies in the background to all early art videos. The need to distinguish it from film that Antin mentions, takes a secondary position to the more important distinction—its separation from the everyday, common medium of television. Antin identified two ways that the understanding of video as a distinct art medium emerged from television in the then-new critical discourse surrounding video art: (1) a non-academic blending of critical media theory based in Marshall McLuhan and more general information/communication theory; (2) a concern with the formal, technical capabilities of video art as an electronic technology. The distinctions between video and film lie along this second dimension; its overlaps with film that Kubota considers more important lie within the first, analytic discourse.

TV commercials form a crucial link between television, experimental film, early video art and motion graphics. The need of advertizing for innovative, engaging visual material, as well as their employment of artists, resulted in a convergence of these otherwise independent trends in the visual form and style of television; their inclusion within these first video exhibitions is not accidental. David Antin's recognition of their role in the development of video contains an inherent connection to the film: by 1955, these commercials were not produced with television cameras—they where shot and produced on film, and then exhibited (Kubota's transmission) through television.

Unlike video art, early television was a medium that fused film production and kinetiscopic transfers of video to film, with the act of broadcasting to the home television receiver: this combination of means enabled the transfer of film techniques (both in production and post-production) to the new, electronic medium. The first "broadcast graphics" emerge from this combination of technologies, employed to enable the rebroadcast of the live shows produced in New York on the west coast. These programs were transferred to film using a kinetiscope—a motion picture camera synchronized with a television screen—as Gilbert Seldes explained in MoMA's *Television U.S.A.: 13 Seasons* exhibition catalog:

> We were told often enough in the early days that the future of television was on film, that the economics of the medium required us to repeat our shows. We were quite willing to have the live performance kinescoped because this gave us (only slightly debased in photographic quality) the actuality we had transmitted. The creation on film of programs to be sent out on the air which we considered the domain of the actual, of life itself, struck us as pollution.[32]

The issue for Seldes (and his peers workin in early television) was the *aliveness* of the performance as it appeared on screen; the transfer to film was simply a means to an end, since videotape would not be commercially available for widespread use in television until 1957.[33] The shift from these programs whose *aliveness* for Seldes was a result of this production with television cameras which required immediate broadcast—thus limiting the ability to edit, arrange, and reorganize footage that characterized the production of dramatic films—to carefully produced works shot using an adaptation of Hollywood's theatrical techniques meant a fundamental shift in the nature and significance of the new medium. Antin also described these early programs' use of film and the transition away from live programs:

> Between 1947 and 1957, kine-recordings, films taken directly from the TV screen were in constant and heavy use, especially for delayed broadcast of East Coast programs on the West Coast, in spite of the much poorer quality of the early kines, and that by 1961 virtually all television dramatic programs were being produced on film. There were, apparently from the industry's standpoint, great inconveniences in instantaneous transmission.[34]

The inability to readily repeat shows—thus to recover the capital investment in their production in the same ways that Hollywood was able to valorize their earlier film libraries by renting them to television stations—which Seldes identifies as the central aspect of the kinetiscopic transfer, suggests the shift to film for the full production was a logical development: it raised the quality of productions simply by eliminating the limitations of a live performance where everything must go "right" the first time in favor of the multiple "take" model of film. It was a shift from a model for television closely related to live theater to one more closely resembling the already established film industry. The shift of television production from live studios in New York to the soundstages of Hollywood thus gains a quality of inevitability to it: it is the financial logic of repeated exhibitions that helped guide this change in production methods. This production-on-film for transmission through television provided a clear technological difference between the work or

early video art and what was shown on television: early video art was a return to the unedited, "live" record that Seldes described as essential to early television, but which posed direct problems for the commercial development of television—this technological basis became a primary feature of the first video art works whose unrepeatability—the altered TV sets Paik exhibited—brought them closer to the unique, original art work or performance than to the repeated programming of TV.

The limitations of early video technology made the artistic uses of the electronic medium of television immediately and fundamentally different from commercial productions, a distinction that became significant for the critics, such as David Antin, involved with establishing video as a serious art medium, and whose argument for aesthetic autonomy from television production depended on the differences between what was broadcast and what was shown in the gallery. The institutionalization video art in 1975 was the result of the direct organization and promotion of video as a new medium by a range of groups that included the grants given by the Rockefeller and Ford Foundations that funded the production of video art within television studios (KQED in San Francisco, then WGBH in Boston, and finally WNET in New York); the artist-organized exhibitions and events of Fluxus, and the programmatic efforts of publications such as *Radical Software,* the magazine devoted to the development of video as a political and artistic transformative force in society. However, essential to these various developments was the availability and accessibility of video production technology outside the television studio. The technological differences Antin used in his analysis had as a foundation the limitations of the only commercially available video equipment that was designed for non-professional (commercial) use: the portable video camera and recorder called the Sony *Portapak.*

The Sony *Portapak*

Sony's introduction of the *Portapak,* the first portable video camera and recording equipment in 1968, costing about $2,000, the price of a cheap car or stereo system,[35] allowed artists an inexpensive means to engage with the same electronic medium as broadcast television. Jon Burris, a photographer and historian, recognized that in the early period of video art running from 1965 – 1975, there were two groups engaged with exploring the potentials of video: the first were fine artists coming from other media (such as performance art or sculpture); the second group were adapting the aesthetics of earlier film and abstraction to the electronic medium.[36] The approaches that quickly emerged following its introduction suggest the wide variety of uses this technology received:

> Whereas previous new media had gradually emerged with one or two styles or aesthetic approaches, the most distinctive aspect of video's formation was the immediate and simultaneous emergence of multiple genres: activity, documentary, synthesized and image-processed, abstract or abstractive, performance, conceptual, ecological, diaristic, agit-prop, dance, music, bio-feedback and other forms all made their appearance in the years 1968–1972. Moreover, there was a high degree of cohesiveness: all these approaches were video (experimental, independent, underground, guerrilla,

artists', as they were variously christened), none were excluded from the field and many artists worked in multiple forms.[37]

The range of the field called "video art" during its formative years is impressive. Burris' history of this collection of apparently divergent, plural approaches identifies the general, commercial availability of the video camera/recorder combination—the Portapak—as the foundational shift that made this range possible: with this technology, it was suddenly possible to work with the same type of electronic imagery as television, but at a fraction of the cost. While the quality of this new technology was much lower than the established broadcast studio equipment, its introduction began a process of democratization, a change reflected in the range of uses that includes a specific genre (agit-prop) and approach (guerrilla). If the history of non-commercial (consumer) video begins with the *Portapak,* its logical development is towards the cell phone video camera: the universal presence of high quality video cameras in the hands of the general public, and the high speed, low cost distribution made possible by the internet was first imagined during this period as part of this foundational moment.

These various trends and developments in video were covered and documented by the magazine Radical Software, which was edited and published by video artists Beryl Korot, Phyllis Gershuny, and Ira Schneider. The first issue appeared in Spring 1970, the same year that Gene Youngblood's book *Expanded Cinema* was published, and included a hyperbolic description of the potential for television and video art written by him. Youngblood's description follows a technological-utopian strain of engagement with the new technology:

> Global information is the natural enemy of local government, for it reveals the true context in which that government is operating. Global television is directly responsible for the political turmoil that is increasing around the world today [1970]. The political establishments sense this and are beginning to react. But it's too late. Television makes it impossible for governments to maintain the illusion of sovereignty and separatism which are essential for their existence. ... Television, like the computer, is a sleeping giant.[38]

Youngblood's article, published under the heading "Hardware," is literally the opening essay in this publication. The piece sets the tone for what follows: an "information wants to be free" engagement and enthusiastic promotion of the various trends Burris identified. The centrality of television as both cultural and politically transformative medium was extended to video art as well. The inherent political engagement apparent in Youngblood's article becomes in video art a rejection of the organizing principle of broadcast, network (commercial) television.

Writing in 1975, after *Radical Software* had ceased publication, and reflecting on what had happened in the five year period between Youngblood's essay appeared and when 'video art'—separated from television—became a feature of museum exhibitions, David Antin identifies a unifying factor in these early video works: an adaptation of a structural concern with the organization of time. This principle reflected both the different technical capabilities of artist's using video and was a means to distinguish early video art from television. In a discussion titled "Input-Time and Output-Time," video pioneer Nam June Paik explains this

organization as being, at least in part, a rejection of commercial television's editing and presentation techniques:

> In the overzealousness to counter the CBS-type entertainment, or in order to preserve the purity of information or experience, some video artists refuse to edit or to change the time-structure of performances or happenstance. In other words, they insist that INPUT-time and OUTPUT-time be equal.[39]

His "INPUT-time and OUTPUT-time" is more commonly termed "real time" since there is no editing or "compression" of the works duration: the time it takes to perform any action shown is the actual time required for that action. The emphasis on actual, uninterrupted continuity is not only a feature of video art; it also appears in the avant-garde films of Andy Warhol, and many of the *FluxFilms* produced in the early 1960s. In the case of video, the use of real time was an aesthetic choice partly determined by the constraints of the technology—editing equipment was an order of magnitude more expensive than the porta-pack camera systems used in these productions.

The aesthetic which developed from this use of real time was strictly limited in structural ways to the duration of the actions shown on screen; Antin's catalog essay recognized the structural principle as being directly linked to the precise duration required to perform the activity:

> The work ends whenever its intention is accomplished. The time is inherent time, the time required for the task at hand. The work is "boring," as Les Levine remarked, "if you demand that it be something else. If you demand that it be itself then it is not boring."[40]

The emphasis in this statement—the work ends whenever its intention is accomplished—makes the limitations clear: however long any given work may be, it is only the time required for that work to happen, and no longer. In this regard, these tapes are recognizably documentary in the same, fundamental sense of documentary that the Lumière films were documentaries: they show only "the time required for the task at hand," and once that task is completed, they are over. These limitations are immediately apparent in the "boredom" of many early video art tapes which show the actual duration of whatever their subject happens to be, ending when the process reaches a concluding point.

This rupture between television production and video art, meant at least initially, that artist's videos and commercial videos (TV shows as well as advertising) would diverge from one another; however, not all aspects of early video art can be so easily separated from commercial engagement. The genres (synthesized and image-processed, abstract or abstractive, dance, music) that had an immediate impact on commercial work are the same ones whose historical basis lies with the earlier abstract films of the 1930s and 1940s. These varieties of video art found application in broadcast television as "special effects" in a range of non-serious programs: children's shows as well as sci-fi and horror programs targeting children and the teen audience; as decoration for variety shows' performances (typically of popular music) that allowed the creation of psychedelic ("trippy") visuals which countered the otherwise relatively static camera work and editing. Ron Hays used

the Paik/Abe video synthesizer to create abstract visuals that were mixed into a broadcast of Maurice Ravel's ballet *Daphnis et Chloé*.

Other commercial uses for procedures developed by video artists appeared in the projects of the *Children's Television Workshop*, founded in 1967. Their pioneering educational programs employed the innovations of video art in both *Sesame Street* (1969) and *The Electric Company* (1971). This embrace of image processing techniques and abstract animation in motion graphics had its origins with work by John Whitney, and developed simultaneously in both film and video art during the 1960s. The emergence of works in both media that employed transformations of live action into abstraction and semi-abstraction is an essential part of the "psychedelic aesthetic" in film and video—both commercial and avant-garde.

SIGNAL/IMAGE PROCESSING

While the advertizing industry's motion graphic productions treat the formal and aesthetic innovations of the avant-garde film and video art as stylistic features to emulate, at the same time, the foundations of those techniques lie outside the range of what is considered a high-quality, 'good' signal and image by broadcast engineers. What began as a necessary, technically determined feature for artists becomes a signifier for the truthful, authentic work of art. The transformation of limitation into meaning and stylistic identifier by artists is also what makes these innovations of interest to commercial production. The emulation of these graphic dimensions of art by advertizing is an attempt to appear "truthful" in the same ways—and to the same audience—addressed by the verisimilitude of art.

The "breaks" that appear in the editing of early art video tapes is a typical example of this process. David Antin regarded these signs of the tape being edited as the marker which distinguished early video from television (and by extension, film as well), a product of the equipment most artist's used technical capacity:

> Alignment of a particular frame edge with a particular frame edge is out of the question. If the frame edges don't come together, the tape is marked by a characteristic momentary breakup of instability of the image. You may or may not mind this, but it's the distinctive mark of this type of editing. Since this is absolutely unlike television editing, it carries a special mark of homemade or cheap or unfinicky or direct or honest. But the dominance of television aesthetics over anything seen on a TV screen makes this rather casual punctuation mark very emphatic and loaded with either positive or negative value.[41]

The medium, "video art," that Antin describes is one specifically oriented towards a particular group of technologies which consequently give their results an ideological value in opposition to what must then be slick, industrial, anonymous broadcasts of commercial television. It is an opposition whose particular set of values, translated to a new technology and focused on the signs that what we see is handmade connect this explanation of television to the same set of aesthetic values first championed by art historian John Ruskin in the nineteenth century: hand craft, the artisanal production independent of "industry"—even though made with video machinery. Antin's definition of video is as a Modernist medium, and the category of artist's videos he designates "video art" belong to this heritage; it is an appeal and

positioning of video art as not only serious work, but as Modern art worthy of the museum attention it was receiving. The case of artist Nam June Paik is typical of this artist-engagement with the video medium, as curator George Fifield has noted about Paik's use of video:

> What Paik wanted to accomplish was to make video as malleable as paint. ... The synthesizer itself was designed to do exactly what all the WGBH engineers prided themselves on avoiding. It contaminated the video signal. By wiring up seven old black and white surveillance cameras to a colorizer and scan modulator, Paik and Abe were able to distort the color and misshape the image on the television screen. In the early sixties, Paik had displayed old television sets with huge horseshoe magnets sitting on top. This wild distortion of the magnet on TV was exactly the effect Paik wanted on everyone's TV. With the synthesizer, he was finally able to achieve it.[42]

The transformation of the image processing techniques created by artists into a stylistic "tool set" for TV commercials depends on understanding the difference between the commercial and art applications. Paik was responsible for the invention of signal processing, first in the sculptural, modified TV, then through the Paik/Abe video synthesizer which allowed the translation of those effects to broadcast, color television. The distortion and 'error' created by breaking the standard norm for a video signal was essential to the kinds of visual effects created by the Paik/Abe video synthesizer. The problem posed by this device for commercial broadcast was both technical and aesthetic: creating the imagery required the systematic violation of what was recognized as being "good" and "standard"—yet the results, opened up new kinds of imagery and visual potentials for television generally.

The varieties of image processed (or signal processed) video in early video art take a wide range of forms, but this variety can be grouped into a limited number of technical approaches. There are digital analogues to these procedures, but historically they are all based on the analog signal:

(1) the separation of the various signals of video
 (chroma, hue and brightness)

(2) the addition of distortions to the signal, or to the TV set itself

(3) the translation of a non-video signal into video

(4) the mixture of several, distinct signals into a single signal

The technique of visual processing is based in the rasterized nature of the screen image: many of these distortions and transformations can only be "saved" by rephotography a TV set or video monitor—they are produced by physical interventions in the image shown on a TV—a reflection of image processing's origins with Paik's Fluxus sculptures using altered TV sets.

The history of video art, and to a lesser extent, digital video, is concerned with this procedure. Individual video elements are manipulated separately, and then combined into the final signal that is displayed on a screen. It is fundamentally a matter of engaging with the video signal as a physical material apart from whatever

imagery it might encode. In this regard, it follows the Modernist "purity" so important to Clement Greenberg's aesthetics—it removes the excess elements of video, leaving only the most basic: the electronic picture signal.

Because analog video suffers from generational loss—each successive copy of a video signal degrades the amount of information present in the signal—artists working with analog processing were forced to "gang up" complex series of monitors, cameras and processing devices so as many of the procedural transformation can be done at once, in real time, as possible. This "live" element was shared by all the experiments with image processing done with analog video. Recording of the output from these procedures would be done either with videotape, as was the case with video art, or using a special film camera (a kinetiscope) that runs at 30 fps, synchronized to the video monitor. This combination of technology makes possible what Gene Youngblood termed "videographic cinema"—a cinema that is a hybrid of video and film combined in ways that are impossible in either medium alone.

Scott Bartlett (1943 – 1990)

Bartlett produced the paradigmatic example of signal processing converted into film with *Off/On* (1968). It is both a technologically sophisticated combination of film and television (video), as well as a work bridging the fields of live visual music (the light show performance), the abstract film, and then-emergent video art; these fields merge in the production process. It shows the connections between film and video are more technical than aesthetic. Youngblood explained how Bartlett produced his imagery. This processing parallels those of video artists working at the time on the east coast at WGBH in Boston. Before the construction of Nam June Paik's Paik/Abe video synthesizer, the creation of complex abstract and semi-abstract imagery in video required a complex mixture of film, video and feedback loops:

> Like all true videographic cinema, *Off/On* is not filmed TV, in the way that
> most movies are not filmed theater. …The basic source of video
> information was in the form of twenty loops … made for
> multiple-projection concert. [These] were fed through a color film chain in
> [the] television control room., adding electronic phosphor-texture to the
> cinematic graphics. Simultaneously, other loops and portions of Glen
> McKay's light show were rear-projected onto a screen on the studio floor,
> which was televised as a second video source. A second TV camera televised
> the monitor, feeding the signal to a videotape recorder. A special camera was
> set up in front of [another] monitor that filmed at a video rate 30fps instead
> of the movie rate of 24fps.[43]

Off/On required then state-of-the-art TV production equipment to produce its imagery. The use of feedback is a key feature of the signal processing developed in early video art, yet his imagery emerges from a combination of factors: the types of footage run through the film chain that allowed the broadcast of filmed programs, the "looping" of that footage with chromakey using a live camera and video feedback, switching and video effects possible in the control room (such as mirror effects), both recording the results to video tape and transferring the material

generated live to film with a kinetiscope. However, this description gives only the most general sense of the imagery in this composite video-film work. The hybrid status of the project is immediately announced by the presence of phosphor dots on screen, and its connection to earlier abstract film is evident through the soundtrack's oscillating electronic score.

The opening image of *Off/On* is a phosphor-dot eye shot in close-up that blinks between fully open and fully closed, the iris repeating internally in a swirling repetition of itself. This image sets up vision as a series of connections between the open/closed circuit, the psychedelic evocation of interiority, and the pulsations audible in the soundtrack. Its origins in material used in a light show performance connects this film with the visual music tradition of live spectacle, as well as the visionary mental states these presentations dramatized. Hallucinatory states of consciousness form the immediate references of these visuals, as does the progression of imagery: moving between abstracted footage of the human body and biomorphic abstractions that glide and oscillate in symmetry, the visual material follows a common progression pattern of hallucinatory experience.

The 'loop' of abstract and avant-garde film influencing advertizing to advertizing and design influencing avant-garde film/video distinguishes the work of later generations of avant-garde filmmakers from the earlier group: the aesthetic forms and 'traditions' of the field were developed simultaneously by artists and their commercial imitators. The relationship between these two groups formed a dynamic recognized during the 1960s, but which was minimized and occasionally denied following the institutionalization that happened during the 1970s. The relationship, however, because it was based in formalist concerns with the organization of material on screen, through editing, and most especially through the graphic treatment of the image established the basic parameters of motion graphics. The overlap between motion graphics and avant-garde film is increasingly apparent as digital technology erases the distinctions between industry standard production and independent, artist's productions; the more the 'tool set' used to produce work becomes consistent, the more obvious their shared historical origins emerge.

The Paik/Abe video synthesizer

The first systematic video processing machine was the Paik/Abe video synthesizer. This powerful processing device was also an experimental machine, designed to enable the creation of complex, visually dynamic imagery, but with only limited ability to reproduce that imagery at a later time. Constructed by Nam June Paik and engineer Shuya Abe, the ability to recreate its imagery was developed by another video artist, Ron Hays, who systematically explored and documented what was required to create a specific range of visual forms on screen.

The first version of the videosynthesizer was built in 1970 following Paik's work at the PBS station in Boston, WGBH; it would later be joined by other versions housed and built at WNET in New York, and the Experimental TV Center in Oswego, NY. This device was constructed under grant from the NEA and the Rockefeller Foundation specifically to address the difficulties encountered in the translation of the artistic demands on video and entirely different constraints of the broadcast signal and engineers trained to meet the industry standards for signal quality, strength, etc. This discrepancy between the innovative aesthetic form and

the limitations of commercial media is a recurring issue throughout the field of video art.

Starting with the show *The Medium is the Medium* (1968), organized by producers Pat Marx and Ann Gresser in conjunction with the Howard Wise Gallery in New York, and under a Ford Foundation grant, in collaboration with Fred Barzyk, Olivia Tappen and David Atwood from the Boston public TV station WGBH, artist's videos came to television. In March 1969 the program aired nationally, showing six short videos done at the station by Allan Kaprow, Nam June Paik, Otto Peine, James Seawright, Thomas Tadlock and Aldo Tambellini.[44]

Medium is the Medium was followed by a more ambitious program, the Rockefeller Artists-in-Television residency, that ran until 1972. It was a pioneering effort that was supported by a grant from the Rockefeller Foundation, the same organization that had funded MoMA's *"Television Project"* in 1952. This new program grew from existing relationships between Howard Klein, the foundation director, artists such as Nam June Paik, and televisions stations interested in experimentation—KQED in San Francisco, then WGBH in Boston, and finally WNET in New York.[45]

Again, WGBH allowed artists work produce videos with their facilities, and then broadcast the results in a series of artists' programs. Nam June Paik and engineer Shuya Abe constructed their Paik/Abe video synthesizer to overcome the difficulties he encountered during his first residency at WGBH. Paik's first WGBH experiment, *9/23/69* (the show's recording date), aired on the program *Mixed Bag*. This initial image processing piece required Paik to relay instructions through engineers and technicians; the decision to construct the videosynthesizer was to create a tool that would provide Paik direct, fluid control over his video imagery. The construction was funded by the foundation, and the first videosynthesizer was housed at the WGBH studio in Boston. David Atwood, producer and director at the station remembers the device was custom built and shipped from Japan:

> At the heart were two small racks, two mixers—color encoders where you controlled in a very basic way the mixing of the video signals. Each of these racks was capable of putting out a signal, thus: in reality there were two synthesizers, not one. ... Besides these two encoders were two regular full size TV equipment racks. The first houses monitors and scopes etc, the second had a couple B&W cameras pointing at small B&W monitors that had been Paik-ized to distort a video signal. The signals were distorted by tone generators, oscillators feeding amplifiers to hand wound coils Paik had wrapped around the picture tubes of the TVs. The cameras were basically Sony surveillance-grade. These two camera, and the 10–12 odd others fed their signals into the encoder racks where they were colorized and mixed.[46]

This complex collection of cameras, mixers and altered television sets allowed the distortion of a video signal in real time in a range of ways—all of which could then be mixed into a single video image. According to Atwood, a year later, after building the first video synthesizer and returning from Japan to WGBH with it, on August 1, 1970 for the *Video Commune, The Beatles Beginning to End,* (a video that used the entire catalog of The Beatles' songs, arranged in chronological order as the soundtrack), was the premiere of the Paik/Abe video synthesizer. The imagery shown in this

four hour marathon program of The Beatles' music and abstract video were described by Susan Dowling, a producer at WGBH, in George Fifield's history of the image processing device. What is notable about her description is the use of common, everyday items rendered abstract by their handling in Paik's video, a catalog of mundane items transformed in the production process that recalls the early abstract films of the 1920s and 1930s:

> All the images on the show—surreal landscapes (crushed tin foil), eerie abstractions (shaving cream), bursts of color (wrapping paper)—were transmogrified by the Synthesizer at the very moment of broadcast: "live" television at its most unexpected. [47]

As Fifield noted, the Boston TV audience had never seen anything like it, and the kinds of imagery it produced were entirely different from the kinds of video signal that normally aired. Assembled from a mixture of custom-modified, cheap TVs and inexpensive video cameras, the videosynthesizer was "industry standard." In fact, it was entirely different in construction and function than the other equipment at the station, as David Atwood, the director who became the machine's custodian and advocate, noted about the image processor:

> WGBH in 1970 had close to the top of the line broadcast equipment and prided itself in setting the highest technical standards. In fact, it was a technical leader in the PBS system. The Synthesizer was a collection of the cheapest electronics around, the bare minimum. It was a miracle that it even made an image. But it was open to be used by anyone. And unlike the pro gear in the care of experienced engineers, which would yield precise video results, the Synth was electronically organic. Duplicating an image was illusive, in fact, almost impossible. [48]

The device offered a democratic alternative to the strictly controlled, regimented technology that met industry standards; that it created unrepeatable results suggests the underlying complexity built-in to analog equipment that was subject to the vagaries of the physical world. The videosynthesizer was not designed to follow the 'standard' since it was, from its inception, a device that created new potentials for video that lay outside the parameters of the broadcasting industry. This difference proved to be a problem for using the machine to create broadcast-ready material: the signal output by Paik's *Video Commune* burned out the station's chroma filter.

Ron Hays (1946 – 1991)

Ron Hays worked with both video art and commercial production, winning an Emmy award for his contributions to the children's variety show, *The Krofft Superstar Hour* in 1979 and a nomination for his work on the PBS science show Omni in 1982. In both cases, it was a commercialization of his work as a video artist applied to broadcast design. He organized *The Music–Image Workshop* (June 1972 – January 1974), a video art program that followed the Rockefeller Artists-in-Television residency program at WGBH, again with the assistance of producer/director David Atwood.

The project was explicitly an expansion of earlier work done with visual music, and engaged in explorations of the direct audio-visual relationships. In the grant

report, Hays explains how the project developed. His aspiration to create a systematic language of visual form mirrors those of other visual music artists, abstract filmmakers, and the early abstract painters working before World War II:

> Our objective is nothing less than to bring to music–image making the beginnings of a common grammar and framework. Without it, music–images will never attain the marks of a mature artistic discipline—to be both demanding and satisfying at a high order of creative expression... The first task of the workshop, led by Ron Hays as project coordinator, will be to screen existing music–image materials and consult with various artists, musicians, critics, filmmakers, producers and directors.[49]

For Hays, the Paik/Abe video synthesizer offered the possibility to create not only a language, but a general-purpose performance instrument. This starting point links his project to both the synaesthetic tradition, and places it in relation to other kinds of musical performance shown in motion pictures; among the artists who consulted were both Nam June Paik and Stan VanDerBeek, as well as examinations made of Norman McLaren's and Oskar Fischinger's films (via his fragmentary work in Walt Disney's *Fantasia*). Atwood recognized the difficulties in trying to use the Paik/Abe video synthesizer in a controlled, repeatable fashion:

> Ron spent hundreds of hours experimenting and cataloguing. He wrote it all down, image types, settings, camera positions. And he could, with time and his notes, recall an image that would be close to the previous version. ... One fraction of an inch difference in camera position, distance, horizontal or vertical, would yield very different results. One tiny twist of a knob on the encoders or an oscillator, would throw it all off.[50]

Atwood noted that even the knobs were unmarked—any calibrations had to be done with a pen and piece of tape. The Paik/Abe video synthesizer housed at WGBH was, literally, a device assembled without concern for creating precise, repeatable imagery. Achieving repeatable results with a highly complex, otherwise undocumented processing machine is impressive, as was getting its results put into programs since the machine was not a favorite of the industry-trained engineers at WGBH, who Atwood noted, "hated" it.

In his description of the project, Hays makes the importance of the Paik/Abe video synthesizer to the creation of the finished works apparent: it is the image generation and processing capabilities of this device that created the imagery used by his videos. Video feedback was central to how the *Music–Image Workshop* developed its imagery. Hays described his experiences working with it as being more than just a particular kind of imagery, but as a medium unique to the electronic medium:

> Early in my work with feedback, I began to see it not just as an image type, but as a medium of light. I liked to think of it as a new kind of electronic light. I compared it with what the pioneer light sculptor, Thomas Wilfred, had written about and created.[51]

Wilfred's work with Lumia was the first variation on visual music to include imagery: skeins of light that slide and rotate through an imaginary space on screen, creating the appearance of a three dimensional, abstract space; the connection of

video feedback with the dynamic, organic imagery of Wilfred's work is not accidental. Both present a continuous stream of imagery on screen; it is appropriate that when MoMA moved his *Vertical Contrasts* to storage, the room where it was shown became their first video gallery.

Hays found a means to control his feedback imagery by modulating it with the other controls on the videosynthesizer and carefully recreating his earlier set-ups. The basis for his electronically generated "vocabulary" of graphic images was feedback coupled with wave-form, sweep modulation, and sine-square waves. By adding these simple structures to feedback, Hays was able to create and modulate dynamic imagery composed in time. As with other video art of this early period, it was directly concerned with the manipulation and modulation of duration, a connection that Hays linked, in a recapitulation of earlier abstract films and with color organs theorization, to musical form:

> This form of image most appropriately conjoins with music because, like music—but unlike painting or other static visual arts—one of its defining parameters is duration.[52]

While the fundamental organization of his music–image was based on the structure of imagery in time, the problems of synchronization with actual music—one of the goals of his *Music–Image Workshop*—presented aesthetic as well as technical difficulties:

> Almost immediately, upon introducing music to the experiments, I concluded that no single image type, nor even any single combination, could be developed enough to complement the whole of a piece of music. Permutations of the different types were needed to achieve contrasts and complexities, as might be found in the music itself. [53]

The visual conception implied by these comments is striking: unlike the earlier abstract animation developed by Fischinger where there were direct tone-form relationships, the organizing principle that early video imposed was one where the full image related directly and immediately to whatever was heard in the musical score. This basis in the full frame is much closer to the kinds of immediate, full-frame visualizations that John Whitney was developing during the same period, and recalls Bute's work with Schillinger's ideas in the 1930s. Hays' construction of visual music using an electronic medium is thus closely connected with earlier American ideas of audio-visual counterpoint and structural, rather than direct, synchronization. Following his experiments with the *Music–Image Workshop*, Hays would work with the Scanimate process, a similar technology, that generated a more stable and controlled output used for the laserdisk *Music–Image Odyssey*.

Scanimate

Developed by television engineer and inventor Lee Harrison III, scanimate is an example of convergent development—produced after experiments during the 1960s, his imaging processor was designed to automate the animation process for graphics captured with a video camera. Dave Sieg, a Scanimate animator and historian of the technique, explained the commercial applications of the process:

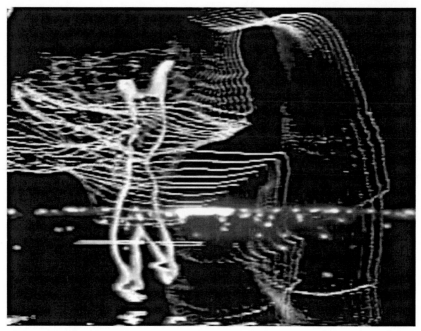

Ron Hays, still from *Delta 1, Music–Image Odyssey,* 1980

Scanimate's video mode was generally of more interest than the film mode, because clients could bring in a logo, have it animated, interact with the animator programming the Scanimate, get exactly what they wanted, and walk out a few hours later with a finished product ready for air. In the late seventies and early eighties, most animation was either hand-drawn or done painstakingly with stop-motion streak techniques. This "real-time" capability was unheard of, and was even incorporated live in the 1978 Grammy Awards presentation.[54]

The Scanimate animation system was produced by the Computer Image, company, and marked internationally. The animations it produced converge with the abstractions generated by the Paik/Abe video synthesizer, but unlike that machine produced a stable, ready-to-air signal that could be recorded either on video (it's main application) or on film. The technology became a common part of commercial broadcast design in the 1970s and early 1980s, in part because it opened "Image West," a branch in Hollywood, California in 1977 to market the technology to film and television.

The scanimate process began with standard animation art—a high contrast image mounted for photography on an animation stand. This art work would be photographed with a video camera, and then animated in real time. Sieg explains:

> The Scanimate process started with backlit light tables, which had animation pegs onto which high-contrast artwork was mounted. These were scanned by a progressive scan monochrome camera which ran at the NTSC or PAL field rate and about twice the horizontal rate.

This image was displayed on a 5" precision monochrome CRT using deflection signals generated by an analog "CPU." All of the functions producing the scan for this CRT were programmable with voltages, and available at various patch panels on the front of the Scanimate. This gave Scanimate the appearance of some early music synthesizers with their maze of patch cords, function blocks, and knobs. [...]

The CRT displaying the animation was re-scanned by a monochrome camera running at NTSC or PAL video rates. This camera fed an analog "colorizer," which implemented a smooth mapping of gray scale values into colors. Scanimate's output was colorful, extremely smooth moving, and surprisingly flexible and diverse in the variety of its effects. Dolphin Productions in New York City produced a lot of this type of "Scanimation" that appeared on PBS's *"Sesame Street"* and *"The Electric Company."*[55]

The animations produced using the scanimate process closely resemble the graphic animations of the Paik/Abe video synthesizer, and the shift from that device to the Scanimate process—which produced more stable, more controlled and easily repeatable imagery—followed the typical progression towards greater precision and control.

The early work with analog video processing would rapidly be supplanted by digital technology during the 1980s. This technological change came as a solution to the problematic nature of analog processing: the types of video imagery produced by the Paik/Abe video synthesizer was highly unstable and presented problems when it had to be combined with more typical industry standard equipment; the similar imagery generated by a standardized system, Scanimate, allowed this innovative imagery to find its way into broadcast and commercial graphics in the 1970s as a way to enliven live performances, then during the early 1980s in the music videos shown on MTV as an occasional 'background.' As digital technology improved and replaced analog processing, the creation of these kinds of synthesized imagery would be a "push-button" feature—the first video effects modeled digitally were those created with analog technology by video artists.

Video art was only one variant of a collection of tendencies emerging between the 1950s and 1970s. The signal processed video tapes and the machinery that enabled their production, both the Paik/Abe video synthesizer and the Scanimate process, were part of a rich, experimental period where artist's use of new technologies was in a dialogue with the older, more established film medium. The Modernist purity of medium-exclusivity that emerged as a dominant understanding of film and video in the 1970s was an inherent rejection of the hybrid nature of these works. In place of a fluid movement between film and video, these media fragmented into discrete arts, each with their own, independent histories and canonized artists. The break-up into separate fields, one firmly embraced by the art world—as "Video Art"—the other much less so, depending more on institutions invented by those involved with avant-garde film than on the art world for validation. Against this background the emergence and initial experimentation with a radically new, different technology, *the digital computer,* proceeded with only minimal attention from either group of media artists, critics, and historians even though key figures in the developing "computer film" of the 1960s began working with avant-garde film.

06

INVENTING COMPUTER ART

Contemporary motion graphics took shape based on a new technology that emerged during the 1960s as the third, institutional, phase of the American abstract film began. Computer graphics was invented during this period, named by the Boeing Aircraft Company computer scientist William Fetter in 1960,[1] and would ultimately give greater control over compositing and production, supplanting earlier image-manipulation technologies such as optical printing. Digital imaging was developed in laboratories around the United States as part of the Defense Department's investment in new technologies for both the Cold War nuclear arms race and NASA's space program as a visible proof that computers could become accessible to people who were not specialist programmers. The digital computer had its foundations in technologies being invented during the 1930s and used during World War II. In the 1950s new developments made at IBM in their Military Products Division employed computers to track and monitor aircraft: the SAGE system was an improvement on radar systems built during World War II, but used computers to model the real-time positions of aircraft and make predictions about their future movement. By the 1960s this digital technology was finding applications far beyond the limited range of military applications, and by the 1980s was ascendant as the new "technical marvel" of the decade.[2] As the century grew to a close, digital computers would transform all aspects of American life and enable the emergence of the fluid, dynamic control over animation, photography and typography that is essential to the motion graphics field.

Motion graphics bears the imprint of early computer art, and the heritage of the early years of experiment and innovation with digital computers remains apparent in two contradictory ways that artists address the technology itself: the "systems" approach and the "hacker ethic." It is an opposition between a focus on the programming of the machine (the hacker ethic) and a concern with the things the computer can do (the "systems" approach). One type of artist is concerned with building and programming new ways to make the computer do things, the other is concerned with applying the computer to "solve" aesthetic and design problems. Both have left their mark on what can be done in motion graphics: the idea, common since the 1990s, that the solution to making innovative motion graphics imagery is "more software" corresponds to this "hacker ethic" in action.

From its earliest applications in art this division has been apparent—whether the significant part of the computer's use in art derives from programming it to do something, or the use of it as a tool to make art. This difference is essential to understanding both early computer art and the computer films made during the 1960s and 1970s, as well as for evaluating the appropriateness of any contemporary "solution" to a design problem posed to/by digital technology. The recognition that motion graphics has been shaped by computer art at a basic level is fundamental to acknowledging the nature of this contemporary field.

The hacker ethic follows a simple set of guidelines that are implicitly, but directly, in opposition to the commercial development of computer technology. It first emerged at MIT, developing during the 1960s in the Artificial Intelligence lab headed by Marvin Minsky. The "hacker ethic" was concerned with the development and improvement of software for the then-new digital computer technology, summarized by author Steven Levy as a set of principles: all information should be free; mistrust authority—promote decentralization; hackers should be judged by their hacking, not criteria such as age, degrees, race or position; software is an art form; computers can change life for the better.[3] This utopian understanding of computers lent them an aura of magical power, focused around the technical ability to manipulate the digital code that lies at the heart of all computer programming. The peculiar relationship between the products of a computer's functioning—the various graphics, images, sounds, etc.—that may be printed out or recorded on film or videotape and the software that generates those products is a reflection of this early understanding of the computer and emphasis on the code—the programming—that it does what the author wants it to do, rather than on how that code functions or the aesthetics of the products generated. This divergence between the machine-readable programming and the human-readable result is a dynamic essential to the development of computer art and was an essential element in the kinds of collaborations that emerged between artists and computer scientists in the 1960s and 1970s.

Reflecting the hacker bias towards the ability to produce "beautiful" code—programs that were highly efficient and could perform complex tasks in as few steps as possible—early computer art has as its foundational premise the claim that the programming—software—is the art object. Following this logic, the objects produced by that software are simply a proof the program does what it was designed to do; a "proof of function," and not art objects in themselves. Computer scientist and pioneering computer artist A. Michael Noll, who worked at Bell Labs in the 1960s experimenting with computer graphics, discussed the relationship between computation and other creative, visual works:

> The fact that an "op art" picture can be adequately produced by a computer should not detract from the artistic merit of either the artist of the picture resulting from the artist-computer collaboration. The creative process takes place in the mind of the artist; the final painting is only the artist's rendition of his mental image.[4]

The creative process suggested by Noll's discussion does not preclude the creative process; it focuses on the ways that internal, mental decisions are the actual creative work, with any resulting art objects simply evidence for that procedure. Under such

a schematic understanding of art-making, the application of computers to art becomes not only inevitable, but obvious. It devalues the art object in favor of the mental activity, a choice that parallels the dematerialization of the art object in Conceptual Art.

The hacker's emphasis on programming over computer-generated imagery emphasizes the period before the machine follows a program,[5] with the result that the imagery it produces are devalued as simply a "proof of function." Noll identifies this process with a previsualization, and the software that generates the images is thus no different than mental "software" employed to draw images by hand. The "Mondrian Experiment," where he used a computer program to generate an image which was then compared to Piet Mondrian's painting, *Composition with Lines* (1917), in an attempt to determine which image viewers preferred. His discussion of this experiment demonstrates an ambivalence to issue of programming vs. functioning:

> Both patterns were conceived by humans, although certain features of the computer-generated picture were decided by a programmed random algorithm. ... As stated before the programmer-artists working with the computer produced a pattern that was preferred over the pattern of one of Mondrian's paintings. ... The experiment was designed solely to compare two patterns that differed in elements of order and randomness. ... Therefore the experiment compared the results of an intellectual non-emotional endeavor involving a computer with the pattern produced by a painter whose work has been characterized as expressing the emotions and mysticism of its author.[6]

His experiment does demonstrate the program's function, however it emphasizes the actual object produced and its specific, particular relationship to a painting—the product of the software becomes as significant as the software that generated the image. Central to this test is the issue of the aesthetics employed in the manufacture of the object itself. Noll discovered that in at least one case—the one he tested—the resulting work was preferred over that of a similar picture by Mondrian from 1917.

His comment that "the creative process takes place in the mind of the artist; the final painting is only the artist's rendition of his mental image" demonstrates an expansion of procedures employed in Conceptual Art that transforms all art works into schematic, conceptual constructions where the idea of the original artwork resides in the mind rather than in the physical object encountered:

> It is not by mere chance that all of the work done by me included in this exhibit is labeled "model." All I make are models. The actual works of art are ideas. Rather than "ideas," the models are a visual approximation of the particular object I have in mind.[7]

The instructions (the programming) determines the art, is the art.[8] This conception of working with computers is based on the idea that to use a computer to make art, the artist must first become a computer programmer. The computer program should be understood as a "thought" which the artist writes down; the computer "thinks" in making the work, and thus, programming is actually an analogue for the conventions and training an artist unconsciously employs in the process of making

art. Noll emphasized programming as the art work was an attempt to "head-off" the criticism (leveled by some critics) that the images he produced were not art because they were made by an automatically functioning machine rather than by human hand,[9] in a reiteration of the objections raised against photography in the nineteenth century.

Super Mario Clouds (2002) by digital artist Cory Archangel (1978 –), reveals the difference between works that are proof of functions (as Noll describes) and works done where the result—the products of the computer's functioning—are significant in themselves. This piece of computer art used a reprogrammed Nintendo NES videogame cartridge to create a computer generated animation of white clouds against a cerulean blue sky—the cloud background to the videogame Super Mario, but with the game elements removed. His transformation of consumer games into systems that focus on creating video art from the material "inherent" in those computer game systems brings the work with digital video processing back to the early and experimental video art of the 1960s. The use of video games—which become "junk" over time as the computer obsolesces—is a reflection of the same "hacker aesthetic" that produced the Paik/Abe video synthesizer; part of the art work's appeal is based on how it achieves its results.

Super Mario Clouds does not undermine the earlier idea for computer art that the programming is artwork, but does imply that programming should be understood in a historical parallel to a score or libretto, the basis for a performance in music, and thus capable of being excerpted, changed and performed differently than originally written. Such a parallel does have its problems: most performances of such scores are accepted as an artwork made by musicians—the music—just as much as the score is considered meaningful in itself. In fact, scores are generally viewed as instructions for art (music), rather than as art works in themselves. Historically this was not the case with the computer and the program.

THE COMPUTER FILM

The development of computer technology for both special effects and motion graphics followed from a century of work to refine and achieve ever greater control over the film image. Early uses of the computer focused on mathematics—the generation of abstract graphical plots; however, this prehistory laid the foundations for more specifically designed works appearing between 1959 and 1961 as hackers began to play with the computer in complex, interactive ways. The hacker's desire resulted in a series of video games being written for the experimental TX-0 computer and the more powerful DEC PDP-1 at the Massachusetts Institute of Technology (MIT). These first digital video games helped lay the foundations for both computer generated imagery and the video game industry. Steve "Slug" Russell, who conceived the game *Spacewar!* with fellow hackers Martin "Shag" Graetz and Wayne Witaenem, programmed it in 1961. This game used line-drawn space ships controlled by two players that could move around the screen and shoot missiles at each other. Created during the "off-hours" at the MIT computer lab, this video game would eventually become the pre-installed demo on the PDP computers shipped from the DEC factory where it provided both a technical check that the large computer had been properly installed and a proof of what it was

capable of doing. The linkage between computers, video games and moving graphics is an integral part of how the digital technology and its application to motion graphics depends on the carefully planned developments of industry and the unsanctioned independent developments of artists wanting to make things with computers—the hacker ethic in action.

Computer graphics and animation is one of the primary elements of contemporary motion graphics. It is the ability to automate and render large portions of the animation process with digital technology that is responsible for the flowering of motion graphics as a specific media industry in the 1990s. Central to this emergence is the shifting of animation tasks from hand-work to the procedural automation common to all computer systems. It is the ability to use digital software to model, and then generate, visual imagery depicting complex, labor-intensive subjects for traditional animation that is the initial reason for the development of computer animation in the 1960s at both Bell Labs in Murray Hill, New Jersey, and at IBM in Los Angeles.

By the early 1980s the potential of the digital computer to replace optical printing was obvious, even if the ability to actually meet that potential was uncertain. It was an area of concern and research for computer scientists, as Nelson Max and John Blunden, researchers at the Lawrence Livermore National Laboratory, explained in their discussion, "Optical Printing in Computer Animation" (1980). The use of optical printing in making computer films was, by then, well known:

> Optical printing can expand a few frames of computer output into a longer film, using repetition, freeze framing, changes in speed, reverse motion, repositioning, magnifying part of the image, or combining several different images. ... Note that many of the pixel-by-pixel procedures carried out digitally in an image processing system can also be achieved in parallel by optical analog methods in the printer.[10]

The development of digital techniques was a direct adaptation of similar procedures already produced with optical printing. The technological improvement of the digital imaging made possible with the computer followed the historical trajectory of optical printing generally towards ever greater control over the image. In their analysis of the optical printer as a variety of mechanical, analog "computer" they recognize the limiting factor on producing these same effects with digital means was a function of cost per frame produced. Fielding considers the potential for digital technology at the very end of his textbook:

> There is no question that the introduction and perfection of an electronic optical printer could theoretically revolutionize the process of composite cinematography and optical printing. In addition to all of the capabilities of a modern optical printer, such a system could be able to enhance photographic images, minimize grain, add color to black-and-white images or alter colors radically, multiply image elements to whatever extent desired, correct over- and under-exposure, and remove scratches or wires from within the picture area. It is even theoretically possible that such a device could be separate designated foreground details out of the background without the need for blue-screen backings, and that computer software

could be designed to accomplish this, more-or-less automatically, with a minimum of human instruction. With such a system, the images of expensive miniatures, set pieces, props, crowds, water and sky scenes, and the like might be 'stockpiled' and retrieved at will for use in new films! In theory, at least, all things are possible with such a system.[11]

This text was published in 1984 for the final edition of the textbook; the techniques and then-imaginary abilities of the "electronic optical printer" Fielding describes are all common features of digital compositing software, and even the hypothetical library of 'stockpiled' materials now exists—available for immediate, digital download from the companies that formerly provided only still photographs as 'stock' material for use in print advertising. The transformations such a device could create were beyond the limits of Fielding's proposal:

> Whether such a piece of equipment is technologically feasible, and if so, whether it will prove to be both practical and competitive, in quality and in cost, when compared with contemporary optical printing, remains to be seen.[12]

The same issue—cost—that limits Max and Blunden's consideration of digital image processing is what Fielding considers the limiting factor for the future adoption of digital technology. The emergence of this new technology since 1984 has radically altered the entire production process, rendering the physical optical printer not only no longer competitive, but obsolete: the technology and technical effects performed by the optical printer are no longer done physically, but are instead an entirely digital process. Once the computer became both powerful enough and cheap enough to enable its everyday use in the production of motion graphics and all varieties of visual effects, it replaced the earlier technologies entirely, in much the same way that digital technologies replaced physical typesetting at newspapers and the publishing industry between 1970 and 1990. The development of digital imaging machines such as the one Fielding imagines emerged from steady refinements towards greater control, higher quality result, and lower cost.

The invention of computer animation was based on the automation of the laborious tasks in traditional animation—the creation of hundreds (or thousands) of "tweens" that were essential to making things move on screen. Allowing the digital computer to generate the intermediate stages of a moving image freed the artist to focus on other aesthetic issues than the labor intensive hand drawing of each stage of a movement being animated. The computer's ability to quickly generate series of images, each positioned slightly differently, and all following a specific incremental change meant that the most time consuming part of animation could be done by machine. This automation of the tweening process is fundamental to the production of motion graphics with a computer.

The emergence of "computer art" as a distinct field of production was a side-effect of scientific work done with digital computers. The development of these machines for artistic and illustrative purposes happened simultaneously during the 1960s as the machines became more powerful. The production of motion pictures using digital technology was a way for the companies engaged in developing and marketing early computers to show how powerful their machines

actually were. Bell Labs computer scientist Kenneth Knowlton recognized the relationship between traditional animation, computer animation and motion picture production:

> Computer animation may be considered a phase or subsection of computer graphics. However, there are many respects in which movie making endeavors have a quality of their own which distinguished them markedly from areas generally thought of as computer-graphics and time-sharing applications of computers.[13]

Computers enabled the creation of animated imagery that was not otherwise possible if done by hand. The precision of computers, coupled with the potential to create very complex, animated imagery, meant that computer animations inherently opened up the potential for new types of imagery that had not been seen previously on screen. This direction towards every greater complexity, and in the process, greater realism, is a constant feature of new innovations in computer generated animations. However, the underlying technology employed in the creation of these works has remained basically constant—simply evolving towards greater complexity in what it can produce, and how quickly it can produce it: the earliest film was a simple wire-frame animation of a rectangle orbiting a sphere, produced at Bell Labs in 1963.

Edward E. Zajac (1926—2011)

The first digital computer film was created by Zajac as a way to visualize (and explain) his research with the orbital dynamics of communications satellites, a technology that was essential to the long distance communications revolution of the 1960s and 1970s. Even though his work was not an artistic exploration of the potentials of computer graphics, nevertheless, he is responsible for the first application of digital technology in the creation of an animated, graphic film rendered with computer modeling software. His animation was a short scientific film produced to visualize the motion of a satellite in orbit around the Earth. It demonstrated his engineering work: his design, animated in the film, presented the technique for keeping communications satellites oriented towards the Earth, thus enabling the use of satellites for relaying signals internationally.

Simulation of a Two–Gyro, Gravity Gradient Attitude Control System (1963) presents the results of Zajac's statistical analysis in the form of a wire-frame sphere with a rotating rectangular block in orbit around it. This application of digital technology—as a simulation device that can model real, physical phenomena and then present them visually—will produce the foundations of how digital technology automates the physical process of hand-done animation. Zajec explained the process used to create a computer animation in the 1960s:

> First, one writes a program that computes the picture to be drawn. This is fed into a digital computer, usually by means of punched cards. . . . The computer translates the program into a series of commands for the electron beam on a cathode ray tube and the film-advance mechanism in a camera. These commands are read onto magnetic tape. Next, the magnetic tape is read into a device consisting of a cathode-ray tube and a camera. As the tape

is played into this device it causes the cathode-ray tube to display the computed picture, which is recorded on the film of the camera. When the picture is complete, the film advance command on the tape goes to the camera, causing the film to advance to the next frame (the camera shutter is always open). The next picture on the tape is then traced out on the face of the cathode-ray tube and recorded on film, the film is advances, and so on, frame after frame, until the film is complete.[14]

The process of computer animation was time intensive, saving on the labor of traditional animation only through the automation of the animating itself. The film recorders used in making computer generated films differed from regular film cameras: where a motion picture camera exposes a frame of film quickly, in a fraction of a second, keeping the shutter closed except during the moment of exposure, in a film recorder, the opposite happens: the photochemical emulsion remains exposed for long periods of time, allowing the faint cathode-ray tracings to be fully exposed onto the film. The film shutter playing no role in the production of the film's imagery. This complex sequence of programming, recording the instructions for the film to a computer tape, and then recording that tape to film meant that the earliest films only emerged after everything had already been done; these earliest films offered little ability to develop imagery prior to this animation process; instead, everything needed to be elaborately pre-planned, even when the actual results might be somewhat unknown.

The field of "computer art" in the 1960s was fundamentally experimental and computer films are typical of the exploration process common to experimental media. The production of any graphic work required the invention of software with the capacity to generate visual images. It is the connection between art and commerce that led to the emergence of computer art and the creation of "art in residence" programs in research laboratories working with advanced technology. The presence of artists at these facilities was not unusual, it was part of a larger development process that was focused on using the computer as an image-generating system.

PROGRAMMED ANIMATIONS

The generation of computer animations during the 1960s was not an easy task. It required elaborate preplanning to create the imagery; the actual output to film did not create a finished film, producing instead a collection of fragments which would then be optically printed to add color and looped to lengthen the film's running time. But none of this could even begin without the creation of specialized programming languages. It was this development—inventing the programming language supporting graphics—that was the focus of artist-programmer collaborations done at Bell Labs and at IBM. The films that resulted were demonstrations of the aesthetic potentials of the computer, and a way to showcase the graphics-generating languages being invented.

Kenneth C. Knowlton (1931 –) worked in the Computer Techniques Research Department at Bell Labs in Murray Hill, New Jersey starting in 1962. His work at Bell Labs was concerned with the use of computers to create graphics, and while there he produced twelve films between 1963 and 1967. He developed the

first programming language specifically meant for animation: BEFLIX, a portmanteau of "bell flicks."[15] The animations this language created used a limited number of pixels arranged into a grid 252 by 184 pixels in size, with seven shades of grey, plus black.[16] Finished films had color added through optical printing.

During his time at Bell Labs, he collaborated with fellow researcher Leon Harmon, who became the "artist" by a flip of a coin,[16] followed by collaborations with artists-in-residence: Stan VanDerBeek, Lillian Schwartz, Laurie Spiegel, ending with Emmanuel Ghent. He described their collaborations, retrospectively, as being an undirected exploration:

> During that period, I was developing experimental programming languages and methods — terms loosely defined, in those golden days of Bell Labs, and thus "artistic applications" was a plausible use of part of my time. I did not have to defend that interpretation in detail to my superiors, which was fortunate because I'm not sure that any of us really knew what we were doing, or why.[17]

Knowlton's work inventing computer animation developed through the collaboration process: it was an exploration of technical and aesthetic potentials within an unknown field—the digital production of motion graphics. His comments reflect the ambiguity about what were and were not appropriate areas for research into the applications for computers during the 1960s. New developments were understood to be significant simply for the fact of being new, even if those developments did not have any immediately obvious commercial applications—these collaborative projects developed for their own sake, as research into the potentials of a fundamentally new technology.

In his work with computer animation, Knowlton recognized the potential of computer animation to change the production process, allowing the production of new kinds of film that would be impossible without the computer. Writing in 1976, after working on computer films for more than ten years, Knowlton recognized the limitations that were preventing computer animation from quickly advancing:

> There are a large number of educational and research activities which could use computer-animated movies in a creative and productive way—movies which, without the computer, would be too intricate, time-consuming and expensive to draw and film. But if each potential animator attempts to write his own programs and movie systems from scratch, his accomplishments will be of little use to anyone else and no one movie maker will advance very far.[19]

Knowlton, one of the main pioneers of computer animation, recognized that the animation of computer films as programs limited the aesthetic and technical range of what was possible within any particular program: early computer animated films were made individually, not as products done by a particular software application or program (as became increasingly common after the 1980s). Instead, they were written in specialized programming languages created to produce digital animations; the programming language functioned in the same way that later applications would—as a platform enabling the design and production of animations. These languages offered the first possibilities for digital, computer

generated films, but required the use of programming each individual film as a unique piece of software—a limitation common to early computer animations—each was a singular production rendered by custom written, unique programs. Each new film required, in effect, a re-invention of the basic techniques and procedures that create the imagery on screen, preventing different artists from being able to build upon the work of other, earlier, artists. Knowlton's work with computer films focused on the creation and elaboration of field-based imagery—forms that filled the entire screen, occupying the entire graphic space of the screen. It is a formal element uniting his collaborative projects that were otherwise distinct from one another; he termed these fields of imagery "mosaics," a name that is occasionally used to identify the BEFLIX programming language that produced them.

STAN VANDERBEEK (1927 – 1984)

Stan VanDerBeek began working with film while in college at the Black Mountain College, becoming friends with other artists such as Robert Rauschenberg while they were students there; VanDerBeek would collaborate with Rauschenberg, Claes Oldenburg, Robert Morris and other Pop artists, filming early performance art.[20] During the early 1960s VanDerBeek's work moved fluidly between the film and art worlds, adding the aesthetics of Minimalism and Pop Art to the already established, narrative aesthetics of the avant-garde film. While he is not the only artist bringing these two communities together—other artists such as Andy Warhol and Paul Sharits were also active artists and filmmakers—his involvement in both worlds shows how complex the interchanges between art and film avant-gardes were before 1970. VanDerBeek was atypical for experimental filmmakers: his focus on collaboration, coupled with a continuous engagement in new technologies—fax machines, television and video art, and expanded cinema—may have contributed to the marginalization of his work during the early 1970s as the institutional period came into focus. Nevertheless, his importance for the development of motion graphics is two fold: first through his innovative animated collage films, and then through pioneering work on computer imagery done at Bell Labs and at MIT as artist-in-residence.

The film experiments produced at Bell Labs in collaboration with Knowlton were not concerned with the development of a visual music or a general purpose instrument for creating a visual analogue to music; instead, the computer films done at Bell Labs engaged with written, kinetic typography as a graphic material capable of complex manipulations while at the same time remaining legible as language: he called these works "*Poemfields.*" The series of eight films become progressively more complex, both as computer animation, and in how they were handled in post-production. The first Poemfield was finished as a black-and-white film; nos. 2 through no. 8 were finished by using optical printing to add color, making their forms easier to read on screen.[21]

All of these films were programmed in FORTRAN language (to control the microfilm recorder, combined with Knowlton's revisions to BEFLIX that resulted in a new graphics language called TARPS (Two-dimensional Alphanumeric Raster Picture System) to generate the imagery.[22] This language broke the screen into

modular units that could have the same effect applied to each block at the same time, including zooming in and copying a section of the screen, setting pieces of the image in motion, or superimposing one part many times over the screen as a whole. All these effects appear in the *Poemfield* films. VanDerBeek explained the graphic potentials used to make the imagery of these films in an article published by *Art in America* in 1970:

> Pictures can be thought of as an array of spots of different shades of gray. The computer keeps a complete "map" of the picture as the spots are turned on and off. The programmer instructs the system to "draw" lines, arcs, lettering. He can also invoke operations on entire areas with instructions for copying, shifting, transliterating, zooming, and dissolving and filling areas.[23]

The visual reproduction of different parts of the same image on screen creates the mosaic patterns and graphic effects that disperse the text into a field of graphic elements some of which resemble language. The result is a visual form that moves the central content of the frame—the computer generated lettering—outwards towards the edges of the screen, in the process dispersing it into a series of blocky, component elements.

The *Poemfields* present a flow of language where individual words flow into each other, alternating between being an individual statement and the background for the next in a continuous progression that included the titles and credits. The organization of these films was around a sequence of words that appeared centered, on screen, and gradually transformed from text into a mosaic that filled the screen; there is a constant balance between being readable and being illegible in these films. The *Poemfield* films were not completed in the order they were planned; this difference between their planning and actual completion is a reflection of the costs and difficultly involved in creating computer films (costing approximately $500/minute in the 1960s). The 'poem' part of the *Poemfield* is concerned with the elaboration of meaning within language, an appropriate subject given the graphic dissolution of words into mosaics of graphic form. Even though these films were completed in a different sequence than they were written, a sampling of just the first three of VanDerBeek's poems reveals the progression from statement to decomposed, text designed for digital manipulation. The breaks indicate how the text was divided into different "title cards" on screen:

Poemfield No. 1 (1967)
GESTURES | DO NOT | MISTAKE | PLACE | YET......... | FINGER POINTING | TAKES A WORD TO COMPLETE | SOME HOW | WORDS | FILL | THE SPACE BETWEEN | BETTER | MEANING | MOVES | POSITION | LOVES FINGER | DIRECTS | SPEECH | THAT | SILENCE | FALLING | TOUCHES

Poemfield No. 2 (1966)
similar | LIKE | TO | CLOCK | TICK | WE PICK | LIFE | OUT | OR APART | SEEMING | TO SEE | SEPARATE | THINGS | TOGETHER | SO | YOU | SAY | IT | WOULD | SEEM LIFE LIKE | THIS | LIVING | BUT WE ALWAYS SUSPECT IT

Poemfield No. 3 (1967)
PO | POE | POEM | FIE | FIELD | POEMMM | FIELD NO. 3 | NO.
3 | A MAP OF IDEAS | A | VOICE | WRONG | A WHEEL |
WRONG | A WHEEL | BUT NOT REALLY | A HAND | REALLY |
MEMORY IS A TIGHT ROPE | A FIRE | AIEEEEE | CRYING IS AN
EDGE | NOT OVER | LOOKING | BUT A CUTTING EDGE |
REALLY | THE DARK IS A QUESTION | I BELIEVE YOU |
NAKED IS LIKE | TOMORROW | NAKED IS | LIKE TOMORROW
| YOU ASK | YOURSELF | ABOUT IT | A LAUGH | IS PROGRESS
| REALLY | SI | LENCE | SILENCE | AN ATTEMPT

The free play with rhythm and rhyme in these 'texts' also becomes a visual play and repetition as the words are transformed into fields that fill the screen with the component textures of the basic graphic elements generated by BEFLIX itself; it sets up a conflict between the meaning of the words and their dissolution into mosaic patterns. The abstract, graphic potentials of the computer-generation and manipulation of imagery contrast with the organization of text on screen. This mismatch provided the aesthetic basis for their film *Collideoscope* (1968).

The repeating graphic elements used in the *Poemfields* films fragmented and replicated parts of the text and background around the screen, but did not use symmetry. Instead, blocks of image would appear at different scales, producing graphic patterns thorough their interaction as they accumulated on screen. The animation was less one of movement between different positions—it was an intermittent accumulation of elements, suggesting a collage of different parts over time. The 'animation' of these films was primitive as a result; *Collideoscope* (1968) was a more complex animation than the earlier *Poemfields*. In this film symmetrical patterns work to create kaleidoscopic effects, but are often contained by other, geometric forms that do not move so much as replace one another, forming graphic containers for a more complex, and continuous animation. Triangles, circles and squares constrain and hold these kinetic networks of lines that symmetrically converge on the center of the screen. *Symmetricks* (1972), done with assistance of MIT, would explore the possibilities of symmetrical graphics more closely, creating looping faces and other forms on-screen in real time using a light pen.

LILLIAN SCHWARTZ (1927 –)

Like many of the first generation of abstract filmmakers, Lillian Schwartz did not begin with training in either film or computer science. She was initially trained at the College of Nursing & Health of the University of Cincinnati, but spent her career working as an artist in New York. She met Kenneth Knowlton following the Museum of Modern Art exhibition *The Machine as Seen at the End of the Mechanical Age* (1968) that included her kinetic light sculpture, done in collaboration with Per Biorn who created the electronics used in it. *Proxima Centauri* (1968) was a collection of different components designed to display abstract paintings done for projection onto a hemispherical screen. Schwartz's sculpture appeared in the first episode of the final season of *Star Trek,* episode #56 ("*Spock's Brain*") that aired on September 20, 1968; a reminder of the relationship television had with the art world in the

1960s, its role was as the machine containing Mr. Spock's brain. The tendency in this period was for a convergence of popular and elite, "fine art" cultures.

Knowlton's collaboration with Schwartz making the film *Pixillation* (1970) involved the development of a new animation language that offered greater potentials for animating imagery. EXPLOR (EXplicit Patterns, Local Operations, and Randomness) allowed the generation of rectangles and squares in black, white and grey, and enabled their arrangement and frame-by-frame animation. The blocky imagery they animated was combined with stop motion animation done by Schwartz using combinations of oil, water and acrylic paint in a process of convergence with the digital imagery:

> I experimented with glass lenses of various sizes in which I would put oil and/or water and oil and acrylic paints. Light was projected from beneath the stand upward through the lenses and their contents. Once I found the best arrangement of lenses, lights and paints, I resorted to stop-action photography. After exposing one frame I would repaint a portion of the image, repeating that procedure until I had a sequence of shapes related to the computer images. Later I color-matched, by means of an optical bench, the black-and-white computer material with the colors of the paints.[24]

Their finished film shows a series of overlapping squares that move between the hand-painted shapes and the computer-generated shapes in a pulsating montage synchronized to the soundtrack. The result is a film that directly addresses the relationship between the transitional hand-processes and the automated ones of the computer. The highly complex montage that Schwartz employed uses a combination of animation and flicker effects, in a structure that both resembles the more traditionally-produced structural films by Paul Sharits and Tony Conrad, while at the same time being directly concerned with the hybrid of physical and digital technology. The 'purity' of film is not an issue in *Pixillation*—it is the underlying hybrid of techniques and technologies that is the primary focus.

The film starts with titles produced with the mosaic effects common to the BEFLIX animations done with VanDerBeek rendered in a limited palette of red, white and black. They are immediately followed by clouds of red, white and black spreading across the screen, synchronized to the pulsating soundtrack by Gershon Kingsley. Square shapes appear and disappear in these clouds, and cut into this organic footage are short bursts of computer animation oscillating between positive and negative, creating the effect of motion—either expanding or contracting—as concentric series of square collide on screen in complex organizations suggesting microchips and circuit boards. Drops of liquid spread as red circles in a dark cloudy field; followed by a dark digital field that quickly fills with forms grown from small 'seed' pixels moving in ever-widening circles that fill the screen with branching red pixels; as the screen fills, the process begins again. A digital face appears on screen as a flash frame, grey against black, followed by short bursts of computer animation, then a new "section" begins: microscopic enlargements of crystals grow across the screen, flat geometric shapes that glow brightly against a dark background. They are followed by similar patterns of rectangular computer-generated blocks that spread in the same direction and at the same speed: a digital analogue to the organic growth of the crystal forms.

The important image in this sequence is the brief flash of the digital "face"—the imagery is guided by a conscious mind operating through the computer, translated into a digital form through its use of the technology. It is a statement about the role of the artist in producing and organizing the imagery seen in this film: not simply a digital translation of one form into another, as the juxtapositions produced by the montage suggest, pixilation is a transformation of superficial physical forms into a more basic geometric form. This shift from a perception of appearance to a more fundamental, abstract form links *Pixillation* to the earliest abstract films produced in Germany during the 1920s. It is a connection that Schwartz developed while working with computers, one that had its basis in the abstract films made during the 1920s by Viking Eggeling and Hans Richter. Their work with creating an abstract language based in the manipulation of lines, squares and patterns over time converged with the limited geometric forms that computer films were able to generate in the early 1970s. These connections between digital technology and earlier abstract art are more than simply a formal convergence; the potentials of digital computers to enable the creation of visual music—and the attempts to realize that potential—are a significant part of the development of computer graphics.

JOHN WHITNEY'S 'DIGITAL HARMONY'

John Whitney's work with the computer was concerned with creating an instrument to produce visual music, a reflection of his early concern with music translated into visual form. His theory of formal synchronization called "digital harmony" developed from the combination of his earlier abstract film work using an analog computer and his later digital films made with a film printer and custom-written software. His analog computer was built from an obsolete US Army M-5 Anti-Aircraft tracking system from World War II into a machine that used a pen to draw elaborate patterns which would then be photographed with an animation stand; a series of these drawn-out spirals appear in the Saul Bass' title design for *Vertigo* (1958). These designs are analog plots which trace curving vectors in a flat plane with a degree of complexity that made their production by hand, not impossible, but prohibitively time consuming led Whitney to a further refinement: the elimination of the stylus in favor of a light source, in the process creating an analog film printer that would directly expose each frame, producing an animated sequence without the need for human animation. It is the first application of 'computer technology' to automated image production, even if it is not the first digital computer animation.

The direct use of light in Whitney's work converges with the devices built in the 1920s by Mary Hallock-Greenewalt and Thomas Wilfred. He directly recalls their aspirations in his book *Digital Harmony* published in 1980:

> Almost any material an artist might select is too sluggish to sculpt in time and motion—too languid, or too inertial for a visual medium meaning to imitate music, or vie with music's dynamism.
>
> In the last third of this century, we acquired a visual medium which is more malleable and swifter than musical airwaves. That medium is light itself. While it was always available, the means to modulate light precisely and

faster than sound (on a cathode-ray computer display, for example) is a very recent practicality. Musical instruments that modulate the air medium of hearing are now matched by other instruments which modulate, with greater exactitude and speed, the light medium of sight.[25]

The instruments Whitney describes all exist as software run by the digital computer; he helped develop the programs used with this technology based on his earlier work with mechanical animation and analog computer graphics. The origins of his conception of digital harmony lie with the graphic language he invented with the analog computer he built in 1957, refining the design, expanding its potentials and automating the production process so that by 1960 it was a highly versatile machine capable of creating a wide range of visual patterns and optical motion effects. This device became the central technology exploited by his new company "Motion Graphics, Incorporated."

Catalog (1961) presents a visual selection of the visual designs his animation machine could produce, and was exhibited as an avant-garde film, but could also function as a "catalog" for his production company, Motion Graphics, Inc. The fim is loosely synchronized to music by free jazz innovator Ornette Coleman (1930 –); *Catalog* presents approximately twenty-two designs in seven minutes, plus a striking opening title where multiple, colored copies of the film's name slowly converge on the center of the screen—an effect also used in James Whitney's *Lapis* (1964)—coming together in three colors: *CAT* (blue) *A* (red) *LOG* (green), followed by the date—1961—in blue and green. The dissolution of these numbers into graphic patterns (first wave forms) then, resetting to the date, broken in what resembles a moiré effect begins a series of abstract forms; the first is the "mandala" shape that is the primary image of *Lapis*. It advances, and is replaced by slowly undulating horizontal fields of overlapping color spaced with black; they become vertical and their complexity increases to fill the screen with color. The next sequence separates the shapes on screen from their color—squares and rectangles gradually morph into each other, sliding around a black screen where the color moves independently of these shapes. Initially these rectangles are an illusion which emerges from how groups of small squares move in unison; as the sequence progresses, other, more complex forms, also morphing rectangles, but made from the moiré effect also appear on screen. These multicolored shapes have curved edges, creating a three dimensional effect as they move around each other in the center of the screen before being replaced by the earlier rectangles. Rhythmically interspersed with these forms made from the small squares are fast-moving solid rectangles whose bright colors flash on screen and disappear.

The next sequence in *Catalog* begins with a rotating bar of color that becomes a series of concentric rings, the impulse is to read these as contour lines, creating a virtual depression in the center of the screen that expands and contracts as the colors change from red to green to yellow, then back to red, finally becoming a colored spiral broken across the circles. Variations in distance between these rings creates a different spatial effect than the earlier rectangles, but still remains within the realm of a purely graphic third dimension. This interplay between flat patterns moving in a plane and shifts into an apparent third dimension structures the organization of these sequences in ways independent of the music on the

soundtrack: it moves from rectangles to spirals of various types to bars that become expanding circles before returning to constrained patterns, circular rather than rectangular, again followed by spirals, but this time of greater complexity, and whose movement implies motion through three dimensions. The spirals will reappear, with a more dynamic, faster animation, in his computer film *Permutations* (1968) where these formal elements become containers for other graphic, linear forms suggested by the middle sections of *Catalog*.

The final section begins with an apparent curved plane made from red circles, that ripples through arrangements that suggest concave, then convex surfaces. It is followed by rectangular outlines whose replication create forms that resemble wire-frame models generated by digital 3D animations. The movement and transformation of these shapes anticipates the Matrix series of digital animations Whitney would make at the end of the decade. *Catalog* ends with a looping curved form, similar to the typeface used in the "1961," that moves through a series of compositions as it spins on screen. The development of Whitney's later work is clearly visible in this film: his works through the 1970s, depend on the graphic vocabulary of shapes, motions and harmonic interactions of similar forms at different scales established in 1961. His later work with digital computers elaborates the visual dimensions of this film, but with a more apparent relationship to the music used in the soundtrack.

His theory of *digital harmony* developed after his work at IBM as artist in residence from 1966 to 1969 where he explored the aesthetic potentials of computer graphics—a program paralleling the one at Bell Labs in Murray Hill, New Jersey. Of the artists who worked at IBM—including documentarians Albert and David Maysles and designers Charles and Ray Eames—only Whitney used the computer as an image-generating system.[26] His conception of the relationship between visual and musical form required a the specific technical potentials offered by computers:

> The search for a viable system of motion graphics has ranged far and wide among abstract filmmakers. ... My point of departure would seem to be at the crossroads where computer designers abandoned mechanics altogether and introduced electronics. This in turn was fortuitous, since it made obsolete a $33,000 device which was then placed in surplus which I can now buy for less than $200. ... It happens to be an "Anti-Aircraft Gun Director." It contains a beautiful network of cams that are variable and made an exceeding versatile two dimensional coordinate design instrument—with a few alterations.[27]

Whitney's development of audio-visual organization in the his films produced after *Catalog* demonstrate and refine the idea of "digital harmony" in their organization and through the imagery derived from his experiments. The essential part of this construction were the "differential dynamics" that would emerge from having similar forms in motion at different rates on screen simultaneously. The graphic potential for this type of work reflected the same Pythagorean foundations as musical tones:

This hypothesis assumes the existence of a new foundation for a new art. It assumes a broader context in which Pythagorean laws of harmony operate. These laws operate in a graphic context parallel to the established context of music. In other words, the hypothesis assumes that the attractive and repulsive forces of harmony's consonant/dissonant patterns function outside the domain of music. Attractions and repulsions abound in visual structures as they become patterned motion. This singular fact becomes a basis for visual harmony with a potential as broad as the historic principles of musical harmony.[28]

Unlike the classical Greek application of this harmonic principle, most apparent in the architecture on the Acropolis in Athens, Greece, that does not unfold over time, the harmonic structures Whitney identifies in his study *Digital Harmony* (1980) are specifically a function of both computer graphics and formal elaboration over time.

Permutations, (1968) the first complete film exploring his conception of harmonic form structured as counterpoint to music, was produced while he was artist in residence at IBM. Like all his early computer films, Permutations was done in a collaboration with a computer scientist, Dr. Jack Citron, whose interest brought Whitney to the company. It was programmed with a new language created specifically for the project called "Graphic Additions To Fortran" (GRAF), and generated with the IBM Model 360 computer. The images were filmed frame-by-frame off an IBM 2250 Graphic Display Console—a black-and-white display—using a high-contrast film stock designed for the optical printing which would complete the production process by adding color and changing the timing of the animation through loop printing, the photographic creation of animation cycles, and in some cases combination with live action footage. This film was produced following a similar process to that used by the Whitney brothers with their *Five Film Exercises* in the 1940s: a limited amount of footage would be rephotographed with an optical printer, making the finished film a composite of digital imaging and traditional optical printing. The material produced by the computer was "raw" footage that required additional work to become a completed film. This process was partly a function of efficiency, since while the digital computer could generate the whole film, it was both cheaper and faster to do it in short pieces, especially since color could only be added through optical printing.

The computer generated raw material Whitney would then manipulate with his optical printer to create the finished work. Both the film printer and optical printing were an essential element in the creation of computer films, and digital work generally, a combination of physical and digital technologies that was in use from the 1960s until the 1990s. The creation of motion graphics with digital tools provided a novel means to generate imagery, but offered only limited abilities to combine those visuals with photography and other imagery without the intermediate stage of compositing with an optical printer; digital technology since the 1990s has enabled these combinations to happen inside the computer, eliminating the role for optical printing in this production process.

GRAF was able to generate the same spiraling imagery as Whitney's analog computer, but was much faster. It employed a polar-coordinate system that enabled the creation of circular, spiraling patterns, which would be produced by using a light

pen to program the animations which would then be filmed. The color and compositing were done with optical printing to take short pieces of animation and combine them into the much more complex final film. Whitney explained the structure of *Permutations* in the *Cybernetic Serendipity* exhibition catalog in 1968:

> The film contains various types of dot patterns which might be compared to the alphabet. At the next level of complexity the patterns are formed into 'words,' each having basically a 200-frame [eight-second] duration. These words in turn can be fitted contextually into 'sentence' structures.

> My use of a parallel to language is only partly descriptive. I am moved to draw parallels with music. The very next term I wish to use is: counterpoint.

> Having described dot pattern 'words' of 200-frame duration, I must strain the parallel beyond its limits in order to explain that these patterns are graphically superimposed over themselves forward and backward in many ways, and the parallel now is more with the counterpoint, or at least polyphonic composition.[29]

The individual elements of Whitney's compositions remain distinct in the finished film because of the intermediate stage where each visual element would be optically printed in different colors. This rephotography gave him the high degree of control over these compositions, their color and arrangement given the extreme limitations of composition and design in a computer where all animation must first be created physically, although more quickly than using traditional hand animation or Whitney's analog computer. The complete production process for *Permutations* was explained in the 1967 film *Experiments in Motion Graphics,* a documentary made during production that demonstrated the process.

Arabesque (1975) employed vector graphics programmed by Larry Cuba who collaborated with John Whitney on its production. Single dots in motion create the images, their complex animation creating a procession of geometric figures in a variety of different colors. As in *Permutations*, the basis of the imagery is a single dot that, once in motion, draws geometric shapes based around the circle—curves, loops, five-pointed stars—animated on screen both alone and in combination. The structural basis of this film is Whitney's conception of "harmonic progression" using Islamic decorative patterns and architecture as its reference; this film visibly demonstrates the relationship between these progressions and the technique of incremental drift:

> An early intuition about how to control total dynamics led me to activate all graphic elements through a motion function that advances each element differentially. For example, if one element were set to move at a given rate, the next element might be moved two times that rate. Then the third would move at three times that rate and so on. Each element would move at a different rate and in a different direction and rate, and none drifts about aimlessly or randomly, then pattern configurations form and reform, stated in explicit terms.[30]

Whitney employed this technique as the central part of his films made while artist-in-residence at IBM: *Permutations, Matrix I, Matrix II* and *Matrix III* all

demonstrate the emergent order created by moving similar geometric forms along the same path but at different scales and speeds—complex shapes flash into and out of existence during the rotational movement of the simpler, basic shapes. It is a semiotic procedure where the base geometry combines and transforms from parts (the shapes, like letters) into complex forms (words) whose sequential development and the break-up of them into sequences offers a way to see these groupings as statements. In *Arabesque*, these forms combine in ways that are much more complex than in the earlier IBM residency films: not just individual elements moving and forming single forms, but the realization of several different, distinct motions at the same time—a compound group of drifts, each identifiable by color, whose forms reiterate each other at different speeds and in distinct combinations. These groupings create gestalt patterns of shapes—lattices, mosaics, wave forms—not actually present in the film that are created only in the viewer's mind while watching the motion. The synchronization of these forms to the traditional music performed by Manoochelher Sadeghi.

Whitney spent his career attempting to build a general purpose visual instrument; when confronted by the potentials presented in the computers available in the 1980s, he abandoned his earlier attempts to focus on implementing it as software; the animations generated by the software application Whitney developed with Jack Reed during the 1980s generated imagery that was qualitatively different than his earlier computer films of the 1960s and 1970s, but that originated with the software developed during his residency at IBM.30 The sixty minute video *Moon Drum* (1989–1991) is typical of his later computer films. Composed from a twelve individual sequence-movements synchronized with electronic computer music: *Moon Drum, Navajo, Hopi, Kwakiutl, Qxaquitl, Black Elk Requiem, Chaco, Mimbres Star, Chumash, Kachina, Chapala,* and *Acoma,* each section's animations proceed as semi-static graphics drawn on screen in real time: once an image has been generated, it must be removed from the screen. This drawing-then-"erasing" process is different than a video image. The "erasing" part of the animation is actually a drawing-over, a replacement of the individual forms shown on screen by an identical form in black, a factor that offers the potential to stagger the timing between drawn and drawn-out, giving the imagery a rhythmic character dependent on the chosen timing of the drawing/drawing-out process—how long elements are on screen before being erased.

The limitations of early desktop computers are fully on display in these animations: the music has the 8-bit quality of video game sounds, and the display and modulation of the computer graphics in these videos are done without the intermediary stage of optical printing: the finished animation is directly composed/generated by the computer. The basic unit of the graphics is a dot, but one that quickly becomes a heavy line. Because the machine is very limited in what it can generate, the resulting videos are less visually complex than his earlier computer films. There is only one 'layer' of animation in motion on screen at any given moment, giving these animations a more minimal character than the highly complex motion and counter-motion in Arabesque.

However, in *Moon Drum* it is possible to see the continuing development of the graphic language of dots, shapes and motion that Whitney described in 1968. It is a

formal arrangement utilizing only a small selection of the computer's graphic potential. Where in *Arabesque* the organizing graphic element is the circle and its harmonic division into arcs, for *Moon Drum* the visuals employ linear graphic patterns drawn from native American art: medicine wheels, zigzag patterns, and the linear weaving of colored bands. These recurring motifs are elaborated across the sixty minutes, directly related to the individual sections.

"Computational periodics" was the description Whitney posed for the musical visual forms made possible by digital technology. It is a fusion and transposition of concepts common to musical form applied to the temporality of motion pictures. The transformation of frequency, intensity, meter, rhythm and tonality to graphic form depends on their repetition and duration—the "pause" between drawn-in and drawn-out that the graphics of *Moon Drum* display—which allows a visual structure to evolve over time that elaborates a periodic form comparable to that of music.

Larry Cuba (1950 –)

Larry Cuba programmed the animation for John Whitney's film *Arabesque*, and the influence of Whitney's digital harmony is visible in Cuba's later work. He programmed his first computer animation, *First Fig* (1974), using the mainframe at NASA; this was his first involvement with producing computer films, done while he was still a graduate student at the California Institute of the Arts. The different computer systems used to generate the imagery of these films is a crucial part of what and how computer-generated imagery appears on screen. Between 1978 and 1985 Cuba made three abstract films and worked on a number of commercial projects, including the computer animation of the Death Star for *Star Wars* (1977). The constraints imposed by how different computers handled imagery resulted in the different formal approaches used in his films:

> The most obvious difference [between *Calculated Movements* (1985) and the earlier computer animated films] comes directly from the hardware. The other films were done on vector systems, so I was using dots. Going to the Zgrass machine meant not only going down from a mainframe to a mini to a micro [desktop computer] but also going from vector to raster graphics. So this is my new palette, so to speak. New in two ways: I could draw solid areas so that my form became delineated areas instead of just dots, and I had four colors: white, black, light grey and dark gray. Every film I've made was done on a different system. This is the only piece I've made on this machine. So the evolution of my work is directly parallel to the evolution of systems I've used.[31]

The changes in technology Cuba describes follow the development of computers from large, expensive and complex machines towards both smaller size and greater power. The ability to work with a desktop computer (a micro-computer) to produce animated graphics reveals the major shift during the 1980s that would become commonplace during the 1990s—the invention of "desktop video"—enabling the creation of all types of computer graphics. The significance of technology in this transformation is also apparent in Cuba's discussion. In a parallel to the differences between various physical media—watercolors vs. oil paints for example—the

imagery used in different films is limited to those types of imagery that particular medium (vector or raster) generates.

MEDIA CONVERGENCE

From their earliest introduction, the conception of digital computers and the software being created to run on them fell into two categories: specialized programs to accomplish singular tasks, and generalized "tools" that would allow all sorts of other creativity to happen using the digital computer as a general "medium" capable of emulating other, older, physical media—typewriters, drafting equipment, cameras, etc.—and it is by simulating these other, existing media, that software began to allow the use of computers for tasks unrelated to mathematical computations. The movement towards general tools capable of performing several, previously unrelated tasks, (such as telephone calls, editing film and processing video), was the major, accelerating trend during the 1980s and 1990s called "convergence": it described the growing together of these formerly independent activities.

The digital manipulation of imagery appeared first in broadcast television studios, and the role of WGBH's New Television Project was central in enabling artists to have access to this technology as it became available. The connections between this new digital technology and earlier media works, especially those produced using optical printing by Hy Hirsh and Pat O'Neill—where the reassembly and use of different "parts" of images whose grouping into a new "whole" created a new, unique work—when produced using digital technology has been called both "windowing" and "spatial montage." It is not unique to avant-garde film, having a close relationship to design and photocollage in use since the 1920s.

This "windowing" concept has moved from an unusual visual effect whose use was relatively unusual in the 1980s and 1990s—confined to short sequences or employed in title designs—to a common, even everyday, part of not just our media consumption, but our engagement and use of digital tools: the concept of 'windowing' describes the break-up of a screen into a series of smaller, related but discrete units that are each capable of being handled and manipulated independent of one another. The choice of this term, window, refers to the commonplace experience of using a digital computer where multiple interactive elements—windows—all appear on screen at the same time. The first and most well known variant of the concept of "windowing" was proposed in the late 1990s by the media theorist Lev Manovich using the term "spatial montage." This development means that our collective ability to engage and understand what we are encountering when we see a work using a collection of windows is based on a graphic juxtaposition of discrete images within an implied framework of "windows" on screen. Manovich's theorization is based on the models in use with digital computers, there are many examples of this kind of design and its application to media works recurring throughout the twentieth century. Manovich's theorization of "spatial montage" is brief, and the "spatial dimension" is simply the presence on screen of several images at once, a common feature of motion graphics since the 1960s:

Spatial montage represents an alternative to traditional cinematic temporal montage, replacing its traditional sequential mode with a spatial one. ... Twentieth century film practice has elaborated complex techniques of montage between different images replacing each other in time; but the possibility of what can be called "spatial montage" between simultaneously co-exiting images was not explored as systematically. ... But when, in the 1970s, the screen became a bit-mapped computer display, with individual pixels corresponding to memory locations which can be dynamically updated by a computer program, one image/one screen logic was broken. Since the Xerox Park Alto workstation, GUI [Graphic User Interface] used multiple windows. It would be logical to expect that cultural forms based on moving images will eventually adopt similar conventions. ... The logic of replacement, characteristic of cinema, gives way to the logic of addition and co-existence. Time becomes spatialized, distributed over the surface of the screen. In spatial montage, nothing is potentially forgotten, nothing is erased. Just as we use computers to accumulate endless texts, messages, notes and data, and just as a person, going through life, accumulates more and more memories, with the past slowly acquiring more weight than the future, spatial montage can accumulate events and images as it progresses through its narrative. In contrast to cinema's screen, which primarily functioned as a record of perception, here computer screen functions as a record of memory.[33]

This description does not, immediately, suggest media art so much as interactive art working with a graphic user interface; his conclusion that the GUI offers a challenge for film theory is logical; however, the embedding of motion imagery within that interface, —perhaps by playing a movie in a viewer—would not seem to require the elaborate theorization of Manovich's analysis. The historical concerns that inform this engagement primarily emerge with the canonized film and video art, reflecting the institutional period's neglect of commercial productions. The connection between the multiplicity of visual images on screen Manovich calls "*spatial montage*" and the break up of the frame into windows—a style employed by title designer Pablo Ferro throughout *The Thomas Crown Affair* (1968). It is a common feature of both static Modernist design, and of title design during the 1970s—especially on television for a wide range of shows: *The Brady Bunch, The Rookies, Charlie's Angels* and is still in use for *Buck Rogers in the Twenty-Fifth Century* (1980). The technology that enabled this production was not computers, or even the model of the GUI, but graphic design. "Spatial montage" was first systematically explored in commercial title design—i.e. motion graphics—as it adapted the Modernist collaging of imagery in print to motion pictures using optical printing.

The central element of windowing is the manipulation of (fragmentary) images on screen at the same time—essentially breaking the visual frame into smaller, discrete units; this activity is not unique to the current age of computers. Stan VanDerBeek theorized this construction as specifically environmental—using actual, physical space, not just screen space—in his 1965 discussion of the studio/experimental theater called the *Moviedrome* he constructed at his home in New York:

For my multiprojection I've built a 31-foot diameter dome which I'm calling a "movie drome theater." (I use it a lot as a studio as well as a theater.) In it I want to have a lot of projectors running at the same time, their images spaced all around the dome screen from various points of view, but all run from some master control. That way I'm about to just push cartridges [of films] in and out to change the whole scene. I intend to fix them so that all the projectors can be phased in and out on cur so that I can ease images in and out and double and triple expose them.[34]

His description is not simply a space where there are many different film projectors creating a singular image, but a collection of discrete images that combine and overlap on the screen-space of this theater: it is the 'spatial montage' idea, rendered using literal space. It breaks the continuity of screen space into smaller, individual images whose manipulation and combination is the focus. Various techniques of fragmentation—in the forms of disruption, reassembly, variation and flux—are a central theme in the past century of media art—both in the static works of print and in motion pictures—a factor that is continually emergent in the work of disparate artists because, to a certain degree, this modern era we live in is defined by 'continuous partial attention,' what is euphemistically called "multi-tasking."

The various relationships between disparate elements within a grid system (moving images or otherwise) is firmly within the realm of established theory and history of both painting and graphic design. The limitations of Manovich's description are immediately apparent, developing from both a narrow historical framework, and an ambiguity about what type of media is being addressed by this description: that used to produce a finished piece, or the finished piece itself. Windowing describes a collection of closely related conceptual approaches to the specific Modernist heritage that informs not only our use of computers (the source of the name) but how we interpret various media works that also fragment the image along similar lines.

Employing the Modernist grid, an essential part of how graphic design organizes its materials, as a compositional device resolves the underlying issues of traditional composition: it is instead a matter of simply placing the visual material within a structure of blocks. It escapes from typical modes of pictorial composition; this organization is fundamentally variable: it is the break up of the screen into individual blocks (the grid itself) that provides the pictorial organization. Relationships between discrete units in a grid system is a function of their placement, size, and content. The additional element of time (motion) alters this grid principle, depending on how the elements within the grid are manipulated and what role motion has for that construction. Beyond a simplistic juxtaposing of imagery on screen, the break-up of the frame into different compartments offers a range of potentials based on the displacement of either the time displayed, the motion shown, or the spatial positioning of the elements on screen. Depending on how the various elements are related both graphically and temporally within the image itself, we can create a permutation matrix of potential applications that describe a range of visual displacements and juxtapositions that the grid provides. Within such a construction that shifts emphasis from user interface to the graphic arrangement of discrete parts on screen, the serial dimensions of windowing become apparent. It is a technique immediately apparent in both avant-garde films

and in commercial advertizing and title design for both television and feature film, but was being explored in the 1980s by video artists working with broadcast standard equipment at WGBH in Boston.

Daniel Reeves (1948 –)

Daniel Reeves is an American ex-patriot who moved to Europe, and has lived in Scotland and France since the 1980s; he is research fellow in Visual Communications at the Edinburgh College of Art. His work with video began in 1979, and his early tapes were directly concerned with his experiences as a Vietnam veteran, the best known of which was *Smothering Dreams,* (1981) a video that won three Emmy awards for its portrayal of the war, its aftermath, and the exploration of the foundations of violence in American culture. This critical engagement with American culture and the role of violence in the contemporary world informs his later work.

A Mosaic for the Kali Yuga (1986) was produced at the New Television workshop at WGBH in Boston and broadcast on television in 1986 on the show of the same name that highlighted new media works; (this program was the successor to the earlier video art residencies at the station during the 1960s and 1970s that included the creation of Nam June Paik's Paik/Abe video synthesizer.) Reeve's program breaks the screen into a grid, each section of which contains a piece of a larger, full-screen image that only becomes visible as fragments. The organization of the video proceeds through a complex sequence of "demonstrations" composed around the fragmentation-presentation process, accelerating as it develops.

The significance of the title is reflected in the choices of material shown and in the synchronization between those clips and the soundtrack: the "Kali Yuga" is the fourth age described at the beginning of the Hindu scripture called the Vishnu Purana and is the age identified with vice, immorality and deceit in which people pursue power and material wealth. This book is regarded as the most significant of the Mahapuranas; according to Hinduism, the contemporary world is passing through the *Kali Yuga* age. Existence during this time is devoid of spirituality and the only values people recognize are materialistic—the ownership of property and wealth—making the *Kali Yuga* a period of spiritual darkness. Reeves' choices of imagery for this mosaic appropriate new footage and videos of war, violence and destruction. Central to the whole sequence is then-president Ronald Reagan saying the word "power"; all the footage is looped, creating a kinetic field of violence and destruction.

Reeve's work uses the broadcast studio's digital equipment to produce a work that could also have been done with optical printing, in the process reinforcing the connections between earlier image compositing technology, broadcast design and contemporary motion graphics. The convergence of art and commercial design in the broadcast studio illustrates the shift from artisanal production common to the avant-garde film to the commercial production that is common in motion graphics using digital technology. The historical foundations of both fields combine as digital video becomes the industry standard and desktop computer begin to replace more expensive broadcast equipment during the 1990s. This transition—the

appearance of "desktop video" at the end of the 1980s—marks the consolidation of "motion graphics" as a distinct field from these earlier histories.

DIGITAL VIDEO

Digital video was initially so expensive that only television studios could afford to buy it. However, challenges to this broadcast network exclusivity began almost immediately: Mindi Lipschultz, a producer/director who worked with video and broadcast production starting in 1979, recognized the importance of the digital "revolution" in a 2004 interview with *Creative Compulsive*:

> [In the 1980s] If you wanted to be more creative, you couldn't just add more software to your system. You had to spend hundreds of thousands of dollars and buy a paintbox. If you wanted to do something graphic – an open to a TV show with a lot of layers – you had to go to an editing house and spend over a thousand dollars an hour to do the exact same thing you do now by buying an inexpensive computer and several software programs. Now with *Adobe AfterEffects* and *Photoshop*, you can do everything in one sweep. You can edit, design, animate. You can do 3D or 2D all on your desktop computer at home or in a small office.[35]

The radical reduction in cost that new digital technology brought to digital video began gradually during the 1980s: while complex compositing effects remained a high-cost, relatively difficult procedure, the transition to the desktop video productions of the 1990s began as low cost, small machines designed to perform specialized tasks in the 1980s. These machines, built around the small microchip processors that enabled the micro computer (or desktop) revolution during the 1970s, were appearing the marketplace by 1984. By decade's end, inexpensive systems radically reduced the cost of video compositing, while at the same time simulating the video processing effects developed by the first generation of video artists in the 1960s and 1970s.

The *FairLight CVI*

The first of these "game changers" was the *Computer Video Instrument* made by the Australian company FairLight Instruments, an audio equipment company that was one of the pioneers in the transformation from analog to digital audio during the 1980s. They developed two innovations that transformed music making: the sampler and the sequencer. Following their successful introduction of these digital instruments, the company developed a video device capable of recreating many of the effects pioneered with analog video synthesizers and signal processing in the 1960s and 1970s—but using digital technology. Their *CVI* was a breakthrough in using computers for video production because unlike broadcast standard equipment, it was small, portable and inexpensive—the same features that enabled the Sony *Portapak* to become immediately essential for video artists.

The first version was designed from an earlier experiment that did not go into production, the *Kaleidopen*, that used the same interface as the Fairlight Computer Music Instrument—a light pen. The first *CVI* would retain the stylus as an interface, but using a tablet and sliders instead of the light pen to control the device.

Later models could also be used with a keyboard. Developed by Kia Silverbrook for the *CVI* was commercially released in 1984, and remained in production until 1989, passing through six different models. Initially costing between $5,000 and $6,500 depending on the model, it enabled the production of real time effects, color keying to composite two video signals and animation. The machine was a mixture of analog and digital components: analog video equipment worked in conjunction with a digital buffer that allowed the storage of animation and the generation of video effects in real time (live). It incorporated video effects similar to those produced by the Paik/Abe video synthesizer: chroma keying, mirror effects, and a colorization effect using a palette of 4,000 colors that created highly saturated, bright colors—a characteristic of analog video processing. In addition to these 'standard' video processing effects, the digital frame buffer allowed freeze frames, stretching and zooming the video signal, and brought paintbox effects out of the broadcast studio, allowing electronic drawing and painting to be overlaid on video, enabling both the use of broadcast technologies (colorization and keying effects) and the kinds of visual effects produced by video artists in the 1970s with analog equipment by anyone who ran the device. As Fairlight Instruments technical manager Will Alexander observed, it was a device whose target market was not the broadcast network or TV studio, but the smaller production house with a more limited budget:

> The *CVI* can accomplish many of the same functions as equipment like Quantel and Bosch. But we're obviously not trying to compete with those manufacturers; the *CVI* is a much lower resolution device.[36]

Because it was marketed to smaller production houses—and later acquired by video artists as well—the effects produced by the *CVI* were used in commercial productions: music videos broadcast on the Cable TV station MTV. The *CVI* acted as a "democratizer" of video processing, making the types of visual effects and composite imagery that were only possible in a few places—notably the Experimental TV Center, and stations WGBH and WNET—where video artists worked with custom-built analog processing equipment. Unlike these hacked together electronics, the *CVI* produced a standard video signal, enabling its general use in commercial productions for a mass audience, even though the graphics it generated had a blocky 8-bit appearance. This 'style' rendered by the technical limitations of the *CVI* gave its footage a "look" that was immediately recognizable as being computer generated.

While the *CVI* could produce complex visuals, to run more than one effect at a time required several *CVI*s set in sequence, each performing a single task. Because it developed from the model of a stand-alone musical instrument, rather than a general purpose computer, the *CVI* was conceived as a single unit, complete in itself. At the end of the decade, systems based on the expandable desktop computer—a combination of hardware and software that allowed the same machine to do a variety of different things—were more powerful, more flexible and less expensive alternatives.

The NewTek *VideoToaster*

The *Video Toaster,* created by NewTek for the *Commodore Amiga 2000* computer and introduced in 1990, was designed as a combination of hardware and software that enabled the creation of broadcast quality mattes, masks, and animation using a home computer. As with the Sony Portapak in the 1960s, the *Video Toaster* was available for about $2,400, making it comparable in price to a used car—and thus available for artists to buy and use in their work. Marketed to a "pro-sumer" audience for video production equipment that lay between the expensive, broadcast industry standard and that used by non-professionals, the Video Toaster made studio effects—keying, wipes, etc.—available using a digital computer. The connection of this technology to what was a standard desktop computer provided a model for later developments in the 1990s.

While the video toaster used a digital computer to produce its effects, it remained a specialized combination of hardware and software: video had to be run through the *Toaster's* video digitizer, and as with the *CVI,* the effects it produced were done in real time. The video toaster appeared shortly before Adobe began releasing it's software that would quickly become the standard for smaller production houses, and would be embraced by the industry as a whole by 2000.

The software produced by the Adobe company incorporated many of the effects and features of earlier systems into single, expandable software packages that enabled the fluid movement between still image and motion image. With the introduction of *Adobe Photoshop* (1990), *Adobe Premiere* (1991) and *Adobe AfterEffects* (1992), digital technology gave artists the ability to manipulate video in the same way as film, on a frame-by-frame basis, by hand, but with the additional capacity to alter entire sequences all at once, in the manner of a video synthesizer, presented the same ease of access offered by the Sony *Portapak.* Motion designer David Robbins explained the importance of this software for the commercial expansion of motion graphics by 1995 in his book *Motion By Design:*

> The Apple Macintosh computer was fast becoming a design fixture in most commercial art departments. It had changed how projects were designed, from a standard of atoms where tactile things are used in the paste-up/mechanicals process, to bits where these things could be manipulated instantly on a computer, allowing greater precision and whole new vistas of design approaches. ... [In 1995] MACs and PCs had become more powerful and faster in the corporate world, while much of academia was still sitting on the fence about graphic technology. Graphics-oriented software had been designed to take advantage of this speed and economy of production. ... Since the early 1990s *Illustrator* and *Photoshop* had allowed designers to re-conceptualize type and therefore nearly to redefine its graphic appearance. By 1995 Adobe's *AfterEffects* was fully in use in the making of broadcast motion graphics.[37]

Adobe software was initially used in graphic design, and its expansion into photographic imaging, followed quickly by motion, is a prime example of the "convergence" that digital technology had on existing, discrete, industries. While the early versions of these programs were hindered by the limited computational power available in the early 1990s and by the difficulties of acquiring digital video,

within five years their impact would be appearing in the commercial world, and within ten their effect would be apparent in video art as well. Because computers' apparently different functions—among them being a word processor, video editor, or communications medium—are all a simulation, the ability to move between what were individual, independent and incompatible technologies is an inherent potential once those industries engage with using digital computers. To a computer, there is no inherent difference between a static and a moving image; it is simply a matter of how the data file is displayed, making the combination of photography, animation and typography with computers simply one potential that was waiting to be developed.

This digital convergence, a hybridity of formerly distinct media united thorough common technology, is the essential feature of contemporary motion graphics. The aesthetic problems that formerly occupied the designer's attention—the ability to produce combinations of image, text and animation—shifted in the convergent era of the 1990s to become first an exploration of unprecedented complexity: the blending of animation, special effect graphics, typography and live action into dense images filled with motion and typography, followed by a period of simplification coupled with fluid movement between drawn animation graphics and realistic live action: a shift from one extreme to the other in terms of visual complexity, but at the same time, a reflection of greater computing power enabling greater degrees of photographic realism in computer generated imagery. The linkage between what can be feasibly done with available technology, (both with the allocated budget and within the available time frame of deadlines and production schedules), and the types of motion graphics executed for any given commercial project has always been an explicit limit on the style and form of commercial production. This process began in the early 1960s with the first computer films made using digital technology. The aesthetic impact of increased access to powerful computers, hardware and software is directly apparent in the kinds of motion graphics being designed, their visual complexity, and their degree of realism.

07

FEATURE FILM TITLE DESIGN

Kinetic typography, coupled with the heritage of the abstract, synaesthetic motion picture, defines the field of motion graphics. Just as the abstract film emerged from the heritage of color organs and abstract painting, motion type first appeared in the silent film. By 1920 typography on screen had established the parameters of how it functioned in film: developing initially as both the "title card" required by the US Patent and Copyright Office for identification of unique film works, and as the intertitle used to convey dialog and other written or verbal information during the "silent era," text on screen and animated lettering were part of the structure and organization of narrative cinema from its beginnings. This rapid emergence came as a direct result of the commercial and dramatic pressures placed on early film production to tell stories—but to do so without spoken language. Because early film did not allow for the synchronous recording of speech, typography filled the role of speech in film narrative structure. In the later silent films of the 1910s and 1920s, the arrangement and type styles used to show dialogue and other speech would provide details about how the words were being said.

Both title cards and intertitles were initially conceived as static, reflective designs filmed and presented on screen as graphic compositions shown at the appropriate moment, but kinetic typography is an inherent potential in motion pictures: any time text appears on screen, there is the possibility to animate it. In the early years of film production, these graphic designs only rarely included motion, but would often include decorative elements (borders and art type faces) as well as linear drawings or other visual art to embellish the static typographic designs. The ability to have characters actually speak to each other did not become a part of standard film production and exhibition until *The Jazz Singer* in 1927—more than thirty years after Auguste and Louis Lumière had their first commercial film screening in 1895, and approximately fifteen years after Hollywood made the transition from producing short subject films to the longer features. It is during this time, running from 1915 to 1927, that feature films achieved epic lengths—D. W. Griffith's *The Birth of a Nation*, the film which began this process in 1914, was more than three hours long; Erich von Stroheim's *Greed* (1924) had an initial running time of more than ten hours. The silent era succeeded in telling the highly complex stories in pantomime, using only on-screen typography.

AMERICAN FEATURE TITLE DESIGN PERIODS

Early (Experimental) Period	(beginning until ~1915)
Silent Period	(until ~1927)
Studio Period	(until ~1955)
Designer Period	(until ~1977)
Logo Period	(until ~1995)
Contemporary Designer Period	(1995 to present)

Feature film title sequences are probably the single highest-profile, most apparent overlap between the commercial and art world applications of motion graphics. The history of the title sequence in motion pictures can be broken into a series of distinct periods that do not always have clear transition points. For most of the history of title design there were only two main technologies for the production of title sequences: elements that were shot with an animation stand, then either combined with other footage in the printing of the release prints, or the use of optical printing to combine different visual materials into a singular film strip.

The first titles serve the functional purpose of securing copyright in the silent era; the earliest record of a film title is for Edison's film, *Dickson Greeting* (1891), an experiment filmed at Edison's laboratory in West Orange, New Jersey on May 20, 1891.[1] This title simply serves to identify the particular production for its registry at the copyright office; actually "titled" film production does not begin until 1893 when Edison began to market his new invention, the kinetoscope. During this first phase, the titles are, like all aspects of early film, an arena of experimentation. These earliest titles and their gradual lengthening and development move without a clear transition from the Early Phase into the longer, more complex narratives of feature films. The shifts to accommodate the production system of the studio period necessarily employ several different styles of typography for intertitles and title cards in the elaboration of credits, narrative, and dialogue.

Pacific Title and Art Studio, Inc. (sometimes called *"Pac Title"* or credited as *"Pacific Title"*) was founded in 1919 by animator Leon Schlesinger, the producer better known for his animated films produced for Warner Brothers in the 1930s. This company, which began producing title cards and intertitles for silent films went bankrupt in 2009 as a result of the financial crisis that started in 2008. It was the first and longest lasting specialty production house for title design in Hollywood. While it produced titles for many films and TV shows, including the features *The Jazz Singer* (1927), *King Kong* (1933), *Gone With the Wind* (1939), *Ben Hur* (1951) and on TV shows such as *The Twilight Zone* (1959), it was also the training

ground for title designer Wayne Fitzgerald. While Pacific Title was prolific in the production of titles, it was rarely credited, and the designers who employed there did not receive credit for their work. This lack of on-screen credit for title design was typical for Hollywood productions prior to the Designer Period; it is only in the Contemporary Period that credits have become common.

The studio period of the 1920s, whose ending blurs into the talkies of the 1930s and 1940s shares with the silent era both the techniques of production, and the common stylistic organization of titles typically superimposed over some type of background art—whether a static title card or other visual—kept within a strictly regimented block of time. The design of a master title card functioned as a graphic emblem for the title sequence design, and in cases such as *Dracula* (1931), for some of the poster designs used in advertizing the film. The master title card's visual style provided continuity throughout the title sequence is the most common technique of title design, remaining the primary method used from the silent era into the 1940s; combined with B-roll, or burn-in titles that would be produced while making the final release print, it is the dominant mode, both technical and aesthetic, for title design into the 1980s. By the 1930s, the design and use of the title card as a background for B-roll titling had also become common. Instead of shooting a live action long take, an extended take of a primary title card would provide the "live" background element for typography printed using B-roll or optically combined with a projection printer.

Connections between title sequences and the film narrative are uncommon in feature film production, but in the *"2-reeler"* (or film serial), the titles credit the production crew, actors, and provide essential stage-setting for the narrative that follows: each storyline was structured as a 'cliff hanger' leaving hero or heroine in danger at the end of the episode, these dangers are immediately resolved at the start of the next installment. Understanding this on-going story poses specific narrative requirements on how the story 'picked up' from the earlier "chapter." It is precisely because the serial films represent only brief installments of an on-going narrative, within a limited amount of screen time (typically 30 minutes or less), that the titles developed as a combination of credits and back-story. The integrative techniques developed in titles sequences for serial films exert little apparent influence on titles used by TV serials until after the 1960s.

The shift from the "talkies" of the studio period to the progressively longer, graphic, animated titles produced from the 1950s through 1970s marks the emergence of the credited title designer and the recognition of the title sequence as a specific element in the film production; however, there are abundant examples of complex title sequences employing animation, B-roll, and even optical effects throughout the 1920s, 1930s and 1940s—the period before the spectacular animated titles produced by credited, "star" designers became a significant element in film production.

The integration of animation with static title elements is not unusual for title sequences in Hollywood films: because the text for titles was almost always filmed on an animation stand using standard cel animation techniques, the addition of motion and animation to the titles was inherently a potential for their production, limited only by the available production time and budget constraints. Because animation requires more production time than either live action or filming what are

essentially still images of typography, the industrial schedule employed by the studio system was often a limiting factor on how much could be done, and how complex a title sequence in the 1920s and 1930s could be, as Oskar Fischinger's experience with running out of time to correct design flaws in his titles for *The Big Broadcast of 1937* so effectively demonstrates.[2] The result of these constraints was a limited range of motion effects in any given title sequence: the "scroll" where credits run up the screen in a column, still a common feature in titles, developed as a way to reduce the amount of screen time needed for a title sequence. As with the use of B-roll titles added during the production of an answer print, the text scroll and optical printer introduced animated elements into what might otherwise have been very static. The design problem posed by text-on-screen provides continuity across the entire history of kinetic typography. This prehistory to the animated title sequences of the 1950s gives context to the emergence of Saul Bass, Maurice Binder, and Pablo Ferro, as well as defines the technical dimensions employed in their title designs; their innovations are primarily stylistic.

During the 1970s there were two parallel developments as the Hollywood studios addressed the challenges posed by foreign films, a new "rating" system, and renewed competition from independent production companies. The integration of the credits superimposed over the opening scenes of the film, with no particular "title" design elements as the complex, lengthy title sequences produced by high profile designers became less common in studio productions; at the same time, and overlapping to a degree with this approach, was the development of a title-logo that would appear in both print and in the film. The shift from designer title sequences to the various alternatives, chiefly the "logo opening" commonly used by independent producers in the 1960s, was an attempt to assimilate these challenges within the studio system itself. There are numerous examples during this transitional period, including *The Godfather* (1972) and Dan Perri's logo design for the 1977 film *Star Wars*; however, in the case of *The Godfather* the title is still placed at the beginning of the film, and in *Star Wars* it is part of a longer opening. By 1984, designers Nina Saxon and Richard Morrison had transformed the opening titles so the title-logo was placed apart from the rest of the credits, which then disappear into the body of the narrative. The direct heritage of this approach is the dispersal of the credits into the opening scenes of the film, with only minimal apparent "design."

The lengthy title sequence that stands apart from the main narrative, as an obviously designed production, does not reappear until 1995 with the sequence designed by Kyle Cooper for *Se7en*, after which the designer title sequence becomes an increasingly common part of film production. The "return" of the title designer these titles signify comes during the transition from the physical manipulation of animation, optical printing and B-roll in the production of title designs, to the use of a digital tool set whose direct ancestors lie with the various computer-video combinations of the 1970s and 1980s.

Understanding the history and development of kinetic typography in motion graphics depends on the particular technology utilized, the specific context of when the titles were being produced, as well as the production constraints imposed by the legal contracts of the actors, producers, director and technical staff—always limited by the funding set aside to create these elements for the finished motion picture.

Earlier approaches and design solutions persist throughout the entire history of title design—the transitions points from one "period" to the next are less a matter of abrupt rupture with the past than the emergence of a new solution.

THE EARLY (EXPERIMENTAL) PERIOD

The first period of title design was essentially experimental—as were all elements of the newly invented technology and art. It is distinguished by a rapid process of invention and the adaptation of various solutions throughout the emergent film industry. As the first short films grew steadily longer, the transition point between the "early" period where films were predominately shorts, and the later, "silent" period, characterized by the creation of "feature length" films that posed more complex demands on the use of text-on-screen as both titles and intertitles.

The history of the title sequence began with Thomas Edison's concerns about piracy and securing the ownership of the films he was making at his Black Maria studio in New Jersey. The securing of patent rights for the kinetoscope technology and copyrights for the media played by those machines were both part of Edison's standard procedures with all his inventions. Edison's film company spent the first decades of the twentieth century engaged in a losing battle with competing motion picture companies and theaters showing pirated film prints. The initial development of the "title" in motion pictures was result of the US Copyright Office demand that to copyright a film work, even as a paper print, required that the work have a specific title to distinguish it from other copyrighted works. To protect these early films, the US Copyright Office required that each production have a unique identifier—a title—and that a copy be stored with the copyright office itself; however, since early nitrate film stock was highly flammable, actual film prints were not accepted—instead, a copy would be printed onto paper and these were stored instead. The "paper prints" of early films were then recorded as photographs in the copyright office's records; the acceptance and storage of paper prints continued until 1912 when the copyright office changed its policies.

The films preserved in the paper print collection represent two distinct periods of motion picture production: the first period that began in 1893 with Edison's "kinetoscope"—essentially a "peep show" where viewers looked into a freestanding machine, watching the film directly—and the later "vitascope" productions that were shown in a theatrical setting to a large audience. The transition in the United States from "peep show" to theatrical presentation happened rapidly; theatrical projection had become the international standard by 1900 following Louis and Auguste Lumière's historic presentation of actualities to a theatrical audience on December 28, 1895 in Paris.

Humorous Phases of Funny Faces (1906) animated by James Stuart Blackton (1875 – 1941) at Thomas Edison's Vitagraph Company demonstrates the presence of complex, animated title sequences in motion pictures during the earliest years of film production3; these early films reveal the process of development for titles, intertitles and motion graphics. The combination of stop motion, puppetry and live action used to produce this film resulted in a very popular film, one of the earliest

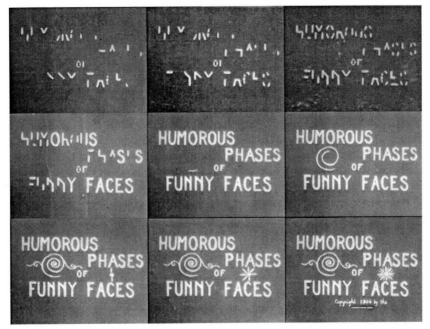

Stuart Blackton, *Humorous Phases of Funny Faces*, Vitagraph Company, 1906

examples of animated film. Prior to working at Edison's studio, Blackton had worked as "lightning sketch" artist in a vaudeville act drawing, then quickly changing his drawings done with an easel pad on stage, then as a newspaper sketch artist for the New York Evening World. He became involved with Edison's studio after being sent there to cover it for a news story.

The title sequence for *Humorous Phases of Funny Faces* is an unusual for a film from the beginning of cinema; it is one of the earliest that engages in the production of a graphic, animated title sequence. The sequence runs a total of approximately 20 seconds in a short one-reeler whose total running time is under three minutes. Their design is a significant part of the animated piece, since the complexity of the titles is greater than the complexity of the animated faces (which combine stop motion and live action). In the title sequence, the film begins with an abstract pattern of vertical and diagonal slashes that are progressively added to—resulting in a sequence of abstract designs anticipating the much later broken typography of David Colley's titles for *Alien* (1979). This decomposition-reassembly of typography as the animation for the title sequence is unusually Modernist for 1906: the letterforms are sans serif, hand drawn, (but resembling Helvetica), and do not "write" themselves on screen; instead, the complete title "HUMOROUR PHASES OF FUNNY FACES" suddenly emerges, half way through the titles. The remaining run time in the sequence presents first a spiral decoration, then a star, and finally the copyright in small type at the bottom of the screen. The appearance of an animated title sequence, while unusual for this period, is simply an extension of the animation techniques being used to create the "funny faces" that are the main subject of the trick film itself: a mixture of stop motion animation and live action where Blackton draws the faces live, then they become animated using the camera "trick" of stop

motion. This close association between aesthetics, technology and the context of the titles in the production as a whole defines the title sequence and the history of kinetic typography.

THE SILENT PERIOD

The Silent Period was never actually *silent*: music, actors performing dialogue and other kinds of accompaniment remained common until the 1920s. This period begins with the production of feature-length films in the early 1910s. The distincts between the first titles produced during this period and the Eaerly Period are minor: refinements of form and a consolidation of functions between the titles used as credits and the titles used to convey non-diegetic information, such as dialogue. These films often fused their opening sections exposition with the opening credits and the start of the film.

The silent era produced both the title sequence and intertitles at the same time, developing them in tandem as distinct elements of the film's construction. The use of intertitles can be recognized as emergent within even the earliest title sequences through the basic function of the intertitle within the film: as a necessary informational device that enables the audience to remain cognizant of what is happening on screen; their branching into distinct roles within the silent cinema—as narrative or dialogue—each with its own on screen graphic form and character is a reflection of the complexity surrounding the intertitle. By the 1920s, the intertitles had evolved into an integral part of the silent cinema, essential to both the dramatic action and the visual language of the silent film.

The Birth of a Nation (1915), pioneering director D.W. Griffith's infamous film, was originally titled The Clansman. In the first fifteen minutes presents on screen text in a variety of styles, each of which corresponds to a different narrative function: titles, narration, dialog and diegetic text (written correspondence for example). The distinct visual style of the other uses allows the seamless identification of what the text represents: the non-diegetic text presented as the title sequence, historical narration, and transitional text all employ the same design. The term "title card" originates with this production technique: white text on black. In *The Birth of a Nation,* the title cards are contained inside a stylized, Art Nouveau-esque frame and dialog is identified by quotation marks, and always follows the sight of someone speaking on screen; diegetic type is similarly accompanied by images of someone looking at a letter.

The Birth of a Nation has an extensive opening credit scroll for "The Players" that lists the actors in the film. What is notable about this opening is the lack of credits for the production personnel; they are not credited at the end of the film either—the final closing credits consist of an epigraph about Freedom and Liberty, followed by a single card stating "The End." This format for organizing the titles in a film—putting all the credits at the beginning, and then closing with a "The End" title becomes the standard titling method common to Hollywood film.

The Cat and the Canary (1927) has a title sequence designed by Walter Anthony (1876 – 1945); he receives on-screen credit for his design. Because the role

Title card, *The Birth of a Nation*, 1915

of typography and title/intertitle design in silent films is an important part of their narrative form, this crediting of a title designer is uncommon during the silent era; Anthony worked at Universal Pictures, a studio notable for producing elaborate title sequences, as a screenwriter, intertitle writer and title sequence designer from 1926 to 1930. His roles as screenwriter, intertitle writer and title sequence designer were recognized as being closely related—since all three were concerned with the organization of the story and its telling on screen. The integration of the title sequence into the design of the intertitles is a common feature of the silent era.

These titles for *The Cat and the Canary* blended an opening sequence that began with a dusty box marked with the film's title and cob-webby shots with B-roll text—each of which dissolves into the next—concluding with a title listing "The Players." The expository narrative works through a series of paired intertitles and images. It begins by pairing a literary description, "On a lonely pine-clad hill overlooking the Hudson stood the grotesque mansion of an eccentric millionaire," with a matte painting of a Gothic mansion; a few seconds after the cut, an old man sitting in an elaborate chair appears inside the space of the building. The old man in the chair provides continuity through the introductory sequence that follows. He is surrounded by bottles, then another intertitle explains the premise of the film—that his greedy relatives are (metaphorically) cats pawing at him for his money—a description visibly illustrated by black cats pawing at something unseen, but in the combination of shots appears they are pawing at him. These opening images and intertitles establish the backstory to the narrative. This intermingling of images and text as opening exposition is an element of the silent era that remains in use even after the transition to optical sound starting in 1927; these opening narrative

intertitles become a key element in the design of the title sequence, bridging the space between it and the film that follows.

THE STUDIO PERIOD

In the 1920s and 1930s titles sequences for Hollywood films were produced using a range of techniques, often in combination: title cards and other still materials shot with an animation stand, live action generally filmed as a long take and used in B-roll title printing, and by the end of the 1920s these titles also included a broad range of optical printing effects (wipes, dissolves, matte effects), and superimpositions (not just as a burn-in for type). This full complement of techniques were in common use in the Hollywood title sequence by 1931.

White Zombie (1931) directly integrates the title sequence into the following narrative; in the pre-World War II period it is an atypical, unusual approach to title design. The film opens with a single long take showing group of figures burying a coffin at a crossroads in extreme long shot. The soundtrack is dominated by a vodun chant which is apparently synchronous to the picture since the figures clearly move on beat. Superimposed over this 2 minute long scene are the B-roll titles. There are several important features to this sequence: the title "*White Zombie*" is made from 3D animated letters that zoom up into the screen, and the scene shown does not end when the titles end—it is actually the first shot of the narrative, and is explained by the dialog that follows—the audience is put in the position of the characters waiting for the funeral to end, essentially watching the burial (and the titles) opens the drama, and hints at what is to come later: the white zombie eponymously in the title.

Title card, *White Zombie*, 1932

The Mummy (1932) incorporates a combination of three-dimensional models, sculptural typography, and B-roll; it is composed from two distinct shots: a model of the Giza plateau, followed by a live action shot of a hieroglyphic wall and burning incense. This construction of models with the main title literally attached to the side of the great pyramid produces a dramatic effect anticipating the later development of longer, more complex title sequences. The limitations of the period—strictly set timing for the titles, scheduling and budget—often resulted in openings that did not use such complexity in their production design. Directly following the title sequence fade out is the "Scroll of Thoth" that starts the actual film narrative. The titles explain the significance of this document (shown on screen), implying the role it will play in the drama that follows. The presentation of this information at the onset of the narrative establishes the parameters for events that follow. These secondary titles originate with the interstitial titles of the silent period, providing narrative and contextual information essential to understanding the dramatic narrative of the film itself. Their inclusion at the start of the film is redundant with events shown on screen since the nature and significance of the "Scroll of Thoth" is apparent from the discussions about it and its role in the story.

Duck Soup (1933) is a more typical approach to the title sequence, one with a clear distinctions between titles and narrative. As in *White Zombie,* a long take of four ducks swimming in a large cooking pot, provides a background for B-roll titles. However, following the first part of opening titles, this shot dissolves into a limited animation under the heading "The Players" that identifies each of the four Marx Brothers—Groucho, Harpo, Chico and Zeppo—as a duck with a human face. After this brief animated interlude, the titles return to the ducks in a pot with more B-roll text. The end of these titles is a fade out, followed by a fade in on an expository text setting the scene for the comedy. The clear demarcation between opening titles and following narrative enables this sequence to simultaneously reflect upon the film's action while at the same time being detached from it, a self-contained sequence in itself. This separation of titles from narrative sets the stage for the emergence of title designers as creative actors whose work parallels the director in the production of the main narrative.

My Man Godfrey (1936) employs a standard cell animation in the design of its titles, but with a key shift at the end of the sequence: as the titles pan across a series of lighted signs that display the credits of actors and production crew, it moves from "high society" to a Hooverville built beneath the Brooklyn Bridge, ultimately dissolving from the painted background of the titles to a live action shot of the Hooverville in a graphic match, creating a direct connection between the title sequence and the opening action of the film. The flow from titles into film is seamless.

Citizen Kane (1941) integrates its titles completely into the narrative of the film, creating an exceptionally brief title sequence. In the typical opening titles of the 1930s and 1940s interstitial materials following the credits that establish the narrative and fictional "space" are clearly identified, yet in *Citizen Kane* they are integrated not only with the opening scenes of the narrative, but with "newsreel"

The only title cards shown in *Citizen Kane*, RKO 1941

that follows. The organization of these opening materials is as follows: title cards, tonal montage, newsreel, reporters talking about the newsreel which starts the narrative. This integration was designed to confuse fiction and reality; the "interstitials" do not resemble an interstitial from earlier films. The news reel includes a combination of fictional live action footage, unaltered documentary footage, and staged footage that inserted Welles-as-Kane into historical events to create an extended opening sequence with a compelling documentary effect.

The precedent for this opening lies with Orson Welles' 1938 radio broadcast of *The War of the Worlds*. The concept of that production where the fictional narrative

was set up and presented as a news story is the model for the newsreel in Citizen Kane. His radio program simulated a real news broadcast so well it caused a panic among listeners who tuned in late and did not realize they were hearing a work of fiction. The obfuscation of fiction and reality in this opening sequence is not limited to the structure and organization of the newsreel in isolation; it reflects a careful consideration of how the film would be shown in theaters in 1941, and incorporates this knowledge into the design of the opening sequence.

The connections between Welles' film and the earlier radio program are explicitly acknowledged in the opening title sequence where there are only two titles: "*A Mercury Production by Orson Welles,*" followed by the main title "*Citizen Kane.*" The "*Mercury Theater*" was the ensemble cast Welles' assembled for both his 1938 radio broadcast and used again in his 1941 film. The authorial proclamation at the start is highly unusual for a Hollywood studio production during the 1930s and 1940s, itself indicative of the difference between Welles' film and other, more standard, studio productions.

The opening sequence in *Citizen Kane* was designed to create a confusion of fiction and reality similar to what he did in his 1938 radio broadcast of *War of the Worlds* on Halloween where the radioplay pretended to be a news broadcast. This confusion depends on how films were shown in movie theaters in the early 1940s. Theatrical film programs typically shown in movie theaters during this time included a number of short subject films (cartoons, movie serials, and news reels) that would run before the main attraction. The organization of the start of *Citizen Kane* is significant: in place of the 60 to 90 seconds of titles and opening materials, there was only a minimal title, followed by a tonal montage set to music and what appeared to be a newsreel, the opening to *Citizen Kane* creates the potential for confusion about whether the "*News on the March*" sequence is an actual newsreel, or a fictional part of the feature itself. The creation of an instructional "film" within the main feature is an exaggeration of a technique common to other Hollywood films—the "scroll of Thoth" in *The Mummy*, or the epigraph after the credits in *King Kong* (1933), and the opening scenes of *The Cat and the Canary* all provide the same narrative function. These opening materials serve as preamble to the mystery story the newspaper reporter follows throughout the remainder of the film, as with the connection of opening title animation to opening shot in *My Man Godfrey*; the difference between them is the opening to *Citizen Kane* is fully integrated into the dramatic narrative, occupying nearly twelve minutes of screen time and laying out essential biographical details for the investigation of "rosebud" and Charles Foster Kane that follows.

These opening sequences, rather than providing information about the cast and crew responsible for the production, work to set the tone and establish the mood for the investigation that forms the plot's core. The overtones of the opening, both directly and indirectly, are exclusionary; silent. Kane speaks during the newsreel only once—towards its end—his appearance throughout being as a visual enigma, silent, like the opening montage. It is the direct transition from the "*Citizen Kane*" title card to the tonal montage sequence which opens with the *Keep Out* sign, and then proceeds through a series of graphic-match dissolves towards the distant lighted window, an approach that by degrees moves through walled gardens, a bestiary, a venetian canal, and finally more gardens to approach the window where

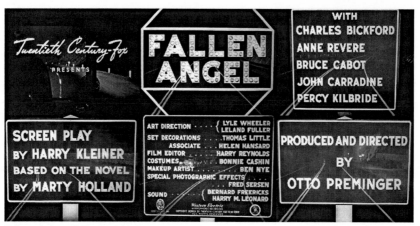

Title cards from *Fallen Angel*, 1945.

suddenly the light goes out. The connecting graphic match from outside the darkened window into the dark interior with a lighted window resumes the forward motion of this sequence. This use of the title sequence as a technique in service of the dramatic action, rather than the presentation of production information becomes increasingly common to the design of an opening sequence during the Designer Period.

Hollywood in the 1940s saw an influx of producer/directors whose work was different from that of the standard studio production. Otto Preminger, Alfred Hitchcock and Billy Wilder arrived in this period and used different kinds of title sequence than what was common in the 1930s. Their interests would lead to the emergence of the designer title sequence in the 1950s; all three directors would hire Saul Bass early in his career to produce distinctive titles for their films.

Otto Preminger's film *Fallen Angel* (1945) suggests the changes in the role and organization of the titles in the 1950s: the opening titles are clearly linked to their context within the film. This title sequence is composed from superimpositions that are worked into a long take looking out the front of a bus as it drives on the highway at night. Each title "card" is actually a road sign with the titles written out in Highway Gothic, complete with reflectors. Otto Preminger, the director for *Fallen Angel*, is one of the filmmakers exploring the title sequence as a part of a unified concept in film design; his other films also employ titles integrated into the narrative context—*Where the Sidewalk Ends* (1950) writes its titles on the sideway. In a similar fashion, Billy Wilder's *Sunset Boulevard* (1950) puts the titles onto the road behind a car. The integration of the titles on a conceptual level into the opening sequence—road signs used in a long take watching the highway at night, or written on the sidewalk—prefigures the transition to the graphic animated titles characteristic of the designer title sequences.

THE DESIGNER PERIOD

The studio period title sequences made during the 1930s and 1940s tended to run approximately 1 minute, gradually lengthening to 2 minutes by 1950. Their

format and design depended on a combination of factors, most significantly, the director in charge of the film. The graphic animated titles that mark the stylistic shift of the 1950s would be a change in degree, rather than a revolution in aesthetics, resulting in film openings of rapidly increasing complexity between the 1950s and 1970s, but remaining within the time constraints operative in the studio period. Even though this period marked the first appearance of the credited title designer, most title designs went uncredited on screen. The Designer Period is divided into three phases:

(1) The **Early Phase** where the conception of the title design is closely associated with Modernist graphic design work, and is "signed" in the same way that Paul Rand and Alvin Lustig signed their designs.

(2) The **Middle Phase** in which the designs become increasingly long and are overtly concerned with the creation of "spectacle" and spectacular, complex openings.

(3) The **Late Phase** during which the "signature" nature of the designer's work is in decline, and the dominant concern of the design is less with a Modernist idiom than the construction of an integrated linkage between the design and the film.

The Early Phase is very closely associated with the Modernist-informed, graphic animated sequences produced by Saul Bass, and the transition to the Middle Phase from this Early Phase comes as a direct result of other designers seeking to distance their work and approach to the title sequence from the graphic approach so closely associated with the Modernist idiom Bass employed. At the same time, during this Middle Phase the title sequence grew progressively longer and more elaborate, producing what were, by 1963, short animated films—as in *It's A Mad, Mad, Mad, Mad World* (released November 7, 1963) and *The Pink Panther* (released January 9, 1964)—around the credits themselves. The decline characteristic of the Late Phase is apparent in the shifting style and form of the titles themselves—instead of the designer being responsible for a "signature style," they work in protean fashion, changing technique, conceptual approach and style with each new design—as well as the introduction of the first "logo" based designs where the credits were withheld until the end of the film.

After World War II and the resumption of normal commercial activity in the United States, there was a general shift from the realism that dominated the American art world during the 1930s towards the previously rejected abstract Modernism developed in Europe between the wars. This transformation was already underway in the graphic design work done in the 1930s, and post-war it became part of popular culture: the demand was to be "new"—which meant Modern (and by extension, abstract.) These transformations found their greatest popular supporters on television, especially at CBS' design department under the leadership of William Golden.

At the beginning of the 1950s film confronted a new competitor for what had previously been a captive audience's attention: the broad introduction of television to American households. The transition from the Studio Period to the Designer Title Period reflects the immediate impact early television had on the motion

picture industry. Their relationship was complex; initially threatened when TV began full time broadcasting after the war, by 1955, the film studios had not only embraced TV as a way to redistribute their "back catalog" of older films made before the war, they were producing filmed programs specifically for broadcast by the new medium. Yet the film industry that most visibly reveals the competitive impact of television was the newsreel: *The March of Time,* the last of the newsreel companies to begin production (1935) was also the first to end its run in 1951. The other newsreel companies, attached to major theatrical production studios lasted only slightly longer. *Pathé,* a French film company that began its news production in 1910, ended in 1956; *Hearst Metrotone News (News of the Day,* after 1936) produced in conjunction with William Randolph Hearst's newspaper network—begun in 1914, ended in 1967—was distributed by Metro-Goldwyn-Mayer. The American studios' own newsreel productions all end production by 1967: *Paramount* (1927 to 1957), *Fox Movietone News* (1928 to 1963), and *Universal Newsreel* (1929 to 1967); the end of the theatrical newsreels marks the triumph of Broadcast/Network TV and the end of the production code for Hollywood feature films; the MPAA ratings system would come into effect on November 1, 1968.

In the context of this increasingly close engagement, the emergence of Modernist designs in promotional materials and title designs by the film industry should not surprise anyone. However, the challenge posed by television is apparent in variety of factors that include the change to various panoramic, wide-screen format films, the transition from primarily black and white to color film production, and improvements in sound reproduction; Studios did work to differentiate the feature film from the smaller-scale productions of television, resulting in technical and aesthetic changes to what films looked like, making the differences between feature films and TV immediately obvious to 1950s audiences. the rise of the credited title designer is part of this transformation, indicative of the reconsideration of basic assumptions about how feature films were produced and exhibited. It is a change in degree and emphasis, rather than a technological or aesthetic "revolution."

The development of the extended title sequence was part of this shift, and the emergence of the designer title sequence belongs to these innovations and Modernization of film design. Director Otto Preminger was working towards the creation of title sequences that were engaged with the dramatic content of the film throughout the 1940s and 1950s; these earlier title sequences, uncredited, anticipate the recognition given to design work done by Saul Bass. The invention of the 'title designer' can be precisely dated to 1954 when Bass designed the first of these credited title sequences for Preminger's film *Carmen Jones;* the period itself fully begins with the next title design Bass executed for Preminger in *The Man With The Golden Arm* (1955). The end of the studio approach came gradually, as the significance of the opening title sequence became apparent; the emergence of the title designer was less a matter of a new approach to title design than the decision to acknowledge the design work already being done in the production of titles. This recognition was symptomatic of the changes in studio production happening throughout the 1950s.

Saul Bass (1920 – 1996)

Saul Bass was the first of the new "title designers" to emerge, moving to Hollywood in 1946 after spending time in New York as a student working and learning graphic design. Once in Hollywood, he worked as a graphic designer, title designer, visual consultant, and director of both short films and one feature, reflecting the basic paradigm shifts underway in the 1950s and continuing through the 1970s as Hollywood production abandoned the industrial model of the studio system. He would ultimately produce fifty-nine title sequences between 1954 and 1996, revealing the influence of Modernist graphic design in his engagement with both static and motion elements on screen. These transfers between screen and print are apparent in the form and style of the work he is best known for producing: highly graphic, animated designs that translated the types of Modernist forms used in print by designers, such as Paul Rand and Alvin Lustig, into motion. Bass was principally responsible for the "title designer" as a major role in media production, and the field of motion graphics was partly defined by his work.

Before working in film as a title designer, he trained in graphic design as a part-time student at the *Art Student's League* in New York with Howard Trafton, then at the Brooklyn College under György Kepes from 1944 to 1945. Kepes' influence on Bass is apparent in his embrace of the highly minimal, geometric Modernism characteristic of the Bauhaus. It is through this relationship to the aesthetics of print that his work brought a new design aesthetic to the production of animated film titles. His first film project with Otto Preminger was as a graphic designer. He produced an advertizing poster for the film *Carmen Jones* (1954). When he was hired to adapt this design for the credits of the film itself was the beginning of his work as a title designer; Bass was hired again on Preminger's next film to create another poster, this time for *The Man With The Golden Arm* (1955). He would collaborate with Preminger on a total of thirteen films. As before, he subsequently animated his poster design for the main title sequence, again receiving on-screen credit as the titles' designer. The animation itself was executed by the UPA company, and it was through that connection that Bass would meet the abstract filmmaker John Whitney. While *The Man With The Golden Arm* made Bass into the first of the title designers to become a "star," even before the success of this title sequence he was working on other title sequences that collectively established his reputation: Robert Aldrich's *The Big Knife* (1955) and *Attack!* (1956), Jose Ferrer's *The Shrike* (1955) and Billy Wilder's *The Seven Year Itch* (1955). Bass would produce the majority of his film titles during the 1950s and early 1960s. It is this period when he established himself as the premiere title designer, and had designed sixteen title sequences, often with associated print campaigns, between 1954 and the end of 1957, and a total of thirty-eight by 1970, more than half his career total.

The title sequence for *The Man With The Golden Arm* (1955) marks the arrival of the Designer Title Period. In the accompanying print campaign the images of the stars were either eliminated or minimized, allowing Bass' iconic form to dominate; as with Preminger's titles for *Fallen Angel*, the design and visual content of the titles reflects elements of the dramatic narrative, as Bass explained about his design concept for the original poster:

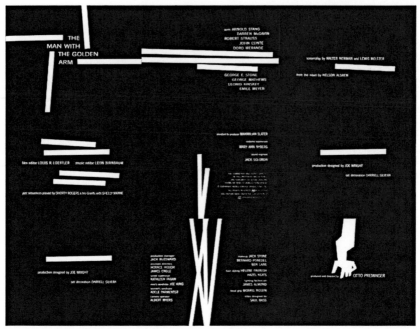

Saul Bass, title cards for *The Man With The Golden Arm,* 1955

> *The Man With the Golden Arm* was a film about drug addiction, and the jigged
> form of the arm expressed the jarring disjointing that exist in a drug addict
> which expressed the climax of the film.[4]

The film was an adaptation of Nelson Algren's novel that focused on the taboo of
drug addiction. It is a design that obliquely referenced its content—abstracting the
references to heroin into a more conceptual engagement with the subject while still
confronting its content through the contorted shape of the arm itself; this story of a
Jazz musician struggling with his drug addiction is reflected by the implied violence
of the graphics. Unlike Preminger's earlier design for *Fallen Angel* where road signs
combined with a long take watching the bus navigate the road is obvious, perhaps
even cliché, the titles designed by Bass are more conceptual in their sourcing and
Modernist in design. The limited formal vocabulary of lines, sans serif type and
graphic composition mark these titles as belonging to the International Style that
emerged as the dominant post-war graphic design school.

At the same time, these titles draw on a specifically American Modernist
source: the painting of Stuart Davis, whose combinations of flat graphic planes and
sharply cut angles evoke Jazz both indirectly through their visual form, and directly
via their titles, (combined with the American version of International Style
common to graphic design in the 1940s and 1950s). Thus while the design is
specifically Modernist, its references make the meaning apparent to knowledgeable
audience members: the connection of painting concerned with Jazz to a film
narrative concerned with a Jazz musician is no less obvious than in *Fallen Angel,* but
results in a title sequence where the conceptual linkage requires a recognition of
Davis' painting in the design executed by Bass.

The title sequence for Alfred Hitchcock's film *Vertigo* (1958), brought Bass into collaboration with John Whitney who produced the spirals that dominate this opening.5 It reflected the convergence of avant-garde film and commercial media production that had been developing throughout the 1950s, most especially around television. The relationship established between Bass and the Whitneys continued throughout his career—the 1984 animated logo for AT&T (the new company formed after the anti-trust suit's end) was done by John Whitney, Jr. This collaboration reflects Bass' comment about the American avant-garde to historian Pat Kirkham in 1995 that:

> They created a great yearning in me to emulate this, to do something that would embrace this kind of daring.[6]

His focus on the American avant-garde films of Maya Deren and Kenneth Anger, both central figures in the New American Cinema of the 1950s and 1960s. The influence of avant-garde film on the development of film titles and television design (especially advertizing design) was part of the shift towards the Modernist aesthetic that came to dominate design during the 1950s. As in Bass' earlier sequences, the visual design of the titles in *Vertigo* proceed through an ambiguous visualization of the film's central themes—in the case of Hitchcock's film, both dizziness (one meaning of "vertigo") and the internal psychological state itself (another meaning). Unlike the narrative, however, which follows Scottie, played by James Stewart, Bass' sequence focused on Kim Novak, his co-star, who played Julie. He explains this focus on Novak by choosing to focus his design on her character, rather than Stewart's detective:

> Here is a woman made into what a man wants her to be. She is put together piece by piece. I tried to suggest something of this, and also the fragmented mind of Julie, by my shifting images.[7]

Bass' description of the film is simultaneously accurate and misleading; it is Scottie whose mind fragments in the film, (and he who experiences vertigo), yet from the title sequence and his commentary on it, the film might tell a different story. Yet the focus of these titles on themes of sight and the spiraling dizziness that is vertigo proves effective.[8] Each potential meaning of the film's title appears in the organization of this sequence: the a design that recalls William Golden's animations of the CBS logo, the slowly rotating spirals rise out of a close-up of Kim Novak's eye, their graphic form reiterating this movement throughout the entire sequence: ovals lying at the center of Whitney's spirals become eye-shapes, each succeeding spiral playing the role of "pupil" to the earlier one's "eye."

North by Northwest (1959) was the second title sequence Bass designed for Alfred Hitchcock. It has an uncharacteristic studio graphic at the head of the film: instead of the customary black background for the MGM logo, it is the same green used throughout the rest of the titles. This integration of the studio's logo design into the title sequence is highly unusual, (only at the end of the twentieth century would the meshing start to become common as the WB logo became an integral part to the opening of title sequences). During the 1960s, this type of integration was highly unusual—MGM would do something similar with André François' titles

for *The Fearless Vampire Killers* (1966), but this integration did not appear in the majority of its other productions.

In addition to the studio logo, the design used in *North by Northwest* integrates the opening abstract animation into the opening shot of the mirrored surface of the United Nations building in New York, a graphic match recalling the titles of *My Man Godfrey*. This movement between abstraction and realism develops the linkages made in *Vertigo* further—what was only a conceptual connection in 1957 becomes a literal transformation in 1959. The combination of realist and abstract elements in this title sequence anticipated the emergence of full character animation for film titles in the next decade.

Psycho (1960) was the last title sequence Bass produced for a Hitchcock film. However, the main credit Bass received on the film was as 'pictorial consultant,' an ambiguous credit that requires some explanation. Bass' explained this role was to "strangify" the Bates house, and work on the now famous shower murder sequence where Marion Crane, played by Janet Leigh, dies. For "strangifying" the house, Bass' solution relied on optical printing:

> Finally I hit on it. I matted a time-lapse moonlit, cloudy night sky—but no scudding clouds—just moving somewhat faster than normal. In the two to three-second cuts to the house (which was not long enough to reveal the abnormal rate of movement), it resulted in an undefined sense of weirdness.[9]

This solution directly shows the close technological relationship between special effects and motion graphics—both use basically the same technologies; in effect, the "solution" Bass devised was a motion graphics solution to a narrative concern. The combination of masking and compositing in optical printing are common features of Bass' title design work, highly visible in the titles done for his previous designs for Hitchcock. It is a solution that reversed the elements of Belgian Surrealist Rene Magritte's painting *L'Empire des lumières* (Empire of Light, 1953–54) where a nighttime landscape filled with shadows is combined with a bright blue daytime sky with white fluffy clouds. The peculiar alienation of Magritte's painting remains in Bass' shots for *Psycho*: the reversal of night and day elements produced a similar sense of unease, but without an immediate understanding of why.

For the shower sequence, Bass was given the task of designing the storyboards, which Hitchcock then followed precisely in shooting. Hitchcock had collaborated with artists in earlier films—*Spellbound* (1946) had a dream sequence designed by Surrealist painter Salvador Dalí, and the dream sequence in *Vertigo* was created by Abstract Expressionist John Ferren. The shower sequence presented particular challenges: less than half way through the film, it showed the death of the film's apparent heroine; unlike most detective stories, *Psycho* has a surplus of investigators and only one suspect. The handling of this sequence was crucial to the success of the film. Its elaborate montage could only have been produced by careful preplanning, which Hitchcock hired Bass to produce.[10]

The titles design itself is a dramatization of the psychoanalytic term 'schizophrenic' that literally means a 'splitting of the mind'—shown on screen by the splitting and disjuncture of the typography itself. The motions are irregular, and the moving bars that cross the screen are of different lengths and move at different

speeds. The typography becomes legible only when the different parts of the type briefly align, even then sliding back and forth in sync to Bernard Herman's staccato score. It is a title sequence where the fragmentation and momentary unities of schizophrenia are dramatized through the misalignment and break-up of the design into elements whose formal basis recalls the opening titles to *The Man With The Golden Arm*.

THE MIDDLE PHASE

By the start of the 1960s, the graphic animated titles that are so closely associated with Saul Bass had become a stylistic approach that designers and directors were specifically reacting against—these titles had become a model to be avoided, not because they were overdone, but because they were too clearly derivative of Bass' work. This awareness marks the shift to the Middle Phase. The result was apparent in the change from graphic animation and towards other models—cartoon titles, and combinations of live action, optical printing and typography. However, unlike the short title sequences and overlaid type of the 1940s and early 1950s, these new titles were long—as long as 6 minutes in some cases—and they were carefully shot as independent montages whose structure might only obliquely relate to the film that followed. As with the other designers who sought to avoid the Bass-style, Ba
ss himself produced titles that reacted against his earlier work, such as *Walk on the Wildside* (1962) a montage of two cats meeting among some cement pipes in an alley, and the lengthy animated cartoon title sequence for *It's A Mad, Mad, Mad, Mad World*.

It's A Mad, Mad, Mad, Mad World (1963) is a dramatic shift from the highly graphic titles Bass is best known for doing, to a more conventional animated cartoon sequence of exceptional length for a feature film title. These titles were done for an almost encyclopedic compendium of Hollywood film comedy that included actors from the silent era as well as contemporary figures from both film and TV. These titles done in the style of the UPA studio, reflect their Modernist, limited cel animation style. They were part of a trend towards larger, more expensive and complex films in the early 1960s. The adoption of cartoon titles, however, followed earlier work done for television shows such as *I Love Lucy* (1954) by Gene Hazelton working at Hanna Barbera. Animators Isadore "Friz" Freleng (1906 – 1995) and David H. DePatie (1935 –), adopted a design for feature films starting with *The Pink Panther* (1964) that incorporated Modernist graphic elements, but followed the more traditional and familiar character animation style developed at Warner Brothers in the 1930s and at MGM in the 1940s by Tex Avery. The cat character designed by Hawley Pratt for the opening and originally animated at the former Warner Animation division, renamed DePatie-Freleng Enterprises, would reappear in later sequels: *The Return of The Pink Panther*, animated by Richard Williams (1975), and in both *The Pink Panther Strikes Again* (1976) and *Revenge of The Pink Panther* (1978) again animated by DePatie-Freleng. While highly memorable, the complex character animation of these title sequences was also both rare and unusual in Hollywood film. The titles for *It's A Mad, Mad, Mad, Mad World* are a

symptom of the appearance of other title designers whose work also received critical and popular attention.

Bass would produce other title designs as well as logos, advertizing campaigns, and continue working until his death in the 1990s; however, his later work did not achieve the iconic status of his earlier design work. The importance and role of the title designer in the creation of a feature film that he established in the 1950s enabled other artists to make titles, in the process opening up the field for experimentation and elaboration. During the 1960s these other artists became more prominent, bringing other approaches and aesthetics to the design problems posed by the title sequence.

Maurice Binder (1918 – 1991)

Maurice Binder began as a graphic designer like Saul Bass, working first for Macy's Department Stores, then on print advertisements for films produced by the National Screen Service company, in the 1940s he worked as the West Coast art director for Columbia Pictures, designing posters for the films *Gilda* (1946) and *The Lady from Shanghai* (1947). Even though Binder only began receiving credit for his title designs on British films, his first title designs were uncredited: for a documentary made in Hollywood titled *The James Dean Story* (1957), followed by the feature film *Indiscrete* (1958). It was after he moved to the United Kingdom in 1959 that he began receiving on-screen credit as "title designer" in *The Mouse That Roared* (1959).

He is best known for his title sequences for the *James Bond* films produced by Albert R. Broccoli: he produced the first Bond titles in 1962 when the series started with *Dr. No,* and continued through to *License to Kill* (1989), with only two exceptions, the second and third in the series—these were designed by Robert Brownjohn: *From Russia With Love* (1963), and *Goldfinger* (1964)—for a total of fourteen individual titles. Such a consistent body of work is highly unusual, not only for its breadth, but for its duration, spread over a twenty-seven year period. The consistency of these title sequences was achieved through a combination of techniques: the reuse of mask elements and typography from one film to the next and adaptations of earlier graphic forms across a series of different title sequences that created a recognizable visual schema operative in all the sequences.

An examination of the Bond titles reveals a consistent construction, broken into several distinct groups, not based on the actor playing Bond, but rather the stylistic organization of visual materials. *Dr. No* (1962) stands apart from this series with only the white, circular "gun barrel" spot that begins the titles being retained throughout the later variations. This initial title sequence appears muddled in comparison to later sequences: it is composed from three distinct parts: in the opening a Modernist (International Style) animation and arrangement of colored circles and typography; followed by a group of Caribbean dancers printed separately using a color separation process first employed by Len Lye in *Rainbow Dance* (1936); finally a rotoscoped section of three apparently blind men walking that leads-in to the opening shot after the titles end. This breakdown of the titles into different "movements" is unusual for Binder, and is never repeated in any of the Bond film title sequences.

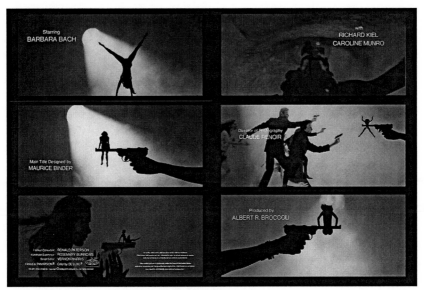

Maurice Binder, stills from *The Spy Who Loved Me*, 1977

 The first group of Bond title sequences are composed of films made prior to 1969. The transition from these earlier sequences too is subtle, a shift in explicitness that became possible with the end of the *Hollywood Production Code* and its replacement with the MPAA ratings system in 1968. In these two sequences Binder introduced stylistic elements that run through the remainder of the Bond films, but with a single important distinction: the figures in these openings are always in silhouette, and shown in an ambiguous fashion so it is unclear whether they are nude; after 1969 this ambiguity disappears. *Thunderball* (1965) consists entirely of swimmers and divers moving against monochrome backgrounds; the typography is animated with a ripple effect that corresponds to the underwater theme of the opening. Elements of this animated typography will reappear in later title sequences: *You Only Live Twice* (1967), *Diamonds Are Forever* (1971), *Live and Let Die* (1973), and *The Man With The Golden Gun* (1974) all reuse the ripple-effect typography first designed for Thunderball where the water effect can be directly related to the underwater photography of the sequence; in the later sequences, it is pure stylization.

 The unique nature of the *James Bond* series, and Binder's titles for those films, is that over the course of their thirty year run the titles reflect social changes in America. The earliest title sequences from the 1960s incorporate mixtures of tonal montage, the optical compositing of live action and graphic masks, yet do not become "music videos"—yet during the 1980s, nothing changes except the overall character of the imagery: the openings for *A View to A Kill* (1985) and *The Living Daylights* (1987) contrast strongly with *Octopussy* (1983)—these two sequences employ the bright colors, pop music, dancers who move on beat, and imagery that is directly synchronized with the song's lyrics (a feature only suggested in earlier films—the use of diamonds in *Diamonds Are Forever* cannot be tied to any particular lyric). The result is an opening that could easily play on MTV as a music video and

not seem out of place; this influence from TV is apparent throughout the entire film industry during the 1980s.

Barbarella (1968) marks a transition point for both Hollywood productions and the title sequences produced by Binder: it is this title sequence where the ambiguous nudity of the women appearing in the Bond title sequences becomes full nudity, shown on screen—a reflection of the end to censorship imposed by the Hayes' office under the *Production Code of 1934*. The opening of *Barbarella* is (quite literally) a strip-tease, and was an explicit violation of the production code:

PARTICULAR PRINCIPLES:

(1) The more intimate parts of the human body are male and female organs and the breasts of a woman.

(a) They should never be uncovered.

(b) They should not be covered with transparent or translucent material.

(c) They should not be clearly and unmistakably outlined by the garment.

(2) The less intimate parts of the body, the legs, arms, shoulders and back, are less certain of causing reactions on the part of the audience. Hence:

(a) Exposure necessary for the plot or action is permitted.

(b) Exposure for the sake of exposure or the "punch" is wrong.

(c) Scenes of undressing should be avoided. When necessary for the plot, they should be kept within the limits of decency. When not necessary for the plot, they are to be avoided, as their effect on the ordinary spectator is harmful.

(d) The manner or treatment of exposure should not be suggestive or indecent.

(e) The following is important in connection with dancing costumes:

—Dancing costumes cut to permit grace or freedom of movement, provided they remain within the limits of decency indicated are permissible.

—Dancing costumes cut to permit indecent actions or movements or to make possible during the dance indecent exposure, are wrong, especially when permitting:

a) Movements of the breasts;

b) Movements or sexual suggestions of the intimate parts of the body;

c) Suggestion of nudity.

Actual nudity is so far outside the realm of what is permitted that even the implication of nudity in a costume worn for a dance scene is forbidden. The common perception that Binder's titles were voyeuristic, a factor especially in evidence in the Bond films, has its greatest demonstration in *Barbarella*. The entire sequence is edited and filmed to resemble a strip tease in freefall, with Jane Fonda's costume and the animated letters flying around inside the spaceship. The dynamic this sequence constructs is precisely about actual nudity hidden behind the animated letters of the titles. This translation and incorporation of typography as both opening scene and title sequence is indicative of the changes happening during the 1960s and 1970s—the failure of the classical studio system to retain control

Maurice Binder, still from title sequence for *Barbarella,* 1968

over film production and distribution, coupled with the challenges posed by both imported films and independent productions—changes reflected in the title sequences as the Designer Period transitioned to the Logo Period of the 1980s.

Pablo Ferro (1935 –)

Pablo Ferro born in Cuba, his family emigrated to New York when he was twelve, and while still in school, his first job was doing illustration for horror comic books published by *Atlas Comics* starting in 1951; by 1952 he was learning animation and worked at a series of production companies in New York. His work in animating commercials using a variety of experimental techniques, including "quick cut" and stop motion animation made him a leading artist in the adaptation of the film avant-garde to commercial motion design during the 1950s and 1960s. It was his work in commercials that led to Stanley Kubrick hiring him as title designer in 1963. His career continued through the 1970s and 1980s, experiencing a revival during the later 1990s during the Contemporary Designer Period. Much of his work in this intervening period continued to apply new techniques to the title sequence, but, as was common for the authorial designers of this first period of designer sequences, the iconic nature of his early work overshadowed later designs.

Dr. Strangelove, or, How I Learned to Stop Worrying and Love the Bomb (1963) was the first title sequence Ferro designed. Several features of these title designs would become "signature" elements of his style: the elongated, hand-drawn lettering superimposed over a live action narrative that starts the film. This "background" sequence presents a montage showing the refueling process for American bombers armed with nuclear weapons in carefully composed and edited shots whose significance becomes apparent once the narrative action begins—these are the aircraft dispatched in an unauthorized attack on the U.S.S.R. The integration of narrative and opening title design, a common feature of the period before the rise of the designer title sequence in the 1950s, was revived by Ferro in his designs.

Like Bass, Ferro also worked in other capacities on film production than just the design of title sequences. He adapted the Modernist break-up of the designed page to feature films in *The Thomas Crown Affair* (1968), an title sequence produced during the transition to the Late Phase. This graphic approach, called "spatial

montage" by media theorist Lev Manovich, had not been used to such an extent in a feature film since the French director Able Gance's *Napoléon* (1927) created montages across a superwide screen image using three synchronized projectors. In Ferro's design, the screen is broken into discrete image blocks whose direct sources lie with Modernist graphic designs done by Paul Rand, Alvin Lustig and other International Style designers. This break-up of the screen could only be done using optical printing; its revival in 2001, used extensively in the television show *24*, followed digital technology's radical reduction of production costs for this type of compositing.

Ferro's work with television continued throughout his career, both in the form of commercials and opening sequences for television programs. His use of montage to summarize and condense narrative into a sequence of thematically-connected shots eventually became a standard approach to TV titles. This radical reduction enabled the presentation of backstory quickly—the same process that is apparent in his title designs for feature films.

THE LATE PHASE

Long, costly, and essentially independent of the film that followed, the title sequences made throughout the Designer Period stand apart from the feature film. As the 1960s progressed, opening titles generally became more complex and less obviously related to the film that followed; the exceptions to this tendency (such as Pablo Ferro's *Bullitt*) are notable precisely because they indicate the transition to the Late Phase of title design. The use of animated openings for films during the 1960s, where the titles were integrated into the action of a cartoon, represents a logical development of the designer title sequence—the titles for feature films were often produced at companies that also made animated cartoons for television—such as UPA and Hanna Barbera—and whose studios provided the technical expertise to animate the titles produced by graphic designers. Only occasionally did cartoon animation play a role in the title sequence, but the complex titles first produced during the 1960s—both in cartoon form, the composites of live action and animation familiar from James Bond films, and the exceptionally complex, optically printed titles that integrated psychedelic animation and live action, by Richard Williams for *Casino Royale* (1967) are the high point of complexity and elaborate design, coming at the end of the designer title period. A simplification and minimalization of the title sequence would become increasingly common in the 1970s and 1980s.

Bullitt (1968), designed by Pablo Ferro, is an exceptional example of the integration of the title sequence with the opening scenes of the film. There is almost no "editing" during the opening sequence: instead of cutting from shot to shot, the opening sequence has been created through optical printing that allowed the typography to become the transitions between shots. This use of optical printing to create opening titles combines B-roll printing with compositing to create its effects. The compositing takes the form of the individual titles themselves. Each title slides on screen as white text that pauses in the center, then moves off; as the white text scrolls off screen, it reveals the next image as a credit-shaped "hole" that then moves towards the viewer, allowing the next shot to fill the screen instead of cutting to it. While this opening sequence lasts 6 minutes, the narrative action is of equal

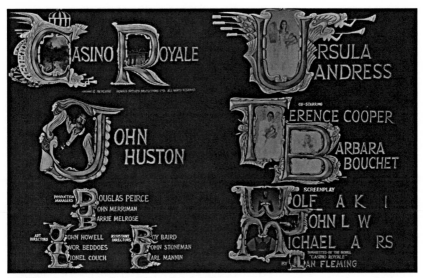

Richard Williams, title cards from *Casino Royale*, 1967

importance to the graphic handling of that montage—a shift that provided a precedent for the reduction of the titles themselves over the next decade as the Late Phase shifted the focus from the stand-alone opening sequence to the prompt, and engaging opening to the narrative itself, unslowed by an elaborate, independent title sequence. This shift of priorities can be related to the rise of Film Studies and the aesthetic reappraisal of Orson Welles' films during the 1960s and 1970s—it is the opening titles of *Citizen Kane* (1941), and (ironically) the titles added to *Touch of Evil* (1958), that provided the most direct model for the transformations of the title sequence and the emphasis on the story beginning immediately with the first shot of the film.

THE LOGO PERIOD

The shift from elaborate, animated titles to more limited opening credits with an extensive production credit scroll becomes increasingly common starting in the 1970s as the Hollywood studios addressed the challenges posed by foreign films, a new "rating" system, and renewed competition from independent production companies. The integration of the credits into the opening scenes of the film, with no particular "title" design elements became common in studio productions in the 1980s. This shift reflected the changes imposed in the 1970s where the opening credit sequence grew progressively shorter until it entirely disappeared. It was a change in organization for titles, part of the transformation of the credits themselves from an autonomous sequence to a careful placement within the opening shots of the narrative itself. This transformation emerges from the work of designer Pablo Ferro whose sequences, starting with *Dr. Strangelove* in 1964, explore techniques for inserting and integrating the titles with the opening scenes of the narrative itself. It is a gradual transition that reflects the changing organization and distribution of Hollywood films after the replacement of the production code with the MPAA ratings system in 1968.

Title card for *Psych-Out*, 1967

The designers, such as Nina Saxon and Richard Morrison, who came to prominence during this new phase of title design are closely associated with the development of the logo graphic as a visual emblem for the film, beyond its use in the title sequences and posters for the film. During this period, the opening title sequence is replaced by a singular logo design, dispersing the other credits into the narrative of the film, effectively removing the "title sequence." It is not an entirely unprecedented change, since it does retain one element from earlier title sequences: a combination of the "title card" commonly employed in the silent era, and the graphic background shot as B-roll for titles made during the 1930s, as in the case of *Dracula* (1931), but transformed from a minor graphic element into the film title-logo—the main subject of the opening title sequence.

The concentration of the title design into a singular, iconic element first starts appearing during the 1960s with independent productions such as *Psych Out* (1967) where the organization of the opening with a graphic logo, where the main credits are subsequently distributed into the opening scenes of the film. There are numerous additional examples of this type of opening during the 1970s transition to the logo-dominant period; the logo-based title sequence was rare in the 1970s, simply one approach among several competing techniques. The direct heritage of this approach is the dispersal of the credits into the opening scenes of the film, with only minimal apparent "design."

Wayne Fitzgerald (1930 –)

Wayne Fitzgerald started working in title design in 1956 at the production house Pacific Title and Art Studio, Inc., but unlike the other title designers of the Early Phase, Fitzgerald spent the first decade of his career *uncredited*; his first "title designer" credit was in 1966 for *Incubus*. This difference is apparent in the approach employed to his designs: where the "title designers" of that era such as Bass, Binder or Ferro established a signature style that is associated with them, Fitzgerald did not. This first decade of working without on screen recognition is reflected in the mercurial nature of his style—where the title sequence adapts to the specific needs

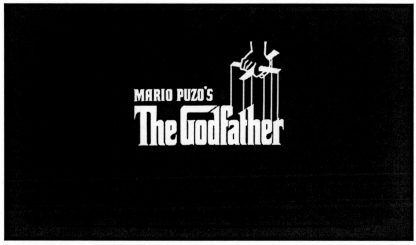

Wayne Fitzgerald, title card for *The Godfather,* 1972

of the film it accompanies—a feature of his aesthetic that would become the standard approach to title design in the 1990s. Throughout this long period he produced title designs for both feature films and TV shows. Many of these programs achieved a "cult" status among their fans: *The Unknown* (1964), *The Invaders* (1965), *Columbo* (1971–1976), and both *Battlestar Galactica* (1978) and *Buck Rogers in the Twenty-Fifth Century* (1980). His career moved fluidly between design for television and film—part of the convergence of feature film production and television production that began in the late 1970s, evident in his titles for both *Battlestar Galactica* and *Buck Rogers in the Twenty-Fifth Century.*

While *Glory* (1956) was the first title sequence he produced as an uncredited designer, of greater note are the titles for *Touch of Evil* (1958) where Fitzgerald was given the task of inserting titles into the famous long-take elaborately choreographed by director Orson Welles for the film's the opening sequence, against Welles' explicit wish that the opening be left without any titles. It is an organization that most closely resembles the titles created by Wayne Fitzgerald for *Touch of Evil* (1958) where the opening long take introduces the main characters and the event that will set the story in motion, and the credits are carefully arranged on screen not to interfere with those opening scenes. Fitzgerald's "invisible" style reflects the historically uncredited design work done by title designers—fitting his particular designs to the specific demands of each film individually; it is also the reason Fitzgerald work consistently producing titles continuously throughout his career that spanned from the first Designer Period through to the second one thirty years later.

The beginning of the Logo Period came during the 1970s, initiated by Wayne Fitzgerald's and Dan Perri's designs. Following the transformations being imposed on the industry by a new generation of directors trained in film schools, a group including Francis Ford Coppola, George Lucas and Steven Spielberg. These directors, following the model pioneered by independent productions, began to minimize the title sequence, replacing it with shorter sequences or avoiding it

Wayne Fitzgerald, *The Dead Zone*, 1983

entirely in favor of a graphic logo that identified the film. This transition includes designs done by Wayne Fitzgerald for *The Godfather* (1972) and its sequels, and Dan Perri's title design for *Star Wars* (1977) whose iconic logo typography—the singular "Star Wars" element that recurred across all the various franchised products, and appeared at the head of every sequel—fully established a new paradigm for the organization of both motion picture and other elements unrelated to the film itself, both in the form of the advertizing campaign and other, apparently unrelated things such as novelizations of the screenplay. In *Star Wars* there are no opening credits: the title credits only appear at the end, in a fundamental shift from the standard organization of a Hollywood film opening.

The Dead Zone (1983), designed by Wayne Fitzgerald, shows this on-going transition during the early 1980s between the extended title sequence and the logo-based approach. This sequence begins with two title cards: "Dino De Laurentiis Presents" followed by a second card for the film title in a standard organization for the opening of the film, "*The Dead Zone*," optically printed in white over a black background; this opening is followed by a series of dark, cool-toned still images of New England houses, roads and countryside. Gradually black voids appear in these images, steadily accumulating until they form the empty spaces around the letters of the film *logo*—a type composition that also spells out "*The Dead Zone*." This secondary title design is the one associated with both the film, via its posters, and is the logo design from the Stephen King novel. The redundancy between the opening white title and the emergent logo at the end of the title sequence is peculiar: it reveals the ambivalence of this title design at the moment of its production—in the transitional phase as the fully logo-based openings were starting to be produced, but still contained within the older, more traditional opening sequence of title cards that stand apart from the dramatic action. As the 1980s progressed, the logo would come into the foreground and the remainder of the titles would become a part of the opening scenes of the film.

The logo paradigm never achieved an undisputed dominance over title design in the 1980s; however, it was the primary, new development in that decade, and its impact on the organization of titles proposed an alternative to the traditional organization of a sequence independently from the film narrative: the importance and emphasis placed on the organization of the title sequence within, (and integrally to), the marketing and advertizing of the film while at the same time reducing the apparent importance of the individual titles credits is an indication of the changing relationship between the production, exhibition and ancillary marketing of motion pictures that began with *Star Wars* in 1977 and accelerated throughout the 1980s.

Nina Saxon (1953 –)

Nina Saxon emerged as a major title designer in the 1980s, having initially worked in the 1970s on *Star Wars*. Her designs for highly successful films in that decade helped establish the new, "logo" paradigm for the design of titles. She explained her approach to title sequences as being instrumental to how the audience engages with the film narrative:

> I see my work as providing an introduction to a film that sets both an artistic and a thematic tone. When I do my job well, the audience is involved with the film, before the credits have even finished.[11]

This engagement with the narrative results from a limitation on the extent of the title sequence itself, dispersing the credits into the opening scenes and radically limiting the "sequence" itself in such a way that the titles' placement within the dramatic action are secondary to the film narrative. The distinction between her means to incorporate the narrative and that employed by Pablo Ferro is immediately apparent: where Ferro's titles for *Bullitt* incorporate the opening shots into a typographic composition where the titles are immediately apparent and their organization as a title sequence is obvious, in Saxon's work, the typography and title sequence begin to disappear entirely.

Romancing the Stone (1984), the third title sequence designed by Saxon, marks the beginning of the Logo Period: the opening titles are broken into to two discrete units—the logo opener, followed by a narrative sequence. The individual titles do not begin to run until this "preamble" ends and the actual narrative action starts. Titles are positioned within the framing of individual shots as a secondary on-screen element, composed, but subservient to the action. The initial logo design functions iconically for the title as both a visual design that arranges the words of the film's name, and as a graphic image, entirely independent of its linguistic contents; these logo designs are then used in all the publicity materials for the film. The emphasis in them is the production of a graphic type/image combination, where the other credits assume a secondary position in relation to the development of the dramatic action they accompany.

The typography occupies a subservient position in relation to the images, organized and composed within those shots not as the central focus of the composition or the action being shown—instead it is a supplemental element, aligned within the image in such a way as to become a part of the visual space. The first actual credit (for the actor, Michael Douglas) appears in the title sequence

nearly five minutes after the *Romancing the Stone* title logo—at this point in the film the narrative is underway, even if the plot has not actually started.

R/Greenberg Associates (R/GA)

R/Greenberg Associates (R/GA) was an animation company founded by brothers Richard and Robert Greenberg in 1977. Their combination of skills—Richard was a graphic designer and Robert a producer—enabled their creation of what would become the model for motion graphics designers such as Kyle Cooper. R/GA incorporated then-new digital technologies into the production of their title sequences in the form of digital animation control which, as with John Whitney's analog motion control developed in the late 1950s, allowed a greater range of visual effects on screen. *Superman* (1978) was the first title sequence produced by R/GA, done using the familiar sans-serif outline typography, but animated with their digital controls to create an extruded, three-dimensional effect where the letters appeared to fly towards the audience.

Both *Ghostbusters* (1984) and *Ghostbusters II* (1989) designed by Richard Greenberg at R/GA are extreme examples of the logo period's emphasis on the production of logo graphics for the film title. The logo appears several minutes into the film, following a lengthy opening to the narrative; it is immediately followed by a return to the story—any other credits are entirely eliminated from the beginning of the film, with the actors, director and other crew being credited only in the end titles. The organization of how the shots are framed in both films reflect the impact that production-for-television was having on feature films: even though both films were shot and shown theatrically using an extreme wide-screen anamorphic format, the important action in any shot is confined to the "TV-safe" area, a small 1:1.33 rectangle contained within the wider anamorphic aspect ratio. This confinement meant the film could be cropped for a larger, post-theatrical market where the films would be shown on television and packaged for home viewing first on videotape, then later on CAV and as DVDs. The elimination of the title sequence during the Logo Period can be recognized as part of how films were adjusting to this emergent home market for film, and the embrace of television as an essential part of a film's profitability.

The general-purpose motion graphics production company was pioneered by R/GA in the early 1980s where the company both hired a full time staff of visual effects artists and designers to produce work on a variety of projects. Where earlier companies were built around a single artist or designer, R/GA expanded this model, employing innovative designers (David Carson, Kyle Cooper) as well as working in the overlap between special effects and motion graphics on Woody Allen's film *Zelig* (1983) by producing pseudo-archival footage integrating Allen's title character into historical scenes of the 1920s and 1930s. This complex relationship where kinetic typography, special effects, new technologies for animation and compositing are all done at a single production company organized to resemble a Hollywood studio would become the primary model for motion graphics companies by the end of the twentieth century.

Richard Morrison

Richard Morrison, who began working with Maurice Binder, came to prominence during the Logo Period as one of its most accomplished proponents. However, where Saxon's designs emerge from graphic design and logos, in Morrison's case, his work in the 1980s employed a mixture of photography and prop/model making where the logo form was physically fabricated and then photographed. The neon sign that provides the title for *Brazil* (1985) is typical of the period's reduction of the opening to a logo graphic, but because it is a physical object, it enables a dynamic interplay between light and shadow not otherwise possible at the time. The transformation of the title sequence into a minimal opening element accompanied by a graphic logo lead into a pair of contradictory trends by the end of the decade: a general elimination of title sequences entirely, where a minimal title/logo would be embedded within the opening sequences of the film at an "appropriate" moment, with the remainder of the titles being dispersed through the narrative scenes that followed, with no appreciable title sequence at all.

Batman (1989), designed by Richard Morrison, presents the other trend in title design: a subtle shift within the logo model, anticipating the return of the designer title sequence in the 1990s. In *Batman*, there is a return to the title sequence, but it is primarily concerned with the visual exploration of the *"Batman"* logo; this opening indicates a return to the creation and elaboration of title sequences, but modified by the logo and graphic concerns that dominated the Logo Period. This title marks a movement away from the reductive titles of earlier in the decade: a physical prop of the *Batman* logo provided a moving background, showing the peculiar curving forms of this icon in extreme close-up, revealing the actual design only at the end of the sequence. It was a physical translation of Fitzgerald's hybrid sequence-logo design for *The Dead Zone,* but without the redundancy.

The impact of the Logo paradigm on title design was primarily through, not the conversion of the film title into a singular graphic image that would be used in marketing (the influence of Dan Perri's 1977 design for *Star Wars*), but in the elision of the title sequence, with the typography being integrated and organized within narrative shots so there is no clear demarcation between the titles and the narrative itself. This merging of the title sequence with the main organization and structure of the film finds its strongest precedents in the title designs produced by Pablo Ferro, starting with *Dr. Strangelove* (1964): the change is a matter of degree—the shifting of emphasis from the typography to their background. It is this dominance of the image over the typography that distinguishes the later Designer Period titles from Ferro's earlier designs.

THE CONTEMPORARY DESIGNER PERIOD

The return to complex, lengthy title sequences in the 1990s came at the end of a twenty year period where only a limited number of complex, self-contained title sequences of the type common during the height of the Designer Period were still being produced for feature films. Instead, a variety of alternatives emerged during the Logo Period: the dominant form, a logo graphic at the start and the remainder

of the titles either dispersed into the opening scenes, or moved to the end as a brief to minimal title sequence accompanied by a lengthy title "crawl" listing all the crew and production personnel. The complex, independent titles at start of the film and the complex montage, animation and design common to the Designer Period became progressively rarer during the Logo Period. The "return" to an opening designer-produced title sequence in the mid-1990s reflects a shifting aesthetic driven less by new competition (a role TV played for feature films in the 1950s) than by post-modern attack on the established model for typography and film titles.

Se7en, (1995) directed by David Fincher, opened with title designer Kyle Cooper's innovative adaptation of the grungy typographic style being in print design by David Carson. This typography broke with the Modernist design still in common use for the lettering, using instead overlapping, broken letter forms and constructed around a rhythmic montage sequence that resembled a music video as much as a film opening; a combination reflecting both Fincher's beginnings directing music videos for Madonna and a contemporary engagement with sound-and-image developed by MTV and television. This integration of opening titles into the narrative in an oblique manner reminiscent of the most iconic titles of the first Designer Period; its critical success, coupled with the digital revolution then arriving in film and video production, helped revive the extended designer title sequence. However, unlike earlier periods, this revival came as one variant among others—the logo approach continued to develop, as during the 1980s, even as complex designer titles became a common part of film production.

These new title designers, unlike the earlier period, where particular designers such as Saul Bass or Maurice Binder established a "signature style," the new designers followed an example closer to Dan Perri or Wayne Fitzgerald adapting their particular design approach and aesthetic to the project, resulting in a highly complex titles without an apparent authorial "signature" from the designer. This shift reflects the impact of a post-modern aesthetic view of style, one dependent more on the particulars of context within a larger, independent work than an 'authorial' imprint. It is this shift from conceiving of design as based on absolute, independent values to one based in the specific demands of placement in an individualized work. It is a change from the mass produced to the particular, a feature of Modernism that artist Andy Warhol identified in the 1960s:

> You can be watching TV and see Coca-Cola, and you can know that the President drinks Coke, Liz Taylor drinks Coke, and just think, you can drink Coke, too. A Coke is a Coke, and no amount of money can get you a better Coke than the one the bum on the corner is drinking. All the Cokes are the same and all the Cokes are good. Liz Taylor knows it, the President knows it, the bum knows it, and you know it.[12]

Warhol's observation that *"All the Cokes are the same and all the Cokes are good"* is a description of mass produced uniformity: the transformation from a widely variable, individual production to one where designs are dictated by other concerns than the particulars of individual desire; in Warhol's description, it is democratic, but as a design approach, it is authoritarian. The violation of this uniformity is what

defined the initial burst of Post-Modern design—a violation done simply through a particular concern for the specific context where a design would be seen, by whom, and for what purpose—all factors extraneous to the "purity" of Modernism. The return of the visibly designed title sequence during the 1990s retained this Post-Modern concern for the context of the film, but filtered it through the design temperament and aesthetic of an authorial designer.

The designer responsible for this revival, Kyle Cooper (1962 –), began his career in motion graphics working at Robert Greenberg and Associates (R/GA) in New York; when they opened a branch office in Los Angeles, Cooper moved there to head it. RGA/LA was reorganized as Imaginary Forces in 1996[13]; he left in 2003 to shoot a low budget feature film, *New Port South*, and shortly thereafter started a new company, Prologue. The model that Cooper uses is one very different than that of earlier title designers—Cooper's approach is to build an atelier that employs multiple designers, allowing his company to work on several title design projects at the same time—the approach he learned at R/GA. This results in a corporate model for title design that approaches that originally created by William Golden for CBS TV.

The return of "authorial" title designers in the years after 1995 did not mean an end to the earlier approaches to title design; instead, it posed an expanded field of technical approaches to the creation of title sequences, one where there may be more than one designer responsible for the titles—depending on the film, one designer may produce an opening sequence, another an "end title sequence" and a third company may create the full credit "crawl" listing the full production credits. The heterogeneity apparent in contemporary titles reflects a broad range of coexisting aesthetics where earlier styles and approaches remain active along side more contemporary styles. There are essentially three types of title produced in this latest period of title design:

(1) The opening sequence that follows the iconic model of the Logo Period, often with limited to no credits, or with credits fully integrated into the actions on screen.

(2) The designer title sequence, whether in its Modernist, independent form, or following the contextually-related Post-Modernist paradigm.

(3) The main-on-end title sequence, often heavily designed and independent of the narrative, followed by a title crawl.

The only new, innovative approaches within this collection of solutions to the title design problem is the contextually-based integration of elements of narrative into an otherwise independent title sequence. This is the approach developed by Kyle Cooper in *Se7en*: elements of the backstory are elaborated within the title sequence, proving the audience with a preamble to the film itself. It is a model more closely related to the opening of on going serial TV shows (or the movie serials of the 1930s and 1940s) where the titles function less as a credit sequence than to provide essential information to make sense of what's happening in the story itself. The masterful integration of backstory into film opening is the primary innovation of Cooper's work in title design.

The Incredible Hulk (2008) designed by Kyle Cooper, reveals the close relationships between quotation, the influence of TV title design and the integration of narrative into the opening title sequence. Cooper's title is based on the title sequence for the 1976 TV show of the same title, and uses that earlier sequence as a schema for elaboration and expansion. Composed as a montage of animation, microphotography, and live action, this opening shows the backstory of how David Banner became contaminated with "gamma" resulting in his transformation into an angry green giant and his flight from the military. Their subsequent pursuit of him is told through a pin board using maps, photographs and news reports. Included in this montage are schematics for machinery that will later appear during an action sequence set on a college campus. The entire opening is ultimately revealed as a mental recounting of events by Banner while meditating.

The relationship between past precedent (the TV sequence) and the current narrative opening is a common feature of Cooper's titles of this type; combines strategies used in his earlier titles—*Mission Impossible* in 1996, and *Dawn of the Dead* in 2004. In *Mission Impossible,* the titles quote from the earlier TV show, but do not elaborate on the narrative set-up, while in *Dawn of the Dead,* the titles run as a short montage of documentary and news footage showing the spread of a zombie-creating contagion. Each case produced a finished opening sequence that encouraged audience consideration of the quotations employed, and used their past experience to "fill in" the missing elements to make the narrative shown complete. These are titles that offer a more dynamic conception of the audience than that posed in the earlier title sequences, and is a specifically Post-Modern aesthetic employing memory, quotation and marshalling references beyond just the film's narrative itself. This type of engagement is common to the contemporary designer titles generally—while at the same time being a feature that occasionally emerged in the work of both Fitzgerald and Perri, revealing their on-going influence on feature film title design.

* * *

The importance of digital technology for the production of title sequences, and the increasingly close relationship between formerly different industries—film, television, and video games—became apparent during the first decade of the twenty-first century as designers specialized in motion graphics began working on title design for media rather than a particular medium such as film or television. At the same time, the significance of feature films as a primary model for video games was becoming increasingly obvious. The structure and organization of the title design by Stephan Burle for *The Kingdom* (2007) is typical of this influence of film designs on other media. The compactness of the "documentary" background to the story given in his opening sequence has been very influential—both in graphic form and approach to blending documentary material with graphics—on the titles for video games. It is the stage-setting function of Burle's title that coincides with the elaboration of the parameters for game play in video games, as well as the "action" content and suggestions of clandestine conspiracy that link the contents of his "documentary" with the interactive (adventure) concerns of the games which imitate his design.

Title sequences and kinetic typography have both benefited from the fluidity and ease-of-production enabled by digital animation technology, and the convergence of video and computers that began in the 1980s has expanded to include the video game industry during the 1990s and 2000s. In shifting from the labor-intensive hand animation and optical printing to digital automation of those tasks, combined with highly realistic computer graphics, the computers used by motion graphics have transformed the entire production process for motion pictures generally. The convergence of these different media has enabled the creation of hybrids of typography, animation, graphics and live action that bring the potentials first explored by the Bauhaus and Soviet Constructivist artist-designers such as the Russian designer El Lissitzky whose work combined graphics, typography and photographs into the realm of not just of commercial-viability, but of the commonplace: mixtures and transitions between painterly, graphic and live action that would have been prohibitively difficult (if not impossible) in the 1970s routinely appear in television commercials just thirty years later. These connections between early avant-garde graphics, the aspiration to musical form, and the fusion of photography with computer-generated animation are explicitly developed in motion graphics.

This convergence is a reflection of a dramatic aesthetic shift away from the 'pure' Modernism where each specific medium retreats into a self-sufficient solipsism towards a new, hybrid ambiguity where overlapping media and shared technologies enable the creation of intermediate and mixed works. In this new context, the medium-specific stability of Modernist design no longer applies. This transformation is the direct heritage of the Post-Modern artistic and cultural revolution, a change partially enabled by television. The distinct approaches and aesthetics of this period inform not only design but all of American culture; it is a change shown most clearly in the ways that design at the end of the twentieth century differed from that done in the middle—the feature film title sequence serves as a reminder of how closely popular design is linked to the more particular aesthetics of fine art.

08

TV & VIDEO GAME TITLE DESIGN

Kinetic typography in feature films, television and video games developed in parallel rather than as a direct matter of emulation or a transfer of aesthetics from the earlier feature designs to the smaller screens. Instead, there was a continuous back-and-forth between feature films and television after the mid-1950s when Hollywood studios embraced television as a secondary market. Both original productions done for television distribution and the licensing of the studio's back catalog films made in the 1940s and earlier provided supplemental income to the studios. This mutual influence of television on feature production is most apparent in the first designer title period that began with Saul Bass' designs in 1955 for *The Man With The Golden Arm,* a feature film whose animated graphic title sequence employed both Modernist design and typography which were also employed in the print campaign to promote the film. This shift in design towards Modernism in the titles shows the influence of William Golden's work at CBS, and is typical of an era concerned with being "new" and "modern"—by the end of the decade concerns with "space age" would dominate both popular culture and further embrace the minimal International Style of design that emerged as the dominate aesthetic after World War II.

The development of titles for TV shows initially reflected this Modernist concern, being produced in-house for the live broadcasts of the earliest years of that medium. These designs passed through four distinct periods, closely related to the distribution technology and immediate historical context: Live TV, Broadcast/Network TV, Cable TV, and the Internet. The full transition from one phase to the next is marked clearly by shifts in the nature of new coverage and distribution: the dominance of each new mode over the preceding one becomes apparent in the significance of the new distribution model for the presentation and reception of news. Initially a function of film (via the newsreel), each succeeding model of television distribution has its own characteristic techniques both for distribution and presentation of news. As the dominance of each model reaches a transition point, it becomes apparent in the importance of that new distribution model for the dissemination of news programming and information.

The progression in the United States from one phase to the next describes the steady movement from live programs to recorded shows, accompanied by the

AMERICAN TELEVISION PERIODS

Live TV	(beginning until ~1954)
Broadcast/Network TV	(until ~1990)
Cable TV	(until ~2009)
Internet	(2009 to present)

ability to time shift when the program is actually seen by its audience, while at the same time increasing the quantity of programs competing for viewers. The evolution from a captive audience that watches a program aired live on a limited number of networks, to programs produced on film or videotape, (but still shown to a broad audience with only limited viewing options), to the rapid proliferation of channels showing many programs describes the trajectory of television's history.

The rise of the video cassette recorder—the VCR—first developed in the 1950s, but not marketed to a general audience until the 1970s and becoming common until the 1980s, enabled both archiving, or the saving of programs, and time shifting where viewers record a program at one time to watch at another. These changes were part of a general shift in the United States from what were fundamentally local TV stations showing a mixture of national and locally-produced shows to the more competitive Cable TV, where programming becomes increasingly a national and an international issue by the 2000s. The transformation of television in the United States from an era where any given market would only have between three and ten television channels to the larger selection offered by Cable TV (initially only slightly larger, but growing to hundred by the end of the twentieth century), followed quickly by the emergence of Internet TV (or web video) that offered not only a wide selection of programs on demand to their viewers, but also introduced the ability to share programs directly and interact, respond, or create and distribute original material without the need for the broadcast or TV studio.

The organization of television shows within strictly defined "genres" whose origins lie with both radio programs and the popular fiction (the so-called "pulp magazines") of the 1920s and 30s—*Thrilling Wonder Stories, Detective Stories, Adventure Stories, Amazing Stories, Weird Tales,* and other weekly fiction magazines featuring lurid covers and simple plots—established the horizons of expectation in American popular culture, first for radio programs such as *The Shadow,* and then for television programming, and the breakdown of programming into specific time blocks: quarter hour, half hour and full hour also reflects the heritage of radio.

The transfer from radio to TV was a logical, obvious shift for the broadcast networks: the American Broadcasting Company (ABC), National Broadcasting

Company (NBC) and Columbia Broadcasting System (CBS) had been radio networks before making the transition to television. In 1941 the FCC began licensing commercial television stations in the United States. Broadcasting would become a major industry after World War II as television receivers became common and the market for programming started to increase. Because the earliest television programs were not pre-recorded, but performed live, and the first television networks carried their earlier heritage of being radio networks with them in the design and production of their title sequences: the use of voiceover at the start of the show. Unlike the film serials of the 1930s that faced similar problems, but adopted the style and techniques initially used in the silent era, the title sequences of early TV treated their show openings as radio programs with imagery, crafting an entirely distinct aesthetic composed from minimal graphics and visuals, but employing complex sound design. This reliance on sound, principally in the form of an opening narration (that evolved into a theme song by the 1960s), which audibly sets the tone and provides the background to the individual episode's story, is the most apparent element that unites title sequences produced by/for the broadcast networks' programming.

The close connection between advertizing and early television is apparent in the organization of the titles themselves: individual programs were explicitly sponsored by a single advertiser that was often presented in the title sequence more prominently than the title for the show itself.

William Golden, CBS Eye logo, 1951

LIVE TV

The first television programs were produced and broadcast live—they were essentially more like theater than film in this regard: there could only be limited preproduction of the titles and other graphics, and the resulting shows were staged in New York where the broadcasting headquarters were located. The programs were produced by companies that began as radio networks, and their transition to broadcasting pictures as well required only the addition of new equipment. It was a development that began experimentally during the 1930s, but became a commercial production after World War II.

With the separation of radio and television broadcasting into two different companies at CBS, the need to differentiate these companies became the first design problem for William Golden's new *Department of Advertizing and Sales Promotion,* formed in 1951. The most important of the designs Golden produced became the iconic logo for CBS. His designers used it for both on-air and in-print promotion of the new television broadcaster:

> The function of the symbol was not only to differentiate us from the other television networks, but from our own radio network as well. It was first designed when CBS established the Radio and Television Networks as two separate divisions. The two networks were urged to do everything possible to create their own identities.[1]

Golden's design served to emphasize the difference between CBS radio and CBS TV, but it, along with the innovative Modernist print design used to advertize and promote CBS programming, also worked to immediately differentiate the CBS programs from those on their rivals NBC, ABC and DuMont. The technical limitations of early television meant that the differences between programs on the networks was actually quite small—a police drama, game show, or comedy on one network would not be noticeably different from those produced on another. Distinguishing between different networks was a matter of style and design more than actual content or programming. The homogeny of 1950s programs is especially pronounced during the earliest years of live production.

In 1951 Golden hired well-known illustrators to draw the visuals used to promote CBS programs. French illustrator known for his fashion illustrations in *Vogue,* R. R. (René Robert) Bouché, created a series of portraits showing the network's stars. These blotted-line images that balanced smudgy details with empty white space were used in print and on-air as part of the titles for each of these live programs. The series began with newscaster Edward R. Morrow and included comedians Jack Benny, Red Skelton, George Burns and Gracie Allen, as well as actors Bing Crosby, Eve Arden and Raymond Burr. All these illustrations included Bouché's signature and gave the impression of being artworks not simply advertisements—this transformation from ad to prestige artwork was crucial to CBS' identity as the "Tiffany Network" in the 1950s. Golden's rationale for this decision reveals how Modernist design served the goal of distinguishing CBS from other television networks:

> Faced with the new fact of consumer advertizing, we tried to consider it carefully. . . . We tried to consider it as a new entity. We didn't think we

should imitate the advertising of motion pictures or the theater, because it was neither of these things. We knew very well that theatrical advertizing was burdened with its own baggage and its obsolete traditions. We considered it an opportunity to make a new kind of advertizing for a new medium.[2]

The rejection of motion pictures as being a different medium and the relegation of theatre as coming from an "obsolete tradition" is distinctly Modernist: it is an insistence on the medium-specificity of television as a distinct form, independent of other media and past traditions. At the same time, it was a distinction of especially great importance given that TV and live theater otherwise were very similar in production capacities and were technically limited in similar ways to what could feasible be done in front of an audience. This division of television from other, obviously related fields is a common feature to all Modernist artists, and its appearance in Golden's justification reveals the close connections between design and art during this period. The embrace of what had been avant-garde aesthetics twenty years earlier had become the 'mainstream' understanding of the 1950s.

On CBS the title designs for the shows and the print designs promoting those shows were standardized by Golden's department, enabling a highly uniform engagement and presentation of their networks' content. Thus while the titles on screen might be relatively inanimate, their design would follow the same standard and use the same graphics as the newspaper ads for that show, linking the various presentations through a consistent "look." It is a model that Hollywood films would embrace—under the influence of Saul Bass' work—by the middle of the decade.

BROADCAST/NETWORK TV

The rise of Broadcast/Network TV imposed a complete shift in distribution paradigms on TV production that was almost completely in place by 1963; with the final end of newsreels in 1967, the dominance of the three television networks, ABC, NBC and CBS, became apparent. During this period the organization of television titles underwent a consolidation as the presentation of programs shifted from black and white to color and from having a sole-sponsor for any given production to a more contemporary model based on selling commercials that appeared in periodic program breaks. This change enabled the opening titles to serve a different purpose than during the live television era: titles became more explicitly concerned with the show's content and generic identification.

The programs produced during this period were pre-recorded before broadcast—shot on film (or less commonly on videotape)—allowing for a complexity of production and story that was nearly impossible for the live studio productions of the Live Period. Creation of these title sequences was done by contracting with a designer or a company to produce the titles for a set fee and deliverable on a specific time schedule. Pacific Title and Art Studio, Inc. in California, (like its counterpart Robert Greenberg and Associates in New York), provided production services for both television and film title sequences. These companies were responsible for the creation of graphics and title sequences for television broadcast.

Pacific Title and Art Studio, Inc., titles for *The Twilight Zone,* 1959

Pacific Titles' iconic design for *The Twilight Zone* (1959) title sequence shows the Broadcast/Network TV paradigm shift. The design of titles and their relationship to the program established in these titles becomes the standard by 1964. The titles for *The Twilight Zone* were highly influential not only on other, similar programs such as *One Step Beyond* (1959) or *The Outer Limits* (1961), but on later programs that can be connected to the science fiction and horror genre; it is notable that all these later programs emerged during the 1980s as Cable TV began to challenge the Broadcast/Network paradigm. The combination of a sequence of iconic imagery synchronized to the music worked to establish a specific generic form expressed via the title sequence itself.

The sequence of images, each presenting an iconic aspect suggestive of horror in science fiction, proceed as a sequence synchronized to Rod Sterling's narration. It is a combination of elements whose structural organization translates the synchronous form of visual music—note to shape correspondences—into a verbal-visual relationship of narrative and floating image. It was a novel translation of elements in visual music into a vernacular form. The closest parallels for this connection of language-to-image are in documentary films and the animated information graphics occasionally used in them: the connection of voice over to the on-screen image works in the same synchronous fashion: the images become a visualization of the language, creating the same effect as lip sync where actor's words and movements correspond. It is a model for narration to image synchronization commonly employed in TV title sequences.

Similar to the voice over narration in titles is the use of "singing titles"—the creation of a theme song that told the back story for a show—is one of the primary identifiers for the "sitcom" or half-hour situation comedy, a format that emerged during the transition from live to recorded programming. In these openings, the titles served as illustration of the backstory that was presented through the theme song. It is an organizational technique that developed specifically in the Broadcast/Network television period, with numerous examples across the entire period. It is a format that all three broadcast networks used in the creation of their series: *Gilligan's Island* (1964), *The Beverly Hillbillies* (1964), *The Addams Family* (1964), *The Brady Bunch* (1969), *Welcome Back Kotter* (1975), *The Jeffersons* (1975), *Bosom Buddies*

(1980), *Family Ties* (1982), and *The Fresh Prince of Bel Aire* (1990) all employed an opening theme song to explain the premise of the show. Each episode was essentially self-contained, with a limited cast of recurring characters often coupled with a special guest star around whom each episode's story centered.

Detective and crime programs have been a continuous part of television programming since its beginnings. The organization of the title sequence has been an essential indicator of specific sub-varieties of detective program: the distinction between an action-based detective show and one that follows the investigation process, whether a private detective or the police, is reflected in the style of the show opener, even though there are definite points of contact and overlap between the more action-based and investigation-based variants.

POST-MODERN DESIGN

Both Modern art and design aspires to create universal, formal languages. The formal 'purity' described by critic Clement Greenberg is an example of how this process worked (at least rhetorically): by eliminating the overlaps and borrowings from other art forms, the Modernist work would become immediately recognizable as itself—in effect, becoming an essential, fundamental expression—thus allowing the works produced in that way to be immediately recognizable and comprehensible without concern for the subjective and idiosyncratic features of personal experience, knowledge and expertise: this is the "universal" aspiration of Modernism by the middle of the twentieth century.

It is a desire that creates uniformity and promotes an authoritarian demand for conformity to whatever *essential* elements were being promoted; it is this exclusivity that is built-in to the 'purity' of Greenberg's theory—and is apparent in each historical avant-garde's writing manifestos and demand that all artists adhere to their particular program. No alternatives are allowed within a construct—that is the *authoritarian* element to this Modernist construction; it is inherent to the idea of a universal language. There can be only one because to admit alternative is to suggest that the proposed universal is only one of a set of independent and mutually exclusive options.

This Modernist conception of art, design and culture is a consistent feature of the twentieth century, as is the critical response some artists had to it throughout that period. The rejection of this Modernist universality is not Anti-Modernism, which was equivalent to an affirmation of the traditional, academic art Modernism replaced, but a collection of tendencies that would become Post-Modernism. This development began as a rejection of the idea of "universality" by Marcel Duchamp who introduced the idea of 'chance operations' in its place. "Chance operations" are left "open to chance" only in the sense that the missing details of the instructions are open to interpretation in their implementation, as the instructions for the readymades, recorded on a note his *The Green Box* make apparent:

Specifications for 'Readymades'

By planning for a moment to come (on such a day, such a date, such a minute), 'to inscribe a readymade'—The readymade can later be looked for.—(with all kinds of delays). The important thing is just this matter of

> timing, this snapshot effect, like a speech delivered on no matter what occasion but at <u>such and such an hour</u>. It is a kind of rendez-vous.[3]

The character of a "speech delivered on no matter what occasion but at such and such an hour" would be a statement of whatever happened to be the most recent subject of personal thought; a representation of the "desire" of that particular instant. By making this the analogy for the process—a snapshot—Duchamp implies the readymade is a presentation of his subjective moment, but which is then connected to some physical support (the actual 'readymade' we know) whose choice depends on how he implements his instructions at some later time which could include reconsideration, revision and reinterpretation (the "delays"). The initial statement limits the possible implementations, but only just. Depending on how the framework for making the selection is decided based on the written instructions, different results will follow. The initial conditions of the search determine the outcome.

Duchamp's proposal is *not* random: it is the idiosyncratic, personal response that fundamentally alters the results produced by "chance"; it is a redefinition of the common meaning to refer instead to the individual choices made outside the logical and limiting instructions employed to make an artwork. It is this idea—personal subjectivity—that undermines the universal aspiration by demanding that individual responses and differences be considered valid.

The emergence of the Post-Modern as an alternative to Modernism began in the 1960s, (not as a rejection of the established Modernist paradigm), as a reconsideration of priorities within the existing Modernist approaches. It is a change of emphasis that produced a shift from a view of art as isolated—art for art's sake—to contingent—art as a reflection and expression of a culture, dependent on social, economic and political concerns as much as aesthetics. This transformation has been called both "pluralism" and "relativism" since it acknowledges there are alternatives to all cultural constructions (both intellectual and aesthetic) and insists on considering the ways that art and media reflect and engage with social and political power relationships between different groups, often emphasizing the ways that those with power use it to consolidate and maintain their positions within society.

The development of quotation and structural designs that insistently rely upon their audience's ability to recognize recurrent elements is a feature of this Post-Modern shift: the potential for a universal language disappears once the role of past experience and memory is brought into the consideration of how audiences understand media. It changes the fundamental assumption about viewers: either they are passive, acted upon by media (Modernism) or they are actively engaged with evaluating and anticipating what appears in media (Post-Modernism). This new conception of active viewers followed changes in psychoanalysis also happening during the 1960s. Psychologist Abraham Maslow argued against understanding the human mind as a passive recipient of experience, or as a slave to unconscious drives beyond conscious awareness or control; instead, his conception of mind based in ideas of individual autonomy and the necessary role of personal development is reflected in the Post-Modern understanding of human actions as motivated and active. Maslow's ideas were popularized through the 1960s counter-culture, making them not only the domain of specialists.

The Modernist absolute conception of mind and the Post-Modern concerns with individuality are mutually exclusive, but relate directly to the development of motion graphics through its role in commercial TV ads: the development of audience response surveys by marketing and advertizing appeared during the 1950s and 1960s as *Symbology*—a search for universally effective symbols that could be used to make advertizing more effective. The 1959 conference on "Visual Symbols" promoted in the magazine *Art Direction* makes the universal aspirations of this period the direct focus of the conference itself:

> You have at your disposal the vast apparatus of language and pictures, of numbers and insignia of media that reach into every far-flung corner of world—short wave radio, trans-oceanic telephone and telegraph, the miracle of the television tube.

> And yet, in many crucial instances and in many vital areas, communications break down. Your message becomes a blur of print, a blob of sound—meaningless and incomprehensible.

> Why?

> Because there is, as yet, no international system of symbols hurdling language barriers; no single codified and reciprocal nomenclature—instantly comprehensible to the Swahili engineer, the Chinese physicist, or the manufacturer of oil derricks in Oklahoma City.[4]

This proposal—*a universal visual language*—requires an elimination of all differences, the submission of any local deviation to an imposed, American standard. This is the type of universal and authoritarian proposal that was a common feature of Modernist approaches to language and communication. The Post-Modern critique emerged as a specific rejection of these aspirations to dominance: the desire to produce one singular message that would then be distributed everywhere without concern for local differences and the specific heritage of those locations was termed "colonial." It necessarily creates an imperial center whose authority is then applied uniformly throughout the world. "Symbology" was an example of the appropriation of scientific methods for non-scientific ends by the advertizing industry; this adoption of pseudo-scientific forms was a tendency common in Modernism, and a feature of the avant-gardes generally. Their wide-spread adoption by ad agencies in the 1950s and 1960s was a symptom of how Modernist and avant-garde practices became a common feature of culture in the United States during this time.

The transition to Post-Modernism that happened during the 1960s developed from a broad spectrum of critical engagements with the popular culture of the United States. The idea of "post-modern" was initially proposed in relation to American architecture. Architect and theorist Robert Venturi wrote *Complexity and Contradiction in Architecture* (1966) followed by the collaborative project, done with Scott Brown and Steven Izenour, *A Significance for A&P Parking Lots, or Learning from Las Vegas* (1972, revised 1977) that argued against the standard Modernist forms then in use. In their place, Venturi argued for a vernacular architecture based in local traditions, tied to social function, and reflective of the local context where the building was erected. Combined with a conception of the audience as active and

participatory rather than passive, the rejection of abstraction in favor of popular imagery in art, (as well as the embrace of variation and idiosyncratic local traditions), and increasingly during the 1970s and 1980s, the use of complex critical theory that challenged both authority and fixed meaning, the 'shape' of Post-Modernism becomes apparent as a general reversal of the unitary, dominant and singularity of Modernist art and theory generally.

This replacement of Modernist hierarchies and 'authoritarian' aesthetics with an aesthetic based in popular, immediately recognizable imagery and singular, fixed meanings. The emphasis became the contextual and particular history of society. It is marked by ideas of difference, the plurality of meanings, a tendency to treat all experience as a variety of language (text) that can be interpreted through semiotics, and finally by a skepticism of all universal explanations and explanatory systems. The internal contradiction between a skeptical approach to all knowledge and the certainty of that skepticism's validity lead to a general "abandonment" of Post-Modernism during the 1990s by the artists and theorists who helped define it. In the period after this transition point, no single set approach to cultural interpretation and investigation has been dominant; at the start of the twenty-first century, in place of Post-Modernism, a variety of revivals—especially Modernist-derived ones—have appeared and disappeared, suggesting the end of Post-Modernism resembles fashion more than any of the historical art movements in the nineteenth and twentieth centuries.

Motion graphics first consolidated as an industry during the early stages of what would become identified as the Post-Modern. Throughout this period broadcast or motion graphics have consistently found a commercial application in advertizing and commercial media of all types. Unlike the abstract films and other art world variants of motion graphics, the designs used by commercial media are constrained by the already-existing "*brand*" designs—to create a new motion graphics piece for a company that already has an existing ad "look" or "style" places specific demands on the design of any motion graphics produced; this is commonly called "branding," but from a formal design perspective, the problem is concerned with questions of "seriality": innovations within an established set of limiting conditions the audience already knows and recognizes. The development of this "serial aesthetic" is one highly visible feature of Post-Modern design generally.

Yet what does it mean to suggest that motion graphics employs a "Post-Modern aesthetic"? This is not simply a rhetorical question: it identifies one of the central issues in interpreting and understanding the difference between how designers and artists related to the history of their medium at the end of the twentieth century vs. the beginning of that same century. Where at the start of the twentieth century there was an increasingly vocal call for over throw of established conventions and forms, at century's end, there was an acute historical consciousness of precedent, relationship to established forms, and the contingency of current work on what had come before. It is how this connection between the past and present impacts the designers and artists working that offers the potential to think about a "Post-Modern aesthetic."

Semiotician Umberto Eco suggested this changed consciousness of past precedent and historical connection constitutes a distinctly Post-Modern approach

in his description of the ways that serial form has been applied in the Post-Modern period. The expectations that we-as-audience have when confronting a media work are his focus:

> Let us now try to review the [concept of serials] from the point of view of a 'modern' conception of aesthetic value, according to which every work aesthetically 'well done' is endowed with two characteristics:
>
> It must achieve a dialectic between order and novelty, in other words, between scheme and innovation.
>
> This dialectic must be perceived by the consumer who must grasp not only the contents of the message but also the way in which the message transmits the contents.[5]

The essential characteristic of serial structures—variation—where the audience's knowledge, awareness, and ability to recognize references and quotations becomes one of the organizing principles employed in the production of new works. Aesthetic validity for a serial work derives from the audience recognizing how the schema (the ways that expectations are met) conditions their ability to understand the innovations (differences from expectations) as being *innovative*. The audience's role as spectator is crucial—they must be a self-consciously interpreting, anticipating audience. A dialectic between order and novelty requires the audience to have an internal model for the serial (the order itself is such a model)—otherwise they cannot recognize any of the characteristics Eco values: variation, repetition or novelty. This recognition proceeds through the ways that serial forms are organized structurally.

As a formal design principle, "variation" shifts emphasis from originality to the minute differences and divergences that make each new example unique, and at the same time, consistent with what has already been established. Variation proceeds through a process of substitution and alteration. The photograph of a row of *Roland Cherries* provides a direct illustration of variation. The various flavors of "cherry" present a range: *Maraschino, Lemon, Lime, Wild Berry* and *Passion Fruit*. Each label is a different color, as are the artificially flavored, processed cherries inside—the color of the fruits correspond to the color of the label, identifying each jar with its content. The designs of each label are utterly consistent, varying only in the color of the ink (to match the fruit) and the identification of the flavor: they are all instantly recognizable as "*Roland Cherries*" without needing to read the label. This structure is the essence of serial form in action: it unifies a variety of otherwise potentially unrecognizable things, since what remains of "cherry" if the fruit is neither red, nor cherry-flavored?

The order posed by the designs for *Roland Cherries* provides a coherent framework for the creation of variations—in this case, not only of the design, but the product identified by that design. As an aesthetic model the schema depends on the audience recognizing variations as different potentials, even when the actual design is at great distance from the original form. Bright blue, wild berry-flavored cherries may have only a cursory resemblance to their maraschino-flavored fellows, yet the serial construction describes this situation precisely and, at the same time depends on our understanding—and recognition—of the variation happening

Roland Cherries shelf display showing serial variation, August 15, 2009

within the serial form. While Eco's theory is concerned with story telling and narrative structure, he identifies three structures that also apply to visual design:

(1) **The Retake**
 where both factors are equal in the order | novelty dialectic

(2) **The Remake**
 where novelty dominates in the order | novelty dialectic

(3) **The Series**
 where schema dominates in the order | novelty dialectic

Television programs in particular provide abundant examples of the serial forms in use as narrative structures. In each formal organization of material, the relationships between established forms and innovative development are of great importance to the multiple, serial designs commonly used in motion graphics: there is rarely only one example of any given design: instead, it is iterated, presented as a collection of similar designs rendered at varying lengths, with a variety of different uses, and increasingly on a variety of screens—TV, cell phone, computer—yet must retain a semblance of uniformity and coherence. This situation is true of all serial constructions, no matter how they are organized and is especially apparent in the generic identifiers in TV titles from the broadcast/network period. These similarities enable the connection of new programming to existing genres. The influence of *The Twilight Zone* on the entire genre of science fiction, fantasy and horror programs becomes increasingly apparent starting in the 1980s: *Amazing Stories,* (1985) *The New Twilight Zone,* (1985) *The X–Files,* (1993) and *Fringe* (2008) all quote elements of this earlier sequence. Of these later titles, *The New Twilight Zone* is an explicit *remake* of the earlier title sequence.

All three of these organizational forms develop a particular set of potentials from a limited number of initial elements, and each variation is defined by its relationship to previous models and by how it reworks those schemas to produce a

novel example. This is an *active* conception of audience viewership: it is more than simply a permutation of limited elements, the serial form fundamentally uses the viewer's knowledge and awareness of previous examples is an essential feature of the work. These designs are, in a sense, quoting themselves. This shift to an explicit quotation is a basic feature of a Post-Modern design aesthetic. Every Post-Modern serial is both a new, unique work, and—at the same time—drawing from the audience's knowledge; the term for this relationship is "intertextual," and serial forms of all types (including designs) are always intertextual—it is a description of our ability to recognize the variation and repetition essential to these designs.

THE RETAKE

The various animated logo designs used by TV networks vary in length, but remain consistent in their design and organization are a prime example of the retake's consistency-within-variation were a limited set of elements permute through a series of superficially novel designs: the idea of variation is evident in the "bumper" graphics used on Cable TV as station identifiers, a model pioneered by MTV starting in 1981. This design approach employs a limited number of consistent elements whose arrangement and organization changes in each individual design.

The early MTV logo graphics employed a specific set of transformations applied to the station logo; the evolution of this design approach is apparent in the bumper graphics for *Nickelodeon*, a children's Cable TV network from 2008. Produced in a variety of lengths, each animated sequence has the appearance of novelty and uniqueness yet is highly constrained and follows a set sequence of actions. The reiteration of a limited quantity of elements, arranged into a complex sequence of repeats, variations and alternative 'camera angles' creates variety within a highly homogenous library of visual elements.

THE REMAKE

Logos provide one of the strongest examples of retakes in action: the Hollywood film and TV studio, *Universal Studios*, has redesigned its logo every few years since the 1920s to reflect changes in studio ownership, shifts in technology (color, widescreen) and the occasional re-naming of the company. At the same time, these logos have retained essential, consistent features that render them recognizable in spite of their radical transformation between the 1920s and the 2000s. While all the Hollywood studios have been confronted with similar changed circumstances, only the *Universal Studio* logo has exhibited a high degree of transformation over the decades.

This particular designs' consistency throughout this transformative process reflects the organizing structures that enable the serial form known as a retake to function. Not reducible to any singular (and absolute) listing of elements, it is never the less immediately recognizable. The *Universal Studios* logo design used in 1927 shows a spinning globe with a small, animated plane flying around it; the name "*Universal Studios*" appears in its contrail smoke. This logo was replaced by 1932. The new design changes the camera angle, replaces the plane and adds the sound of an engine running; the text appears in a diagonal wipe, reading, "*A Universal Picture*" with a slight distortion, implying it follows the curvature of the globe. By 1943, the

airplane is gone, and three dimensional, mirrored text, its contents unchanged, now spins around a mirrored sphere with twinkling stars that project rays around it; a trumpet fanfare plays. This design again changes radically: the new name "*Universal International*" is optically printed with a drop shadow over a three-dimensional relief globe that slowly spins, and there is a different fanfare; this design, in use by 1948, recalls to the earlier designs of the 1920s and 1930s; the fanfare will change by 1950. By 1960 the transformations have again changed the fanfare, added color, more complex camera movement (a dolly-in on the spinning globe), and the return of "*A Universal Picture.*" This graphic organization remains consistent through the 1970s—the fanfare and text change, but the visual structure (a camera move in on a spinning globe) remain constant—but with two variations in use in the 1980s: the first employing the moving opening; the second a fade-up on the end section of the motion with text and globe together on screen at the same time. By 1997 digital animation technology enabled a radically new design: the "sunrise" opening where light plays around the edge of a digital globe synchronized to the fanfare, with the text orbiting the earth as the camera pulls back to reveal the spinning globe. This organization demonstrates the active dimensions of audiences watching media works. They are active interpreters, employing their knowledge gained through previous encounters with similar types to anticipate and recognize divergences from each specific serial form. This interpretive interaction between schema (past experience) and the novel example is common to all serials—both those of fine art as well as those created in the popular media—the difference between one serial and another is a matter of references employed, not of formal construction.

Each of these designs for the *Universal Studios* logo retains certain, essential elements: the spinning globe in space, the text suspended in front of the earth, and by the 1940s, a fanfare that in later versions is synchronized to the animation shown on screen. However, even within these constraints everything changes: the name of the studio, the placement of the text, the style of animation, the globe and its background. There are no features that appear in all the variations, yet the logo remains a coherent, recognizable design. In the case of *Waterworld* (1995), the opening logo is also the opening shot of the film: the ice caps in the globe melt, and flood the land, leaving an entirely blue sphere. The serial "play" with the standard *Universal Studios* logo in *Scott Pilgrim vs. The World* (2010), where it was converted into a design resembling 8-bit video game graphics, complete with an 8-bit styled fanfare, is more closely related to the serial manipulation and insertion of the "WB" shield logo in Warner Brother's films such as *Sherlock Holmes* (2009) where it was fitted into a cobblestone road.

THE SERIES

In a series, very little changes from design-to-design.Gene Kraft's titles for *The Hardy Boys/Nancy Drew Mysteries* (1979) employ the existing book cover art as a means to establish a direct relationship to the already known book series about teenaged detectives. The then-contemporary cover illustrations provided the foundation for the development of the title sequence: the actors playing Frank and Joe Hardy, and Nancy Drew were posed to match the characters on the book cover illustrations, allowing them to replace the painted figures from those covers. The resulting restaged book covers created a direct relationship for knowledgable

viewers between the show and the mystery stories. There were two versions of these titles to use the bookcovers: in season one, they provided monochromatic superimpositions where full-color actors would run around in a darkened space; in season two, there were two versions of the titles—one for the *Hardy Boys,* the other for *Nancy Drew*—the bookcovers, now in full color, appeared in a grid, framing live action shots of the actors from episodes in season one. These optically printed titles showed a matrix of potential mystery stories linking the individual books with the "other stories" shown on TV. The nature of these as a 'series' extending the books into a new medium was explicit in the construction and development of both season's titles.

CABLE TV

The development of "Community Antenna Television" began almost as soon as broadcast television went on air; by placing antennas where there was good reception, these high quality broadcast station signals would then be distributed to those communities by coaxial cable by the nascent cable companies for a fee. Initially a local phenomenon, designed to bring television to communities with poor reception due to geography or distance from a broadcasting center, it only began to expand following a change in regulatory guidelines by the FCC in 1977. Its evolution into "cable television" proceeded gradually; in 1950, early cable connections served 70 communities in the United States, reaching 14,000 homes.[7] Initially heavily regulated, between 1965 and 1977 the rules governing Cable TV franchises were eliminated, enabling a major expansion of Cable TV into new areas that were otherwise well served by broadcast TV.

This expansion lead to new regulations for Cable TV by the FCC in 1984. *The Cable Communications Policy Act* of 1984 resolved a range of legal issues arising from the expansion of cable: passed in October 1984, it amended the earlier *Communications Act of 1934,* defining issues of ownership, channel usage, franchise provisions and renewals, subscriber rates and privacy, obscenity and lockboxes, unauthorized reception of services, equal employment opportunity, and pole attachments. The new law also established regulations for cable television systems, which were amended in 1992 and again in 1996 to reflect the changing media environment as Cable TV replaced Broadcast/Network TV as the dominant media distribution technology in the United States.

Just as the final end of newsreels clearly marked the dominance of Broadcast/Network TV, the dominance of the Cable TV became apparent through the distribution of news: during the Gulf War in 1990 the primary source for information about new developments was the cable station CNN. The transition from the Broadcast/Network TV model was in progress throughout the 1980s as Cable TV became more common and the number of available channels provided on Cable quickly expanded beyond the limitations of local markets; also during this decade the technical quality of both television as a medium and the distribution of the video signal through cable increased, resulting in higher resolution, clearer pictures and sound at the end of the decade, showing the increasing impact of digital technology on the production and distribution of television programs.

Titles for television programs underwent a metamorphosis in the 1990s, not in terms of style, but in production: the development of progressively higher power, faster computers starting in the 1980s reached a critical threshold in the mid-1990s, making the production of computer graphics for title sequences both economical and more efficient than the traditional methods using optical printing and compositing with either film or video. The immediate result of this change can be seen in the increasing complexity, visual density and kinetic quality of the imagery in titles beginning in the middle of the decade. The title sequence for *Buffy the Vampire–Slayer* (1996) is markedly different from those produced only a few years earlier: faster paced and employing a mixture of composited text and imagery (initially still images shown in very short montage groups interspersed with live action), these titles reveal the impact of digital technology. The balance between production time, available budget and computing power appear clearly in the rapid changes that appeared in the period between 1995 and 2000; as the twentieth century came to an end, the power of the computers being used to make these titles radically increased, allowing the images that were static in 1996 to be in motion.

During this same period between 1980 and 2000, the commercial development of the Internet as a distribution platform happened in several stages, moving gradually from an academic tool to share computational resources to public communications network. The initial shift from academic tool happened when *Compu-Serv Network, Inc.,* a company that sold hourly connections to their computer network, became a publically traded company in 1975, and changed its business model from selling access to its computers (time-sharing so programmers could run their own software), to selling access to packages of pre-written software, email, and other network-based services to people who were not programmers. In 1989, CompuServe would be the first company to enable access to the internet itself by accepting email originating outside its proprietary network. This opening onto the larger Internet was the first of a series of changes among the early internet service providers that helped make the development of hypertext and the WorldWideWeb (W3) by Tim Berners-Lee and Robert Cailliau—a development they announced on August 6, 1991—into a new, general distribution technology as the connections between different, private networks became more common and important to communication and business.

The revival of earlier programming in the 1980s was a symptom of the challenge posed by Cable TV to the Broadcast/Network TV distribution model: *The New Twilight Zone* (1985) following on the success of *The Twilight Zone: The Movie* (1983) and the start of a sequel to the 1966 *Star Trek* series with *Star Trek: The Next Generation* (1987). In both cases the program's title sequences explicitly reference the earlier show. In a similar way, the reference to the earlier *The Twilight Zone* (1959) title sequence also appears in other shows of this period, suggesting that the revival and reference to/of earlier forms comes at moments of crisis for the dominant paradigm. Both *The New Twilight Zone* (1985) and *Amazing Stories* (1985), as well as *The X–Files* (1993) appear when the Broadcast/Network paradigm is threatened by the newer Cable TV; similarly, *Fringe* (2008) appears as the Internet threatens the dominance of Cable. The emergent dominance of a new paradigm happens over a period of years, as audiences and advertizing begin to shift their emphasis towards

James P. Bissell and Ron Cobbm titles for *Amazing Stories,* 1985

the new, disruptive technology. These changes appear symptomatically as ruptures with established form, as much as through regressions or revivals of earlier successes.

The crossover between feature film production and television production that began in the 1950s began developing towards explicit crossovers where productions done for television might include a theatrical-length premiere that resembled a feature film more than an TV program. The title sequences for these programs, such as *Dallas* (1978) designed by Wayne Fitzgerald, would typically be theatrical in nature: longer, more complex, but would only be used for that premiere; the regular programs would have shorter, more typical TV titles generally running less than sixty seconds. This trend towards convergence of TV and feature film reflects an early response to the challenges posed by Cable TV's emergence in the 1970s. Both *Battlestar Galactica* (1978) and *Buck Rogers in the Twenty-Fifth Century* (1980) were designed by Wayne Fitzgerald and their opening sequences explicitly evoke the titles for theatrical feature films; in the case of *Battlestar Galactica* the two hour premiere was released as a theatrical feature. During the 1980s, such explicit crossovers from TV to feature film distribution would begin to shift from TV shots being launched as feature films, to feature films being made based on TV shows.

Yet the titles for TV shows did not change dramatically during the 1980s as feature film titles produced during the Logo Period essentially disappeared into the opening scenes of the film, and the mise-en-scene of the action was staged within a "TV safe" area to facilitate the broadcast of the feature on television. The market-based opposition between film and TV was rapidly disappearing. The creation of title sequences on TV remained much the same, as did their

location—at the start of the program—throughout the decade. The impact of new digital technologies and Cable TV was initially subtle: improved picture quality and sound reproduction, but not a new aesthetic.

The titles produced at Pacific Title for David Lynch's fantasy-horror detective program, *Twin Peaks* (1989) employed a title sequence unlike anything produced for an on-going, broadcast television program before it, although there are direct parallels for the typography in the title design for *Alfred Hitchcock Presents* (1962). The theatrical feature length title sequences designed by Wayne Fitzgerald for the premiere episodes of *Battlestar Galactica* and *Buck Rogers*, while longer than the titles in other television programs, were also special title sequences that were not used again during the course of the program's run; instead shorter, more typical titles for television programs replaced them for the remaining episodes; this was not the case with *Twin Peaks*. Running almost three minutes, organized around a tonal montage contrasting nature with industrial machinery, it did not show any scenes or characters drawn from the program itself: these titles would be more appropriate for a commercial feature-length film than a television program.[6]

There are a number of significant differences between David Lynch's TV show and earlier broadcast programming, ranging from how it was shot, (as a theatrical feature film would be, both on the level of camera work and lighting to the framing and editing of sequences), to the use of actors better known for working in commercial feature films. Pacific Title's design for *Twin Peaks* is representative of the ways the entire program challenged the standards for the design and production of television programs generally; it comes at the moment when the Broadcast/Network TV paradigm was in transition to the Cable TV paradigm that would dominate the 1990s.

INTERNET

The response of both Broadcast/Network TV, and its successor Cable TV, to the challenge posed by the emergent competition of the Internet in the later 1990s, as the technology became wide spread and "web access" became common, has been less focused and coherent than that of the Hollywood studios to the challenges posed by television in the 1950s. The shift from Cable TV to the Internet first came into focus in 2009 with the Iranian elections and the protests, followed shortly in 2010 by the use of "social media"—made possible by the online distribution platforms *Twitter* and *Facebook* coupled with cellular telephones capable of connecting to the internet, shooting video and communicating with text messages—demonstrating the changed relationship between production, distribution, and interpretation of news and current events. The distribution shift that these news events revealed had been anticipated throughout the first decade of the twenty-first century in the increasing prominence and ease-of-use for online video and the development of both the DVR and home media servers that allowed the downloading and viewing of programming on demand.

At the same time as this shift is underway, television's response to the challenge of the Internet has been to replicate a successful program, but in a new locale with an entirely different cast. These "franchise" shows use a title sequence that is essentially identical to the original program—but with a subtitle added

indicating the difference. This approach emerged at the end of the twentieth century with the various *Law and Order* (1990) variants: *Law and Order: Special Victims Unit* (1999), *Law and Order: Criminal Intent* (2001), *Law and Order: Los Angeles* (2010) each of which uses known actors from feature film production. These programs produced for a Cable TV audience seek to attract an audience using famous actors not known for their roles on television. The appearance of these film actors in recurring roles on television shows the influence of Twin Peaks on later programming.

In a diametrically opposite response to the franchise show, but sharing common elements with it, was the rise of "reality TV"—programs produced quickly and without detailed scripts that adapted a hybrid form of a game show and documentary (*Survivor, Big Brother*) that used unknown, "everyday" people as the cast. These everyman programs are possibly the most direct response to the challenges of the Internet, reflecting and anticipating the phenomena of the "*YouTube Star.*" The titles for these programs, however, remained comfortably within the boundaries of established precedent.

Part of the difference in response lies with the ambivalence of the online competition: it is marked by both a parasitic redistribution of existing media from television and film, and by a non-professional, do-it-yourself mode of media creation—the world wide distribution of what are essentially home movies. What was unclear about this emerging distribution system was what relationship it would have to the existing media companies and their programs. The impact on television titles, similarly was unfocused: many programs steadily shortened their title sequences with each season's renewal, reaching a level of absurd brevity in *Lost* (2004) whose titles ran only fourteen seconds—just long enough to identify the show, functioning as a singular logo with the remaining titles integrated into the narrative scenes that followed—a convergence with the aesthetics and approach that characterized the Logo Period designs used for feature film titles in the 1980s.

VIDEO GAME TITLES

Video game titles and end credit sequences emerged relatively late compared to other forms of kinetic type and title design: film was employing titles almost immediately, a requirement of the copyright office, and titles always had a role in TV programming. The first video games, produced in the 1950s and early 1960s were collaborative projects done by small groups of hackers as experiments and for their own amusement. As a result, the title sequence in a video game does not appear until much later in the medium's evolution.

Unlike the first developments in television titles, the video game title sequence has explicitly used the theatrical feature as its point of reference, not only for the creation of titling but for its style as well. As the technology of video games improved, the design and organization of title sequences has moved closer to the techniques and aesthetics employed in other types of motion graphics. In this regard, the title sequences for the *Metal Gear Solid* games designed by Kyle Cooper and produced by the company Prologue—both of whom are better known for their feature film title designs—demonstrates the connections between titles for traditional, linear media and the title designs for video games. The development of

titles in video games followed two parallel paths—the fully graphic arcade model where dedicated controllers allow game play, and the home computer that initially enabled more complex games with intricate narrative action. As these two models converged in the 1990s, a new, more cinematic game became the common.

The early title sequences in video arcade games followed a similar trajectory to those created in motion pictures: initially designed simply as identification screens providing title information and copyright, video game title sequences moved towards a more cinematic, narrative construction as computers became more powerful; the industry term for these opening sequences reflects their relationship to motion pictures: "cinematics" are digitally rendered animations done in the style of the game's graphics, but are motion pictures, rather than interactive, playable scenarios. They emerged in the 1990s as computers became powerful enough to support complex, animated graphics while at the same time loading the game into memory and getting it ready for play.

Early video game titles present a variation of the pattern established by Edison's kinetoscope parlors: individual machines presenting different games. The titles for all of these early arcade games show a combination of information about how to play the game and what playing the game looks like: they demonstrate the activity and compete with the other game machines also set up in the same arcade to attract players.

Pac–Man (1980), designed for the public arcade, used its title sequence to present the individual characters of the game: the four ghosts (Shadow, Speedy, Bashful and Pokey), their point values, and the copyright for the game. This use of titles as an information graphic describing, and showing game play—part of the "opener" for video arcade games was the demonstration of how the game runs—by having a repeating loop of automated play running in between the title cards when the game was not being played. The design of titles and opening graphics for games in an arcade setting—where different game machines compete with one another for both attention and player's money—were more active and engaging than those used in home video games.

In contrast to arcade games, video games designed for home play, whether on a console system, or the home computer did not need to compete with other games around them. These opening titles functioned as identifications of the particular game, presenting a "boot screen" while the game loaded that would often include a progress indicator. The first games for the home computer were not graphics intensive; instead they were text-based, requiring the player to read descriptions of their environment and interact through a series of commands entered into a command line. The games produced by Infocom—starting with *Zork* (1980), *Zork II* (1981), and *Zork III* (1982)—were designed as interactive fictional worlds where the game play consisted of exploring a lost underground kingdom. The material that would be in an "opening sequence" in later games appears in game as a leaflet: "Zork is a game of adventure, danger and low cunning. In it you will explore some of the most amazing territory ever seen by mortals. No computer should be without one!" The actual boot identification was brief, simply listing the game title *Zork I: The Great Underground Empire* followed by copyright, revision

information and a serial number. As computing power increased and the technical capacity to include complex, interactive color graphics in the game became more common, a market for adaptations of arcade games (and original) graphics-based games appeared around the home computer. However, the majority of these games retained a hybrid character, incorporating both graphics and text-commands into their interface and using text in both the opening sections and during game play.

Neuromancer (1988), produced for the home gaming market, presents a single title card, showing a cover graphic and the game title. This "intro screen" serves to give players something to look at, and identifies the game while it loads, a function that remains the standard for the cinematics of video games. As computers become more powerful, able to support more complex graphics and animation, the static intro screen was replaced by the more cinematic opening sequence.

Wing Commander: Privateer (1993) provides an essential set-up for the game play which follows by establishing the role of Brownhair (the character later named Grayson Burrows) that players assume inside the game, as well as identifying the basic elements of the game dynamic: flying a spaceship, fighting with other ships, and buying/selling cargo. At the end of the sequence, the alien drone whose destruction is the goal of the game, lights up and appears to follow Brownhair's ship off-screen. This opening serves as a preamble to the title of the game, reflecting the organization of motion picture sequences that emerged during the 1980s: the organization of the film titles around a block of narrative with the use of a logo graphic as the main title; individual credits would then be distributed into the narrative action of the film itself.

Syndicate (1993) follows a similar organization of its opening: a tonal montage sequence showing a futuristic city where cars float a few feet above the ground, gradually reveals itself as a narrative where one of the cars hits a man standing in the street. The visual design shows the influence of both the 1982 film *Blade Runner* and Japanese anime films. He is taken to a large building, and his right leg is replaced with a mechanical one; this montage appears to repeat, but with the difference that instead of being run down, he turns to the camera, draws a gun and fires. The game title follows as a series of animated letters. The opening sequence serves to establish the space where game play happens, as well as showing the isometric style of the game itself; it established the science-fiction elements of the world, and the cybernetic nature of the character used in game play.

Tomb Raider (1996) uses its opening sequence to introduce the story line and main character. These titles begin a subtitle stating "Los Alamos, New Mexico" that is immediately followed by a nuclear explosion, and UFO (literally a flying saucer-shaped craft) crashing into the desert and sinking into the ground. The camera follows it into the depths and fades into a new sequence that uses the uses a subtitle "Imperial Hotel –Calcutta, Present Day" to introduce Laura Croft and her identity as a rich adventurer who seeks out the paranormal (the magazine marked "Adventurer! Laura Stamps Out Bigfoot"). She receives word about the UFO from a laptop, and the game is ready to begin. The opening sequence is highly cinematic,

even though rendered in the low resolution graphics common to games in the mid-1990s. The speed of delivery as well as the complexity of information presented visually relies on the use of established editing techniques, narrative organization and visual production techniques already in use for theatrical motion pictures; this adoption of cinematic narrative techniques to explain the story and provide background becomes increasingly pronounced over the next decade.

Half-Life (1998) has an opening title sequence that begins with the game title, followed by a fade-up on a long take of a tour ride on a train. The intertitle, "*Black Mesa Research Facility, Black Mesa, New Mexico*" is superimposed on the center of the screen; the use of a long take with titles unobtrusively superimposed is an explicitly cinematic technique. It is possible to watch this opening without realizing it is a title sequence; the organization and integration of titles into the shot is subtle—they are placed in the lower left of the screen, allowing the player to concentrate on the tour and the important information it provides for the game play that follows. Significantly, this game was the first to incorporate scripted, cinematic elements throughout the game as part of its story development, reflected in the break-up into chapters that guide players and force the advancement of the plot. This structure, while superficially novelistic, is organized around cinematic events that punctuate the action.

Cinematic design in titles for video games converged with traditional media production in *Metal Gear Solid 2: Sons of Liberty* (2002), which was the first game title sequence designed by Kyle Cooper, who continued working on the Metal Gear Solid series, producing titles for *Metal Gear Solid 3: Snake Eater* (2004) as well titles for *Goldeneye* (2004) and *Darkwatch* (2005). The titles in *Metal Gear Solid 2* were constructed to be explicitly interactive, allowing the player to control aspects of the action shown on screen. Cooper explains in a 2004 interview with *Metal Gear Solid: The Unofficial Site*:

> In the finished opening scene, we plan on having a high level of interactivity; from shooting animals during the intro, to switching from planes to bees to snakes swimming in a certain trajectory by pressing a button, things like that. It is a new thing for me to do this kind of an opening sequence.[8]

The integration of interactivity into the title sequence fundamentally alters the design and construction of those titles, while at the same time, maintaining a cinematic construction; this approach is a hybridization of the typical style of cinematic titles and the normal play of a video game, resulting in a title sequence that gives a degree of control to the viewer. It was essentially an experimental approach to the titles for a video game, and one that remained atypical for the title sequence design of other games.

Bully (2006) opens as a short animated film containing the title sequence that shows how the player's character arrives at the boarding school where the action takes place. This sequence is fully animated as a 3D CGI film, broken into recognizable shots, with the title shots interspersed between the narrative shots of dialogue between Jimmy, his mother and step-father. It establishes the

estrangement between the character and his parents, as well as his rebellious nature. The sequence itself could be the opening to an animated feature film as easily as a video game; this overlap of techniques and design styles reveals a convergence of theatrical and interactive title sequence.

Call of Duty: Black Ops (2010) presents a montage sequence closely resembling a feature film; within this series of images of soldiers, animated maps and graphics is a narrative about attacks on the United States. As in earlier games where the influence of theatrical features provides an organizing style for the title sequence, in the case of *Call of Duty: Black Ops,* the titles show the influence of the title design by Stephan Burle for *The Kingdom* (2007) whose opening sequence served a function common to video games: the need to educate the players quickly about the subject that follows. The titles for *The Kingdom* did this by creating a graphic documentary using a combination of historical news footage, animation structured around audio clips that tell the recent history of Saudi Arabia; this format provided a clear model for the organization of fictional and true materials in the creation of an information-rich, easily accessible opening sequence.

VIDEO GAME END TITLES

The end credits serve a different function in video games than in motion pictures, even though both sequences provide similar listings of production personnel and acknowledge the roles played in the creation of the game itself. While it is not unusual for a game to provide a button to jump to the credits at the end, unless this potential is offered by the developers, the credits only appear once the player has won the game.

Portal (2007) has an end credit sequence that comments upon the game itself, while at the same time borrowing elements from feature films: GLaDOS, the computer/opponent in the game, sings a song to the player, and the design of the credits/computer interface recall the scene in *2001: A Space Odyssey* (1968) where Dave Bowman disconnects the HAL 9000 computer. These titles take the form of an amber display with three text areas: the credit scroll, a window where GLaDOS's report (the text of the song) appears as it is written up, and a smaller window showing ASCii pictures that synchronize with her song. This sequence also self consciously engages with the history of video games, both formally (the interface recalls the text-based Infocom games of the 1980s) and explicitly by talking about Black Mesa, the site of *Half-Life*. The discursive aspects of these credits reflect on the content of the game play, providing an increasingly threatening, sarcastic commentary on the events that bring the homicidal dimensions of the computer's actions into sharp relief while at the same time suggesting a critique of the military "play" simulated by all first-person shooter (fps) games—most apparent in the references to the earlier, highly influential fps *Half-Life*.

End credits, unlike the opening titles, have the potential to provide different experiences for the player depending on what happens within the game itself. Because the technical function of cut scenes—to provide "filler" while the next level of the game loads in the background—reflects the hybrid dimensions of the

titles and other cinematics within the game structure: because these elements come at the end of a "level" (suggesting the successful completion of a section of the game), the appearance of the cinematic at these moments suggests a reward. As with cut scenes, the end credit sequence that only appears after the player wins the game becomes a 'reward' given to the player for successful completion.

Gran Turismo 5 (2010) contains multiple versions of its end credits. One sequence is simply a text scroll, listing the developers and designers who produced the game. An alternative sequence exist for players who not only successfully complete the game, but do while scoring above a preset level; this alternate sequence contains the same credit information, but is also visually exciting, superimposing the scroll over a car bumper-level camera filming a high speed drive through the *Nürburgring Grand Prix* race course in Germany, followed by driving on the highway around Tokyo—an extended "victory lap" for the player.

THE CONTEXT OF TITLE DESIGN

Title designs emerge from the particular moment of their production, reflecting the context of social forces and technical/aesthetic concerns operative at the moment of their creation. In this regard, the title sequence is less an autonomous form than a symptomatic one that allows a consideration of how larger societal forces emerge and direct the development of media productions. For media in a minor role, such as early television, the new productions of the internet, or video games, the title sequence serves as an indicator of aspiration, an index to how the medium as a whole—as much as the individual designers working with it—relates to the dominant, established older media forms, most especially the feature film. It is the prestige that the feature film title sequence has had since the rise of the credited title designer in the 1950s which these media works borrow through their adoption and adaptation of the feature title sequence's organization, and in this process achieve a higher level of seriousness and critical assessment. Understanding the title sequence, then, is not simply a matter of identifying important designers or historically significant creations, but of also recognizing and acknowledging the conceptual role the designed title sequence has and the various dimensions of its meaning beyond simply being the opening of the production that enumerates the names and roles of the people involved with the project's completion. Title design, especially in TV and video games plays a distinct role from the assertion of ownership and copyright that guided the initial development of film titles. The greater role of titles as a serial construction—informing and linking different episodes of an on-going program—is especially important in motion graphics used on TV; while the instructional dimensions of titles for video games, as preparation for an interactive experience, makes the tradition of video game titles distinct from those in both film and TV.

09

THE CONTINUING SYNAESTHETIC TRADITION

Synaesthesia presents an underlying thread that reappears in various forms throughout the twentieth century, and with the advent of powerful, inexpensive and portable digital computers at the end of the twentieth century enabled a new "flowering" of interest and engagement in/with the issues of live synaesthetic performance that are a common feature of both color organs and visual music, and the idea of synaesthetic performance is hardly new. Dance is perhaps the most obvious example of a synchronized performance that achieves the linkage of several otherwise normally discrete senses: kinetic movement organized and performed in relation to sound, either seen by an audience or performed as a group. The idea of "dance," as with music, has served as a metaphor for the construction and design of imagery and graphics composed in counterpoint and direct synchronization to sound—and has provided one of the guiding frameworks for the development and aesthetics of motion graphics.

Because the digital computer offers the potential for immediate, interactive control of imagery and sound, it was the focus of attempts to develop a general purpose "visual instrument" whose heritage lies with the color organs built since the seventeenth century. It is not a new aspiration to create such a device; however, with the emergence of digital technology capable of real time image production, distortion and presentation this aspect of visual music, long submerged in the technological limitations of physical media such as film, became the focus of a wave of renewed popular interest matched, paralleling the earlier psychedelic era of the 1960s interest in immersive environments and expanded cinema.

Throughout the twentieth century there have been various attempts to create visual music devices and color organs that would allow the performance of color, graphics and kinetic form as if they where music. This history, running parallel to motion graphics itself—often intersecting with its development, and starting in the 1980s, (and accelerating in the 1990s), with the rapidly declining costs for the real-time generation, keying and compositing of video and graphics—has converged with motion graphics once again in the form of VJ and various types of synaesthetic performance.

Understanding the emergent contemporary VJ practice in the context of motion graphics requires a return to the beginning of the twentieth century and the

inventions of color music, visual music and motion pictures. Because VJ is specifically a real-time—live—variant of motion graphics, recognizing the lineage of how it developed prevents the mistaken illusion that VJ suddenly sprang into being in the 1980s. Originally used by Cable TV station MTV to describe it's announcers, what the "video-jockey" does is closely related to the work of video artists. At the same time as this commercial appellation was being used, the "VJ" was also appearing in the night club and producing an entirely different type of visual "work" than on MTV.

A variety of meanings for the two letter term "VJ" have been suggested by the artists involved in its production: "video-jockey," "visual-jockey," and "video-jam." The performance of visuals is essential to this practice, and the term describes the live manipulation of projected images at electronic concerts called "raves," inside art galleries, and at parties or clubs, where the improvisation employs a databank of both motion and static imagery. It does not require a digitized database—it is a practice that emerged during the 1980s, using analog video and a mixing board connected to several discrete inputs—only that there be a volume of individual sampled images (realist or abstract) that provide the source material which is then manipulated live in relation to music.

VJ reflects the heritage of earlier synaesthetic, immersive performance concepts, and its linkages to both "raves" and electronic dance music are a part of this history: the *Vortex* Concerts done by Jordan Belson, along with later light show groups (*Single Wing Turquoise Bird*) and multimedia performances (Andy Warhol's *Exploding Plastic Inevitable* or Stan VanDerBeek's *Moviedrome*) all share a focus on immersive, synaesthetic audio-visual environments whose organization is live and theatrical. It interacts with the audience's engagement, working within the performative tradition to produce live shows that tend towards being unique experiences even when there is a "script" that makes repeat performances a possibility.

International in nature, the development of VJ does not follow a uniform organization or standard approach. Instead, regional and technological differences have resulted in only general commonalities, rather than a singular, particular "style" for these shows. However, there are features that are commonly shared: the use of multiple screens dispersed in an environmental fashion, even when there is no central "stage"; the rapid, rhythmic presentation of imagery; a common blending of popular sampled imagery with abstract graphics and animation; synchronization and counterpoint with the accompanying music; and an emphasis on visual spectacle integrated into a complex, live environment where the VJ performance is one part of a larger experiential environment. While it is rare for all these elements to be present at the same time, they describe a collection of tendencies that unite otherwise idiosyncratic performances and theatrical settings that tended towards uniqueness rather than standardization.

STAN BRAKHAGE (1933 – 2003)

Stan Brakhage was the most prolific of the filmmakers to emerge during the second period when the avant-garde consolidated, and motion graphics emerged as a commercial medium. Brakhage is exceptional, both in the sheer quantity of films

he made, and in the innovative aesthetics and novel techniques he created that characterize the wide variety of his films. As one of the founders of the *Anthology Film Archives* in New York, he was instrumental in the canonization characteristic of the third phase. Actively producing film work from the 1950s until his death in 2003, the last decade of his life was spent primarily working on abstract films whose finished form was created through a combination of direct hand painting processes and optical printing. These works provide a direct linkage between the earliest abstract films and contemporary media art (such as VJ and the visual music renaissance brought about by digital technology).

His work as an experimental film theorist provides an explicit connection between the Modernist aesthetics of the fine art world and the specific visual engagements used by experimental film. It is through the synaesthetic dimensions of his theory, developed over the course of his career and demonstrated through his film practice, that the linkage between contemporary synaesthetic performances, motion graphics and the abstract film become apparent:

> Imagine an eye unruled by man-made laws of perspective, an eye
> unprejudiced by compositional logic, an eye which does not respond to the
> name of everything but which must know each object encountered in life
> through an adventure of perception. How many colors are there in a field of
> grass to the crawling baby unaware of "Green?" How many rainbows can
> the light create for the untutored eye? How aware of variations in heat waves
> can that eye be?[1]

The opening of his first major publication, *Metaphors on Vision* (1963), establishes the foundations of his film theory: a phenomenological interest in perception disconnected from linguistic constraint or expression. His interest in this treatise is the unfettered exploration of visual perception—and yet at the same time, it reflects the same inspiration of color and light (even in this opening statement) that guided earlier color music inventors. However, where color music sought to prove a correspondence between color and sound, in Brakhage's theory, the emphasis falls on an attempted recovery of primal experience—the initial sensory encounter with pure color and form, independent of later linguistic interpretations.

In pursuing this perceptual understanding, his theory turns to transitory, almost imperceptible sense experiences as a means to start a recovery of the more primary experiences that are the focus of this engagement. In the process, his writing suggests a lurking synaesthetic dimension:

> My eye, again, outwards (without words) dealing with these "indescribable,"
> "imaginary" vibrations, producing the categorized colors, best known
> negatively, this sensibility dealing with this phenomenon, an irresponsible
> gamble thwarting the trained response link between retina and brain,
> breaking the associational chain, this mind-eye partnership playing the game
> with an unmarked deck, as in the beginning, giving eye's-mind a chance for
> change. ... Under extreme non-concentration, fixed by effortless fascination,
> akin to self-hypnosis, my eye is able to retain for cognizance even those
> utterly unbanded rainbows reflecting off the darkest of objects, so transitory
> as to be completely uninstructable, yet retaining some semblance in
> arrangement to the source.[2]

These afterimages that Brakhage describes so poetically belong to the "noise" in perception that is normally ignored: like the bright spot that is the camera flash afterimage in the retina, afterimages are for his theory a suggestion of a nether-realm of perception that is both immanently present and thoroughly inaccessible, hidden beneath normal perceptual actions. It is through the self conscious disengagement that we can recover this more accurate experience of the perception process—and it is this specific engagement with these marginal phenomena normally ignored that provides the aesthetic foundation for his theory.

This conception of film and the film image is one where the photographic basis of most film production is a hindrance rather than an aid to image production (apparent across Brakhage's work as a whole; he sought to overcome the naturalistic image). The avant-garde focus on breaking down boundaries and seeking out novel types of experience and imagery depends on a recognition that the camera's typical function, as well as the dynamic response range that different film stocks had a limiting effect on the ability of that medium to produce imagery corresponding to experiences outside the narrow focus of a commercial industry whose products correspond only to a narrow, mimetic realism. This issue is a common factor in the avant-garde film's experimenting with accidents, errors, glitches and other mistakes as a means to locate new types of imagery. Those techniques developed by the avant-garde for creating these moving images followed from a process of engagement with the limits of what commercial, industry-standardized technology would allow; it is also the reason that avant-garde films are of interest to TV advertizing as a source of innovation.

Brakhage's theory is a formalization of the avant-garde process of rejection that separates it from commercial production. His phenomenological basis suggests a desire to bracket off of prior knowledge in an attempt to set it aside to engage in a direct experience; this focus on primary forms is common to the Modernist avant-garde. (This philosophical position was specifically critiqued by Post-Modern theorists—especially Jacques Derrida and his followers who developed the theory of Deconstruction.) Yet, it is important to recognize the qualification in Brakhage's theory—this setting aside of past experience to directly interpret is an idealized goal, not necessarily a feasible possibility. His concern in this construction is not the recovery of a past, utopian state of direct experience, but rather the attempt to recover such a state. His focus is not in the results of such a setting-aside, but in the experiences that emerge from attempting to engage with a direct perceptual experience. In this regard, the film camera worked as a proxy for the perceptual state Brakhage describes, limited by its own technological nature:

> We have the camera eye, its lenses grounded to achieve 19th century Western compositional perspective (as best exemplified by the 19th century architectural conglomeration of details of the "classic" ruin) in bending the light and limiting the frame of the image just so ... By deliberately spitting on the lens, or wrecking its focal intention, one can achieve the early stages of impressionism. One can make this prima donna heavy in performance of image movement by speeding up the motor, or one can break up movement, in a way that approaches a more direct inspiration of contemporary human eye perceptibility of movement, by slowing the motion while recording the image.[3]

The motion picture technology itself constrains the kinds of potentials available to an artist such as Brakhage—and so, his solution to the constraints that the film industry developed to make certain the film image produced a consistent, repeatable visual form was to advocate for an assault upon the technology; this is the same variety of technological attack on "industry standards" that the Paik/Abe video synthesizer performed on the television signal. In Brakhage's theory these attacks on the technology are necessary for philosophical—and aesthetic—reasons: the motion picture camera-projector combination reify a specific aesthetic of facile, everyday, mimetic realism in the technology used to make and show films. Only a direct engagement that challenges that reification directly is capable of producing imagery that violates those aesthetic foundations. Only when the optics, motion, and other technologies of film production break with the assumptions of this mimetic realism does the film begin to potentially allow Brakhage's hypothetical untutored eye.

This process of breaking the assumptions built-in to the camera and film technology requires a transformation of that technologies' function. His discussion of sound follows a similar trajectory in its recognition of the role that sound plays in relation to the images it accompanies:

> Sidney Peterson recently made a statement to me (of which Jane [his first wife] just reminded me) that: "There are only two kinds of sound tracks: mood-music and lip-sync." Now I think it very relevant that he designated the other-than-atmospheric (or choral)-sound track with the specific term: "lip-sync." Jane does think of it most clearly in relation to the image of a rock: "You either have some comment upon the rock or you have The Song of The Rock, the rock's lip-sync, so to speak."[4]

This recognition as an aesthetic principle appears through the silence of his films; the direct relationship between image and sound means that there is always some type of correspondence, some association, made between whatever is on the soundtrack and what is shown on screen. This conjoining of image and sound imposes an audible aspect on the pictures, transforming their meaning and superimposing the kinds of interpretation that Brakhage is focused on avoiding. This recognition makes the potential for a silent, yet synaesthetic, visual form an explicit part of his theorization.

Stan Brakhage's Hand-Painted Films

The hand-painted films produced between the 1980s and his death in 2003 are uniformly silent, and even when there is a photographic substrate beneath his hand painting, their focus in on other types of non-optical "vision" than what a camera-lens-projector assembly presents in a more typical film. These hybrid films were made using a combination of techniques to produce their imagery. While the most evident part—the hand painted film strip—belong to the well established tradition of direct films that stretch to the early avant-garde films made by the Futurists in Italy, their specific form and structure depends on the reproductive capability of optical printing. The descriptions Brakhage wrote for these films obscure their hybrid nature:

(*Black Ice*, 1994) I lost sight due a blow on the head from slipping on black ice (leading to eye surgery, eventually); and now (because of artificially thinned blood) most steps I take outdoors all winter are made in frightful awareness of black ice.

These "meditations" have finally produced this hand-painted, step-printed film.

(*Stellar*, 1993) This is a hand-painted film which has been photographically step-printed to achieve various effects of brief fades and fluidity-of-motion, and makes partial use of painted frames in repetition (for "close-up" of textures). The tone of the film is primarily dark blue, and the paint is composed (and rephotographed microscopically) to suggest galactic forms in a space of stars.[5]

These descriptions for two of the better-known examples, *Stellar* (1993) and *Black Ice* (1994), are typical of how Brakhage explained the films themselves. While seeming to explain the intent and process involved in making these films, what happens instead is a confusion of what was involved in their production: hand painted film strips provide only a basic part of the finished film that was rephotographed, enlarged, looped and otherwise manipulated through optical printing; the role of this process was so significant to the finished films that Sam Bush, the optical printer technician at Western Cine, where the optical printing was done, received special credit on many of these films, as the end of *Stellar* states:

> This film is to be considered a collaboration with Sam Buch, optical printer at Western Cine, in the sense that I was the composer, he the visual musician.

This credit is revealing: *without the optical printer's transformation of his film strips, the final film would be utterly different.* Composed from short sequences of colorful black and light fields (resembling stained-glass windows) where some parts of the image fade in and out, while other imagery grows larger, moving off the edges of the frame, suggesting forward motion through black space; white specks (bubbles) in the thickly applied aniline dyes become the stars evoked by the film's title. It is a rhythmic montage, tempered by variations of speed, fades and the hold frames. A limited quantity of original footage provided a foundation for a complex sequence of transformations, tempo changes and movements that all depend on the transformative potentials of the optical printer. What Brakhage has done is to combine the technical effects of direct film with the optical manipulation characteristic of the Whitney brother's films where a smaller quantity of footage provides the raw material—a visual database—for a remixing and reassembly into a new project. The significance of these films for motion graphics lies less with their specific nature as direct cinema modulated through optical printing than with their presentation of an optical, silent synaesthesia:

> I now no longer photograph, but rather paint upon clear strips of film—essentially freeing myself from the dilemmas of re-presentation. I aspire to a visual music, a 'music' for the eyes (as my films are entirely without sound-tracks these days). Just as a composer can be said to work primarily with 'musical ideas,' I can be said to work with the ideas intrinsic to

film, which is the only medium capable of making paradigmatic 'closure' apropos Primal Sight. A composer most usually creates parallels to the surroundings of the inner ear—the primary thoughts of sounds. I, similarly, now work with the electric synapses of thought to achieve overall cathexis paradigms separate from but 'at one' with the inner lights, the Light, at source, of being human.[6]

Unlike Brakhage's more theoretical discussions, this is a statement that closely reflects the production process for his hand painted/optically printed films. His statement makes them specifically into 'scores' whose performance is recorded through the optical printing process—to continue this metaphor, the finished film is then a recording of a purely visual analogue to audible music. This conception is synaesthetic, but on a structural level rather than in terms of relationship between sound and image: what is being visualized is a compositional arrangement whose organization, repetition and visual design is fundamentally based on the kinds of compositional structures experienced in the composition of music.

This particular paradigm for visual music is not unique to Brakhage, even though his specific implementation is unique, its underlying premise converges with those of other artists, most notably the structural modeling proposed by Joseph Schillinger's work. It is an adaptation of the rhythmic, tonal dimensions of music applied to the temporal organization of visual material. The near-abstraction of a film such as Stellar where the title reflects the visual content and that content implies the title in a circular relationship where the invocation and evocation of movement through the cosmos guides the interpretation of a film organized around short, measured sequences of images. The reappearance of similar imagery at different points during the roughly two minutes of the films' running time has its basis in the melodic statement and restatement common to musical compositions.

While Stan Brakhage's theories reflect his aesthetic origins within the Modernist paradigm that dominated the 1950s and 1960s, they also reaffirm the significance of the hybrid approach to technology in the production of synaesthetic media art. It is the hybridity of Brakhage's hand painted films that separates them from earlier direct film work by Len Lye, Norman McLaren and Harry Smith. His use of optical printing was not as a way to preserve his painted imagery or correct minor errors in the registration of hand painted elements, but as a primary constructive technique—these films cannot exist without the optical printer; this approach to abstract film resembles that used by the Whitney brothers in the 1940s with their *Film Exercises*. The connection between Brakhage's optical printing of hand painted material employs his film strips as a "database" whose manipulation and recombination creates the finished film. It is a model that overlaps with Raymond Fielding's recognition that optical printing and digital technology work in analogous ways to create new works from the manipulation of existing materials. Understood in these terms, the hand-painted films present a terminus point for synaesthetic developments on celluloid during the twentieth century.

DENNIS H. MILLER

Computers have generally replaced film and other physical media as the foundation for synaesthetic media production. Their use has enabled the simultaneous creation of both sound and image with a high degree of precise control and the flexibility to experiment and explore different potential relationships without the expense and time required for traditional film production. Work such as Dennis Miller's continues the types of exploration begun by the Whitney brother's earliest experiments in the 1940s where both image and sound were created synthetically—the shift in Miller's work is towards programming and digital synthesis rather than the construction of mechanical systems. His embrace of computer technology enables his videos to present artificial "worlds" and "spaces" where a new synaesthetic relationship based on texture instead of tone can dominate the work.

Trained as a composer at Columbia University where he received a Doctorate in music composition, Miller works with 3D computer animation and programming with the *POVray* programming language to create his videos starting in 1997.[7] These works are structured in an audio-visual counterpoint where the audible character of the music develops visually using color, texture, camera movement and editing to create synchronization. These visual music pieces are orchestrated with clear demarcations between different movements in the music corresponding to sequences that elaborate upon individual visual themes; the end of one visual sequence corresponds to the end of that section of the music composition. These works do not employ a direct synchronization of particular tones-to-form; their structural principle proceeds primarily from the sonic texture and complexity in the audio, following the compositional organization in a counterpoint distinct from the synchronization models proposed by John Whitney and Leon Schillinger.

Starting with the video *Residue* (1999), Miller composed both the music and the animation and music at the same time; the finished video was made from a series of still images which required conversion to video using Adobe Premiere, a software-based video editor. The development of both sound and image simultaneously enabled a dynamic interplay between visual and audio that would become a common feature of his later videos.

Second Thoughts (2000) was created for performance as a concert. Broken into three sections, the video develops from claustrophobic, interior spaces towards larger environments, then retreats into the opening, interiors. Miller has explained this organization:

> The opening section explores the inside of a virtual object and depicts many of the surfaces and textures found therein. The second section moves into 3D space and presents different perspectives of the initial object, as well as adding a number of new elements that derive their form from the elements in the opening. The short, third section is a recap of the first and adds several minor variations to it. The music contributes an emotive element as well as an added layer of continuity to the piece.[8]

The soundtrack works to unify the disparate visual elements, creating unity in the organization and providing the linkages between the interior and "external" spaces of his animation. Miller's creation of three dimensional spaces and the animation of objects using familiar visual cues—perspective, reflection, shadow, texture—might result in a sense of uncannyness if these abstract environments were not so closely related to the audible sounds of his music. The digital 'purity' of these animations—they do not create photorealistic environments, focusing instead on the growth and evolution of his geometries in a gravityless space, allowing his forms to hang, their moving parts passing through one another fluidly in the weightless ballet of free fall. The result is a normalization of what could be quite alien: these forms 'fit' in the abstract space they inhabit, their connection to the audio never being in doubt.

Like the earlier *Second Thoughts*, *Vis a Vis* (2002) is composed in three sections, but unlike the earlier video, each movement in this composition develops independently; the continuity in *Vis a Vis* emerges thorough the consistent coloration of the visual forms. The video develops from the concept of "convolution," a term proposed in mathematics at the start of the twentieth century, and was put into common use by video processing. It involves the manipulation of a limited number of elements that are combined in specific ways: one 'signal' is reversed, shifted to a new position, and then modified by using another 'signal' to multiply it. This creates a new, distinct 'signal' that is recognizably derived from the earlier ones: in Miller's film this is the "vis a vis" of the title.

Texture is the foundation for both visual and audio compositions; this use of texture, in place of melody or harmony in Millers music, provides the opportunity for a different kind of synchronous relationship, one that is based in a reconception of the initial foundation of color and visual music: the visualization of sound. His focus on texture and forms evoking the specifically tactile implications of his sonic compositions offers a distinct conception of audio-visual linkage: it is one that finds its origins in the machinic utopianism of Constructivist art produced in the Soviet Union during the early 1920s. This relationship between these videos and earlier abstract art was noted by avant-garde film critic David Finkelstein:

> Miller writes electronic music which, eschewing conventional harmony, melody and rhythm, is essentially about texture and therefore about space, and so is perfect to accompany these spatial abstractions. Distinct sound events such as pops and plings are typically heard over background washes of hissing and droning sound. The animations follow the general outlines of the music and seem at times to be actually explaining the music to the viewer, changing visual texture each time there is a major change in the sound texture. ... Their shifting spaces reveal momentarily stable configurations which immediately break down and reform themselves into radically new spatial relationships. The constantly shifting point of view creates a sensation that one is always flying, floating or falling onto an ambiguous surface which one wouldn't know how to land on, even if one were to touch down for a moment. ... *Vis a Vis* (2002) features crisp, constructivist compositions in which black and white shapes are tinged with

color, while sharp-edged forms are tinged with noise, and flat compositions suddenly rotate into enormously deep spaces.[9]

The constructivist element Finkelstein notes in *Vis a Vis* becomes a direct reference in Miller's next video, *Faktura* (2003). The title is the Constructivist term "faktura," proposed by Alexander Rodchenko in 1922 as the particular material properties of an object, as its title. His later videos, such as *Circles and Rounds* (2006), elaborate on the visual forms of his earlier videos, developing them in greater complexity and with a wide variation in speed and rhythm that gives their spiraling whiplashes a grace and fluidity greater than in his previous works. The blocky, rectangular forms of his earlier works become curved arcs in later pieces, a transition that follows a similar development to that of the constructivists, a relationship first developed by Lillian Schwartz in her work with computer animation in the 1970s; by focusing on the relationship between visual textures—all his videos employ forms that become "hairy" or "spiky," erupting into complex, tactile surfaces as the piece develops—and the texture of sound moves Miller's visual music away from the more traditional modes that focused on the organization of form in relation to notes and melodies. This difference reveals the impact of Miller's training in contemporary musical composition: rather than coming to visual music as a painter or visual artist, his approach is fundamentally that of a musician engaging with visual production.

THE DIGITAL INSTRUMENT

Digital technology replaced the physical optical printer as the primary means to recombine, manipulate and transform existing motion picture material in the 1990s. By the end of the decade, portable computers—laptops—enabled the use of real time, high resolution rendering and compositing of fully computer-generated imagery. Just as the expansion of electrification in the 1890s and early years of the twentieth century were accompanied by a wide range of experiments and new machines being invented that could perform color and visual music—both Mary Hallock-Greenewalt and Thomas Wilfred were part of this earlier surge of development—the rapid increase in both processing power, storage and digital technology generally have been accompanied by a revival of the desire to create a kinetic visual art. Where the instruments constructed at the start of the twentieth century were electro-mechanical arrays of lights, gears, and glass, the instruments "built" at the start of the twenty-first were written as software.

During the 1980s, even as general-purpose software/hardware combinations were becoming commercially available for manipulation of video digitally, creating computer animations by programming them—the earliest approach—continued with the development of new programming languages for creating visuals, taking advantage of the same powerful desktop (mini) computers. As in the 1960s, these films continued to emphasize the artist-as-programmer aspects of computer animation. The computer programmer and visual musician Fred Collopy, an artist who wrote a software-based instrument called *Imager* for the Apple II in 1977, has noted the significance of this digital technology for the development of visual performances:

> With the ability of computers to project color graphics of high resolution in
> real-time and to respond to input from an unlimited variety of controllers,
> we are re-entering the age of the visual music inventor. What was difficult in
> the 18th century is no longer so difficult. What is more, we have almost 300
> years of thinking and experimentation to guide us.[10]

His focus on the creation and use of the software in the production of visual
"music," where imagery develops and evolves in a fluid fashion comparable to the
production of sound, is an idea that reappears among artists engaged with using
computers for both creating abstract movies and for live performance, including
Whitney, Collopy and other artist-inventors such as George Stadnik, whose work is
also oriented towards the Lumia tradition. The overlap between this use and that of
VJ is immediately obvious, but VJ is only the simplest of these applications, as it is
based in the manipulation of a predetermined library of already existing materials
arranged and shown live. It exists at one end of a range of digital approaches to
visual performance, where at the other end of this spectrum lies the imagery created
and rendered live without the intervening use of a recorded "clip" library.

Collopy has theorized, based on his own work with *Imager,* what a visual music
instrument might be like rendered with digital technology. Thomas Wilfred's Lumia
is the historical reference point for Collopy's proposals, a terminological choice that
allows a critical recognition of how the live works he described are different from
other types of live performance (such as VJ) and the recorded work in abstract films
and videos of various types. The system Collopy constructed used a MIDI interface
to compose with color, lines, planes, and rhythmically arrange these elements in
motion.[11]

As in the historical color music, the role of color is central to Collopy's variant
of Lumia; however, his conception of color is formal rather than the
spiritual/mystical view common to color music:

> The earliest visual-music instruments often provided little more than general
> washes of color. As the field developed, so did control over color. Today, it
> can be used to reinforce rhythms in the music. Combinations of colors can
> be used to create visual harmonies or cacophony. And color is a carrier,
> perhaps the most essential visual carrier, of expression. It is through
> controlling color that the lumianist most controls mood.[12]

Collopy's color is *inherently* tied to form—the historical "washes of color" are full
fields of uninflected hue, not the motion of tinted forms moving in an imaginary
space. The central place he assigns to color marks his variation on Lumia as distinct
from Wilfred's where the primary focus is on form-in-motion as the bearer of
expression. Color provides the essential expressive element, and the organization of
color over time describes the "narrative" arc of the emotional content. The three
elements of contemporary color space described by RGB technology—hue, value
and saturation—that enable the specification of any particular, specific color
produced provide the technological foundation for his instrument's manipulation
and modulation of color in its compositions. Unlike Wilfred, whose Clavilux
instrument was electro-mechanical, Collopy's instrument is based in software.

In addition to controlling and modulating color, his software-based Lumia
instrument *Imager,* enables the manipulation of two additional factors: form and

motion. It is a computer system that was designed to enable the real-time manipulation of visual forms:

> I have developed a computer-based instrument for "painting" in real time called Imager. It is based on the constructivist tradition: moving colored forms are built up from simple geometric elements, such as points, lines, planes, polygons and cubes. The general purpose of the instrument is to provide its player with collections of presets that can be triggered using MIDI (musical instrument digital interface) controllers. The presets recall and display collections of these constructive elements, the parameters of which can also be manipulated using MIDI controllers.[13]

Wilfred's Clavilux required physical alteration to be able to play different compositions; the instrument Collopy describes proceeds from a common assumption in visual music inventors: that the instrument and visual performance would primarily be the action of a single individual. Thus, his instrument produces a range of shapes (points, lines, planes, polygons and cubes) whose color and motion are at the disposal of the "painter" who runs the machine. This conception is akin to the idea of a VJ, primarily differing in the sources for imagery shown; the overlap between one approach and the other is apparent in the fluidity of movement between VJ and visual music practitioners use of digital computers as controls for their imagery.

The "unauthorized duets" Collopy produced were initially distributed as silent implementations in software form, rendered live using the computer as a performance device; these works were visual "collaborations" with music by Brian Eno, David Bowie and Eileen Ivers. These works combine historical influences from abstract film with the formal innovations made possible by digital technology. This intersection of an historical consciousness of precedent and past formal innovation with the development of new technology creates a direct continuity with that earlier work, asserting the continuation of a specific tradition—Lumia—even though the technology has changed. This relationship between digital/electronic media and earlier film reiterates the connections between painting and color music that appear in the first abstract films. Collopy's work demonstrates the formal continuity across the twentieth century, connections whose consistent formal design and structure imply an internal, structural language of form shared by artists working within this tradition. As he has noted, its organization is related to the Constructivist art movement that built works from simple, geometric forms; it is a historical avant-garde movement that included Vassily Kandinsky, (whose work developed connections between music, painting and synaesthesia), among its members.

Film for Music (2000) is Fred Collopy's "collaboration" with Brian Eno, whose composition *Slow Water* provides the audible reference for the visual composition. Like John Whitney's animation program developed between 1986 and 1991, Collopy's program proceeds through a process of drawing-and-"drawing out"; the black 'erasure' part of this procedure, however, becomes an additional graphic element in motion on screen: a black shape whose appearance emerges as the animation begins to fill the screen with color. The opening three tones are

synchronized with a circle that spreads outwards across the screen, leaving wedge shaped arcs behind; these contain curved striation-marks in black which initially appear to be negative space—but as the sequence proceeds, they become black forms overlying a colored area.

This opening establishes the grammar of the piece, a synchronized transformation of foreground-background relationships that emerges over time. After this opening statement, there is a period of darkness before animated concentric circles spread out from the same locus on screen, evoking ripples (or sound waves) spreading out in space along the bottom third of the frame. The orchestration of forms runs along two axes: from this point, and along the horizontal axis that point rests upon, gradually building complexity, but never filling the screen as the opening did. Halfway through this sequence, the colors begin changing as the music introduces new cords; and at the midpoint of the piece as a whole, some arcs freeze in place and finer lined forms showing the drawing-in and drawing-out process clearly spread around the immediate center of the main locus on screen. The resulting image suggests a blue tunnel with a vortex in orange spinning at the distant end; the bottom third plays the role of "floor" for this passage. When the music changes again, the vortex forms grow larger, rotating outwards, erasing the blue arcs they pass. The differential motion they present suggests the same type of harmonic transformation John Whitney explored in his computer films.

Collopy's organization of time and motion in *Film for Music* falls firmly within the counterpoint tradition, organized with specific moments of direct synchronization, the dominant structure is not a tone-to-form correspondence but a broader synchronization to the breakup of the work into longer 'movements' each of which has a distinct tone and progression. It displays an historical consciousness of the history of abstract film, employing a collection of forms that evoke both representational imagery (water, tunnel, ripples) and the formal developments of earlier abstract filmmakers—the curved forms that provide the basic 'unit' of his animation have work by Fischinger, Belson and Whitney as precedents; the three circular shapes that emerge from the vortex in the final sequence resemble the oscilloscope forms used by Hy Hirsh in *Come Closer* and *Eneri*. This evocation of historical foundations, without specifically quoting any particular work, is common to contemporary synaesthetic media works; it is the Post-Modern element in their organization.

While *Imager* offers a demonstration of the potentials for creating a computer-based performance instrument and Collopy has considered the technical problems involved in constructing one, his experiments in this direction are not unique. The technical requirements for an "ideal" visual performance system have also been studied by other artists focused on making connections between synaesthetic forms and music using computers. Interactive media artist/composer Golan Levin has also critiqued the problem posed by a digital performance device. His analysis focused on five parameters: learnability, predictability, expressive range, granularity and perceived origination.[14] These criteria all allow for a range of different implementations, depending on the particular system constructed. The first four of his characteristics impact the fifth one: the perceived

origination—whether it is with the performer or autonomous, done by the machine. The system created by his analysis is one where it is easy to learn, and produces highly predictable results (i.e. is readily repeatable, the problem Ron Hays encountered in his analysis of the Paik/Abe video synthesizer), has a large expressive range and can create finely detailed work—all within a system where the audience recognizes the "hand" of the artist in the creation of the performance. These issues of performance and flexibility are the underlying problem for designers of visual music instruments—both mechanical and digital—and remain concerns in all contemporary synaesthetic performance.

COMMERCIAL SYNAESTHESIA

The synaesthetic is a thread running through the twentieth century, uniting and linking what would appear to otherwise be separate, independent fields. The present history and the story which it tells are just a starting point, a collection of various trends, artists, and ideas that collected around and built upon a much older, simpler goal: the elaboration of a visual art that would be capable of achieving some of the same affects as music. Purely as a function of storytelling, this current becomes an active force that helps motivate and inspires successive waves of innovation, experiment and translation to commercial application. It is less an underlying cause than a shared context and culture: a generative matrix where concepts are joined and aesthetic solutions proffered quite independently of a concern with particular media, formalist development, or the "need" imposed by aesthetic fashion. In the synaesthetic, one finds a continuity that defines cultures beyond national boundaries, and unites both commercial and avant-garde media in their orchestration of sound and image.

The close relationship between commercial TV and avant-garde film that existed during the 1950s has since faded into history; it has become one of the "myths" of the American avant-garde, a tale where commercial interests used the aesthetic and stylistic developments of the art community to find ways to make selling soap seem exciting. However, like most myths, this story confuses the actual history of close relationships, mutual exchanges and the artists who translated their experimental art into a business practice to support themselves, their families, and the continuation of their experimental media productions.

The seeming decline in the prominence of avant-garde film and video since the 1970s as the institutional period firmly established itself may be nothing more than a superficial appearance: what made the earlier avant-garde works much more prominent was their promotion through commercial media, as commercials, and in the overlapping with the art world—an overlap that has since been eclipsed by the same changes that led to the establishment of the institutional period. Yet, at the same time, there have been shifts: the role of publications in supporting the avant-garde have been replaced by other, less permanent records of activity—websites, email listservs, short running magazines of various types—and the serious discussion of new work has been replaced by the more conservative demands imposed by the academy. It is the nature of the institutional period to focus on the established history, presenting a rehearsed narrative that was being institutionalized at the start of this period.

Yet, both avant-garde media and commercial media continue to intersect, although in less dramatic ways than in the 1950s when their conjunction was surprisingly new. The transfer between fine art, the avant-garde film or video, and commercial forms has become a commonplace part of the media landscape. Television imitates the informal, unrehearsed form of documentary film—cinema vérité as game show—while carefully scripted scenarios, but where all the action is improvised present "everyday" dramas in a similar variety of "reality" on TV; both approaches began as avant-garde.

In motion graphics this close connection has become a part of the field's mythical origins. The translation of art to commercial design has become a complex task in the digital environment of contemporary motion graphics, requiring a combination of techniques and technologies to achieve visuals resembling those of the avant-garde. The title sequence for the TV show *Kingdom Hospital* (2006) created at the company Digital Kitchen in Chicago, and designed by Colin Day and Thai Tran translated the fine art photocomposites of Jerry Uelsmann into motion:

> Selective animation of the multiple-image tableaux required gathering
> separate images of Uelsmann's composites and then determining what could
> be animated and what had to be re-shot to emulate the original. Using
> particle generation and existing motion content as matte elements meant that
> surprisingly few images needed to be re-shot in film. The final resolve in to
> the hospital-tree was inspired by an Uelsmann image, but needed to be
> rebuilt entirely in 3D in order to match parallax and keystoning as the
> camera pans from earth to sky.[15]

The *Kingdom Hospital* TV show opening employed images by photographer Jerry Uelsmann (1934 –) that were created in the 1960s and 1970s in a traditional darkroom. The individual photographs were licensed for broadcast on TV and combined into this title sequence; the result is a dramatic illustration of the connections between art and commercial production as well as the ability of digital technology to translate not simply graphic material but photocomposites into motion: this fusing of animation and photography is done in tight synchronization with the music. Camera motion visually links imagery-in-motion to the melodic sequence in a direct synchronization whose origins lie with the abstract films of the 1930s. The intersecting histories of art and commercial media provide a constant background to the innovations and developments in both fields.

* * *

How we watch media determines what we believe it to be. This is more than just an issue of works shown inside or outside the confines of an gallery, it is an issue falling between the audience and the media being shown. Those works done live—performed in a gallery or theater—are regarded as "art" because the venue easily allows the media to dominate the audience, a situation that commonly reverses itself outside the gallery setting, as in a night club media performance, or video shown on television, becomes a background to other concerns, an opportunity to shift one's attention to something entirely different.

The choice to critically engage or consume (disengage) depends on the perception that the visuals are created by an unseen human agent. The presence of a

more conscious relationship between sound-image than mechanical synchronization or mere accident is essential, to merit an engagement with it as art—the possibility that something may be communicated through the performance itself. The audience's perception that the media performance has an intelligence directing the work enables the transformation of motion graphics from decorative background to art form—a factor that emerges through the synaesthetic tradition of structural relationships between image and sound. The close integration of these earlier traditions into commercial motion graphics makes these relationships part of a shared culture, a common "language" where direct synchronization is assumed. This "natural" relation between music, image and motion is an inherent part of how contemporary motion graphics present their information and organize their development over their duration.

Acknowledgements

This book would not have been possible without the generous support of the Savannah College of Art and Design in the form of a Presidential Fellowship that allowed me the time and focus to produce it. When I began teaching in the motion graphics at the Savannah College of Art and Design, we were in the process of revising the curriculum to include a survey course focused on the history of motion graphics; however, no textbook adequately covered the entire history of the field. The ones that did exist, instead of covering the development and aesthetic history of motion graphics, focused on the much more recent phenomenon of broadcast design, especially that produced since the 1990s. Similarly, books on title design and kinetic typography are concerned with their technical creation, rather than their aesthetics or historical origins.

The history surveyed in the book could only come into being through a synthesis of many already existing studies, both singular monographs and polemical anthologies. In developing this book what immediately became obvious is the inherently constructed nature of the story this history tells, and the simultaneous importance of crafting these stories when calling a new field into being: the pure invention of a chronology that draws its substance from myriad sources, synthesized into a narrative of how something came into being. It is the nature of such stories to become apparently self-organizing once proposed, even though their actual creation requires labor. Some of the essential sources for the story told in this book are Gene Youngblood's classic *Expanded Cinema* (1970), William Moritz's monograph on Oskar Fischinger, *Optical Poetry* (2004), and the invaluable collection of texts and biographies assembled by Robert Russett and Cecile Starr, *Experimental Animation* (1976). These three studies of the abstract film's emergence and the artists involved with its history provide a valuable starting point for deeper, more comprehensive study of the abstract film tradition.

At the same time, the history of visual music is largely told through a variety of disparate texts, essays, exhibition catalogs, and artists' writings about their own inventions. Understanding the parallel history of color and visual music—unlike its better known development in abstract film—forces careful attention to what are

often primary texts, and the detailed study of the technical patents and assorted other schematics and artist's writings to reach an understanding of a field where technology and aesthetics are closely wed. To fully appreciate the nuances of how A. Wallace Rimington's *Colour Music* differs from and converges upon Mary Hallock-Greenewalt's *Nourathar* necessitates a study of their books about the new art each believed they were inventing.

Developing the materials for the book happened gradually over the course of a decade. It might not have begun without the insistence of Jacek Kolasinski and Rey Parlá who both convinced me of the need for book on the history of abstract film. The project they encouraged me to write, a book following the development of kinetic abstraction through the twentieth century, evolved into the present consideration of the continuity between non-narrative, un-commercial or anti-commercial media produced by artists as diverse as Stan Brakhage, Mary Ellen Bute and Oskar Fischinger, and the commercial design work of Saul Bass, William Golden or Maurice Binder—the commercial field called "motion graphics." In constructing this history, the distinctions between the commercial and non-commercial are instantly evident, even as their aesthetic relationships, shared concerns and formal approaches reveal a common foundation.

<p style="text-align:center">* * *</p>

The final form of this book would not have been possible if not for the support and assistance of Peter Weishar, Dean of the School of Film and Digital Media at the Savannah College of Art and Design who encouraged its development by suggesting I apply for the *Presidential Fellowship* that was instrumental in its writing and completion in a timely fashion.

The invaluable aid and suggestions provided by Jack Mamais and Luis Cataldi in the identification of video games titles and their history; Roger Horrocks for assistance with Len Lye; the Historical Society of Pennsylvania for their assistance with researching Mary Hallock-Greenewalt; my brother John for indulging my seemingly endless quest for progressively more obscure title sequences; and so many others who helped with different parts of the research as this book came together, especially David Atwood and Larry Cuba.

A special thank you also goes to all the various "test" readers whose responses improved the book as a whole; especially Greg Johnson, Dominique Mertens Elliot, Kalin Fields, Oscar Betancur, and Callie Barnard.

NOTES

(NOTES TO CHAPTER 01)

1 Galeyev, Bulat. "Open Letter on Synaesthesia" in *Leonardo*, vol. 34, no. 4, 2001, pp. 362-363.

2 van Campen, Cretien. "Synaesthesia and Artistic Experimentation," *Psyche*, 3(6), November 1997, np.

3 van Campen, Cretien. "Synaesthesia and Artistic Experimentation," *Psyche*, 3(6), November 1997, np.

4 Fry, Roger. "The French Post-Impressionists," (preface to catalog for the Second Post-Impressionist exhibition, 1912), *Vision and Design*, (London: Pelican Books, 1937) pp. 195-196.

5 Greenberg, Clement. "After Abstract Expressionism" in *The Collected Essays and Criticism: Vol. 4*, (Chicago: University of Chicago Press, 1955) p. 131.

6 Schnapp, Jeffrey. "Bad Dada (Evola)" in *The Dada Seminars*, ed. Leah Dickerman with Matthew S. Witkowski (Washington DC: National Gallery of Art/DAP: 2005) pp. 50-51.

7 Dann, Kevin T. *Bright Colors Falsely Seen* (New Haven: Yale, 1998), pp. 94-95.

8 Ione, Amy and Christopher Tyler. "Is F-Sharp Colored Violet?," *Journal of the History of the Neuroscience* 2004, vol. 13, no. 1, pp. 62-64.

9 Dann, Kevin T. *Bright Colors Falsely Seen* (New Haven: Yale, 1998), p. 96

10 Dann, Kevin T. *Bright Colors Falsely Seen* (New Haven: Yale, 1998), pp. 94-119.

11 Rimington, A. Wallace. *Colour Music*, (Holicong: Wildside Press, 2004).

12 Tornitore, Tonino. "Giuseppe Arcimboldi E Il Suo Presunto Clavicembalo Oculare," in *Revue des Etudes Italiennes*, Vol. 31, No. 1-4, 1985, pp. 58–77.

13 Kircher, Athanasius. *Musurgia Universalis*, (Rome, 1650) facsimile edition, (New York: George Olms Verlag, 1970) p. 240

14 Vassily Kandinsky, *Concerning the Spiritual in Art*, (New York: Dover, 1977), p. 31.

15 Rimington, A. Wallace. *Colour Music*, (Holicong: Wildside Press, 2004).

16 Corra, Bruno. "Abstract Cinema – Chromatic Music" in Futurist Manifestos, (New York: Art works, 2001), pp. 66-67.

17 Corra, Bruno. "Abstract Cinema – Chromatic Music" in *Futurist Manifestos,* (New
 York: Art works, 2001), pp. 66-68.

18 Moritz, William. "Visual Music and Film-as-an-Art Before 1950," in *On the Edge of
 America: California Modernist Art,* 1900–1950, Paul J. Karlstrom, ed. (Berkeley:
 University of California Press, 1996), p. 224.

19 Betancourt, Michael, ed. *Mary Hallock-Greenewalt: The Complete Patents,* (Holicong:
 Wildside Press, 2006), p. 47.

20 Wilfred, Thomas. "Composing in the Art of Lumia" in *Thomas Wilfred's Clavilux,*
 Michael Betancourt, ed. (Borgo Press, 2006) pp. 32-33.

21 Wilfred, Thomas. "Composing in the Art of Lumia" in *Thomas Wilfred's Clavilux,*
 Michael Betancourt, ed. (Borgo Press, 2006) pp. 33-34.

22 Miller, Dorothy C. "Thomas Wilfred" in *15 Americans* (New York: The Museum of
 Modern Art, 1950) p. 32.

23 Quoted by Richard I. Land, "Kinetic art: The chromara, a Lumia technique," in
 Kinetic art: Theory and Practice, Frank J. Malina [ed.] (New York: Dover, 1974) p. 30:
 "I am urging all of them to use the word Lumia for the art form itself, the word
 thus corresponding to Music for the art of sound. This will clarify the issue to the
 public and give us all a single banner to work under, also lending dignity to our
 efforts. The old designations 'color music' and 'mobile color' are misleading."

24 Miller, Dorothy C. "Thomas Wilfred" in *15 Americans* (New York: The Museum of
 Modern Art, 1950) pp. 30-32.

25 Russert, Robert and Cecile Starr, *Experimental Animation* (New York; Da Capo, 1976)
 p. 53.

26 DeAngelis, Gina. Motion Pictures: Making Cinema Magic (Innovators, 11),
 (Minneapolis: Oliver Press, 2004) pp. 79-81.

27 Fielding, Raymond. *The Technique of Special Effects Cinematography,* (Oxford: Focal Press,
 1984) pp. 128-129.

28 Fielding, Raymond. *The Technique of Special Effects Cinematography,* (Oxford: Focal Press,
 1984) p. 177.

(NOTES TO CHAPTER 02)

1 Corra, Bruno. "Abstract Cinema – Chromatic Music" in *Futurist Manifestos,* (New
 York: Art works, 2001), pp. 66-67.

2 Corra, Bruno. "Abstract Cinema – Chromatic Music" in *Futurist Manifestos,* (New
 York: Art works, 2001), pp. 66-67.

3 Corra, Bruno. "Abstract Cinema – Chromatic Music" in *Futurist Manifestos,* (New
 York: Art works, 2001), pp. 66-67.

4 Usai, Paolo Cherchi. "The Color of Nitrate: Some Factual Observations of Tinting
 and Toning Manuals for Silent Films" in *Image* vol. 34 no. 1-2 (Spring/Summer,
 1991) pp. 29 – 38.

5 Russert, Robert and Cecile Starr, *Experimental Animation* (New York; Da Capo, 1976)
 p. 37.

6 Russert, Robert and Cecile Starr, *Experimental Animation* (New York; Da Capo, 1976)
 p. 38.

7 Russert, Robert and Cecile Starr, *Experimental Animation* (New York; Da Capo, 1976)
 p. 39.

8 Elsaesser, Thomas. "Dada Cinema?" in *Dada and Surrealist Film,* Rudolf E, Kuenzli,
 ed. (Cambridge: MIT Press, 1996) p. 15.

9 de Haas, Patrick ."Cinema: The Manipulation of Materials," in *Dada-Constructivism,*
 exhibition catalog, Annely Juda Fine Art, (London: December 1984) np.

10 Kuenzli, Rudolf E. "Introduction" in *Dada and Surrealist Film,* Rudolf E, Kuenzli, ed.
 (Cambridge: MIT Press, 1996) p. 7.

11 The "history" he contributed to the *Art in Cinema* catalog would be repeated and
 epanded upon in the years following its publication, both by Richter and by other
 writers. Herman G. Weinberg's article, "30 Years of Experimental Film: Hans
 Richter Has Never Doubted the Validity of Pure Experiment," published in *Films
 in Review* (vol 11, no. 10, Devember 1951) is typical of the emphasis and revisionism
 of Richter's historical reportage.

12 Man Ray. *Self-Portrait* p. 259.

13 Dusinberre, Deke. "Le Retour à la Raison: Hidden Meanings," in *Unseen Cinema,*
 Bruce Posner, ed., (New York: Cineric, 2001), p. 65.

14 Dusinberre, Deke. "Le Retour à la Raison: Hidden Meanings," in *Unseen Cinema,*
 Bruce Posner, ed., (New York: Cineric, 2001), p. 65.

15 Lawder, Standish. *The Cubist Cinema* (New York: Anthology Film Archives, 1980) pp.
 119-137.

16 Freedman, Judi. "Bridging Purism and Surrealism: The Origins and Production of
 Fernand Léger's Ballet Méchanique" in *Dada and Surrealist Film,* Rudolf E. Kuenzli,
 ed. (Cambridge: MIT Press, 1996), p. 39.

17 Stauffacher, Frank. *Art in Cinema* (San Francisco: San Francisco Museum of Art,
 1946) p.53.

18 Ruttmann, Walther. "Painting with the Medium of Light," in *The German Avant-Garde
 Film of the 1920s,* ed. Angelika Leitner and Uwe Nitschke, (Munich: Goethe
 Institute, 1989) p.104.

19 Bock, Hans-Michael and Tim Bergfelder, eds. *The Concise Cinegraph: The Encyclopaedia of
 German Cinema,* (Berghahn Books, 2009) pp. 405-406.

20 Justin Hoffman, "Hans Richter: Constructivist Filmmaker," in *Hans Richter: Activism,
 Modernism and the Avant-Garde,* ed. Stephen C. Foster, (Cambridge: MIT Press, 1998)
 p. 75.

21 Laszlo Moholy-Nagy, P*ainting Photography Film,* translated by Janet Seligman
 (Cambridge: MIT Press, 1987) p. 21.

22 Richter, Hans. "My Experience with Movement in Painting and in Film," in *The
 Nature and Art of Motion,* ed. Gyorgy Kepes (New York: George Brazillier, 1965), p.
 144.

23 See the facsimilie reproduced in *G: An Avant-Garde Journal of Art, Architecture, Design
 and Film, 1923–1926* (Los Angeles: Getty Publications, 2010).

24 Hans Richter quoted by Justin Hoffman, "Hans Richter: Constructivist Filmmaker,"
 in *Hans Richter: Activism, Modernism and the Avant-Garde,* ed. Stephen C. Foster,
 (Cambridge: MIT Press, 1998) p. 76.

25 *G: An Avant-Garde Journal of Art, Architecture, Design and Film, 1923–1926* (Los
 Angeles: Getty Publications, 2010) pp. 146-149.

26 Richter, Hans. *Dada: Art and Anti-Art.* (London: Thames & Hudson, 2004) p. 63.

27 Richter, Hans. "Demonstration of the Universal Language," in Hans Richter:
 Activism, Modernism and the Avant-Garde, ed. Stephen C. Foster, (Cambridge:
 MIT Press, 1998) p. 208.

28 de Haas, Patrick . "Cinema: The Manipulation of Materials," in *Dada-Constructivism,*
 exhibition catalog, Annely Juda Fine Art, (London: December 1984) np., from an
 interview with Eggeling's assistant quoted in footnote 15 in his article: Eggeling
 "could not match his vision to the available technical possibilities, but thought the
 he could force machines to realize them."

29 Gösta Werner and Bengt Edlund, *Viking Eggeling Diagonalsymfonin: Spjutspets I
 Återvändsgränd,* (Lund: Novapress, 1997) pp 132-133.

30 Gösta Werner, "Spearhead in a Blind Alley: Viking Eggeling's Diagonal Symphony,"
 in *Nordic Explorations: Film Before 1930,* (Sydney: John Libbey & Co, 1999) pp
 232-235.

31 Gösta Werner and Bengt Edlund, *Viking Eggeling Diagonalsymfonin: Spjutspets I
 Återvändsgränd,* (Lund: Novapress, 1997) p 131.

32 Lukach, Joan M. *Hilla Rebay: In Search of the Spirit in Art* (New York: George Brazillier,
 1983) pp. 211-213.

33 Norden, Martin F. "The Avant-Garde Cinema of the 1920s: Connections to
 Futurism, Precisionism and Suprematism," in *Leonardo,* vol. 17, no. 2, p. 112.

34 Finkeldey, Bernd. "Hans Richter and the Constructivist International," in *Hans
 Richter: Activism, Modernism and the Avant-Garde,* ed. Stephen C. Foster (Cambridge:
 MIT Press, 1998) p.94.

35 Finkeldey, Bernd. "Hans Richter and the Constructivist International," in *Hans
 Richter: Activism, Modernism and the Avant-Garde,* ed. Stephen C. Foster (Cambridge:
 MIT Press, 1998) p. 96-97.

36 van Doesberg, Theo. "Abstract Filmbeelding," in *De Stijl,* vol. 4, no. 5 (1921), pp.
 71-74.

37 Hoffman, Justin. "Hans Richter: Constructivist Filmmaker," in *Hans Richter: Activism,
 Modernism and the Avant-Garde,* ed. Stephen C. Foster (Cambridge: MIT Press, 1998)
 p. 88.

38 Hoffman, Justin. "Hans Richter: Constructivist Filmmaker," in *Hans Richter: Activism,
 Modernism and the Avant-Garde,* ed. Stephen C. Foster (Cambridge: MIT Press, 1998)
 p. 86.

39 de Haas, Patrick . "Cinema: The Manipulation of Materials," in *Dada-Constructivism,*
 exhibition catalog, Annely Juda Fine Art, (London: December 1984) np.

40 Russert, Robert and Cecile Starr, *Experimental Animation* (New York; Da Capo, 1976)
 p. 53.

41 Gray, Cleve (ed.). *Hans Richter by Hans Richter* (New York: Holt, Rinehart and Winston, 1971), p. 85.

42 Duchamp, Marcel. *The Writings of Marcel Duchamp,* ed. Michael Sanouillet and Elmer Peterson, (New York: Da Capo Press, 1989), pp. 42-43.

43 Sitney, P. Adams. *Modernist Montage* (New York: Columbia University Press, 1990), p. 25.

44 Martin, Katrina. "Marcel Duchamp's Anémic Cinéma," in *Studio International* Vol. 189, no. 973 (January-February 1975) pp. 53-60.

45 Martin, Katrina. "Marcel Duchamp's Anémic Cinéma," in *Studio International* Vol. 189, no. 973 (January-February 1975) p. 54.

46 Sitney, *Op. cit.,* pp. 24-25.

47 Gray, Cleve. "The Great Spectator" interview, *Art in America,* (July-August, 1969), vol. 57, no. 4, p. 21.

48 Duchamp, Marcel. *The Writings of Marcel Duchamp,* ed. Michael Sanouillet and Elmer Peterson, (New York: Da Capo Press, 1989), p. 31

49 d'Harnoncourt, Anne, and Walter Hopps. *Etant Donnés...: 1 la chute d'eau, 2 le gaz d'eclairage: Reflections on a New Work by Marcel Duchamp,* second reprint of the Philadelphia Museum of Art Bulletin, volume LXIV, numbers 299 and 300, April-September, 1969, with the 1973 afterword by Anne d'Harnoncourt (Philadelphia: Philadelphia Museum, 1987), pp. 8-10.

50 Moholy-Nagy, Laszlo. *Painting Photography Film,* translated by Janet Seligman (Cambridge: MIT Press, 1987) pp. 33-34.

51 Schobert, Walter. *The German Avant-Garde Film of the 1920s* (Munich: Deutsches Filmmuseum, 1989) p. 54.

(NOTES TO CHAPTER 03)

1 Max Winkler, "The Origin of Film Music" in *Films in Review* vol. 11 no. 10, December 1951, pp. 34-42.

2 Lewis Jacobs, ed. "Announcement" in *Experimental Cinema* Vol. 1, No. 1 (February 1930) p. 1.

3 Sergei Eisenstein. The Film Sense, trans. Jay Leyda, (New York: Harvest/HBJ, 1975) pp. 157-158.

4 Eisenstein, Sergei. *The Film Sense,* trans. Jay Leyda (New York: Harvest/HBJ, 1975) p. 45.

5 Eisenstein, Sergei. *The Film Sense,* trans. Jay Leyda (New York: Harvest/HBJ, 1975) p. 74.

6 Eisenstein, Sergei. *The Film Sense,* trans. Jay Leyda (New York: Harvest/HBJ, 1975) p. 77.

7 Eisenstein, Sergei. *The Film Sense,* trans. Jay Leyda (New York: Harvest/HBJ, 1975) p. 79.

8 Eisenstein, Sergei. *The Film Sense,* trans. Jay Leyda (New York: Harvest/HBJ, 1975) pp. 174-216.

9 Eisenstein, Sergei. *The Film Sense*, trans. Jay Leyda (New York: Harvest/HBJ, 1975) p. 163.

10 Moritz, William. "The Importance of Being Fischinger," Ottawa International Animated Film Festival Program, 1976 pp 2-6.

11 Schobert, Walter. *The German Avant-Garde Film of the 1920s* (Munich: Deutsches Filmmuseum, 1989).

12 Moritz, William. "Visual Music and Film-as-an-Art Before 1950" in On the Edge of America: California Modernist Art, 1900–1950, ed. Paul J. Karlstrom, (Berkeley: University of California Press, 1996) p. 228.

13 Moritz, William. *Optical Poetry: The Life and Work of Oscar Fischinger* (Eastleigh: John Libbey Publishing, 2004) p. 220.

14 Moritz, William. *Optical Poetry: The Life and Work of Oscar Fischinger* (Eastleigh: John Libbey Publishing, 2004) pp. 67-74.

15 Moritz, William. *Optical Poetry: The Life and Work of Oscar Fischinger* (Eastleigh: John Libbey Publishing, 2004) p. 75.

16 Moritz, William. *Optical Poetry: The Life and Work of Oscar Fischinger* (Eastleigh: John Libbey Publishing, 2004) p. 75.

17 Moritz, William. *Optical Poetry: The Life and Work of Oscar Fischinger* (Eastleigh: John Libbey Publishing, 2004) pp. 75-76.

18 Moritz, William. *Optical Poetry: The Life and Work of Oscar Fischinger* (Eastleigh: John Libbey Publishing, 2004) pp. 76-80.

19 Moritz, William. *Optical Poetry: The Life and Work of Oscar Fischinger* (Eastleigh: John Libbey Publishing, 2004) pp. 78-79.

20 Moritz, William. *Optical Poetry: The Life and Work of Oscar Fischinger* (Eastleigh: John Libbey Publishing, 2004) pp. 74-75.

21 Moritz, William. *Optical Poetry: The Life and Work of Oscar Fischinger* (Eastleigh: John Libbey Publishing, 2004) pp. 25-28; 65-67.

22 Lukach, Joan M. *Hilla Rebay: In Search of the Spirit in Art* (New York: George Brazillier, 1983) p. 213.

23 Moritz, William. *Optical Poetry: The Life and Work of Oscar Fischinger* (Eastleigh: John Libbey Publishing, 2004) pp. 227-228.

24 Lukach, Joan M. *Hilla Rebay: In Search of the Spirit in Art* (New York: George Brazillier, 1983) p. 214.

25 Fischinger, Oskar. *Art in Cinema* (San Francisco: San Francisco Museum of Art, 1946) p. 39.

26 Russert, Robert and Cecile Starr, *Experimental Animation* (New York; Da Capo, 1976) pp. 102-105; Lauren Rabinovitz, "Mary Ellen Bute" in *Lovers of Cinema* (Madison: University of Wisconsin Press, 1995) pp. 315-334

27 Starr, Cecile. "Animation: Abstract and Concrete," *Saturday Review* (December 13, 1952) p. 48.

28 Brodsky, Warren. "Joseph Schillinger (1895—1943): Music Science Promethean," *American Music* (Spring 2003), pp. 51-54.

29 Brodsky, Warren. "Joseph Schillinger (1895—1943): Music Science Promethean," *American Music* (Spring 2003), pp. 54-55.

30 Schillinger, Joseph. *The Mathematical Basis of the Arts* (New York: Philosophical Library, 1948) p. 68.

31 Brodsky, Warren. "Joseph Schillinger (1895—1943): Music Science Promethean," *American Music* (Spring 2003), p. 55.

32 Schillinger, Joseph. "Excerpts from a Theory of Synchronization," in *Experimental Cinema* no. 5 (February, 1934), p. 30.

33 Schillinger, Joseph. "Excerpts from a Theory of Synchronization," in *Experimental Cinema* no. 5 (February, 1934), p. 30.

34 Lewis Jacobs, "Experimental Cinema in America, Part 1," Hollywood Quarterly, vol. 3, no 2, (Winter 1947-48), p. 124.

35 William Moritz. "Mary Ellen Bute: Seeing Sound," Animation World Network (May, 1996), np.

36 Rabinovitz, Lauren. "Mary Ellen Bute" in *Lovers of Cinema* (Madison: University of Wisconsin Press, 1995) p. 322.

37 Rabinovitz, Lauren. "Mary Ellen Bute" in *Lovers of Cinema* (Madison: University of Wisconsin Press, 1995) p. 326.

38 Curnow, Wystan and Roger Horrocks, eds. *Figures of Motion: Len Lye, Selected Writings* (Auckland: Auckland University Press, 1984) p. 41.

39 Curnow, Wystan and Roger Horrocks, eds. *Figures of Motion: Len Lye, Selected Writings* (Auckland: Auckland University Press, 1984) p. 41.

40 Curnow, Wystan and Roger Horrocks, eds. *Figures of Motion: Len Lye, Selected Writings* (Auckland: Auckland University Press, 1984) pp. 41-42.

41 Schillinger, Joseph. "The Destiny of Tonal Art" in *Music teachers National Association Proceedings* 1937, (New York: MTNA, 1937) pp. 31-40.

42 Horrocks, Roger. *Art that Moves: The Work of Len Lye* (Auckland: Auckland University Press, 2009).

43 Horrocks, Roger. *Art that Moves: The Work of Len Lye* (Auckland: Auckland University Press, 2009) p. 93.

44 Horrocks, Roger. *Art that Moves: The Work of Len Lye* (Auckland: Auckland University Press, 2009) pp. 48-53.

45 Curnow, Wystan and Roger Horrocks, eds. *Figures of Motion: Len Lye, Selected Writings* (Auckland: Auckland University Press, 1984) p. 47.

46 Horrocks, Roger. *Art that Moves: The Work of Len Lye* (Auckland: Auckland University Press, 2009) pp. 68-71

47 Wystan Curnow and Roger Horrocks, eds. Figures of Motion: Len Lye, Selected Writings (Auckland: Auckland University Press, 1984) p. 52.

48 Curnow, Wystan and Roger Horrocks, eds. *Figures of Motion: Len Lye, Selected Writings* (Auckland: Auckland University Press, 1984) p. 139.

49 Russert, Robert and Cecile Starr, *Experimental Animation* (New York; Da Capo, 1976) p. 68.

50 Russert, Robert and Cecile Starr, *Experimental Animation* (New York; Da Capo, 1976) p. 117.

51 Hanhardt, John G. "The Medium Viewed: The American Avant-Garde Film," in *A History of the American Avant-Garde Cinema* (New York: American Federation of the Arts, 1976) pp. 44-46.

52 Russert, Robert and Cecile Starr, *Experimental Animation* (New York; Da Capo, 1976) p. 122.

53 McLaren, Norman. "Pixillation" in *Canadian Film News* October 1953, p. 3.

54 McLaren, Norman. "Pixillation" in *Canadian Film News* October 1953, p. 3.

55 Russert, Robert and Cecile Starr, *Experimental Animation* (New York; Da Capo, 1976) p. 128.

(NOTES TO CHAPTER 04)

1 MacDonald, Scott. *Art in Cinema: Documents Towards a History of the Film Society* (Philadelphia: Temple University Press, 2010) p. 3.

2 Harry Smith is an unreliable source about his biography, and his claims to have begun making the hand-painted films in 1939 is not credible. While he was unquestionably highly inventive and intelligent since he built a wax recording device to assist in his anthropological studies of Native Americans, to accept his claims without supporting documentation would be to make a serious intentional fallacy in evaluating Smith's work.

3 MacDonald, Scott. *Art in Cinema: Documents Towards a History of the Film Society* (Philadelphia: Temple University Press, 2010) pp. 214-215.

4 There is a letter dated 7/17/1949 from Arthur Knight to Frank Stauffacher reproduced in MacDonald's anthology. The films proposed for the show did not translate well to the rasterized images of early TV, but parts of work by Frank Stauffacher, Hal McCormick, Jordan Belson and a collaboration between Leonard Tregillus and Ralph Luce were considered, but the program never happened.

5 Lukach, Joan M. *Hilla Rebay: In Search of the Spirit in Art* (New York: George Braziller, 1983) p. 221.

6 Stauffacher, Frank. "Program Notes," in *Art in Cinema,* Arno Series of Contemporary Art No 21, (New York: Arno Press, 1961) pp. 60-61.

7 There are several sources for the mechanics of the Whitney's Five Film Exercises. Lewis Jacobs, *The Rise of the American Film* (New York: Teacher's College Press, 1975) pp. 570-571; Leon Backer, "Synthetic Sound and Abstract Image" in *Hollywood Quarterly* Vol. 1. No. 1 (October 1945), pp, 95-96.

8 Perchuk, Andrew. "Struggle and Structure," in Harry Smith: The Avant-Garde in the American Vernacular, (Los Angeles: The J. Paul Getty Trust, 2010) pp. 3-7.

9 Daniel, Darrin. *Harry Smith: Fragments of a Northwest Life* (Seattle: Elbow Press, 2000) pp. 5-14.

10 Further suggestions that these dates are false is the listing of the films provided in the book edited by Paola Igliori, Harry Smith: American Magus, (New York: Inanout Press, 1996) where the individual films have dates from after 1946—while the collection as a whole is listed as being from 1939. Inconsistency of this type implies falsehood, or at least, prima facie, unreliability—thus the other non-Smith sources for dates should be considered, such as the various programs from *Art in Cinema* that suggest 1946 as the earliest possible date; coupled with Jordan Belson's recollections of him making the films in 1946 and 1947, and who also comments on Smith's tendency to make up stories, the 1939 date is even less credible.

11 "Smith, Harry" in Film-Makers' Cooperative Catalogue, no. 3, (New York: 1965) p. 57.

12 Klüver, Heinrich. *Mescal and Mechanisms of Hallucinations* (Chicago: University of Chicago Press, 1966).

13 Belson, Jordan. *Harry Smith: American Magus* ed. Paola Igliori (New York: Inanout Press, 1996) p. 23; see also the full discussion, pp.19-29.

14 Belson, Jordan. *Harry Smith: American Magus* ed. Paola Igliori (New York: Inanout Press, 1996) p. 23

15 Rani Singh, "Harry Smith: An Ethnographic Modernist in America," in Harry Smith: The Avant-Garde in the American Vernacular, (Los Angeles: The J. Paul Getty Trust, 2010) p. 35.

16 Letter quoted in Rani Singh, *Harry Smith: The Avant-Garde in the American Vernacular,* p. 34.

17 Moritz, William. "Jordan Belson: Last of the Great Masters," in Animation Journal, vol.7 no. 2 (Spring 1999) p. 4.

18 "Smith, Harry" in *Film-Makers' Cooperative Catalogue,* no. 3, (New York: 1965) p. 57.

19 Mary Ellen Bute showed both *Escape* and *Tarantella* in Series Two (4/4/1947).

20 Perchuk, Andrew. "Struggle and Structure," in Harry Smith: The Avant-Garde in the American Vernacular, (Los Angeles: The J. Paul Getty Trust, 2010) pp. 6-7.

21 Singh, Rani. "Harry Smith: An Ethnographic Modernist in America," in *Harry Smith: The Avant-Garde in the American Vernacular (Los Angeles: The J. Paul Getty Trust, 2010) p. 34.*

22 Jacobs, Lewis. "Experimental Cinema in America 1921–1947" in *The Rise of the American Film* (New York: Teacher's College Press, 1975) pp. 543-544.

23 MacDonald, Scott. *Canyon Cinema: The Life and Times of an Independent Film Distributor* (Berekley: University of California Press, 2008) pp 1-2.

24 Potter, Ralph K. "New Scientific Tools for the Arts" in *The Journal of Aesthetics and Art Criticism* vol. 10, no. 2 (December 1951) pp. 121-134.

25 Potter, Ralph K. "Sources of Stimulus: TV Commercials Often Draw on Avant-Garde Films," in *Art Direction* vol. 13, no. 9 (December 1961) p. 63.

26 MacDonald, Scott. *Cinema–16: Documents Towards a History of the Film Society* (Philadelphia: Temple University Press, 2002) p. 4.

27 Lynes, Russell. "Highbrow, Lowbrow, Middlebrow" in *Harper's Magazine* vol. 198, no. 1185 (February 1949), pp. 19-21.

28 Lynes, Russell. "Highbrow, Lowbrow, Middlebrow" in *Harper's Magazine* vol. 198, no. 1185 (February 1949), p. 25.

29 Lynes, Russell. "Highbrow, Lowbrow, Middlebrow" in *Harper's Magazine* vol. 198, no. 1185 (February 1949), p. 23.

30 Theodore F. Wolff. "John Steuart Curry: A Critical Assessment," in John Steuart Curry: Inventing the Middle West (New York: Hudson Hills Press, 1998) p. 81.

31 Calvin Tomkins. Duchamp: A Biography. (New York: Henry Holt and Company, 1996) p. 116.

32 Sue Ann Prince. "Of the Which and the Why of Daub and Smear: Chicago Critics Take on Modernism," in The Old Guard and the Avant-Garde, ed. Sue Ann Prince (Chicago: University of Chicago Press, 1990), p. 95.

33 Milosch, Jane C. "Grant Wood's Studio: A Decorative Adventure," in Grant Wood's Studio: Birthplace of American Gothic, ed. Jane C. Milosch (Cedar Rapids: Cedar Rapids Museum of Art/New York: Prestel) p. 81.

34 Bowman, Leslie Greene. American Arts and Crafts: Virtue in Design (Los Angeles: Los Angeles County Museum of Art, 1991) pp. 36-38.

35 Bing, Samuel. *Artistic America, Tiffany Glass and Art Nouveau* (Cambridge: The MIT Press, 1970) p. 6.

36 Spigel, Lynn. *TV by Design: Modern Art and the Rise of Network Television* (Chicago: University of Chicago Press, 2008).

37 Howard E. Wooden. *American Art of the Great Depression: Two Sides of the Coin* (Wichita: Wichita Art Museum, 1985).

38 Jonathan Harris. *Federal Art and National Culture: The Politics of Identity in New Deal America* (New York: Cambridge University Press, 1995).

39 *Art Digest* 7:5, December 1, 1932, p. 4.

40 Harris, Jonathan. *Federal Art and National Culture: The Politics of Identity in New Deal America* (New York: Cambridge University Press, 1995) pp. 52-55.

41 Corn, Wanda. *The Great American Thing: Modern Art and National Identity, 1915-1935* (Berkeley: University of California Press, 1999) p. xvi.

42 Dennis, James M. *Renegade Regionalists: The Modern Independence of Grant Wood, Thomas Hart Benton and John Steuart Curry* (Madison: The University of Wisconsin Press, 1998) p. 81.

43 Dennis, James M. *Renegade Regionalists: The Modern Independence of Grant Wood, Thomas Hart Benton and John Steuart Curry* (Madison: The University of Wisconsin Press, 1998) pp. 69-89.

44 Dennis, James M. *Grant Wood: Still Lives as Decorative Abstractions* (Madison: Elvehjem Museum of Art, 1985) p. 4.

45 Golden, William. *The Visual Craft of William Golden* (New York: George Braziller, 1962) p. 21.

46 Seldes, Gilbert. "Past and Present" in *Television U.S.A.: 13 Seasons* (New York: The Museum of Modern Art) p. 7.

47 Golden, William. *The Visual Craft of William Golden* (New York: George Braziller, 1962) p. 63.

48 Spigel, Lynn. *TV by Design: Modern Art and the Rise of Network Television* (Chicago: University of Chicago Press, 2008) pp. 79-82.

49 Spigel, Lynn. *TV by Design: Modern Art and the Rise of Network Television* (Chicago: University of Chicago Press, 2008) p. 83.

50 Frank Stanton, introduction in The Visual Craft of William Golden, (New York: George Braziller, 1962) p. 9.

51 Spigel, Lynn. *TV by Design: Modern Art and the Rise of Network Television* (Chicago: University of Chicago Press, 2008) p. 227.

52 Seldes, Gilbert. "Past and Present" in *Television U.S.A.: 13 Seasons* (New York: The Museum of Modern Art) pp. 8-10

53 Seldes, Gilbert. "Past and Present" in *Television U.S.A.: 13 Seasons* (New York: The Museum of Modern Art) pp. 10-11.

54 Sidney Peterson. *The Dark of the Screen* (New York: Anthology Film Archives, 1980) p. 128.

55 The Museum of Modern Art identifies *Architectural Millinery* as having been produced in 1952; all other sources date the film to 1954.

56 Spigel, Lynn. *TV by Design: Modern Art and the Rise of Network Television* (Chicago: University of Chicago Press, 2008) p. 161.

57 Whitney, John. *Digital Harmony: On the Complementarity of Music and Visual Art* (Peterborough, Byte Books, 1980) p. 156.

58 Whitney, John. *Digital Harmony: On the Complementarity of Music and Visual Art* (Peterborough, Byte Books, 1980) p. 158.

59 Whitney, John. *Digital Harmony: On the Complementarity of Music and Visual Art* (Peterborough, Byte Books, 1980) pp. 140-142.

60 Sutton, Gloria. "Stan VanDerBeek: Collage Experience" in *Stan VanDerBeek The Culture Intercom* (Houston: Contemporary Arts Museum Houston/MIT List Visual Arts Center, 2011) pp. 78-87.

61 Currie, Hector and Michael Porte eds. *Cinema Now* (Cincinnati: University of Cincinnati Perspectives on American Underground Film, 1967) p. 16.

62 Spigel, Lynn. *TV by Design: Modern Art and the Rise of Network Television* (Chicago: University of Chicago Press, 2008) quoted on p. 217-218.

63 Golden, William. *The Visual Craft of William Golden* (New York: George Braziller, 1962) p. 61.

64 Potter, Ralph K. "Aimed Design: If 'freedom' is the word for the press, the word for TV is 'conformity'," in *Art Direction* vol. 11 April 1959, p. 70.

65 Minow, Newton N. "Television and the Public Interest," speech to the National Association of Broadcasters, delivered May 9, 1961, in Washington DC.

(NOTES TO CHAPTER 05)

1 Greenberg, Clement. "Modernist Painting" in *Clement Greenberg: The Collected Essays and Criticism, Volume 4* ed. John O'Brian (Chicago: University of Chicago Press, 1993) p. 85.

2 Greenberg, Clement. "Modernist Painting" in *Clement Greenberg: The Collected Essays and Criticism, Volume 4* ed. John O'Brian (Chicago: University of Chicago Press, 1993) p. 86.

3 Greenberg, Clement. "Modernist Painting" in *Clement Greenberg: The Collected Essays and Criticism, Volume 4* ed. John O'Brian (Chicago: University of Chicago Press, 1993) p. 94.

4 Spigel, Lynn. *TV by Design: Modern Art and the Rise of Network Television* (Chicago: University of Chicago Press, 2008) p. 156.

5 Sitney, P. Adams. *Visionary Film: The American Avant-Garde 1943 – 1978* (Second Edition), (New York: Oxford University Press, 1979) p. 370.

6 Cavell, Stanley. *The World Viewed: Reflections on the Ontology of Film* (Enlarged Edition), (Cambridge: Harvard University Press, 1971, 1974, 1979).

7 Hanhardt, John. "The Medium Viewed: The American Avant-Garde Film," in *A History of the American Avant-Garde Cinema* (New York: The American Federation of the Arts, 1976) p. 22.

8 Reed, Dennis. *Hy Hirsh: Color Photographs* (San Francisco: Paul M. Hertzmann, 2008).

9 Peterson, Sidney unpublished letter, quoted in Dennis Reed, Hy Hirsh: Color Photographs, (San Francisco: Paul M. Hertzmann, 2008) p. 2.

10 William Moritz, "Hy Hirsh," in Articulated Light: The Emergence of Abstract Film in America, (Cambridge: Harvard Film Archive, 1995) p. 12.

11 Arthur, Paul. "The Western Edge: Oil of L.A. and the Machined Image," in *Millennium Film Journal* no. 12 (1982).

12 James, David. "Interview with Pat O'Neill," in *Millennium Film Journal* no. 30/31 (1997).

13 Curtis, David. *The Experimental Film: A Fifty-year Evolution* (New York: Delta, 1971).

14 Arthur, Paul. "Permanent Transit: The Films of Pat O'Neill" in *Views from Lookout Mountain* (Santa Monica: Santa Monica Museum of Art, 2004) pp. 66-75.

15 James, David. "Interview with Pat O'Neill," in *Millennium Film Journal* no. 30/31 (1997).

16 *Canyon Cinema Catalog* no. 8, (2000), p. 322.

17 James, David. "Interview with Pat O'Neill," in Millennium Film Journal, no. 30/31 (1997).

18 Mekas, Jonas. *Film Culture* no. 40 (Spring, 1966).

19 Youngblood, Gene. *Expanded Cinema* (New York: Dutton, 1970) p. 41.

20 Youngblood, Gene. *Expanded Cinema* (New York: Dutton, 1970) p. 54.

21 Youngblood, Gene. *Expanded Cinema* (New York: Dutton, 1970) pp. 352-374.

22 Lukach, Joan M.. *Hilla Rebay; In Search of the Spiritual in Art* (New York: George
 Braziller, 1983) p. 214.

23 Adams, Junius. liner notes to *Highlights of Vortex* (New York: Folkways Records,
 Album No. FSS 6301, 1959) np.

24 Adams, Junius. liner notes to *Highlights of Vortex* (New York: Folkways Records,
 Album No. FSS 6301, 1959) np.

25 *Vortex 4* program notes for shows on May 12, 13, 19 & 20, 1958; transcribed by
 Barbara Golden, 4/95 for the History of Experimental Music in Northern
 California website: www.o-art.org/history/50s&_60s/Vortex/Vortex_4.html.

26 *Vortex 5* program notes for shows on January 12 & 13 19 & 20 26 & 27, 1959;
 transcribed by Barbara Golden, 4/95 for the History of Experimental Music in
 Northern California website:
 www.o-art.org/history/50s&_60s/Vortex/Vortex_4.html.

27 Youngblood, Gene. *Expanded Cinema* (New York: Dutton, 1970) p. 389.

28 Youngblood, Gene. *Expanded Cinema* (New York: Dutton, 1970) p. 173.

29 Bauman, Norman. "Five-year Guaranty" in *Cybernetic Serendipity* (New York: Praeger,
 1968) pp. 42-43.

30 Shigeko Kubota, "Anthology Film Archives Video Program; From Film to Video" in
 Ira Schneider and Beryl Korot eds, *Video Art: An Anthology* (New York: Harcourt,
 1976) p. 150.

31 Antin, David. "Video: The Distinctive Features of the Medium" in Ira Schneider and
 Beryl Korot eds, *Video Art: An Anthology* (New York: Harcourt, 1976) p. 174.

32 Seldes, Gilbert. "Past and Present" in *Television U.S.A.: 13 Seasons* (New York: The
 Museum of Modern Art) p. 13.

33 Leonard Dodge Barry's inventions relating to the early videotape recorders produced
 by the Ampex corporation were filed starting with US Patent application Serial no.
 292,013 on May 27, 1952; the final patent issued was no. 3,320,370, in 1967. The
 technology was sufficiently new and innovative that later developments refined
 earlier applications even before they had been granted.

34 Antin, David. "Video: The Distinctive Features of the Medium" in Ira Schneider and
 Beryl Korot eds, *Video Art: An Anthology* (New York: Harcourt, 1976) p. 176.

35 Antin, David. "Video: The Distinctive Features of the Medium" in Ira Schneider and
 Beryl Korot eds, *Video Art: An Anthology* (New York: Harcourt, 1976) pp. 180-181

36 Burris, Jon. "Did the Portapak Cause Video Art? Notes on the Formation of a New
 Medium," in *Millennium Film Journal* no.29, Fall 1996, pp. 3-30.

37 Burris, Jon. "Did the Portapak Cause Video Art? Notes on the Formation of a New
 Medium," in *Millennium Film Journal* no.29, Fall 1996, p. 5.

38 Youngblood, Gene. "Hardware" in Radical Software vol. 1, no. 1 (Spring 1970), p. 1.

39 Nam June Paik, "Input-Time and Output-Time" in Ira Schneider and Beryl Korot,
 Video Art: An Anthology (New York: Harcourt, 1976) p. 98.

40 Antin, David. "Video: The Distinctive Features of the Medium" in Ira Schneider and
 Beryl Korot eds, *Video Art: An Anthology* (New York: Harcourt, 1976) p. 178.

41 Antin, David. "Video: The Distinctive Features of the Medium" in Ira Schneider and
 Beryl Korot eds, *Video Art: An Anthology* (New York: Harcourt, 1976) p. 181.

42 Fifield, George. *The Paik/Abe Synthesizer* p. 2.

43 Youngblood, Gene. *Expanded Cinema* (New York: Dutton, 1970) pp. 318-320.

44 Fifield, George. *The Paik/Abe Synthesizer* p. 1.
 http://davidsonsfiles.org/paikabesythesizer.html

45 Lynn Spigel, TV by Design: Modern Art and the Rise of Network Television,
 (Chicago: University of Chicago Press, 2008).

46 Atwood, David. *Nam June Paik and the Videosynthesizer* unpublished manuscript, pp.
 2-3.

47 George Fifield, The Paik/Abe Synthesizer, p. 3.
 http://davidsonsfiles.org/paikabesythesizer.html

48 Atwood, David. *Nam June Paik and the Videosynthesizer* unpublished manuscript, pp. 3.

49 Hays, Ron. *Report of Activities: June 1972 through January 1974* grant report to the
 Rockefeller Foundation and National Endowment for the Arts, 1974, p. 1.

50 Atwood, David. *Nam June Paik and the Videosynthesizer* unpublished manuscript, pp. 4.

51 Ron Hays, Report of Activities: June 1972 through January 1974, grant report to the
 Rockefeller Foundation and National Endowment for the Arts, 1974, p. 7.

52 Ron Hays, Report of Activities: June 1972 through January 1974, grant report to the
 Rockefeller Foundation and National Endowment for the Arts, 1974, p. 8.

53 Ron Hays, Report of Activities: June 1972 through January 1974, grant report to the
 Rockefeller Foundation and National Endowment for the Arts, 1974, p. 8.

54 Sieg, Dave. "Scanimation in the Analog Days," *ACM Siggraph* vol. 32, no 3., August
 1998.

55 Sieg, Dave. "Scanimation in the Analog Days," *ACM Siggraph* vol. 32, no 3., August
 1998.

(NOTES TO CHAPTER 06)

1 Fetter. William A. *Computer Graphics in Communication* (New York: McGraw-Hill,
 1965).

2 Utterson, Andrew. *From IBM to MGM: Cinema at the Dawn of the Digital Age* (London:
 British Film Institute, 2011).

3 Levy, Steven. *Hackers: Heroes of the Computer Revolution* (New York: Penguin, 1994) pp.
 39-49.

4 Noll, A. Michael. "Computers and the Visual Arts," offprint from *Design and Planning*,
 number 2, nd., np.

5 Goodman, Cynthia. *Digital Visions: Computers and Art* (New York: Abrams, 1987).

6 Noll, A. Michael. "Human or Machine a Subjective Comparison of Piet Mondrian's
 'Composition with Lines' (1917) and a Computer-Generated Picture" offprint from
 The Psychological Record vol. 16, no. 1, January 1966, pp. 9-10.

7 Lippard, Lucy. *The Dematerialization of the Art Object from 1966 to 1972* (Berkeley: University of California Press, 1997) p. 25.

8 Yoko Ono. *Instruction Paintings* (New York: Weatherhill, 1995).

9 Goodman, Cynthia. *Digital Visions: Computers and Art* (New York: Abrams, 1987) pp. 23-30.

10 Nelson Max and John Blunden, "Optical Printing in Computer Animation," ACM Siggraph, 1980 pp. 172-173.

11 Fielding, Raymond. *The Technique of Special Effects Cinematography* (Oxford: Focal Press, 1984) pp. 405-406.

12 Fielding, Raymond. *The Technique of Special Effects Cinematography* (Oxford: Focal Press, 1984) p. 406.

13 Knowlton, Kenneth C. and W. H. Higgins, "Programming Languages for Computer Animation" in *Computer Animation* (New York: Focal Press, 1974) p. 44.

14 Goodman, Cynthia. *Digital Visions: Computers and Art* (New York: Abrams, 1987) pp. 154-155.

15 Goodman, Cynthia. *Digital Visions: Computers and Art* (New York: Abrams, 1987) p. 155.

16 Reichard, Jasia. *Computers in Art* (New York: Dutton, 1971) pp. 77-78.

17 Knowlton, Kenneth C. contribution to Carl Machover, "Computer Graphics Pioneers," (SIGGRAPH) *Computer Graphics* vol. 35, no. 3, August 2001, pp. 20-22.

18 Knowlton, Kenneth C. contribution to Carl Machover, "Computer Graphics Pioneers," (SIGGRAPH) *Computer Graphics* vol. 35, no. 3, August 2001, pp. 20-22.

19 Knowlton, Kenneth C. and W.H. Higgins, "Programming Languages for Computer Animation" in Computer Art (New York: Focal Press, 1974) p. 47.

20 Sutton, Gloria. "Stan VanDerBeek: Collage Experience" in *Stan VanDerBeek The Culture Intercom* (Houston: Contemporary Arts Museum Houston/MIT List Visual Arts Center, 2011) pp. 80-83.

21 "Stan VanDerBeek CV" in *Stan VanDerBeek The Culture Intercom* (Houston: Contemporary Arts Museum Houston/MIT List Visual Arts Center, 2011) p. 115.

22 Knowlton, Kenneth C. "Computer-Animated Movies" in Cybernetic Serendipity (New York: Praeger, 1968) p. 67.

23 Stan VanDerBeek. "New Talent—The Computer" in Art in America, vol. 58 (1970) pp. 91.

24 Schwartz, Lillian. *The Computer Artist's Handbook* (New York: Norton, 1992) pp. 152-153.

25 Whitney, John. *Digital Harmony: On the Complementarity of Music and Visual Art* (Peterborough, Byte Books, 1980) p. 15.

26 Utterson, Andrew. *From IBM to MGM: Cinema at the Dawn of the Digital Age* (London: British Film Institute, 2011) pp. 84-85.

27 Whitney, John. *Digital Harmony: On the Complementarity of Music and Visual Art* (Peterborough, Byte Books, 1980) p. 159.

28 John Whitney. Digital Harmony (Peterborough: McGraw-Hill, 1980) p. 5.

29 Whitney, John. "Permutations" in *Cybernetic Serendipity* (New York: Praeger, 1968) p. 65.

30 Whitney, John. *Digital Harmony: On the Complementarity of Music and Visual Art* (Peterborough, Byte Books, 1980) p. 38.

31 Michael Whitney, "The Whitney Archive: A Fulfillment of a Dream" in Animation World Magazine, Issue 2.5, August 1997.

32 Youngblood, Gene. "Calculated Movements: An Interview with Larry Cuba" in Video and the Arts Magazine, (Winter 1986).

33 Manovich, Lev. *The Language of New Media* (New Haven: The MIT Press, 2002) pp. 269-273.

34 VanDerBeek, Stan. "Compound Entendre" in *Film: A Montage of Theories* ed. Richard Dyer MacCann (New York: Dutton, 1966) p. 331.

35 *Mindi Lipschultz interviewed by The Compulsive Creative* May 2004, www.compulsivecreative.com/interview.php?intid=12, quoted in Lev Manovich, "After Effects, or the Velvet Revolution" in Millennium Film Journal nos. 45/46, Fall 2006 pp. 7-8.

36 Will Alexander quoted in Steven Dupler, "Breakthrough from Fairlight: Computer Video Device Bows" in *Billboard* November 3, 1984, p. 52

37 Robbins, David. "Introduction" in *Motion by Design* ed. Spencer Drate, David Robbins and Judith Salavetz (London: Lawrence King Publishing, 2006) p. 10.

(NOTES TO CHAPTER 07)

1 Musser, Charles. *Edison Motion Pictures, 1890–1900: An Annotated Filmography.*

2 see Chapter 3 for a full discussion of Oskar Fischinger's problematic attempt to create titles for Paramount; the abortive sequence would become a stand alone film, Allegretto (1936), that Fischinger would release in 1941 after buying the color negative for his animation from Paramount. Had his title sequence been used it would have provided a direct precedent for the designer-produced title sequences of the 1950s and 1960s.

3 See *Library of Congress* call number FEA 5523 (reference print).

4 Transcript from the film *Bass on Titles* directed by Saul Bass, 1977.

5 Solana, German, Antonio Borneu. *Uncredited: Graphic Design and Opening Titles in Movies* (Indexbooks, Barcelona, 200)1.

6 Kirkham, Pat. "Reassessing the Saul Bass and Alfred Hitchcock Collaboration," in *West 86th* vol. 18. no. 1 (Spring-Summer 2011) p. 54.

7 Kirkham, Pat. "Reassessing the Saul Bass and Alfred Hitchcock Collaboration," in *West 86th* vol. 18. no. 1 (Spring-Summer 2011) p. 66

8 Haskin, Pamela. "Saul, Can You Make Me a Title?: Interview with Saul Bass," in *Film Quarterly* vol. 50, no. 1 (Autumn 1996) pp. 10-17.

9 Kirkham, Pat. "Reassessing the Saul Bass and Alfred Hitchcock Collaboration," in *West 86th* vol. 18. no. 1 (Spring-Summer 2011) p. 73.

10 Kirkham, Pat. "Reassessing the Saul Bass and Alfred Hitchcock Collaboration," in
 West 86th vol. 18. no. 1 (Spring-Summer 2011) pp. 50-85.

11 West, D. "Nina Saxon Design, One of Entertainment Industry's Leading Film
 Design Studios, Completes Sequences for "Rum Diary," "Yellow Handkerchief"
 and "Dear John," in *Millimeter* March 29, 2010;
 http://blog.digitalcontentproducer.com/briefingroom/2010/03/29/nina-saxon-de
 sign-one-of-entertainment-industrys-leading-film-design-studios-completes-sequenc
 es-for-rum-diary-yellow-handkerchief-and-dear-john/ accessed May 2, 2010.

12 Warhol, Andy. *The Philosophy of Andy Warhol* (San Diego: Harvest, 1977), pp. 100-101.

13 Rex Weiner, "Title card change: RGA/LA becomes Imaginary Forces," in *Variety*
 December 1, 1996;
 www.variety.com/vstory/VR1117435870.html?categoryid=38&cs=1.

(NOTES TO CHAPTER 08)

1 Golden, Cipe Pineles, Kurt Weihs and Robert Strunsky, eds, *The Craft of William
 Golden* (New York: George Braziller, 1962) p. 155.

2 Golden,William. unpublished report, "The Background of Consumer Advertizing"
 (c. 1957), quoted in Lynn Spigel, TV by Design, p. 89.

3 Duchamp, Marcel. *The Writings of Marcel Duchamp* ed. Michael Sanouillet and Elmer
 Peterson, (New York: Da Capo Press, 1989), p. 32.

4 "The Use of Symbols in Visual Communications," (advertisement for conference), in
 Art Direction, vol. 11 no. 4 (April 1959) p. 135.

5 Eco, Umberto. *The Limits of Interpretation* (Indianapolis: University of Indiana Press,
 1994) p. 91.

6 The feature-length film based on David Lynch's TV series premiere, *Fire Walk With
 Me* (1990) does not include the same titles as the TV show; instead, its title
 sequence more closely resembles the opening of an earlier film directed by Lynch,
 Blue Velvet (1986).

7 "Federal Communications Commission Fact Sheet: Cable Television Information
 Bulletin," June 2000, http://www.fcc.gov/mb/facts/csgen.html accessed May 2,
 2011.

8 *Epicentergames.com,* "Kyle Cooper Interview," on Metal Gear Solid: The Unofficial Site,
 http://www.metalgearsolid.org/features/kyle-cooper-interview, accessed April 12,
 2011.

(NOTES TO CHAPTER 09)

1 Brakhage, Stan. "Metaphors on Vision" in *Film Culture* no. 30, 1963, np (17; as MoV
 is unpaginated, approximate numbers were found by counting the first page as 1
 and continuing to the end).

2 Brakhage, Stan. "Metaphors on Vision" in *Film Culture* no. 30, 1963, np (23-24).

3 Brakhage, Stan. "Metaphors on Vision" in *Film Culture* no. 30, 1963, np (18).

4 Brakhage, Stan. "Metaphors on Vision" in *Film Culture* no. 30, 1963, np (66).

5 "Stan Brakhage," *Canyon Cinema Catalog* no. 8, 2000, p. 73.

6 Haller, Robert. *First Light* p. 81.

7 Woolman, Matt. *Sonic Graphics, Seeing Sound* (New York: Rizzoli, 2000) p. 142.

8 Miller, Dennis. Seven Animations DVD, (Los Angeles: Iota Center, 2006).

9 Finkelstein, David. "Seven Animations" in Film Threat, 2009-01-09;
 www.filmthreat.com/reviews/10794/.

10 Collopy, Fred. "As Visual Music Reasserts Itself as a Performance Art." January 23,
 2006, p. 4.

11 Woolman, Matt. *Sonic Graphics, Seeing Sound* (New York: Rizzoli, 2000) pp. 40-41.

12 Collopy, Fred. "Color Form and Motion, Dimensions of a Musical Art of Light" in
 Leonardo vol. 34 no. 4, p. 356.

13 Collopy, Fred. "Color Form and Motion, Dimensions of a Musical Art of Light" in
 Leonardo vol. 34 no. 4, p. 353.

14 Levin, Golan. *Painterly Interfaces for Audio-Visual Performance*, Master of Science thesis
 submitted to MIT, May 1994, p. 116.

15 Drate, Spencer, David Robbins and Judith Salavetz eds. *Motion by Design* (London:
 Lawrence King Publishing, 2006) p. 36.

SELECT
BIBLIOGRAPHY

Backer, Leon. "Synthetic Sound and Abstract Image" in *Hollywood Quarterly*, Vol. 1. No. 1 (October 1945)

Bing. Samuel. *Artistic America, Tiffany Glass and Art Nouveau,* (Cambridge: The MIT Press, 1970)

Bock, Hans-Michael and Tim Bergfelder, eds. *The Concise Cinegraph: The Encyclopaedia of German Cinema,* (Berghahn Books, 2009)

Bowman, Leslie Greene. *American Arts and Crafts: Virtue in Design* (Los Angeles: Los Angeles County Museum of Art, 1991)

Brodsky, Warren. "Joseph Schillinger (1895—1943): Music Science Promethean," *American Music* (Spring 2003)

van Campen, Cretien. "Synaesthesia and Artistic Experimentation," *Psyche,* 3(6), November 1997

d'Harnoncourt, Anne, and Walter Hopps. *Etant Donnés…: 1 la chute d'eau, 2 le gaz d'eclairage: Reflections on a New Work by Marcel Duchamp,* second reprint of the Philadelphia Museum of Art *Bulletin*, volume LXIV, numbers 299 and 300, April-September, 1969, with the 1973 afterword by Anne d'Harnoncourt (Philadelphia: Philadelphia Museum, 1987)

Danchev, Alex. *100 Artists' Manifestoes: From the Futurists to the Stuckists* (New York: Penguin, 2011).

Darrin Daniel, *Harry Smith: Fragments of a Northwest Life,* (Seattle: Elbow Press, 2000)

Dann, Kevin T. *Bright Colors Falsely Seen* (New Haven: Yale, 1998)

DeAngelis, Gina. *Motion Pictures: Making Cinema Magic (Innovators, 11),* (Minneapolis: Oliver Press, 2004)

de Haas, Patrick. "Cinema: The Manipulation of Materials," in *Dada-Constructivism,* exhibition catalog, Annely Juda Fine Art, (London: December 1984)

van Doesberg, Theo. "Abstract Filmbeelding," in *De Stijl*, vol. 4, no. 5 (1921)

Duchamp, Marcel. *The Writings of Marcel Duchamp,* ed. Michael Sanouillet and Elmer Peterson, (New York: Da Capo Press, 1989)

Eisenstein, Sergei. *Film Form*, trans. Jay Leyda, (New York: Harvest/HBJ, 1975)

_____. *The Film Sense*, trans. Jay Leyda, (New York: Harvest/HBJ, 1975)

Fielding, Raymond. *The Technique of Special Effects Cinematography*, (Oxford: Focal Press, 1984)

Foster, Stephen C., ed. *Hans Richter: Activism, Modernism and the Avant-Garde*, (Cambridge: MIT Press, 1998)

Fry, Roger. *Vision and Design*, (London: Pelican Books, 1937)

Galeyev, Bulat. "Open Letter on Synaesthesia" in *Leonardo*, vol. 34, no. 4, 2001

Golden, William. *The Visual Craft of William Golden*, (New York: George Braziller, 1962)

Goodman, Cynthia. *Digital Visions: Computers and Art* (New York: Abrams, 1987).

Gray, Cleve Ed. *Hans Richter by Hans Richter* (New York: Holt, Rinehart and Winston, 1971)

Greenberg, Clement. *The Collected Essays and Criticism: Vol. 4*, (Chicago: University of Chicago Press, 1955)

Harris, Jonathan. *Federal Art and National Culture: The Politics of Identity in New Deal America* (New York: Cambridge University Press, 1995)

Horrocks, Roger. *Art that Moves: The Work of Len Lye*, (Auckland: Auckland University Press, 2009)

Horrocks, Roger and Wystan Curnow, eds. *Figures of Motion: Len Lye, Selected Writings* (Auckland: Auckland University Press, 1984)

Igliori, Paola ed. *Harry Smith: American Magus*, (New York: Inanout Press, 1996)

Ione, Amy and Christopher Tyler. "Is F-Sharp Colored Violet?," *Journal of the History of the Neuroscience 2004*, vol. 13, no. 1

Jacobs, Lewis. "Experimental Cinema in America, Part 1," *Hollywood Quarterly*, vol. 3, no 2, (Winter 1947-48)

_____, ed. *Experimental Cinema*, Vol. 1, No. 1 (February 1930)

_____. "Experimental Cinema in America 1921–1947" in *The Rise of the American Film*, (New York: Teacher's College Press, 1975)

Kandinsky, Vassily. Concerning the Spiritual in Art, (New York: Dover, 1977)

Kepes, Gyorgy ed. *The Nature and Art of Motion*, (New York: George Brazillier, 1965)

Kircher, Athanasius. *Musurgia Universalis*, (Rome, 1650) facsimile edition, (New York: George Olms Verlag, 1970)

Kuenzli, Rudolf E. ed. *Dada and Surrealist Film*, (Cambridge: MIT Press, 1996)

Lawder, Standish. *The Cubist Cinema* (New York: Anthology Film Archives, 1980).

Leitner, Angelika and Uwe Nitschke, eds. *The German Avant-Garde Film of the 1920s*, (Munich: Goethe Institute, 1989)

Levy, Steven. *Hackers: Heroes of the Computer Revolution* (New York: Penguin, 1994)

Joan M, Lukach, *Hilla Rebay: In Search of the Spirit in Art*, (New York: George Brazillier, 1983)

Lynes, Russell. "Highbrow, Lowbrow, Middlebrow" in *Harper's Magazine*, vol. 198, no. 1185 (February 1949)

MacDonald, Scott. *Cinema–16: Documents Towards a History of the Film Society*, (Philadelphia: Temple University Press, 2002)

———. *Canyon Cinema: The Life and Times of an Independent Film Distributor*, (Berekley: University of California Press, 2008)

———. *Art in Cinema: Documents Towards a History of the Film Society*, (Philadelphia: Temple University Press, 2010)

McLaren, Norman. "Pixillation" in *Canadian Film News* October 1953

Malina, Frank J. ed. *Kinetic art: Theory and Practice*, (New York: Dover, 1974)

Futurist Manifestos, (New York: Art works, 2001)

Martin, Katrina. "Marcel Duchamp's *Anémic Cinéma*," in *Studio International* Vol. 189, no. 973 (January-February 1975)

Miller, Dorothy C. "Thomas Wilfred" in *15 Americans* (New York: The Museum of Modern Art, 1950)

Minow, Newton N. "Television and the Public Interest," speech to the National Association of Broadcasters, delivered May 9, 1961

Moholy-Nagy, Laszlo. *Painting Photography Film*, translated by Janet Seligman (Cambridge: MIT Press, 1987)

Moritz. William. "Mary Ellen Bute: Seeing Sound," *Animation World Network* (May, 1996)

———. "Visual Music and Film-as-an-Art Before 1950," in *On the Edge of America: California Modernist Art, 1900–1950*, Paul J. Karlstrom, ed. (Berkeley: University of California Press, 1996)

———. *Optical Poetry: The Life and Work of Oscar Fischinger*, (Eastleigh: John Libbey Publishing, 2004)

———. "The Importance of Being Fischinger," *Ottawa International Animated Film Festival Program*, 1976

Norden, Martin F. "The Avant-Garde Cinema of the 1920s: Connections to Futurism, Precisionism and Suprematism," in *Leonardo*, vol. 17, no. 2

Peterson, Sidney. *The Dark of the Screen* (New York: Anthology Film Archives, 1980)

Posner, Bruce, ed. *Unseen Cinema*, (New York: Cineric, 2001)

Potter, Ralph K. "New Scientific Tools for the Arts" in *The Journal of Aesthetics and Art Criticism,* vol. 10, no. 2 (December 1951)

_____. "Aimed Design: If 'freedom' is the word for the press, the word for TV is 'conformity'," in *Art Direction,* vol. 11 April 1959

_____. "Sources of Stimulus: TV Commercials Often Draw on Avant-Garde Films," in *Art Direction,* vol. 13, no. 9 (December 1961)

Rabinovitz, Lauren. "Mary Ellen Bute" in *Lovers of Cinema,* (Madison: University of Wisconsin Press, 1995)

Reichardt, Jasia. *Cybernetic Serendipity* (New York: Praeger, 1968).

_____. The Computer in Art (New York: Van Rorstrand, 1971).

Rimington, A. Wallace. Colour Music, (Holicong: Wildside Press, 2004)

Robert Russert and Cecile Starr, *Experimental Animation* (New York; Da Capo, 1976)

Schillinger, Joseph. "The Destiny of Tonal Art" in *Music teachers National Association Proceedings, 1937,* (New York: MTNA, 1937)

Schobert, Walter. *The German Avant-Garde Film of the 1920s,* (Munich: Deutsches Filmmuseum, 1989)

Seldes, Gilbert. "Past and Present" in *Television U.S.A.: 13 Seasons* (New York: The Museum of Modern Art)

Singh, Rani, ed. *Harry Smith: The Avant-Garde in the American Vernacular,* (Los Angeles: The J. Paul Getty Trust, 2010)
Sitney, P. Adams. *Modernist Montage,* (New York: Columbia University Press, 1990)

Spigel, Lynn. *TV by Design: Modern Art and the Rise of Network Television,* (Chicago: University of Chicago Press, 2008)

Stauffacher, Frank. "Program Notes," in *Art in Cinema, Arno Series of Contemporary Art No 21,* (New York: Arno Press, 1961)

Starr, Cecile. "Animation: Abstract and Concrete," *Saturday Review* (December 13, 1952)

Whitney, John. *Digital Harmony: On the Complementarity of Music and Visual Art,* (Peterborough, Byte Books, 1980)

Wooden, Howard E. *American Art of the Great Depression: Two Sides of the Coin,* (Wichita: Wichita Art Museum, 1985)

INDEX

Lightning Source UK Ltd.
Milton Keynes UK
UKOW03f0646260914

239162UK00001BA/66/P